Journey to Portugal

José Saramago

Journey to Portugal

IN PURSUIT OF PORTUGAL'S
HISTORY AND CULTURE

———

*Translated from
the Portuguese and with notes by
Amanda Hopkinson and Nick Caistor*

HARCOURT, INC.
NEW YORK SAN DIEGO LONDON

Requests for permission to make copies of any part of the work should be mailed to the following address: Permissions Department, Harcourt, Inc., 6277 Sea Harbor Drive, Orlando, Florida 32887-6777.

www.harcourt.com

This is a translation of *Viagem a Portugal*

Illustrations, as listed on pages ix-x herein, © Pedro Baptista (1999), Centro Português de Fotografía, Centro Doc, e Informação/Diário de Notícias, Câmara Municipal de Lisboa, Dorothy Bohm, José Afonso Furtado/Fundação Calouste Gulbenkian, Luisa Ferreira, Juno

The maps have been drawn by Reginald Piggott

Library of Congress Cataloging-in-Publication Data
Saramago, José
[Viagem a Portugal. English]
Journey to Portugal/José Saramago: translated from the Portuguese and with notes by Amanda Hopkinson and Nick Caistor.—1st U.S. ed.
p. cm.
Includes index.
ISBN 0-15-100587-7
1. Portugal—Description and travel. I. Hopkinson, Amanda, 1948–
II. Caistor, Nick. III. Title.
DP526.5 .S2713 2001
914.6904'44—dc21 00-053613

Text set in Sabon
Designed by Libanus Press, Marlborough, Wiltshire, England

First U.S. edition
A C E G I K J H F D B

Printed in the United States of America

To the one who opened doors for me
and showed me the way –
and also in memory of
Almeida Garrett, master-traveller

CONTENTS

LIST OF ILLUSTRATIONS

MAPS

PHOTOGRAPH CREDITS

Fig 1, 13, 16, 18, 26, 30, 31, 41, 43, 45, 46, 47, 63 Alvão & Co/Centro Português de Fotografía
Fig 2, 3, 4, 5, 7, 8, 9, 10, 11, 12, 14, 15, 17, 19, 20, 21, 22, 23, 24, 25, 27, 29, 33, 34, Pedro Baptista
Fig 6, 28, 38, 39, 42, 48, 61, 69, 70, 71, 72, José Afonso Furtado
Fig 32, 37, 59, 62 Luisa Ferreira
Fig 35, 40, 52, 54, 58, 65, 66, 68, Centro Doc. Informação/Diário de Notícias
Fig 36, 60, 64 Juno
Fig 44, 53, 67, 73, 74 Dorothy Bohm
Fig 49, 50, 51, 55, 56, 57 Câmara Municipal de Lisboa/Arquivo Histórico

Author's Preface to the English Edition

Exactly twenty years have gone by. It was in the autumn of 1979 that I left Portugal, crossing the border at Valença do Minho into the Galician countryside. I wanted the title I had already chosen for my book – *Journey to Portugal* – to obtain its fullest meaning from my very first step and word onwards, for it has to be said that a journey *to* a country must always involve starting from beyond its frontiers. Once undertaken, the journey obviously has to take place *in* and *through* Portugal, and so what was clear to me from the outset should be equally apparent to readers from the moment they set eyes on the book, from its title. For four days I amused myself travelling through the provinces of Galicia and León, staying in towns and villages as though they and nowhere else were the true objects of my journey. It was only on the fifth day that I decided to cross into Portugal, entering from Zamora and the Rio Douro. There I preached a sermon to the fishes, in imitation of St Anthony and of Father Antonio Vieira, as the first chapter comprehensively explains, and so at last came into Portugal.

Where journeys are concerned, insisting on the difference between an *in* and a *through* and a *to* is something much more profound than a play on words or a simple vocabulary exercise. In determining to journey *to* Portugal, the task I was setting myself would require me to leave out any number of things seen and people met; to discount assumptions derived from superficial encounters; forfeit the routine of tourist guides and everyday maps as the one way in to the history and culture of my country. Twenty years on, I am not so sure I was successful, or at least to the extent I thought I was. Even so, perhaps the perceptive reader can observe, here and there, in the odd felicitous moment of my account, an occasional indication that, at best, it constituted the most ambitious project to which I could have aspired: to write a book on Portugal that could not in any respect be confused with any other, a book capable of offering a fresh way of looking, a new way of feeling. (Let us be tolerant

and pardon the author this imprudent spirit, this delirium of will and imagination . . .)

During the lengthy voyage that took nearly six months, the conviction was born in me that in every place I passed through there was a piece of old Portugal bidding farewell to the traveller I was, an ancient Portugal which was beginning, finally, while still doubting whether it wanted to or not, to move towards the twentieth entury. It was like those long, distant Lusitanian ages where, in comparison to any other calendar in Europe (an eighteenth century that ran until the middle of the nineteenth, a twentieth century that only now seemed on the brink of noticing that there weren't another hundred years left to it . . .) there was a sensation of so much that was being tugged onwards by a Time tired of waiting. Sometimes afterwards, as I tried to set down, word by word, the memory of what I'd seen, heard and felt during the journey, I began to think that in some sense I must be writing a sort of last will and testament, an inventory, a list of what had been salvaged, a long farewell.

A mere tourist guide was what I least wanted the *Journey to Portugal* to become, any more than I wished the intervening years to have passed by. Some things described here have either ceased to exist or are no longer immediately recognisable. Landscapes have been transformed, as have towns and their architecture; tastes and ways of life have changed. But this book should not be read as a melancholy journey into the past. Instead the reader should bear in mind the principle which guided the traveller at every step and on every page: a pursuit of Portugal's history and culture. Guided by this principle, there's no chance of losing the way.

J. S.

I

FROM NORTHEAST TO NORTHWEST:

THE DOURO AND THE DUERO

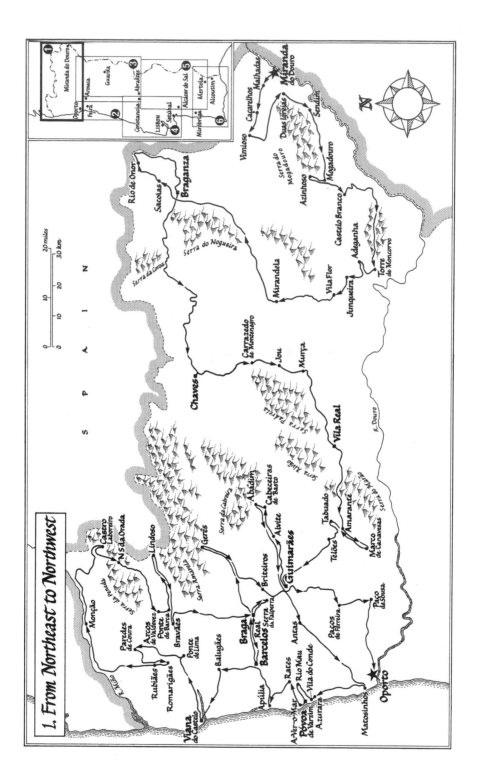

1. From Northeast to Northwest

I

The Sermon of the Fishes

Nothing of the kind had occurred within the living memory of any border guard. This was the first traveller ever to pull up in his car, with the engine already in Portugal but the petrol tank still in Spain, and lean over the parapet at the precise point crossed by the invisible line of the frontier. Then, from across the deep dark waters, echoing between the tall rocky slopes on either side, the traveller's voice could be heard preaching to the fish in the river:[1]

"Gather round, fishes, those of you to the right still in the River Douro and those of you to the left in the River Duero, come closer all of you and advise me which language you speak when you cross the watery frontiers beneath, and whether down there you also produce passports and visas as you enter and depart. Here am I, gazing down on you from this high barrier, as you gaze back up at me, fishes residing in these mingling waters, and who can as easily find yourselves on one shoreline as on another, a grand fraternity of fishes who only devour one another for reasons of hunger and never on a patriotic impulse. Grant me, O fishes, clear instruction, lest I forget this lesson on the second stage of my journey into Portugal: may I learn in passing from one land to the next to pay the closest attention to the similarities and differences, whilst not forgetting something common to both humans and fish alike, namely that a traveller has preferences and sympathies unconstrained by the obligations of universal love, never hitherto required of him. To you, then, I at length bid farewell, O fishes, until a future day: may you follow your own course out of the sight of fishermen. Swim joyfully on, and wish me a safe journey. Farewell, farewell."

This was a fine miracle with which to start the journey. A sudden breeze ruffled the waters, or perhaps it was simply the disturbance caused by the submerging fish, for no sooner had the traveller fallen silent than there was nothing to be seen apart from the river and its shores, and nothing to be heard above the dozy hum of the car engine. That's the problem with miracles: they last such a short time. But the traveller is not a professional miracle-worker, he works them only by accident, so by the time he returns to his car he is

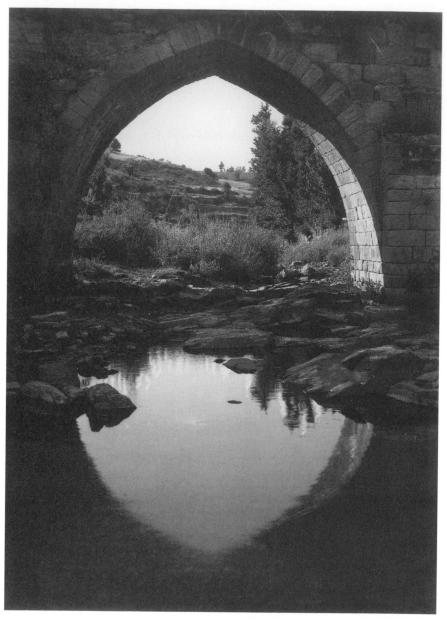

1 *Miranda do Douro, mediaeval bridge*

already resigned to the fact. He knows he is about to enter a country rich in supernatural pageantry, as immediately witnessed by the first town he comes to in Portugal, one called Miranda do Douro,[2] which he enters in the precise manner of the fastidious traveller. Here he is forced to recognise his own shortcomings, and admit he has everything to learn. About miracles, as all else.

It's an October afternoon. The traveller opens a window in the room where he is to spend the night and, at first glance, discovers or recovers the certainty that he is fortunate indeed. He could have faced onto a wall, a miserable piece of stonemasonry, or an area strung with washing, and have had to content himself with the sense of utility, of decay, or simply the hygiene of a washing line. But what he encountered was the stony cliffside of the Spanish Duero, so hard in its composition that even brushwood could scarcely find a hold and, since strokes of luck never occur singly, the sun was positioned in such a way as to create an enormous abstract painting in varying shades of yellow, tempting him to remain there staring for as long as there was still light. At this point in time the traveller doesn't yet know that a few days hence he'll be in Braganza, in the Abade de Baçal Museum, staring again at the same stone, maybe even at the same shade of yellow, only here in a painting by Dórdio Gomes. No doubt he will be shaking his head and muttering: "It's a small world. . . ."

In Miranda do Douro, for example, it is impossible to get lost. Descend the Rua da Costanilha, with its fifteenth-century houses, and we're hardly aware of the city gates but are already out beyond the town, overlooking the vast valleys stretching to the west. We are shrouded in a heavy mediaeval silence: what a strange period to find ourselves in, and what a strange people to be among. To one side of the gateway huddles a group of women, all dressed in black, speaking in low voices; not one of them is still young – few of them, in all probability, can remember ever having been so. The traveller, as you would expect, has a camera slung over his shoulder, but feels embarrassed, still unaccustomed to the boldness normally adopted by tourists, which is why there's no pictorial record of those shadowy women who have been talking there since the world began. The traveller has a melancholic sense of foreboding that a journey which commences thus will come to a bad end. He falls into a brown study, happily only for a few moments then, near at hand, just beyond the walls, he hears the roar of a bulldozer engine, levelling a new highroad: progress at the gates of the Middle Ages.

He climbs back up the Costanilha, turning off into other roads and side

streets. There's no-one at any of the windows, only traces of ancient anti-Spanish rancour in the form of obscene graffiti scored into good fifteenth-century stone. This therapeutic scatology, which runs no risk of offending either the eyes of a child or the most turgid of our defenders of morality, made him want to laugh.

In five hundred years nobody had bothered to get the offending slogans effaced or excised, inescapable proof that the Portuguese don't lack a sense of humour, merely that they exercise it only in the service of their patriotic interests. This was not the place to learn the lesson of the fishes of the Duero, yet perhaps it had its own logic. If at the end of the day heavenly powers favoured the Portuguese over the Spanish, it would look bad if the humans on this side were to override the interventions from on high and defy their authority. The story can be briefly told.

The struggles of the Restoration[3] were underway in the mid-seventeenth century and Miranda do Douro, here on the banks of the Duero was, so to speak, no more than a stone's throw away from enemy assaults. The city was besieged, hunger was widespread, those laid siege to weakened, and, for a time, Miranda seemed lost. It was at this point, so the story goes, that a child appeared, rallying the flagging populace to arms, infusing them with spirit and courage where courage and spirit were drooping, so that in no time they cast off their faintheartedness and low spirits, seized genuine or improvised weapons, and followed the boy against the Spanish like a herd trampling the new-grown corn. Seeing their enemy thrown into confusion, Miranda do Douro triumphed, and another famous page was inscribed in the annals of those wars. Only – where was the commander of the victorious army to be found? Where that gentle combatant who had exchanged a spinning top for a field marshal's baton? Nowhere to be seen, he couldn't be traced, indeed he was never seen again. Therefore, according to the populace of Miranda, it was a miracle. And therefore, it was additionally deduced, he must have been the Child Jesus.

So the traveller can confirm. If he could preach to the fishes, as they could listen to his sermon, he had no reason to disbelieve the ancient strategies of war. Still less so when actually confronted by the Child Jesus of Cartolinha, two handspans high, a silver sword at his waist, a red sash falling from his shoulder, a white bow at his neck and a cap perched on top of his rounded infantile head. This is hardly the uniform of victory, just one taken from an ordinary wardrobe, a regular and everyday outfit, as the Cathedral verger explained to the traveller. Well aware of his duties as a guide, the verger, on observing the scrupulous attention being paid by the

traveller, brought him into a side-building housing a collection of various pieces of statuary, protected from the temptations of professional and amateur thieves alike.

Matters were now resolved. A small tableau, sculpted in high-relief, was the traveller's final proof of how much he has yet to learn where miracles are concerned. Here St Anthony is receiving the genuflexion of a sheep, offering an exemplary lesson in faith to the shepherd who had dared mock the saint, and there, in the sculpture, you can see the latter flushed with shame and therefore, by this very fact, capable of redemption. According to the verger, many still make mention of the picture but few actually visit it. You must forgive the traveller's utter inability to contain his vanity. He came from so far away, without the least introduction, and was admitted to these mysteries simply on account of his honest face.

The journey is but beginning and, meticulous as he is, the traveller immediately falls to questioning his motives. What kind of a journey is this after all? Simply a question of taking a turn about the town of Miranda do Douro, visiting the Cathedral with its verger, its little capped child and the sheep, something that, once accomplished, he ticks off on his map, then hits the road again and says, like the barber shaking off his towel: "So, on to the next!" A journey is supposed to be cast in a different mould, a matter more of being than of moving on. Perhaps recognition should be given to professional travellers, but only for those with a genuine vocation, for the rest who believe in taking their responsibilities lightly are deceiving themselves: each kilometre is worth no less than a year of life. Wrestling with contemplations like these, the traveller ends up by falling asleep. When he awakes next morning there before him is the yellow stone of the cliff, forever in the same place as it is in the destiny of a stone to be, except an artist should come to carry it away in his heart.

On the way out of Miranda do Douro, the traveller continues sharpening his powers of observation so that nothing may get lost and everything prove to be of benefit, and to this end he turns his attention to a little river running close by. As we've established rivers have names, and this one – so near to the abundant Douro – what name might it have? He who doesn't know, asks, and he who asks sometimes receives a reply: "Excuse me please, but what is this river called?" "This river is called Fresno." "Fresno?" "Yes, sir, Fresno." "But *fresno* is a Spanish word that in Portuguese would be *freixo* [after the ash groves]. Why don't you call the river Freixo?" "Ah, that I can't tell you. That's what it has always been called, as far as I know." So, at length, in spite of all the repeated struggles against the Spanish, despite even the

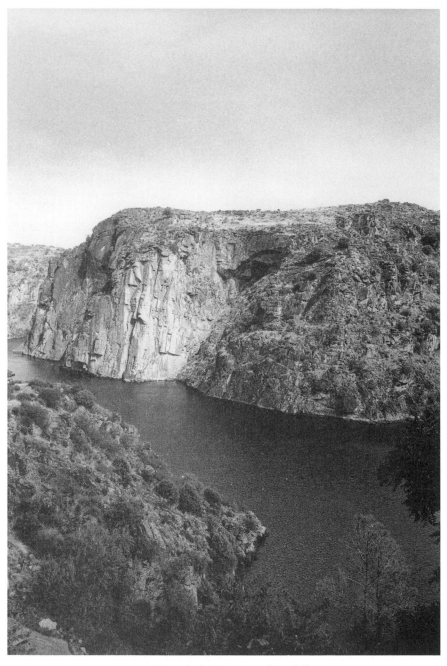

2 *Miranda do Douro, a yellow cliff*

divine interventions of the Child Jesus, we still we have this Fresno ensconced between its pleasant banks, laughing at the traveller's patriotism. He remembers his fishes, the homily he delivered to them, amusing himself with the memories, until he reaches the village of Malhadas where his spirits begin to lift: "Who knows if this *fresno* matter doesn't arise straight out of a Mirandese dialect?" It occurred to him to ask as much, but then he forgot, and when much later his doubts revived, he decided it was of no importance. In usage at least, *fresno* could now pass as Portuguese.

Malhadas is situated a little way off the main road that continues on to Braganza. Close at hand are the remains of a Roman road the traveller has no intention of following. But when he asks after it to a peasant and his wife whom he encounters on his way into the village, they tell him: "Aha! what you mean is the Moorish high road." So be it: the Moorish high road. All that presently interests the traveller is the why and wherefore of the tractor from which the worker dismounts with the familiarity of someone in charge of his own property. "I own just a small plot of land. The tractor's too much for me alone. Sometimes I hire it out to my neighbours, and that's how I manage to stay ahead." The three of them pause to chat, discussing the problems that beset parents with children to maintain, and it soon becomes apparent that there's another one on the way.

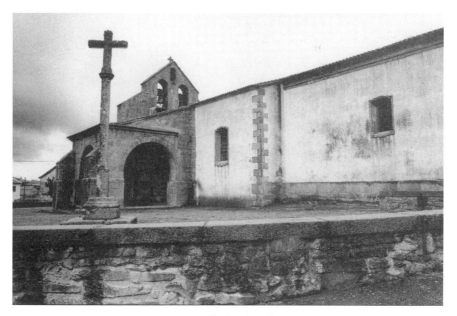

3 *Malhadas church*

4 *Malhadas, detail of a house*

When the traveller announces his intention of heading for Vimioso before returning by the same route, the peasant woman, without pausing to seek her husband's permission, invites him in, saying: "We live in that house over there. Come and eat with us." It was obviously a genuine invitation, meaning that however much (or little) there were in the pot, it would be unequally divided, since it's more than certain that the traveller would find the bigger and better part of it on his plate. The traveller thanked them, postponing the occasion. The tractor sets off, the woman retires to the house. "They're real merrymakers in that village," she'd added, so the traveller took a turn around it which had hardly begun before it was brought to a halt by the spectacle of the giant black tortoise of the parish church with massive walls and hefty flying buttresses forming the creature's feet.

In the thirteenth century and in these the lands of Trás-os-Montes, locals could have known little of the resistance of the materials they employed, or perhaps the builders had renounced all trust in the certainties of this world and determined to construct for all eternity. The traveller entered and surveyed the belfry and the roof, letting his eyes run over them and into the distance, more than a little intrigued by a trans-mountainous land that fails to collapse into the abrupt precipices and valleys his imagination was fabricating. Ultimately it has to be each to its own: this was undeniably a

plateau, and the traveller was not going to gainsay his imagination, particularly given how useful it had proved in transforming the church into a tortoise: only a fellow-visitor can judge just how fair and correct such a comparison really is. Two leagues further on lies Caçarelhos. Here, Camilo Castelo Branco[4] tells us, Calisto Elói de Silos was born and Benevides de Barbuda, Agra de Freimas' eldest son, the rustic hero and the glutton in *Queda dum Anjo*, a novel of considerable humour and a certain melancholia. The traveller estimated the aforementioned Camilo could not escape the censure acidly proffered by Francisco Manuel do Nascimento, in accusing him of making fun of Samardã, as others had before, at the expense of Maçãs de D. María, Ranhados or Cucujães. In linking Eloi with Caçarelhos the place had been subjected to ridicule, or maybe this only serves to demonstrate our own spiritual defects in preferring to apportion blame to the land and not to those the land produces. The apple rots according to the ailment of the apple tree, and not from the sickness of the earth. It goes without saying that the worst ailment of this village was its remoteness, here at the back-end of the world, and it's unlikely that its reputation has much to do with what those in Minho mutter amongst themselves: for the people of Caçarelhos are gossips, incapable of keeping a secret.

Caçarelhos must have its secrets but nobody revealed any to the traveller when he arrived on a local market day to encounter herds of beautiful honey-coloured cattle, eyes like lifebuoys of tenderness, lips white as snow ruminating in peace and serenity while a thread of saliva slowly dribbles down, all this beneath a forest of lyres, their carapace of horns, natural sound-boxes for the lowing which, from time to time, rises from the candelabra'ed company. Clearly there are secrets in all this, but not the kind to be related in words. It's easier to keep counting the bank-notes, so many for this ox, take the beast with you, you won't regret your choice.

The chestnut trees are coated in prickly bobbles, so many that they look like flocks of greenfinches pausing to collect their strength, gathering in the branches ready for great migrations. The traveller is a sentimentalist. He stops his car and picks a spiky sweet chestnut as a simple reminder for many months to come. Now it has dried out, it must be time for him to return and visit the great chestnut tree beside the main road, relishing again the bright morning air culminating in a definite rural promise of chestnuts.

The main road twists and turns towards Vimioso and the contented traveller murmurs: "What a beautiful day." There are clouds in the sky, white fluffy ones which cast scattered shadows over the countryside; a light wind blows; the world looks newborn. Vimioso is built on a gentle slope, a placid

little town, or so it seems to the passing traveller who has no intention of staying there, only of requesting some information from a woman he sees. But here he encounters his first disappointment. His informant is very friendly, to the extent of showing willing to take a turn around the back streets and show him the local specialities, but what she really wants is to sell him her hand-stitched linen. Please don't take this amiss, but the traveller holds to his principles and persists in his conviction that the world is obliged to provide him with nothing beyond the information he is requesting. He descended a steep street down to the bottom, where he met his reward. To his eyes, unfamiliar with the sacred architecture of the countryside, there was no small pleasure to be found in the contrast between the robust seventeenth-century façades and the incipient signs of Baroque frigidity. The nave's interior was low and broad, Romanesque in a character not borne out by other architectural features. But the best was yet to come. Outside, under the trees' shade and seated on the steep stairway giving onto the courtyard, the traveller heard the story of the church's construction. In return for a private chapel, a certain family offered a pair of oxen to haul the stone intended for the church. The oxen devoted two years to the effort, pacing out the steps from the quarry to the outhouse used by the builders, whose part in the labour ultimately amounted to no more than shouting "giddy-up!" as the beasts came and went without either herdsman or keeper, deafening the surrounding wasteland with the groans of badly greased blocks of stone, while profound discussions regarding the presumptions of men and their families raged. The traveller wished to know of the chapel and whether the original benefactors had descendants who continued to make use of it. Nobody could tell him. He found no particular marks of distinction within, although they might still exist. What does persist is the tale of a family who donated nothing of their own beyond the oxen who paid the price with their exhaustion, and in so doing opened up the way to guide their owners to paradise.

The traveller retraced his steps, distracted from the path now familiar to him. In Malhadas there was the temptation to claim the meal offered him earlier, but he held to his sense of timidity even though he suspected he would later repent of it. Instead, he went to where the *pauliteiros* dancers live in the village of Duas Igrejas. Since it was not the season for them to appear, the traveller never learnt any more about them than how the dancers took hours to process slowly through the streets. However the traveller retains a right to his imagination, and as regards the matter of *pauliteiros*, it would then as now have been both more seemly and proper to alter the dance so

that instead of crossing sticks the dancers use sabres or daggers. Then the Child Jesus of Cartolinha would have had sound military reasons for inspecting the army trooping in their embroidered ruffs and cravats. It's a defect of the traveller's: he wishes to improve on perfection. May the *pauliteiros* forgive him.

By the time he reaches Sendim, it's suppertime. What and where should he eat? Someone recommends the traveller to: "Follow this street onto the square, and in the square there's the Restaurant Gabriela. Ask there for Senhora Alicia." Such informality is to the traveller's liking. The waitress informs him that Senhora Alicia is in the kitchen. The traveller looks through the doorway and a great smell of cooking fills the air as he inhales; a pot of greens is bubbling on the hob, while from across a heavy table in the centre of the room, Senhora Alicia asks the traveller what he would like to eat. The traveller is more accustomed to being brought a menu, to choosing as it were in the dark, and now he's obliged to order directly and Senhora Alicia suggests a fillet of veal, Mirandese-style. The traveller agrees and goes to sit at a table, where to make his mouth water he is brought a tasty vegetable soup, accompanied by bread and wine. What is the fillet of veal going to be like? and why is it described as a fillet? a fillet has, to him, always meant a fillet of fish. "Which country am I in?" the traveller asks his glass of wine, which fails to reply but genially permits him to continue drinking. "There's not too much time for questions." The gigantic chunk of veal comes swimming in vinegary gravy, cut down to the size of the plate so that it doesn't drip on the tablecloth. The traveller thinks he is dreaming. Soft flesh into which the knife cuts effortlessly, cooked to perfection, and that vinegary sauce which brings a sweat to the cheeks, the clearest proof that bodily contentment exists. The traveller is eating a meal in Portugal, his mind's eye filled with past and future landscapes, while the Senhora Alicia can be heard shouting in her kitchen and the waitress giggles and shakes her plaits.

1. This is closely based on a famous sermon of St Anthony of Padua (also claimed by the city of his birth, Lisbon), a thirteenth-century Franciscan friar and Doctor of the Church. His homilies were anthologised – including a famous one addressed to the fish in a river.

2. Literally a belvedere over the Douro – whose name follows *ouro,* meaning gold, hence *douro,* coin. Also *douro,* meaning dory, the fish. Whereas Duero (the Spanish version) is simply a name.

3. The struggle to restore the Portuguese monarchy began on 1 December 1640, with an uprising against the Spanish king. Since 1580 Portugal had been ruled by the Spanish Crown and only regained her autonomy through the lengthy Wars of Independence, which lasted until 1668.

4. Camilo Castelo Branco (1826–1890), an outstanding Portuguese literary figure, situated between the traditions of romantic and realist writing. A passionate personality, who went from one crisis of poverty to the next amorous scandal, and confrontations with Oporto's commercial bourgeoisie. Pamphleteer in the style of Dumas, or even Balzac, he has left an ample legacy of 262 works.

The Wicked Ways of Dossel

The traveller is a native of the lowlands from far down south and, knowing little of these uplands, had hoped for something on a grander scale. He's already said as much, and now he's repeating himself. There's no dearth of exceptions, but all tend to prove the rule of relativity: height ranged only in relation to sea level, each peak shoulder-to-shoulder with the next in perfect profile. If ever one pokes out of line, sprouting up unexpectedly, then yes, the traveller is permitted a clear sense of their grandeur, less by approaching close to than from taking a longer perspective. Once the foothills are reached, he notes no great variation in size, but is satisfied with their distant and fleeting promise.

The railway line running beside the road looks like a toy track, perhaps something left over from the ancient of days. The traveller, whose childhood dream was to be an engine driver, fears that the locomotive and its carriages will turn out to be in period, museum objects the enveloping mountain wind still hasn't succeeded in blowing the cobwebs off. The line is called the Sabor, after the river which twists and turns, wending its way to the Duero, but where the savour of those covered carriages has gone is something the traveller fails to discover.

Without noting that he has left the highlands behind him, the traveller touches down in Mogadouro. The afternoon is waning though it's still luminescent, and from the top of the castle it's possible to visualise the labours of the men and women of the region. Every neighbouring slope is cultivated; a jigsaw of terraces and plantations, some gigantic, others smaller, as though existing simply to fill out the shadows of the larger ones. His eyes thus refreshed, the traveller would be utterly at peace if it were not for the remorse at having inadvertently obliged a pair of lovers to flee the shelter of the ramparts where he'd happened on them walking and canoodling together. Here in Mogadouro that had to be yet another demonstration of the age-old conflict between intention and consummation.

It's the nearby hamlet of Azinhoso that kindles the traveller's passion for the rural Romanesque regions of the North. The risk taken by the tiny

5 *Trás-os-Montes, landscape*

churches isn't their boldness, since they are made to a pattern imported from far away, and only lightly adapted to enhance the architect's prestige. Yet anyone imagining that having seen one he'd seen them all would be culpable of self-deception. It's vital to look over each one in tranquillity, waiting silently for the stones to speak, with enough patience to ensure that every departure is an act of repentance, on the part of this or any other traveller. Repentance at not having stayed longer, for it's hardly good behaviour to sojourn merely a brief quarter-hour in a church that's seven hundred years' old, as is Azinhoso's. Worst of all is when people approach the traveller wishing to chat to him, people who would do better to listen, so becoming the beneficiaries of these past seven centuries. The tiny courtyard is overgrown with weeds and the traveller pauses and rests his heavy boots there and feels, without quite knowing why, restored. The more he ponders, the more he decides that's the word for it, that and no other, without knowing how to explain it.

Shortly night will fall, early as it does in autumn, and the sky covers over with dark clouds; perhaps tomorrow it'll rain. In Castelo Branco, fifteen kilometres further south, the air feels as if it has passed through a sieve so fine that, to judge from its clarity, it could catch even ashes; so pure that it shocks the lungs. At the roadside looms the façade of a stately home, rising to great pinnacles at the corners. If Portugal had ghosts, this would be the perfect place for them to scare travellers, with lights flickering from beyond shattered windows, possibly accompanied by clattering teeth and chains. But, who knows, by daylight its decay might appear arguably less depressing. When the traveller reaches Torre de Moncorvo, it has been pitch dark for some time. The traveller considers it discourteous to enter a village at such a late hour. Villages are like people, we approach them slowly, a step at a time, not like this, a sudden ambush, under cover of darkness, and as though by highwaymen. Still, the villages exact a thoroughgoing revenge. The inhabitants put their house-numbers and street-names at an exaggerated height, if they bother with them at all, and, when it suits, name a square the same as a crossroads, leaving the perplexed traveller stopping the traffic and stranded, when a politician with a politician's grin and a band of faithful adherents decide to sally forth in the quest for votes. That's what Torre de Moncorvo does to travellers.

The worst of it was that the traveller was en route to an estate which lay beyond it, in the Vilariça valley, and the night proves so dark he can't even determine whether the banks shoring up the roadside verges are rising or falling. The traveller strives to find his way in an ink blot, without even stars

6 Castelo Branco, Jardim do Paço

for help, since the sky is a mass of unbroken cloud. Eventually, after considerable confusion, he reaches his destination. Unruly dogs bark loudly at his arrival, hailing his entry to the house where he is greeted with a smile and an extended hand. Portentously grand eucalyptus trees make the night outside even darker, but dinner isn't long in reaching the table, and dinner is followed by a glass of Port wine. Thus he whiles away the hours until bedtime which, when reached, leads him to a room boasting a four-poster bed of such a height that only our tall traveller can do away with the ladder, and clamber up atop it. From this position, he is now inclined to consider the profundity of the Valley of Vilariça's silence, the consolations of friendship, and his desire to fall sound asleep. Who knows, but in this four-poster may have slept His Majesty the King or, preferably perhaps, Her Highness the Princess.

He awakens early. The bed is not only high, it's also enormous. Portraits of ancient forebears gaze sternly down on the intruder from the bedroom walls. The traveller hears a noise. He rises, opens the window, and sees a shepherd with his sheep passing by: times have moved on, and this shepherd no longer appears as if he'd stepped out of a bucolic romance. He doesn't throw back his head and announce himself, he doesn't bless me with a "May the Lord go with you, sir." If he weren't so busy doing what he's doing, he'd merely say: "Good day," and what more could a traveller ask for since that's the most one can wish from a day, that it should turn out good?

The traveller bids farewell, thanking those who put him up for the night,

and before setting forth again returns once more Torre de Moncorvo. He has no wish to leave unpleasant memories behind him, nor to abandon the village with a disgust it ill deserves. Now, in the full light of day, there's no longer a need for signs on every street-corner. The church is before him, its Renaissance porch and high belfry giving it the air of a fortress, an impression accentuated by extensive surrounding walls. Inside it has three naves, punctuated by thick cylindrical pillars. With the door shut against military incursions, the enemy would need to push long and hard before gaining access to their next Mass. Yet the tranquillity in which the traveller was able to circulate gave him time to develop a taste for a sculpted and painted wooden triptych representing scenes from the life of SS Ana and Joaquim, not to mention other examples of equal value. In fact the entire Igreja da Misericordia has a Renaissance air, with its granite pulpit and its bas-relief figures, and is itself worth stopping for in Torre de Moncorvo.

Now the traveller is ready to move on from works of art. He's taken to the byways, leading onto a bridge crossing over the River Vilariça, to climb and climb, as the main road unravels endlessly so that, given how bald the mountains increasingly appear on both sides, tumbling into the valley, the traveller starts to fear a puff of wind may carry him off in the breeze, thereby involving him in another means of locomotion with a far worse outcome. At all events, faced with such a landscape spread generously before him, the traveller feels he has taken wings. Within a few months, from here as far as the eye can see, all will be flowering almond trees. The traveller falls to imagining, and in his mind's eye he has conjured up two images of trees in flower, selecting sugared almond pinks and whites, multiplying each by a thousand or ten thousand. Dazzling. The abundantly fertile valley is similarly resplendent, more fortunate for sure than the lowlands of Ribatejo, which derive no benefit from its fertile mud and suffer the afflictions of a sandy soil. Here the waters are carried to join the River Sabor where they become caught up in the abundant waters of the Duero, spreading into the valley, where they deposit the natural fertilisers they carry. The people around here describe it as their hedge against adversity, for come winter, and as long as it doesn't overflow, it affords the valley a prosperous season.

The highway runs on to the village of Estevais, then to Cardanha and Adeganha. The traveller hasn't the time to stop at each, he's not exactly in a position to knock at every door and interrogate the inhabitants about their lives. But, since he doesn't know how to rid himself of his little preferences and obsessions, nor does he desire to do so, and since he is intrigued by the work of men's hands, he presses on to Adeganha, where they tell him of a

delightful Romanesque church only *so* high. He arrives and enquires, only to pause amazed at the vast and unique granite flagstone which serves as a main square, threshing floor and bed for the moonlight in the village centre. It is surrounded by the type of houses generally found in the more obscure corners of Trás-os-Montes, built stone on stone, the door-lintels flush with the roof, the humans upstairs and the animals below. It's the land of communal dreaming. If called to account, a man would assert: "My oxen and I sleep under one roof." The traveller, whenever confronted with this sort of reality, feels deeply compromised. Tomorrow, on reaching the city, will he remember these matters? Will he feel happy? Or wretched? Or both in equal parts? Is it not a pretty thing, kind sirs, to preach concerning the fraternity of fishes? But what of that of men?

Found at last, the church is everything it should be. The person who

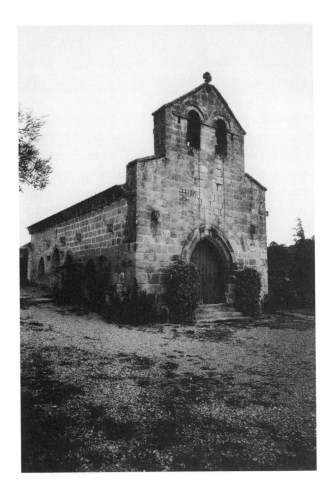

7 *Adeganha church*

described it was not guilty of exaggeration. At heights like these, buffeted by sweeping winds, beneath the iron cold and scorching sun, the church has heroically withstood the centuries. Its arrises are broken, its figurines and gargoyles are fractured on its surrounding corbels, but you would be hard put to uncover a greater purity or a more transcendent beauty. Adeganha church deserves to be carried away with you in your heart, like the golden stone of Miranda.

The traveller starts to make his descent down a road in even worse condition. His car suspension is creaking and protesting, and it comes as a relief when, in among the puddles and quagmires, Junqueira emerges. It's a place of no special significance yet, since the traveller is given to inventing his own works of art, he finds himself before the façade of a roofless Baroque chapel, sprouting an exuberant fig tree in its centre, reaching beyond its rafters. You could get at the figs through an *oeil de boeuf* window, were the fig tree not out of season. His cries of admiration were cause for amazement in the village. Over the wall popped the head of a little girl, then another, followed by the mother of both. The traveller asks some unmemorable question, the answer comes back with restful Trasmontan inflection, all at once a conversation erupts, and in no time the traveller is party to the family's stories, in one of which two princesses are put under a spell and immured in a high tower, and it's true these little girls never leave here, not even to go as far as Torre de Moncorvo, a scant thirteen kilometres away. It is forbidden by their father to do so, for as you know, sir, it's only safe to go out under the strictest supervision. The traveller has heard such tales before, so neither agrees nor disagrees. "What's life like around here?" he enquires. "Wretched," replies the woman.

Such conversations have a tendency to leave the traveller in a bad mood. That was the reason he hardly glanced at Vila Flor. He was obliged to open his umbrella, to go on an errand taking a present to an acquaintance, and in passing casts an eye over St Michael over the portico of the church door. The traveller has observed a considerable devotion to the archangel in these parts. He saw it first in Mogadouro, on an altar for Holy Souls, and again elsewhere, in places preoccupied with the imminence of purgatory. Here, once again disposed to continue on his way, the traveller changes direction. The portico of this seventeenth-century parish church is deserving of serious attention, and an adequate pause for attention: its sculpted columns, with their human and floral motifs, its geometric designs, fuse into a memorable whole. Less fortuitously, a panel of tiles inserted into a wall, showing a certain Trigo de Morais giving counsel to his sons, also sticks in the memory. Not

that his counsels to his sons are bad, but the concept is worse than bad. And what self-importance on the part of the counsellor to thus come and moralise in a public place, in a fashion that should remain behind closed doors. In sum: this journey through Portugal is going to have a bit of everything about it.

It begins raining again. There's nobody left in the main square when the traveller comes around the corner leading into it. But, as he starts to cross, he's aware of eyes following him through the window panes, and there seem to be others looking back over shoulders in the shops, presumably with mistrust. Our traveller departs as if he had all the guilt of Vila Flor, or of the world, on his back. Maybe he had.

Taking the right-hand fork towards the north, along roads that climb and then descend, he reaches Mirandela. It's only a stopping-off point for the traveller, although now he's en route to Braganza he's mulling over the indecipherable reasons why every arch of the bridge over the River Tua is a different height, and if its originality arises from its Romanesque origins, its first builders, or perhaps from later, in the sixteenth century, when substantial rebuilding was undertaken. It deeply irritates the traveller not to know the causes of such simple things as why a bridge has twenty arches, not one the same as the next, but there's no alternative to just pressing on: it would provide something of a spectacle if he paused to interrogate the silent stones while the ripples continued their susurration in the shallows.

In this region there are communities which have become known as "improvement villages". They include Vilaverdinho, Aldeia do Couço and its Romeu. Given the singularity of its title, and also because a large sign informs us of a museum of curiosities, the traveller selects Romeu as his preferred resting place. Yet it was in Vilaverdinho that he learnt the idea for the "improvements" came from a former minister of Public Works, along with the "human idea", likewise praised on a tall billboard, then reiterated in giant letters on rough stonework alongside the road, affirming how "the residents will never forget" the President who attended their hamlet's inauguration in 1964. Such inscriptions are always dubious, imagine what future historians and writers of inscriptions would think should they happen on such signs and attempt to decipher their meaning. Confronted by the President's name someone had added "thief", a subversive term which time would perhaps disown.

The museum is in Romeu. Inside, there's everything under the sun. Dona Elvira's automobiles, carts and ploughs, radios and lead-sulphide receivers; zithers, music boxes, pianolas; a good many clocks; some of the earliest telephones ever made; a few suits; photographs: in short, a picturesque

treasure trove of small objects to make one smile. These are the crude forebears of the new technologies that are currently transforming us into consumers and ignoramuses. The traveller, when he emerges, shrugs his shoulders, but offers thanks to the Meneres family for having had the idea. There is always something to learn.

It's drizzling. The traveller switches his windscreen wipers on and off in the game of discovering the countryside, then vaguely sweeping it underwater, as if into an agitated aquarium. To his left the Serra Nogueira is the mother of mountain ranges, 1300 metres high. The next game to keep him amused is counting the level crossings. No less than five in thirty kilometres: Rossas, Remisquedo, Rebordaos, Mosca and another whose name escapes me. It's just as well that salvation doesn't depend on a name.

Finally, from up on the heights one can see Braganza. The afternoon is rapidly fading and the traveller is growing weary. There has to be a hotel here, somewhere to eat and sleep. Right on cue there appeared an orange signboard before him: *Pousada*. Contentedly he turns the wheel and begins to climb the mountainside, thinking how incredibly beautiful the landscape is in near-twilight, until he reaches the building, the inn, or whatever, since as a place of rest it could hardly appeal to anyone. It has to be made an occasion for homage to the master of us all, to the author Garrett, for on reaching Azumbuja he says – and these are his very own words – : "Let us hurry to rest ourselves in this elegant establishment which combines the three distinct functions of hotel, restaurant and popular café all in one. Holy God! What a devil of a door! What a cavern inside the entrance! . . . My quill falters and falls from my hand." The traveller's quill does not fall from his hand only because he has no quill. There was however nothing ancient about the devil of a door. But the cavern was true to form. The traveller fled, fled until he found a hotel quite devoid of imagination but well maintained. There he stayed and ate and slept.

The Fiery Waters of the River de Onor

Sometimes it appears we set out from the furthest point. The most normal course to follow, having got to Braganza, is to take a look around what the city has to offer, then cast an eye over its surroundings, a stone here, a landscape there, respecting their natural order. But the traveller has an obsession: to get to Rio de Onor. It's not that he expects worlds and wonders of the visit, since Rio de Onor is no more than a little village: it cannot proffer relics of either Goths or Moors. Yet once you start reading up on the subject, certain names always stick in your memory, along with facts and associations, all growing increasingly elaborate and complicated until it reaches the point we've reached, where the myth becomes idealised. The traveller hasn't come in the guise of an ethnologist or a sociologist, nobody counts on him to make ultimate discoveries, or even lesser ones. He is possessed only of the human and legitimate desire to see what others see, set his feet in the footprints of others. Rio de Onor is a place of pilgrimage to the traveller: through it, he came by a book which, as a work of science, is among the most moving ever to have been written in Portugal. It is about a land the traveller wants to see with his own eyes. Nothing less and nothing more than that.

Still another thirty kilometres down the main road. There ahead, on the way out of Braganza, lies the darkly silent village of Sacoias. Entering it is to enter a different world. Seeing the first houses appear around a bend in the road he feels devoured by the desire to stop and shout: "Is anyone here? Can I come in?" Certainly, even today, the traveller remains uncertain whether or not Sacoias is inhabited. The persistent memory of it is of a wilderness or, more specifically, of an absence. The impression doesn't fade even when he superimposes a fresh one, now on his return journey, of three women theatrically displayed on a flight of steps, listening to what someone inaudible to the traveller was saying, as she draped her hand over a flowerpot. The vision so closely resembled a dream that finally the traveller is left with the suspicion he never went to Sacoias.

The road to Rio de Onor is a desert. There are occasional villages along the way: Baçal, Varge, Aveleda, but you travel through them only to regain

the primitive wilderness. Of course evidence of cultivation isn't lacking and there are no virgin forests and rocky outcrops, but there's not even the scattering of houses you find in other regions, offering company to those along the way. To the right lies an open expanse of valley, while below there's a row of beehives with, nearly indiscernible amid the mists, men working in the distance. The fields are green and the curtain of trees looks black. A herd of cows is blocking the route. The traveller pauses, lets the herd go by, and bids good-day to the cowherd, a placid youth. He doesn't seem to be making heavy weather of his task, a testament to the great skill with which he performs it: the cows behave as if surrounded by at least a legion of herdsmen.

And so to Rio de Onor. Going around a curve, and a watery light appears between the trees, you can hear the water itself rippling past the brambles under the stone bridge. The river, in fulfilment of its duty, is called Onor. Nearly all the house roofs are of slate, and in the damp climate they shine and look darker than their natural leaden hue. It's not raining, it hasn't rained all day, but the whole landscape is as drenched as if it were at the bottom of a submarine valley. The traveller regarded it calmly, then continued in the other direction. He was not particularly contented. He had finally arrived at the Rio de Onor he'd so wanted to reach, and now he doesn't feel happy. There are those things we desperately desire, yet when we obtain them they leave us cold. That can be the only way to understand why the traveller wanders around asking the way to Guadramil, which after all, he'd had no intention of visiting, given the poor state of the main road. Or so he'd been told. However, the traveller decides to act in character. He sets off down a street that's little better than a giant puddle, hopping from side to side, so intensely concentrating on where to put his feet that he only latterly notices he has company. He says "good-day" (never having grown accustomed to its city slang abbreviation to "bom dia"), and is echoed in reply by a man and a woman sitting at the roadside, she with a large round of bread in her lap, which she'll shortly begin carving up to share with the traveller. There the two of them sit, out in the open air beside a giant still, all made of copper, with no fear of damp, not so easy to grasp after a quick glance at the hearth underneath. The traveller, as usual, begins by saying: "I'm here to look at the village. What a pretty place it is." The man doesn't offer an opinion. He smiles and enquires: "Would you like to taste our spirits?" Alas, the traveller is not a drinker: he enjoys a glass of red or white wine, but his body seems to reject the stronger stuff.

However in Rio de Onor, you can't turn down such an *onor*, not after

arriving from so far away and at lunch-time. A couple of seconds later a thick glass appears and the still-warm hooch is drawn from the pipe, then decanted down the throat. As rough as a brush. The traveller feels his stomach explode, smiles heroically and repeats the process. Perhaps in an attempt to curtail his ruin, the woman clasps the loaf to her breast with ample love in the gesture, cuts a slice and a slab, and her smile enquires: "Would you like a piece?" The traveller hadn't asked and he was given. Can there be a better way of giving?

The following half-hour passed in the company of Daniel São Romão and his wife, all three of them sitting together, by the soft light of the hearth. Others pass and pause, then continue on their way, each one saying their piece. It's tough living in Rio de Onor. Even a toothache is cured by gargling with spirits. A few gargles and the sufferer no longer knows whether the pain is there or gone, if he's a drunk or a dental patient. Up to this point, such stories still raise a smile. Beyond this point, however, there's the story of the woman pregnant with twins, who didn't realise that, having given birth to the first, there was another to follow. She suffered agonies for twenty-four hours without knowing why, and when the little one was finally born it was to the amazement of all, but he was born dead. The traveller wasn't travelling to hear stories such as these. Brandy is an excellently quaint notion, yes sir, as it is to sit here with my friend Daniel São Romão, serving it up to passing tourists, but you should watch out for tales like these, watch out for confidences imparted by villagers, and what visiting strangers might make of them.

Daniel São Romão explains how the brandy is made. He invites the traveller to accompany him, so he goes along, here's the raw material, a whole barn full of grape pulp. "Unfortunately it's not of top quality," says its producer, and the traveller is astonished at his honesty, his sense of *onor*. Ever since he gave his sermon to the fishes, ever since the episode of the Child Jesus of Cartolinha, the traveller has been preoccupied with the possibility of frontier incidents. "How does it work around here? Do you get along well with the Spanish?" His informant is an ancient old woman who'd never left the place, so knew exactly what she was talking about. "Yes sir. Some of us even own land on the other side." Such imprecision over space and ownership confuses the traveller, who only becomes further confused when a marginally less aged ancient tranquilly adds: "They too own land over here." Addressing his buttons, which at least don't bother to reply and confuse him further, the traveller begs for the light of understanding. In the final analysis who's to say: Where's the frontier? What's the country we're

now in called? Is it still Portugal? Or is it already Spain? Or Rio de Onor and nothing else? These are strange laws. For example, the lad herding the cows is taking animals belonging to the whole community to a common pasture. There's not a lot left of the old communal way of life but Rio de Onor resists change: here they still offer bread and brandy to whoever passes by, and keep a hearth at the roadside, even in the rainy and winter seasons. And if Daniel São Romão is in his shirt-sleeves, passing travellers should not be surprised: that's what he's used to and he refuses to stand on ceremony.

The traveller returns across the bridge. It's time to leave. He can still catch the voice of a woman calling her sons: "Telmo! Moises!" He carries with him the memory of those currently unfashionable names, but he cannot quench those other sounds he never actually heard: the cries of the woman who lost the son she never knew she was carrying inside her.

The Story of the Soldier José Jorge

On arrival at Braganza it began to rain. It's typical of the weather there, large dark clouds which roll around the skies as if the world were covered in slate, like the badly-roofed villages through which the rain heavily leaks, and obliging the traveller to seek refuge in the Abade de Baçal's museum. The abbot was one Father Francisco Manuel Alves, born in Baçal in 1865. Archaeologist and researcher, he did not restrict himself merely to his priestly duties, but completed a long and valiant life's work alongside it. It is, therefore, only fair that his name should be mentioned in every reference to this museum, so magnificently installed in the Bishop's former palace. The traveller is not a man to be easily shocked: he has travelled through Europe, hardly lacking in other grandeurs, but in taking his own emotional temperature, he concludes he must be under a spell. What other explanation could there be for a certain inner commotion as he passes through the rooms inside the museum – so far from the capital and from other capitals, knowing full well that he's merely visiting a small provincial museum, without major works of art – other than the love with which such objects were collected and exhibited? Stones, furniture, paintings and sculptures, ethnographic items, ornaments, all arranged with care and in order. Here is the *Pedra Amarela* [Yellow Stone] painted by Dórdio Gomes, here the excellent works by Abel Salazar, scorned by the critics who label him an amateur. It costs the traveller dear to depart from here, especially out into the rain and the garden, and to pass beneath the commemorative stones, inhale the scent of damp plants, and at last fall to meditating before the granite "hogs", wild boars also called *berrões* around these parts: a famous creature overflowing with life, enormously fertile, with litters of baby piglets, farmed in a fortnight, and when dead converted into haunches, rumps, ribs, ears, trotters and hide, lavish to the last.They say the origins of the crude stones still there go back to prehistory. The traveller doesn't doubt it. For cave-dwellers and those in the rough cabins that succeeded them, the pig must have been the masterpiece of creation. Even more so the swine, for the reasons above. And when the Middle Ages levied taxes on the cities, the swine became the general currency,

a beast of protection, an emblem and occasional guardian. Thus does the populace demonstrate that it is not always ungrateful.

The traveller emerges into the rain. He has no wish to forget what he's just seen, the painted eaves, the traditional Mirandese costumes, the ironwork, a world of small objects which, he knows full well, fresher memories will soon overlay and diffuse: that's the sorry lot of a traveller. Nevertheless, he'll always retain the memory of the sixteenth-century Gothic sculpture of the Virgin and Child, clothed in splendid raiment, their shape interrupted by a brilliant girdle forming a sinuous line around her waist matched by the pure oval of the face, almost Flemish in style. And since the traveller has an excellent eye for contrasts and contradictions, he goes through the rain comparing the painting by Roeland Jacobsz showing Orpheus calming wild savages with the music of his harp with another by a fifteenth-century master of St Ignatius devoured by lions. Clearly, music achieved what faith could not. There's no doubt about it, he pondered, there really was a Golden Age.

Thus absorbed in his reflections, he fails to notice it has stopped raining. He cuts a strange figure, with his umbrella open and, as has happened to all of us at some time, an irrepressible smile on his face. The traveller climbs to the castle, up narrow streets cobbled with ancient stones, taking note of the pillory with its cross on top and its swine beneath, and circles the Domus Municipalis, which is supposed to be open but isn't. Anyone who looks at a photograph of it sees it as rectangular, and is surprised to find it actually composed of five asymmetrical sides, such as no child would deign to draw. What reasoning brought about such a design remains unknown, at least to the traveller. Even harder does he find it to establish whether the construction is Roman, or dates from Greek rule, or is merely mediaeval – the traveller yearns for his curiosity to be satisfied regarding this twisted pentagon, but there seems to be no explanation.

The traveller has only to see the doorway to the church of Santa María do Castelo before, not being all that keen on Baroque exuberances, he determines to pay more attention to the grain of its granite than to the branches and leaves entwined around its supporting columns. Later on he would be bound to swallow his words and recognise the grandeur of Baroque architecture, but there were still many roads to travel before he would be prepared to admit as much. In the other churches of Braganza there remains little of interest, unless it be the church of St Vincent, for reasons of its brief history whereby, according to tradition, Dom Pedro and Inês de Castro were wed. Perhaps so, but of its walls and stones nothing remains, and there is nothing about the place to suggest such a great and political union.

Was Braganza looked at? It was not. But don't ask the traveller about it, for he has other places to see, ones just as capable of retaining a man for the rest of his life, not because of their particular qualities but because such is the temptation of those lands. And when phrases like "the rest of his life" are used, you're talking about time in its infinity, as instanced by the case of the soldier José Jorge, a case we are about to relate.

Let us first of all say, lest there be any mistake, that the traveller has a taste which could be described as morbid by those who rejoice in being of more normal habits. Which is why, given the pleasures or the disposition of his spirit, he enjoys visiting graveyards and appreciates the deathly scenography of the statues, headstones and the rest of the inscriptions, all tending toward the one conclusion concerning the vanities of man, even once he has lost sight of the reason for harbouring them. The day was propitious for reflections

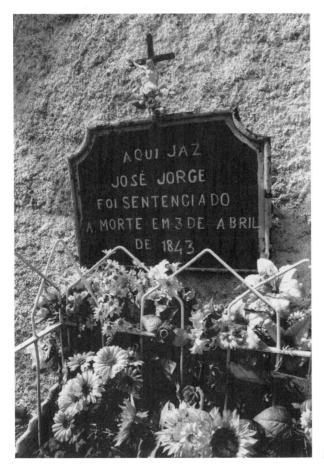

8 *Monument to José Jorge*

of this kind, and chance permitted the traveller's vagabond steps to lead him to the site where they could best be justified. He walked through sweeping alleys that smelled fresh among the tombstones, deciphering inscriptions coated with lichen and eroded by time, and, having made his way all around, he approached a shallow grave, isolated from the pomp and circumstance of the congregation of the fallen, on whose headstone, surrounded by a low verge, there was an inscription which read: HERE LIES JOSÉ JORGE SENTENCED TO DEATH ON 3 APRIL 1843. The case was an intriguing one. Which celebrated dear departed could this be, buried here at the foot of the wall, in a place marked and occupied for nearly 140 years, but hardly abandoned, as the traveller could surmise from the condition of the recently repainted lettering, neatly picked out in white on recently refurbished black? Someone must know. And after all, here beside him was the gravedigger's hut and inside it the gravedigger himself. The traveller hailed him with a: "Good afternoon. Can you please tell me something?" The gravedigger, deep in conversation with a young woman in his soft Tramontan accent, rises from his bench and puts himself at the traveller's service: "Certainly sir, if it's something I know." He must know, surely, it's a question about his job, not something he could keep quiet about. "This José Jorge here, who was he?" The gravedigger shrugs his shoulders and smiles: "Ah, that's an old tale." This is hardly news to the traveller, who's already seen the date marked on the tombstone. The keeper of the vineyard continues: "They say he was a soldier who lived here then. One day a friend came and asked to borrow his uniform, without offering any reason, but since they were friends the soldier didn't see fit to ask, and later on there was the incident of the body of a dead maiden and everyone began muttering that she'd been killed by a soldier, and that the soldier was José Jorge. It turned out that his uniform had become stained with blood, something José Jorge was unable or didn't wish to explain, since it was he who had lent out his uniform."

"But if he'd said that he'd lent it, that would have been enough to save his life," said the traveller, proud of his sense of logic. The gravedigger replied: "That I can't tell you. All I know is what I was told. It's a story that came down to me from my grandfather, and to him from his grandfather. José Jorge kept quiet, his friend acted dumb, useless friend that he was, say I, and José Jorge was hanged and then buried here. And here, some years ago, they decided to build a mausoleum to him, but when they discovered his corpse in perfect condition, they sealed up his coffin once more and never came back to try again." The traveller was curious: "And who's responsible for retouching those neatly-painted letters?" "I am," acknowledged the gravedigger.

The traveller thanked him for his assistance and continued on his way. It had started raining again. He paused an instant at the wayside to ponder: "Why was the man born? Why did he die?" The traveller is always intrigued by questions without answers. Then, perplexed, considers that perhaps he would like to have known the soldier José Jorge, so trustworthy and silent, such a good friend to his friend, and at length he acknowledges that there are miracles and other like forms of justice, including posthumous and unproven ones, like the tale of the body being uncorrupted 140 years after death. The traveller leaves the holy place clutching his umbrella and descends to the city centre, visualising where the gallows would have been erected, whether in the main square or in the castle precinct, or in these outlying fields; then the process of execution, accompanied by the rumble of drums, the poor man with his hands tied and his head down, while in Rio de Onor a woman gives birth to an infant and a priest baptises another in the church at Sacoias.

That night, the traveller went to visit friends and stayed out late. When he left, he lost his way and ended up on the road to Chaves. It continued to rain.

The Devil's Temptations

There are some who confess nothing without swearing to it and others who refuse to pledge more than a simple yes or no. Let's just say that the traveller falls between the two extremes, and for that reason alone makes no formal vow never to travel in the misty, rainy autumn seasons of the future, when the sky is hidden and leaves are falling. The summer is always indubitably beautiful, taking for granted sun, beaches, shady vines and cool drinks, but who can argue with a little track among the woods, where the mists form and disperse, at times blocking out the near horizon, at others vanishing into an apparently endless valley. The trees are of every hue. If there's a colour lacking, or gone into hiding, it's green, and where it still persists, it already assumes a first tinge of yellow, which starts brightly in most cases, before earthier shades surface, the chestnut trees turning pale, then dark, sometimes to the colours of fresh or congealed blood. Every colour can be found among the trees, even providing ground cover for the many glorious kilometres the traveller would like to walk on foot, as far as the trail from Braganza to Chaves, his first destination of the day.

It's customary to say that trees look ghostly in the fog. It's not true. The trees peering through the mists have an intense presence, like people appearing at the roadside to salute passers-by. The traveller pauses, looks down towards the valley, and has an impression he'd always deemed impossible: he enjoys not being able to make anything out beyond an indefinable dawn light which, further on, will clear to reveal the forest again, part of a near-uninhabited world reaching as far as Vinhais.

But the best bit of the day was to be the passage of the River Tuela. The traveller has no memory of a bridge, not even of the river, only remembering the spray of water among the stones, which is all the rivers and streams have to offer in this part of the world. As long as he lives the traveller will remember the breathtaking beauty of the valley in that place, at that time, in that light, on that day. Possibly in May or August, possibly tomorrow, it could all be different but now, right now the traveller is conscious of living a unique moment. No doubt he'll be told that all other moments are unique, which is

true, but he'll reasonably reply that this is no other moment. The mists had now lifted, only a few ragged strands remaining on the mountain-tops, while the valley is an immense green meadow, with trees crisscrossing and marking it in all directions: black, gold, tawny, amid a profound silence: complete, rare, anxious, but essential to the solitude, to this unforgettable moment. The traveller departs, he can't remain there forever, but he swears that, in some way he can't even explain, he is still sitting at the roadside, contemplating the trees, gazing at the first door to paradise.

The rain kept up all the way from Vinhais to Rebordelo. The route is a fiesta the sky accompanies, chucking whatever it can at it by way of demonstration. Between the clouds, a watery blue is beginning to break through, an early promise of a truce. As the traveller draws nearer to Chaves, the area of clear sky rapidly expands, the clouds fulfilling their duty to make maximum use of the high winds to gather up the rain, like flotillas of yachts with white sails and pennants. And that's as it should be: Chaves' fertile plain deserves no less. Doubled in the twin curves of the Tamega, it is divided into fastidiously-cultivated plots which serve as miniature market gardens. The traveller, who is of rustic origins himself, born among simple customs, has once again to get used to the transformations wrought on his native land by labour.

Before going on into Chaves, the traveller visits Outeiro Seco, no more than three kilometres to the north. On the outskirts of the village stands the church of Our Lady of Azinheira, a thirteenth-century Romanesque building famous for many leagues thereabouts not so much for its architectural merits – unless these assist all the rest – as for being favoured by the local upper classes for their weddings and baptisms. They attend from as far afield as Vila Real, Guimarães, even Oporto. At night, when stones can speak without being overheard, there must be lengthy conversations about who is to attend, and whether to get married or baptised, what the bride was wearing, and whether her mother overflowed with tears and natural emotion on watching her daughters leave the nest, a nest that can no longer afford her offspring the protection it did in the past.

The traveller was indulging in like cheap philosophisings, listening with only half an ear to still further explanations being offered by the woman with the keys, who was dissatisfied with her house a scant two hundred metres' away, when behind the church there arose a loud wailing, also female, a lacerating cry sounding as if it were crying out at itself. The traveller began trembling, and could swear the figures in the frescoes began trembling too. He looked at the woman with the keys in amazement, and was yet more amazed when he found her wearing a mocking smile entirely inappropriate

to either the place or the circumstances. "What's going on?" he asked. The caretaker replied: "Nothing at all. She's a woman who has lost her daughter, and comes to have a daily cry at the cemetery. She's completely lost it, and when she notices someone close by, she bawls all the louder."

Bawling there was, to be sure. The traveller no longer had eyes for columns and capitals. He went outside and approached the cemetery wall, sunk into a hollow of ground behind the church, as has already been pointed out. There was the crying woman, standing upright, moaning and shouting and, as the traveller drew closer, he noticed she was engaged in a lengthy discourse, presumably a repetition of every previous recital, close to a prayer, a psalm, an exorcism. The woman held a photo in her hand, which she addressed and sighed over. Even from the top of the wall the traveller, despite his short-sightedness, could make out the portrait of a beautiful young girl. He took the liberty of enquiring what misfortune had befallen and was told the story of a daughter who left the maternal nest in order to emigrate over to France and, as so often happens, there she married. And there she died at the age of only eighteen. As he was listening to her he vowed he would never again go near a cemetery, at the very least not on this journey. For he was only hearing stories of melancholy injustices: of an innocent soldier hanged, a girl lost in the flower of her youth. And since money costs so much to earn, the lamenting mother lost no opportunity in telling the traveller that the expense of transporting the body from Hendaye to Portugal alone amounted to 40,000 escudos. The traveller departed with a clouded brow, tipped the caretaker, who returned him a sly grin, and set forth on the road to Chaves. It was now lunch-time.

The town is compact and agreeable, I mean neatly proportioned, sufficiently large to be a pleasant place in which to live. The Largo do Arrabalde is where it all happens, and a focal point of departure. The traveller has now eaten and is keen to take a turn around the place. He visits the parish church, which boasts the distinction of two porches with little more than a hand's span between them, one Romanesque (sporting a belfry) and the other Renaissance (supporting the façade) and he offers a silent prayer to whoever decided that while erecting the latter it was worth preserving the former. The traveller, who was clearly by now sickening with praise, perhaps as a result of the excellent meal he had over-indulged in at No. 5 Chaves, further praises the masonry of the nave, the splendid statue of Santa María Maior, of immense antiquity, displayed in the apse. Still full of praise, he emerges onto the street and into the awaiting sunshine which now accompanies him to the Igreja da Misericordia, entirely composed of sculpted columns

rather like lacy bolsters ranged along a bedhead. Inside, tiled panels cover the nave from floor to ceiling, a real visual feast. The traveller slowly runs his gaze over its landscapes, inspecting every detail, and departs well satisfied.

The traveller doesn't visit all the castles he sees. Sometimes he restricts himself to observing them from a distance, but it always irritates him to come up against one that is locked. It always seems as if the locked ones must be the best, and he's left with a persistent sense of frustration until common sense convinces him that they only *appear* the better for being locked. They're slackers asking to be let off duty. But the tower deserving the greatest praise, arising out of the city centre, is the one with the most impenetrable aspect, the smooth façade of its walls rendering it all the more tantalising. Patience. The traveller turns his attention to the belvedere on the Rua Direita, overhung by wooden protuberances painted in warm dark colours, its mouldings surmounting the white surfaces of the chalky walls. It belongs to an old-fashioned way of life but, despite it, television antennae flourish in profusion over the roofs, a new spider's web stretched across the world, covering good and bad, truth and lies alike.

Now decisiveness is called for. From Chaves you can go anywhere, a phrase that seems merely banal (from anywhere you can go anywhere) but from here you have the Serras of Barroso and Larouco to the west while below lie those of Padrela and Falperra. That's only to mention the hills and dales, although other equally good reasons abound to account for the perplexity in which the traveller now finds himself. One finally prevails, and it's one which probably he alone could defend. He had fallen in love with a name, with the name of a place en route to Murça: Carrazedo de Montenegro. It's a small but adequate point on which to hang a choice, make of it what you will. The decision wasn't taken without an intense inner debate as the traveller missed a clearly marked signpost and set forth on the road to Vila Real, to Vila Pouca de Aguiar. If happy hours exist, then there are no fewer happy mistakes. The valley extending beyond Peto de Lagarelhos is another the traveller will never forget, and it's true that a few kilometres beyond there the path doubles back on itself, and that too has to be taken as a sign in the right direction. To continue, you would have to go to the limits of the stunningly beautiful countryside, since naturally all good things must come to an end. Except in this instance. In the traveller's memory the deep and misty valley is preserved intact, swathed tenuously in fine mists, mists with a strange capacity to engender brighter colours in the vegetation, contrary to what one should and would expect. Unable to see it all, the traveller simply saw the best of it.

As to Carrazedo de Montenegro: was it really worth all that? It boasts two granite statues from the 1400s, valuable examples of the expressive power of a material with little plasticity, but one which the traveller holds in high esteem. Over a side door there's a crude, rough-hewn St Gonçalo de Amarante with a huge crozier, a crook fit to fell a giant, the saint installed upon a triple-arched bridge (with no river beneath it) which can scarcely support him. Carrazedo can doubtless offer far more in terms of its people, stonework and countryside. In Carrazedo de Montenegro the traveller also underwent his first diabolical temptation, and from here on this victory fed on more and more fresh ones, dark temptations he was repeatedly called upon to rout. The traveller never knows what awaits him when he launches himself down the next highway. Here follows the warning.

The road runs alongside the disproportionately high church, a gigantic edifice considering that it's not exactly intended to compete with the Hanging Gardens of Babylon. The traveller parks his car and takes a turn around the church, his nostrils in the air, inspecting the masonry, in a quest for a door through which to gain entry. At length, on the point of deciding he had either to give up or seek out a halfway competent guide, he found an interior staircase with, at its top, a door ajar. It had to be the way up into the belfry. The traveller couldn't confirm his hypothesis, or if he did he doesn't now remember it but, having reached the top and discreetly pushed open the door, he took another three paces to find himself in the choir gallery, the perfect standpoint from which to view the entire nave. The traveller leant over the balustrade, paused there a while, for he's a traveller who, whenever possible, absorbs things at the leisure they merit, and when at length he was on the point of withdrawing, lacking the kind of soulful disposition that would keep him in church for the purposes of either prayer or vigil, he meets an image of an Our Lady with angels at her feet, and another grabbing her by the hand. He draws nearer to study her at close quarters, and at that moment, doubtless descended from the belfry, the devil appears to him, so well at ease that he didn't even bother with a disguise: he was hairy, long-tailed and with a pointed beard, all by the rulebook. The tempter then enquired: "On your travels then, eh?" (The devil addresses most people informally, with the exception of the enemy.) And the traveller drily replied: "Yes, indeed. Anything I can do for you?" The Evil One again responded: "I've come to inform you those angels are only suspended on a single spike. Pull hard and they'll come away in your hands. I wouldn't advise you to take the Virgin, though. She's large and very heavy, and they'd notice you on the way out." The traveller became annoyed. He seized the devil by one of his

horns, and cast him off imperiously: "Get out of my sight, depart, or I'll
see you off home with a kick up the rump." In other words, go to hell. The
devil, however ostentatious, remains a coward at heart. The traveller still
had things to say, but his words evaporated into thin air: what was seen is
now unseen. Astonished at the Evil One's effrontery, the traveller set off
towards the exit. He opened the door and started down the steps, pausing to
survey the village from the top. Nobody in sight, not even a car on the road.
Then the traveller turned back, returned to the choir stalls, approached the
statue gazing down piously upon him and followed the devil's instructions:
he took hold of an angel, tugged, and it came away in his hands. For a whole
three seconds, heaven and earth stopped to watch what was going to happen:
would his soul be lost or saved? The traveller returned the angel to its
niche, and descended the stairwell grumbling to himself that it was hardly
appropriate for a church to impale tender little angels thus as though they
were some kind of Ganymede. The earth snickered, the skies blushed with
shame, and the traveller continued his journey to Murça.

Outside Carrazedo, the road continues its high route but stops running
alongside the River Curros. These are wide desert lands, you can go for

9 Carrazedo de Montenegro, angels

10 *Carrazedo de Montenegro, an emigrant's house*

kilometres without seeing a soul, and when suddenly you happen unexpectedly upon a village, it's called by the pretty name of Jou, with modest little roads leading off to Toubres, Valongo de Milhais and Carvas. The traveller repeats the names to himself, savouring them for lack of any other form of nourishment. Our ancestors were so imaginative – or maybe the nascent Portuguese language was more graceful in its inflections than it is today – that when we rush to baptise new settlements we should pause to think of the charms of the Village of This or That. Musing thus the traveller continued to peruse the countryside, finding solace in these mountains and those wild or cultivated lands, in rock and stone formations, in the giant ridges of the sierra which cause you to forget the league upon league of plains beneath.

The traveller enters Murça, a place of fame and renown which in times gone by boasted a great sense of humour, and erected a gigantic marble sow, godmother to those lying thereabout, upon a plinth. There she stands, in the main square, a strapping porky side-and-shoulders, inexhaustible hams grunting at the passers-by. She has ascended from the pigsty to the purity of the cleansing rain, with the sun to dry and comfort her, the centrepiece of a garden the municipality guards with care. The traveller goes in search of wine, for which the region is also justifiably famous, buys a couple of bottles, and having thus taken care of future appetites, takes in a glimpse of the past in

appreciating the façade of the Chapel of Mercy, which resembles an altarpiece brought into the light of day. Its humanoid columns, its sculpted foliage of botanical design refer back to earlier examples and copy other patrons, yet continuously renew the revelation of stone worked with a jeweller's or silversmith's implements. Stone birds perched on the pinnacles stare back disdainfully over their shoulders, or perhaps imply a mystical significance of which the traveller is oblivious. What's obvious is that most of all they are there to mock the impatience of a traveller who, once beyond the River Tinhela, enters the labyrinth of the no less famous Curvas de Murça, a to-and fro-ing so that one is led to wish for wings to fly as the crow does. At last he reaches Vila Real and, having suffered some rough roads, the traveller passes up the chance to keep going and takes the ring road, a race track for fast cars flying like bullets around the city. Life has many contrasts, and here once again, on entering the city, the traveller could see an over-elaborate stone escutcheon so embellished with plumes and scrolls that the ornamentation is more prominent than the lineage of the coat of arms. The traveller would feel tempted to uncover a sign of modesty in this, were it not for the fact that the stone is of such a grandiose scale that it must have cost the master stonemason a ridiculous amount of labour to install it.

The Stately Home

Vila Real is not a fortunate place. The traveller is bound to offer better explanations if he is not to arouse the hostility of the natives, so unfairly discredited by his words. But honestly, what more can one say about a place which has to the east Mateus with its manor house of obvious beauty; and to the west Marão; to the south the valley of Corgo, and parallel to it, a valley which flows not with water but with wines? A traveller who fetches up here is bound to be distracted by pondering on all that surrounds him. But there's a further reason for this traveller's responsiveness to the call of the North: "Come! Come!" The call is so imperative that, on awakening, he suddenly becomes agitated and, responding to a deep sense of urgency, in two bounds reaches the staircase. No gold mine or clandestine assignation awaits him, but the morning is certainly glorious, with huge, high, white clouds, and a sun gone crazy.

A few kilometres on from Vila Real lies Vilarinho de Samardã. You must pardon the traveller his weaknesses: coming from so far away and finding so close at hand illustrious sights such as the ancient palace flanked by two equally fine valleys; and the chance of voraciously devouring one poor village after another for the sole reason that Camilo Castelo Branco walked and lived there. Some of us go to Mecca; others to Jerusalem; many to Fatima; the traveller makes his pilgrimage to Samardã. That was the route followed by the young madcap, whether on horseback or in a phaeton. In his own words, it was in Vilarinho he passed "the earliest and only happy years of my youth", and in Samardã he noted the case of a wolf who survived five bullets and still finished dining on the second half of a sheep. Such episodes appear in life and in literature, and are yet another more than sufficient reason for the traveller to go in search of Vilarinho's stately home, questioning two women washing clothes in a watertank, who tell him to keep going further on and on. Castelo Branco's epitaph still stands over the threshold to the front door, but the house is now privately owned, and there's no wait for someone to attend to him. The traveller scarcely has time to register the buzzing of the bees and proceed up the drive to the house, glancing at

the long verandah and ingenuously wishing he lived there, when suddenly
there appears a woman willing to indulge his curiosity. She's Camilo's
great-grand-niece, an accommodating relative who gives the fullest replies to
the traveller's questions. At their feet a stream ripples, and the bees keep on
humming. Life truly has blissful moments.

But they don't last. One could not ask for more of such a delicate lady,
the traveller must be mad to think he's going to be offered the house, there's
no possible reason why he should be, and so he withdraws, muttering his
thanks, and takes a turn around the village. It sports a huge eucalyptus tree,
planted in 1913, so enormous that its highest branches scratch the underbelly
of the clouds. The washerwomen call out: "Have a good journey," and the
traveller goes on his way feeling comforted. There ahead lies Samardã, stuck
to the mountainside, so let's at least posit that it's exactly as Camilo left it.
This house, for example, with 1784 inscribed over the lintel saw Camilo in
the same place where the traveller sets his feet, both occupying the same space
at different times, with the same sun to shine on their heads, the same profile
to the mountains. Local inhabitants might peer at him along the way but
the traveller is in communion only with the beyond, he doesn't belong to this
world, may he be pardoned for it on this occasion. The traveller raises his
eyes towards the concave folds of the mountains, subconsciously seeking out
the ditch where the useful sheep served as bait for the hungry wolf, but he's
aware that times have changed and wolves run further afield, and so farewell.

The traveller returns to Vila Real, and this time he complies with the
rituals. The first has to be Mateus, the palace awarded to the eldest son.
Before going inside, you should go through its gardens, taking your time.
However numerous and valuable the treasures inside, you'd be guilty of the
sin of pride to disdain those without: trees which from all the colours of
the rainbow eschew only blue, leaving it to the skies; they sport every shade
of green, yellow, red, brown, with even a nibble of violet at the edges. These
are the arts of autumn, its freshness lies underfoot, it's a wonderful sight
for weary eyes, with lakes to reflect and multiply the pleasure. The traveller
thought he must have fallen into a kaleidoscope and become a traveller in
Wonderland.

He becomes himself again when confronted by the palace. It's a source of
beauty which, thanks to its architect Nasoni, remains intact even when
abused by being tastelessly labelled onto umpteen wine bottles. Such vulgarity
is indescribable, and if it's true the traveller has become sensitised to the
simplicities of Romanesque architecture, he still remains capable of resisting
wilful obstinacies. This was why he didn't resent its courtly elegance or the

stroke of genius in designing a pinnacle flush with the upper level, at first glance wholly out of proportion. The patio looks bashful, an early indication of an inner intimacy. Its large granite slabs give out echoes, and the traveller re-experiences the sense of mystery at other people's houses. There in the centre is what he is waiting for: its painting, furniture, statues, engraving all give it the precise atmosphere of a secular sacristy struggling with the heavy erudition of a library. Here lie the plates to the original engravings by Gérard and Fragonard for *The Lusiads*, while for those given to patriotic raptures, there are original letters signed by Talleyrand, Metternich, Wellington, even Alexander, Czar of Russia – all grateful for the gift of a book in a foreign language they couldn't read. With the greatest respect, the traveller decides that what Mateus has best to offer is still Nicolau Nasoni.

The world isn't properly organised. It's no longer just the complicated matter of the haves and have-nots but, in this particular instance, there's the serious crime of omitting to bring the Portuguese from all over the country to absorb the formidable imprint of these terraced slopes, covered from top to bottom with vines, while the geography of the supporting walls follows the curves of the mountainside, so rich in colours the traveller has no possible way of enumerating them, and together comprising the grounds to Mateus' stately home, reaching to the far horizon, including the woods abutting the Tuela River. It's an unpaintable painting, a symphony or an opera to the inexpressible. This is the reason why the traveller would like the chance to observe an uninterrupted procession of his compatriots endlessly passing along the highway below, on their way to Peso da Régua, pausing now and then to give a hand to the grape harvesters on the mountainside above, requesting or receiving a bunch of grapes, smelling the must in the wine-presses, sticking their arms inside and withdrawing them dyed with the earth's blood. The traveller indulges his daydreams, and trusts you will forgive him, since they concern fraternity.

The highway follows its peaceful route curving back and forth, now up and now down: on one side the houses are more easily visible, these too blend in with the countryside. Sites like these are not exactly wastelands. Many years ago, in the mists of antiquity, these slate mountains were spiky and terrifying masses, repeatedly baked by summer suns or swept by watery cataracts in the stormy seasons, immense mineral wildernesses, no use even as places of exile and banishment. Then man appeared, and set about working the earth. Men demolished, then built and built again, as if stone crumbled to fragments in the rough palms of their hands. Using clubs and mattocks, they made piles of stone into walls, kilometres of walls, and if

kilometres implies but a few, there are thousands of kilometres of walls, not to mention all those erected around the vines, olive groves and orchards across the countryside.

Here, between Vila Real and Peso da Régua, the art of terracing reaches its peak of perfection. It's a permanent ongoing process, for it's essential to maintain every right-angle, to pay attention to any soil slippage, to any loosening flagstone, or to a root which could transform itself into a lever, and so threaten to topple a wall into the bottom of the valley below. Seen from a distance, men and women appear as dwarves, natural inhabitants of the kingdom of Lilliput, and fiercely mistrustful of the mountains they seek to tame. And it's no figment of the traveller's prodigious imagination, the mountains are real giants, especially when you consider the local inhabitants' natural size as set against them.

He took his dinner in Peso da Régua, a meal of which he retains no memory of either scent or taste. Still seated at table, the traveller pores over his large-scale maps, gradually tracing the route of the highways with one finger and with the pleasure of a child gradually deciphering the world. He has a plan to go along this bank of the Douro to Mesão Frio, but all at once a vast nostalgia for the route he's already taken overwhelms him and, confronted by intense memories, what can the traveller do but surrender? The best thing, the one sure way he couldn't possibly lose out, was to go up to Fontelas and higher still among the farmsteads, gaze out over the terraced vineyards, see the river far below him, pausing with a great sense of peace in his soul before the minutely quartered vineyards – Nasoni's rustic grandsons, descendants of the blessed architect who came to these lands and in them happily fathered his large family. The traveller then resumes his descent of the Peso da Régua, crosses the town without stopping, and finds himself transformed into a traveller riven with doubts, it's sheer force of will that takes him back up the mountainside to Vila Real, as if to settle on the slopes of Fontelas or Godim, among their terraces, or rapping at the doors of the farmsteads like a ragamuffin, and running away when the dogs start barking. Oh blessed life!

You can see how easily the traveller lets himself be swayed by his memories of a childhood spent in other lands and the distractions afforded by Lobrigos' heights: he is once again overwhelmed by the sight of the vineyards, unarguably the eighth wonder of the world. He passes by Santa Marta de Penaguião, Cumeeira, Parada de Cunhos where, turning his back on the River Corgo, he comes face to face with the Marão. This may sound like the dry recital of an itinerary but is, on the contrary, a major step in the

traveller's life. Anyone can cross the Serra Marão, but when you learn that
Marão means the Great House, things fall into place, and the traveller realises
he's not only crossing a heath, but is about to enter a house.

What would any visitor do on entering? Take off his hat, if he wears one,
lower his head if it goes uncovered, in other words demonstrate the requisite
signs of respect. This traveller turns into a visitor and enters, his soul as
conveniently cleansed as his shoes, once wiped on the doormat. Marão is not
the steepest summit, the most vertiginous rockface, or a challenge to Alpine
climbers. We've already established it's a house, and houses are there for
humans to inhabit. Now the world and its brothers can climb them, but
can *he* really do so? Mountains roll on beyond mountains, they obscure the
horizon, or they disrupt it with an ever-bigger mountain; they are rounded,
enormous animal-backs resting on the ground, and forever immobilised.
Down in the deep valleys the sound of water can be heard, while down the
slopes on either side tumble torrents that pursue the road looking out a way
onto every lower level, dropping step by step, falling from a height or gently
joining the main current, one tributary into the next, waters which can as
well flow into the Corgo as remain behind with the Douro, or run as far south
as the Tâmega, which now awaits the traveller.

Over on the other side are the woods. The traveller reminds himself of his
good fortune at undertaking the journey in autumn. If he cannot come up
with the right words to describe a tree, how can he possibly describe a wood?
When the traveller looks over at the side of the opposite mountain he
sees the old timbers of the trunks, alternately sprouting opulent and sparse
branches, covering over the humus, bracken and soft brushwood that's
common in those areas.There he comprehends how he too can travel into
the invisible, converted into a goblin, sprite, even an insect squatting beneath
a fallen leaf, only reverting to a man when, from one afternoon to the
next, the wood breaks in a clearing and the highway runs under open skies.
Always accompanied by the ripple of icy waters, clouds meandering across
the heavens, no more than a passing murmur: how could thunderstorms
possibly arise in the midst of all this? Crossing the lands of Marão, from Vila
Real to Amarante, should be made a civic obligation equivalent to paying
taxes or registering the birth of children. Rooted in the Douro, the Marão is
the spreading branch of a great stone trunk which reaches to Alto Minho and
enters into Galicia; it gathers strength in Falperra then opens out in mountain
after mountain, via Barroso and Larouco, Cabreira and Gerês, on to Peneda,
and into the upper reaches of Lindoso and Castro Laboreiro.

That's where we'll go. For now the traveller is on his way into Amarante,

with its Italian or Spanish aspect, its bridge and the houses on the Tâmega's left bank leaning forwards, the kings' balcony overlooking the main square, and the humble hotel – whose rearview balconies overhang the river where now, at this time of the evening, a mist is rising, dusted with water droplets shot from the rapids, a sound which will persist in the traveller's dreams – for his enjoyment. But before all this, he has yet to dine with satisfaction and pleasure at Zé da Calçada's. This time he'll refrain from preaching another sermon as he crosses the bridge, pausing merely to consider: "This must have its tales to tell." Once the chapel stood here, built in the thirteenth century by one St Gonçalo, a native from among the peoples of Ribatâmega. Good times, those in which the saint bore the mason's mortar, and was well pleased with his handiwork.

The Tame Wolf's Cave

When the traveller awoke the day had scarcely dawned, and he observed that it was not only the river's murmur which had disturbed him. It was pouring and raindrops were rushing in cataracts down the verandah's window panes. Already used to travelling in all weathers, the traveller shrugged his shoulders under the sheets and returned to sleep without a care. It was the best of choices. When he rose, the morning was already well advanced and the sky was clear, with the sun sending miniature rainbows through the raindrops clinging to the leaves. It was a real treat. The traveller was appalled at the mere prospect of the heat in high summertime.

His first port of call was at the Albano Sardoeira Museum, where there are some pieces of archaeological interest, certain sixteenth-century paintings worthy of attention but, in addition to this and all the rest, there are the works by Amadeo, proud canvases of the period between 1909 and 1918, demonstrating his skill with every last brushstroke as though the artist, his work completed, immediately set off at full speed for his house at Manhufe where the grape harvest awaited him. The Museum is also endowed with some works by Elói, Dacosta, and Cargaleiro, but it's Amadeo de Souza-Cardoso who captures all the traveller's attention, his prodigious material and luxuriant style of painting so stand out from the Orientalism and Mediaevalism of the drawings that the traveller humbly went and bought in diminutive reproductions.

It goes without saying that patience is a cardinal virtue. They say of St Gonçalo that although they built the bridge before the present one, way back in the thirteenth century, he was kept waiting five hundred years before he obtained his tomb there, despite all the generous collections taken up for it. The traveller repeats this in a jocular fashion, a well-tried way of compensating for the shock he receives when, on entering the chapel with its exceptionally low roof, he comes up against a massive and recumbent statue, painted to look alive. Since the place was in semi-darkness, his shock was of relief. The feet of the miracle-working saint were well-polished by the kisses and caresses of those imploring his favours. One assumes the favours

were granted, since there was no dearth of offerings, in the form of a variety of miniature wax heads and legs and arms deposited on the tombstone. They were obviously hollow, since times are hard and genuine wax dear, so adulterated material was clearly employed. Yet it's not these objects but faith that saves, in particular a great faith in this St Gonçalo de Amarante, who has a reputation for marrying off old women with the same facility as St Anthony, who after all went down in history for waving his wand over young girls . . .

The traveller takes a walk around the church and the cloister which once belonged to the convent and, in his heart, found he could love Amarante, knowing at once that this love would last forever. He remained unconcerned at the three wicked Portuguese kings outside on the verandah not to mention the fourth and wickedest, the Spaniard: Dom João III, Dom Sebastião and Dom Henrique, the Cardinal and the first of the Spanish Philips. Amarante is such a lovely town that you forgive it its perverse sense of history. So there we are, with the kings, because they were around when the place was built. Reason enough.

The traveller returns to the church, taking a side corridor leading to the sacristy. What he can't figure out is where the rock and roll is coming from. Perhaps from the main square, or perhaps from a neighbouring addict. In provincial towns, the least noise penetrates everywhere. The traveller takes

11 *Amarante, Nossa Senhora da Piedade*

a couple more steps and listens. Seated at his desk a man, either clerk or
sacristan, it's impossible to figure out which, is making entries into a heavy
ledger, a small transistor radio at his side. It is this which is responsible for
the music filling the venerable sacristy with nasty and convulsive sounds.
Nothing surprises the traveller any longer, but he desires to know what
depths the subversion has plumbed. So he enquires: "Would you mind if
I took a glance in here?" The sacristan raises his head, looks around affably,
and replies: "Of course. Make yourself at home." And while the traveller
takes a turn around the sacristy, examining its painted ceilings, the paintings
of artistic note, a gross St Gonçalo, a glutton with an *embonpoint,* the
radiophonic rock and roll draws to a close and another tune begins, affecting
an inventiveness it lacks, the inventions pure repetitions, neither trimmed
nor developed. The traveller says thank-you, the sacristan continues writing,
neither asks but both concur that it is a beautiful day, and the music plays
on. Perhaps soon it'll play a waltz.

The traveller still regrets not having pulled up a chair at the table where
the sacristan was working away at his writing, remaining behind to chat,
knowing so much of life and musical tastes: how much there is to lose through
not speaking to people! Outside Amarante already, it's now a matter of
tracking down St João de Gatão. As to where he is and where's he's not,
there's no shortage of directions from the men bringing in the wine harvest
perched atop their tall ladders: "When you get there, at the big trees take
a left. Then it's down that way." Take a left, that's what the traveller took
or thought he took, but down the road some other men were to tell him:
"When you get to just there ahead, where the big trees are, take a right. It's
down that way." Finally the traveller reached his intended destination. The
house is much like many others in these parts: a small manor house, with
a central structure and two side wings, the sort that on occasions belonged
to the nobility or to the ennobled bourgeoisie, both rural dependants on the
land and its rents, and therefore tough negotiators. But this is a special case.
The house belonged to a poet. Here Teixeira de Pascoaes lived, and under
these tiles he died.

The traveller takes a path made sodden by the rains, pauses an instant and
takes a side turning into a wine-cellar, out to confirm his suspicions as to
"Whether this is or is not the poet's house." Those there quite simply affirm
that it was. His informant serves other customers, explaining that Teixeira
was man of a neighbourhood where no man is too grand for the local wine-
cellar. The traveller still remembers the care with which he had to scramble
over the rubber or plastic tubing coiled there, the scent of trodden grape, the

Pascoaes grape, poetic must, which would accompany him for many kilo-
metres yet to come, until his inebriation dissipated. Or perhaps better to call
it vertigo.

He encounters a simple flight of steps, its flowerpots and bannisters
stained with moss and lichens. Naturally, the traveller is intimidated. He
knocks at the door, waiting for someone to open up to him: "The journey's
a failure if I fail to enter." This house is no museum, it has no schedule of
opening hours, but there is doubtless a god for the protection of well-
intentioned travellers, and it is he who utters: "Enter" and when it's not a
god who materialises, it's the artist João Teixeira de Vasconcelos, Teixeira de
Pascoaes' nephew, who opens each door through a house constructed like
a precious pomegranate and keeps the traveller company to the end of the
corridor. The traveller is on the threshold of the section of the house where
Teixeira de Pascoes spent the final years of his life. He peeps and scarcely
dares to enter. Houses, the places where people lived or live, he'd visited so
many. But never the home of a tame wolf. Just three rooms in a row: one
to sleep and work in, the library, with the hearth at the end. Yet saying this
says nothing, for words cannot express the indefinable colour of clay which
permeates everything or of which everything is made, not that the overriding
colour should have to be as the morning light – it's just like the indescribable
nature of a sudden start of emotion that brings tears to the eyes. A wolf
stalked these rooms for this is not the home of a solitary peasant. The traveller
has need to cover and disguise his emotional eyes, as they would have been
described by a non-existent onlooker, though he'd understand it better if he
remembered that Marão is the great house, and to enter it is to climb the
highest mountain of the sierra, with all the wind in your face, gazing down
upon deep, dark valleys. Teixeira de Pascoaes is not numbered among the
traveller's favourite poets, but he's moved by the human scale of his home,
this minimally comfortable bed worthy of St Francis of Assisi, this rusticity
belonging best to a hermit, the biscuit tin to still the hunger in the dead
hours of the night, the rough table for his verses. We all leave to the world
what we create in the world. Teixeira de Pascoaes deserved to bear with him
this other creation of his own making: the house in which he lived.

There is more to it than walking: when the traveller re-enters the sunlight,
it's as if he landed from another planet. And, emotional as he is, he reaches
Amarante without realising it, but alert enough to feel outraged before
the statue there of Pascoaes, an inadequate and mean piece of work. He
retraces his steps over the bridge after pausing to give a farewell look to the
fourteenth-century Our Lady of Pity in her niche, continuing on under the

heavy fronds overhanging the avenue, taking the highway out to Marco de Canaveses. A smooth route, following the course of the Tamega, beautiful and bland river of the eclogues. According to his reflections, the traveller finally concludes the place is perfect for Arcadian shepherds, for at least sheep don't suffer from homesickness nor their young shepherd from chilblains on his fingers.

The traveller leaves Marco de Canaveses to one side, and goes in search of Tabuado. It's to be assumed that it'll be another demoralising search, but now he's been seduced. Suddenly it appears to his right, as if tugging on his jacket sleeve, with its twelfth-century parish church in a simple Romanesque style, wonderfully decorated with designs of plants and animals. Inside and out, the church merits an entire day's appreciation, provoking the traveller's jealousy for whoever had the time to do so in the past, or would do in the future. What remains of the fifteenth-century main chapel holds his gaze and the traveller is left pondering on the fashion changes from a past when the rustic beauty of these paintings was concealed. Who knows if thus they were spared even worse ravages of time? When the traveller emerges, he pauses to chat outside for a moment with a man and a woman. To them, the church is only what they've always seen in the place of their birth, but they agree with the traveller that yes sir, it's a pretty one at that.

Between Marco de Canaveses and Baião the traveller has time and opportunity to admit to his mistake. According to him, when the Marão spoke, the whole consisted of rounded mountains, gentle forests, even an orchard. He doesn't withdraw a word he said, namely that Marão lies between Vila Real and Amarante, but here Marão is something else, it has a stronger orography, dry and hard, with the sharp peaks lacking further to the north. This country seat is ringed with many walls, and the one the traveller is now visiting has to be a place of wind and mountain goats, a place uninhabited, because today not even a breeze blows and the mountain goats became extinct centuries ago.

Perhaps just because the countryside is like this, the traveller doesn't find himself attracted by more inhabited zones. He doesn't stop in Baião, but continues north, along the River Ovil and in a place called Queimada he finds signs of dolmens. The traveller knows there are plenty of them thereabouts, so if he doesn't see them immediately, neither he nor the journey will lose out. But it's still true to say that in his present mood the traveller prefers the deserts to this lofty path disappearing off into the mountains, promising deep silence and solitude. At first it passes beneath pine groves showing evidence of recent forestry but quite soon, only a little further on, the wilderness

begins. The road is a rough and ruinous track, pocked with deep puddles scoured by the torrents descending from above, and the traveller fears becoming involved in an accident, or a car breakdown. Nonetheless he perseveres, to win his reward when the ascent culminates in a little razed plateau. Not a dolmen in sight. Now he has to proceed across the wilderness, following some thin wheel-tracks which stop abruptly, a decoy that leaves him perplexed. It's like doing a jigsaw puzzle, tracking a mountainside with unclear boundaries. The traveller advances across the scrub, on course to find mines of gold, or a magic fountain, and just when he's beginning to ejaculate curses and imprecations (just as well he does so amid this disturbing scenery), he sees the dolmen before him, the first one, half-buried, its round hat planted on its vertical stones, of which only the tips can be seen. It looks like an abandoned fortress. The traveller takes a turn around it and finds its entry-point, within it the chamber, spacious and far higher than it looked from the outside, so much so that the traveller has no need to stoop for there are no lowered corners. Its silence limitless. Beneath its stones the traveller retires from the world. He slips back into a five-thousand-year-old history, when men used the strength of their arms to raise this enormously heavy slab of stone, as perfectly planed as a vaulted dome, what would you say if they could tell of the dead buried there beneath? The traveller sits down on the sandy floor, holding a tender sprig sprung beside the flagstone between his fingers, and drops his head to listen to his own heartbeat.

Passionate Animals

The traveller returned to Amarante along the road which follows the Fornelo River, this time without stopping. A basic and prudent precaution, as Amarante is endowed with a woman's devices and is well able to capture the incautious for days on end. Only a few kilometres further on lies Telões. Here there's a monastery with a spacious, if heavily restored, portico. Whenever the traveller departs from the main roads, he always reaps the benefits. Telões is situated in a wide, open valley through which runs an unimpressive little river, and as the traveller is about to enter the church, the bell starts tolling. It's the hourly peal, broadcast on amplifiers with four speakers angled at the cardinal points, diffusing a thunderous recording of the bronze bells up and down the streets. The traveller would have preferred the ordinary ding-dong of the originals to their electronic copies, but there was no way that progress would stop short of the valleys simply to please him. So let Telões be, with its newfangled chimes. Inside the church is an altarpiece to All Souls attracting the traveller's attention. It shows St Michael with his sacred lance, painted in strokes of natural colour, but with his eyes ogling the supremely beautiful victim, endowed with firm and tempting breasts, burning voluptuously among the flames. It can't be right for the Church to punish the temptations of the flesh and simultaneously stimulate them in such a fashion at Telões. The traveller departed from the church in a state of mortal sin.

Felgueiras lay behind him, and ahead lay Pombeiro and Ribavizela, a monastery in ruins, as doleful as only monasteries in ruins can be. It's five in the afternoon, already growing darker, and the traveller is seized by a sense of profound melancholia. The church is damp and cold inside, its walls stained with rainwater, and the flagstones of the floor, here and everywhere, are coated with green slime, even in the main chapel. To hear a Mass here must be worth a plenary indulgence, with past and future effect. But the traveller's astonishment reaches new heights when the woman with the keys tells him that the seven a.m. Mass draws the largest congregation, drawn from all the neighbouring regions. Under the cold and humid cloak of the

local climate, the traveller's hair begins to stand on end: what must it be like under the great rains and frosts of winter? As they turn to leave, the woman points to two tombs set either side of the door: "One's the Old One and the other's the Young One," she announces. The traveller approaches closer to confirm what she says. The tombs date from the thirteenth century. One of them lays claim to be that of Dom Gomes de Pombeiro, and presumably contains his bones. That's the Old One. Who, then, is the Young One? The woman with the key can't enlighten him. Therefore the traveller accepts without question what his imagination proposes: the second tomb also belongs to Dom Gomes de Pombeiro, made when he was a green and vital youth, lamentably struck down in battle by a serious wound, from which he felicitously recovered. They made the tomb as a lesson and a warning, and Dom Gomes de Pombeiro awaited old age in order to go and rest alongside his own image as a young man. It's a fantasy as valid as any, but the traveller did not confide it in the woman with the keys, since she didn't deserve this juggling with the dead, all the less so since she was unlikely finally to obtain either a tombstone or a prone statue, but if she did she'd deserve her own double image: the Young One she had been, and the Old One she'd become, with her sunken cheekbones and embittered mourning. The woman locks up the church with her heavy key, and retires to the convent ruins where she lives. The traveller contemplates the rose window high up above, taking a few minutes' pleasure in the hybridised but lovely doorway. The evening is dying, with no chance of prolonging the day.

When the traveller enters Guimarães, the street-lamps are lighting up. He'll sleep in a garret with a view over the Plaza do Toural. He dreams about the Old and Young Ones, watching them walking along the road from Pombeiro to Telões, listening to the heavy tread of their stone feet, then accompanying them to the All Souls altar, all three of them surveying the lovely victim, at long last warming her frozen body at the blazing bonfire not even St Michael could quench.

The traveller wakes to the clear light of morning. He dislikes the dream he awakens from, he's no Don Juan for such stony guests to pay him visitations, and he decides to curtail his fantasies in order not to lose any more sleep over them. He drinks a coffee to disguise his darker innermost thoughts, and goes out into the street to sample the atmosphere. The weather feels unsettled. The sun is only semi-visible, but luminous whenever it does appear. The traveller has no wish to remain in the city. He'll return to it later, but right now what he wants is to get back to wider horizons. He takes a decision to continue on to Basto, seemingly a popular name thereabouts, there being

three, two of them in Cabeceiras and on top of those two more in Mondim and Celorico, Canedo and Refojos, all of them greatly honoured with the name of Basto. The traveller has already discovered numerous examples on his map, but his route does not currently run through them. However, having noted their abundance, it would not appear a good idea to ignore them. There are but few kilometres between Guimarães and Arões. The traveller feels that a stream of words does not create a current of images, lights, sounds, that between the two there's no space for a breeze to circulate, that upon them no rain falls, and that, for example, it would be impossible to hope for a flower to blossom within the circumference of its o. This is as relevant to Arões as to anywhere else, but given the landscape is of such beauty, and since the parish church is Romanesque, kindly permit a poor traveller his instant of respite. From the moment he smells the scent of damp leaves he cannot find a word to express that scent of leaf and water. How to find one word to express all this, when so many have already failed.

And how to explain all there is to this valley? The road proceeds in curves between the hills and the mountains, with all the customary loveliness the traveller has come to expect. All of a sudden, at a juncture between Fafe and Cabeceiras de Basto and at a bend in the road, the traveller is obliged to pause, to inscribe on the most blank page in his memory all it is that his eyes see of its multiple planes, the curtains of trees, its damp and luminous atmosphere, and the mist the sun draws up from the land and which again dissipates along the ground, followed by yet more trees, hills which decline only to rise again, there in the distance, beneath a sky filled with clouds. Over and over again, the traveller is convinced that happiness exists.

Such matters deserve their homage. Over there lies another valley, a vast circus ringed by mountains, deep, wide and tilled. Just where the land reverts to nature amidst pines and wild weeds, a rainbow appears in the arc of the sky, so near at hand the traveller believes he could reach out and touch it. It starts over the top of a pine tree, tracing its curve up above and concealing itself beyond the valley, not so much an arc as the near-invisible segment of a circle consisting in coloured fringes, something like a length of exquisite tulle held up to a cheek. The traveller wearies himself with comparisons, and opts for an ultimate and decisive one, revisiting all the rainbows in his life and affirming that this is the most perfect and complete of them all; giving thanks to the rain and sun; and to the good fortune which brought him here at this precious hour; then he continues on his way. As he passes under the rainbow, he sees the distinct colours cast on his shoulders, but remains unworried: happily they are dyes that persist, remaining like living tattoos.

12 *A corner of Trás-os-Montes*

The traveller has nearly reached Cabeceiras de Basto, but first makes a detour through Alvite, if only to see from outside the Casa da Torre, with its gateway, chapel and tower, the first two Baroque and the latter even older, the most unusual feature being its pointed pinnacles at the corners, a magnificent equilibrium to its voluminous forms and graceful air of architectonic tightrope-walking. In Cabeceiras the traveller is greeted by the first drops of what before long will turn into a real downpour. He goes to the enormous eighteenth-century monastic building, of which now nothing remains of the primitive Benedictine community. It's a place well taken care of by St Michael. Two versions of him reside here: one over the doorway and the other, even larger than lifesize, can be seen from here below raised on the cusp of a dome, contemplating the countryside, in search of lost souls. St Michael must have won all his battles for as a rule only devils appear thus, their tongues hanging out, uncouth rustics supporting the church structure like monstrous plastic Atlases, lacking even the vestiges of grandeur.

The traveller returns to the square, suddenly remembering he still hasn't visited Basto, a crime no more easily forgiven than not seeing the Pope on a visit to the Vatican. He therefore set off in its search, finding it no more than a few paces away, beside him and between the river and its source. But who *is* this Basto? Some talk of a Gallic warrior, a circular shield against his stomach,

according to the fashion of the time. It bears the date 1612, looking more
like a youngster wearing short socks and a painted moustache than a rural
soldier from times past. On his head he wears a beret dating from the period
of the French invasions and, to preserve our earlier comparison, he seems
to be wearing long socks, well pulled up on the express orders of his mother
or grandmother. It makes you want to laugh. The traveller takes his picture,
and he composes his features, looking towards his objective, wishing to retain
his privilege, against his background of green fronds, as befits a gentleman
of the mountains and plains, considerably more so than the oh-so distant
St Michael of the church lantern. Basto is, undeniably, among the most
approved of Portuguese statues, everyone wishes him well.

The traveller looks uncertainly at the skies. Black clouds are gathering,
fresh reinforcements of those that brought the storm. He wonders what to
do, whether to stop for a cup of hot coffee or to make tracks, contemplating
whether to continue on to Abadim, a nearby village. Since the traveller is
setting off in search of he knows not what, he has to take a risk, thus to
go to Abadim resembles crossing the Rubicon. He'd barely walked a kilo-
metre when the skies opened. Within seconds the whole area had turned
white under the constant downpour. Twenty metres away a tree had turned
into something so vague and diffused that it seemed to be obscured in a
dense fog. Worse still, waterfalls were cascading down the mountainside
onto the road.

At this the traveller trembled. He could already imagine himself swept
away by the current, somersaulting among loose stones and dead foliage. He
crossed a fragile bridge and began feeling more at ease, the car still holding
out as it climbed the mountainside, and beyond another thousand twists
and turns lay Abadim. Not a soul to be seen, everyone had taken cover,
and those who hadn't were sporting second-hand overcoats. The rainfall
had diminished but was still falling heavily. The traveller decides to retire,
continuing on his journey more frustrated than he cares to admit. When he
passes a young woman with an open umbrella, the traveller makes the most
of his opportunity: "Good afternoon. Might you be able to help me? Do
they still drive the herds from hereabouts to the Cabreira plain, or isn't
that still the custom?" The woman looks as if she's wondering why on earth
the traveller would want an answer to such a question, but she's friendly,
and accustomed to answering questions politely: "Yes sir, they still do that
around here. From the First of June until the Feast of the Assumption, the
whole flock goes out to the plain with its shepherds." The traveller always
has difficulties comprehending the drovers' trails, but the woman explains

that in the Cabreira plain there are pastures which lie within the common land of Abadim, belonging collectively to the people, and that's where the herds are headed. The traveller remembers the River Onor, with lands on the far bank belonging to us and lands on our side belonging to them, and is even more deeply convinced of how relative is the concept of property, fashioned according to men's wishes. He bids the woman farewell, as she wishes him a good journey, and once back on the road with the rain hardly raining, he sees a shepherd scarcely fifteen years old. Who is or isn't he? "I'm in charge of the cows belonging to my father and to a few of our neighbours. No, sir, not for a salary. When the cattle are sold, the money gets divided between the owners; that leaves little for me, but when I'm older I'll give up herding and become a mechanic in Cabeceiras." The traveller goes on his way thoughtfully: "This fellow will never get to the Cabreira plain with the cows, and will one day even forget he was ever the master of the pastures. Where you win, you lose; and where you lose, you win." Thus, with like musings, he distracted himself all the way from Mondim de Basto to Celorico, without more adventure than that of contemplating the countryside, always mountains and crags, and far away in Mondim, the highest peak of all.

On reaching Guimarães the traveller still has time to visit the church of St Francis, where he is received by a diminutive sacristan who is mindful of his duties. The eighteenth-century tiles are magnificent, traced with a flowing style and in harmony with the Gothic dome of the main chapel. In another chapel the Tree of Jesse is on display, with some jolly kings perched like goldfinches in amongst its branches, garlanding the crowned Virgin. The traveller visited the sacristy and the cloister, listened carefully to the guide and, back in the nave again, saluted the splendid engravings like flowery arbours spanning the chapel ceilings. Having completed his litany, the sacristan remained behind, when the traveller came across a delightful miniature of St Bonaventura, hidden away in an altar, the Cardinal like a little doll at his desk, meditating piously on the scriptures, the bookstand overloaded with books, and a mitre, crozier and crucifix on one side and a tea service on the other, a number of jars and pitchers at his feet, a cage hung from the ceiling, chairs sufficient for any number of visitors, an abacus, a cross for protection – in all an example of the good life of a senior friar measuring a metre-and-a-half wide by 35 centimetres in height. St Bonaventura, a doctor of the Church who became known as the seraphic doctor, a lofty Franciscan, ending up in this doll's house, arguably the work of a nun whose perseverance won her place in heaven. The traveller

leaves the church, pausing for a minute to smile at the memory. Then, suddenly, looking more closely at the capitals over the Gothic porch, sees true love in the leaning heads and linked hearts of two creatures, smiling with sheer joy at the difficult spectacle presented by the world. The traveller stops smiling, surveys the smile transfixed in stone, and experiences a wild envy of the mason who sculpted those two animals in love. That night the traveller returned to his dreams, only this time they became transformed into living stone.

Where Camilo is Not

The traveller has already remarked how Guimarães is truly the cradle of our nation. He had learnt as much in school, heard it repeated in commemorative lectures, so had no lack of reasons for taking his first steps to the sacred site where the Cathedral stands. At one time the slopes on the way up were stripped of heavy vegetation, so the owners might find no impediment on their way out, nor their enemies any hiding place on their approach. Today it's a garden filled with neat alleys and luxuriant woods, the perfect place for new lovers to haunt. The traveller, always subject to exaggeration where historical detail is concerned, would have preferred the entire hillside to be cleared, and left as rough terrain, with only its eight-hundred-year-old stones still flourishing. Thus preoccupied, he lost the venerable shade of Afonso Henriques, lost his way to the front door, before becoming impatient and deciding to go straight ahead, confident of being hailed by some municipal guard who would accost him with: "Gentle knight, where are you headed?" To which our first king replies: "To the castle. My horse is exhausted with going round in circles." The gardener hasn't noticed a horse thereabouts but replies charitably: "Take him to the water, and then follow this track and you won't get lost." And when Afonso Henriques departs, dragging his wounded leg to Badajoz, the gardener comments to his assistant: "You get all sorts around here . . ."

Thus constructing this and further episodes of a revised history of his country, the traveller enters the castle. From outside it had looked considerably larger. Inside there is a tiny enclosure, made even smaller by the thickness of the walls along the main tower of tribute and the remains of the citadel. Within is a typical little Portuguese house, as can be found in any part of the world at any moment in time. The traveller examines his emotions for signs of affection and despairs at finding himself less moved than he would have wished. Among so many stones, which are the most charged with feeling? Many were laid here little more than forty years ago, others date back to the time of Dom Fernando, when the earth and wood was sent to arm the Countess Mumadona, leaving behind only this sodden dust

13 *Guimarães castle*

which sticks to the traveller's fingers when he shakes out his trouser turn-ups. The traveller would prefer the river of history to rashly invade his breast, instead of which a thin trickle of water continually secretes itself there, vanishing into the sands of oblivion.

He is thus unsheltered between the false walls, almost sighing with frustration as, defeated, he looks at the floor and takes comfort in finding the explanation of it all so close at hand, although hitherto unseen by himself. He is standing on the same great stones that Afonso Henriques and his labourers walked upon – who knows whether if here someone was imprisoned or even died, perhaps a Martim or an Álvaro? – but the stone, the floor, the ceiling above, the squally wind, all carry every word ever spoken there in Portuguese, and with the first and final sighs arising from the depths of the profound river that is our people. The traveller has no need to mount the sentry's walkway to view a bit more of the countryside, nor clamber to the top of the tower to see still more. Sitting on this stone, unworn by feet either shod or unshod, he understood everything, or assumed he did, at least for today.

The traveller departed, bidding farewell to Afonso Henriques, who was wiping down the sweat of the day's hard labours from his horse, went down

to the church of St Miguel do Castelo, which he found closed, then on to the heavily over-restored Palace of the Dukes of Braganza. The impression it offered the traveller was to have committed to architecture the same taste for mediaevalisation that our official and officious sculptors adopted from the forties through to the sixties. The artistic wealth of the palace is not in question, still less the Gallic aspect of its construction, there in the original, but it had had a fresh coat of paint, equally distributed across the ancient and merely archaic additions, despite its Gobelins and Pastrana tapestries, the armoury hall, or the collection of furniture and sacred paintings. Perhaps the traveller still bore the castle's boulder upon his shoulders. Something rendered him unable to take in the palace. He made a pledge to return there one day, to repair the present injustices which, through his own fault, he was committing.

It was high time to visit the museums. The traveller started with the oldest, Martins Sarmento, with its collection of the finds from Briteiros, a pre-Roman fortified town, and Sabroso, an Ibero-Roman settlement. Stone for stone, there can be no limit to the examination and appreciation they evoke, even within the bounds of the traveller's scientific knowledge. The statues of Lusitanian warriors are delicious, not to mention the unsurpassed colossus of Pedralva, the granite boar, a brother to the swine of Murça and the rest of the transmontine piggery, and finally the crematorium door at Briteiros, the felicitously-named Pedra Formosa [Beautiful Stone], with its ornately interlocking geometrical loops. The rest of the museum, with other less antique specimens, some hardly dating from earlier than yesterday, do not merit less attention. So the traveller departed well restored and continued on a high to the Alberto Sampaio Museum.

Let the traveller put on record that this is one of the most beautiful museums he knows. Others may have greater riches, more famous collections, ornaments of finer provenance: the Alberto Sampaio Museum has a perfect balance between what it contains and its architectural surroundings. Then there's the cloister at the College of Our Lady of the Olive Tree whose sequestered air and irregular design leaves the traveller with no desire to depart, but rather to linger over examining its arches and capitals, its abundance of rustic and learned statues, all of them beautiful and all putting the traveller at grave risk of falling into temptation and not moving on from there. His salvation lies in the guide's announcement of further beauties within its halls, which he discovered, in such numbers it would take a book to describe them all: Dom João's silver altar and the coat of chain mail he wore in Aljubarrota; the "Santas Mães" [Holy Mothers], the eighteenth-century

"Fuga para o Egypto" [Flight into Egypt], the "Santa María a Formosa" [St Mary the Beautiful] by Master Pero, "Nossa Senhora e o Menino" [Our Lady and the Little Boy] by António Vaz, with their open book, the apple and the two birds, and the picture by Brother Carlos of "SS Martin, Sebastian and Vincent" – and a thousand other wonders in painting, sculpture, ceramics and silverware. The traveller's final conviction is that the Alberto Sampaio Museum contains among the loveliest of collections of sacred objects on display in Portugal, less for the quantity than for the exceptional aesthetic quality of the vast majority of the pieces, many of them truly first-class. This museum merits any number of visits, and this particular visitor swears to return every time he passes through Guimarães. He might not revisit the castle or the dukes' palace although he promised to do so: this, however, is a museum he won't miss out on. The guide and the traveller bid their farewells, each of them brimming with sadness, since the latter was the only visitor. Despite this, the summer supposedly brings many more.

We all make mistakes. On leaving the museum, the traveller followed one old street after another; he admired the ancient Paços do Concelho [Council Chambers], the Salado monument and, having emerged into the Praça do Toural, he involuntarily committed a sin against beauty. There stands a church, whose name the traveller prefers to remain unremembered, for its assault on good taste is fundamental and extends to insulting what a religion has the right to expect: meaning an atmosphere blessed with excellence, an oratory dedicated to aunt Patrocínio or mother Paula, a transgression of the confessional. The traveller enters contented and emerges in anguish. He had viewed the "Santas Mães" in the museum, and the Virgin garlanded with roses who's also there – but neither she nor the pair of them deserve such an offence and such a let-down. There remained much still to be seen in Guimarães, but the traveller preferred to depart.

The next morning it's raining. The weather's like that here, disposed equally to sun as to showers. It'll rain with occasional breaks all the way to Santo Tirso, but the skies will already have opened when the traveller comes to stop in Antas, close by the Vila Nova de Famalicão. To the traveller, the whole region resembles a suburban landscape sown with houses, the focus of the industrial penetration radiating outwards from Oporto. For this reason the Romanesque fourteenth-century parish church of Antas appears somewhat unexpected, incongruous even, in a region whose rural character is disintegrating, the less suited to an ambience in which the most delirious product of the imagination is a "house *maison* with a *fenêtre* window" for returning emigrants. Ever since he left Trás-os-Montes, the traveller's eyes

14 *Briteiros, a pre-Roman fortified town*

have attempted to remain averted from the horrors now strewn around the countryside, roofs tiled in four or eight colours, bathroom tiling transferred to the façade, Swiss roofing, French attics, Loire castles fortified alongside the main road in the form of a cross, the unthinkable addition of reinforced concrete, the boiling vats, the "parrot's perch",[5] the great crime against culture which is being committed and whose commission is permitted. Now, having simultaneously before his pained eyes the pure and sober beauty of the Antas church and the architecturally cretinous outskirts, the traveller could no longer maintain the pretence of not seeing, nor discuss things only in terms of pleasure and praises but must register his protest against those responsible for the general degradation.

Where is São Miguel de Seide? Lavish signposts point in the general direction but from there on, street past street, their scale is reduced, their arrows magicked away, and the traveller is in the ludicrous situation of passing the house that was Castelo Branco's without actually noticing it. Three kilometres further on, at an enigmatic crossroads, he'll ask a man standing there, possibly for the purpose of charitably assisting lost travellers, only to be informed: "It's some way back behind you. On the square where the church and cemetery are." The traveller retraces his steps blushing with embarrassment, and finally hits upon the house. It's lunch-time, the guide is taking a rest, and the traveller is obliged to wait. While he waits, he walks up and down and takes a look at the gatehouse where Camilo Castelo Branco lived and died. The traveller knows that the real house burnt down in 1915 and that this one is as recent as the battlements of Guimaraes castle, yet he still hopes that there will be something inside to move him as much as the wild and stony ground surrounding the castle walls. The traveller remains a man deeply attached to hope.

The guard materialises. "Good afternoon," says the one. "Good afternoon," replies the other. "I would like to see the house if I may." "Yes, indeed sir." The gateway is opened and the traveller goes inside. Camilo had been here. The trees weren't the same, nor the plants, nor probably even the stone floor. But there is Jorge's acacia, beside the stairwell, there's no doubting its authenticity. The traveller goes upstairs, the guard repeats to him things he already knows, and opens the apartment door. The traveller realises there's to be no miracle. The lighting is dim, the furniture and ornaments, however genuine, bear the imprint of having passed through other places and feel strange about returning here, neither recognising the walls around them nor feeling recognised by those walls. When the house burnt down, it only contained a portrait of Camilo and the sofa where he

died. Both were saved. The traveller could therefore see the sofa and, in so doing, see Camilo Castelo Branco seated upon it. It remains true that the possessions inside these little rooms, the ornaments and autographs, the pictures hanging on the walls, every last bit of it all, either definitively or presumably belonged to Camilo. This being so, where does the deep melancholy which invades the traveller come from? Maybe from the heavy atmosphere, maybe it was the fine mould which seemed to cover everything. It had to derive from the tragedy of the life lived within these walls. It had to be down to the distress of those failed lives, however glorious their works. Might it be this, or that, or something else again? This was the house where Camilo slept and wrote. So, where does Camilo reside? In São João de Gatão, or in his lair at Texeira de Pascoaes, also about as dark as he deserved? Seide could be a bourgeois interior of the 1800s either on the Rua de Santa Caterina in Oporto, or on Lisbon's Rua dos Franquieros. Seide is far more really the home of Ana Plácido, and belongs very little to Camilo. Seide fails to move you, it saddens you instead. Perhaps this is why the traveller is starting to feel that it's time to take a look at the sea.

5. A mediaeval torture reputedly used under the military dictatorship, the victim being strung upside down from a pole ("perch") by the wrists and ankles.

Sleeping Beauty's Castle

Looking again at the map, the traveller decided: "I'll start from here." Here is Matosinhos. Poor António Nobre, should he get lost here, en route to Leca. He'd die of anguish before the tuberculosis got him, just from surveying its factory chimneys, overwhelmed by their noise: even the traveller felt confused and concerned at his bustling surroundings. When all's said and done, we have only ourselves to blame in attempting to read reality in books which can only register a very different order of reliability. There are many variations on the theme of *sebastianismo*[6] and this is among the most insidious. The traveller vows not to disregard the warning.

Once in Matosinhos, you have to go and see the church of Bom Jesus and the Quinta do Viso. But the traveller, who can't go everywhere, remained before the Nasoni, a perfect feat of architecture, of a broadly horizontal construction. Nasoni himself is wholly Italianate, but he understood the mysteries of Lusitanian granite which give it space on which to rest our eyes, alter-nating its dark granite tones with the chalkiness of the plaster. It is a lesson forgotten by latterday adulterators and the manufacturers of modern nightmares. The traveller is well aware that now it costs an unattainable fortune to build houses from granite, but given what one can and cannot achieve in balancing the books there should still be a solution compatible with an architectural tradition rather than venturing into its systematic assassination. It was horrific.

Outside in the eviscerated gardens some rough shrines still remain, containing old and routine versions of the Way of the Cross. This almost passes the traveller's understanding: the difficulty men have in comprehending good things and the ease with which they repeat the bad. Inside the church there remain worthwhile pieces of sculpture, including a St Peter made of Ança stone. With such a good example in front of their eyes, what kind of models would potters choose, given not an ounce of sensitivity in their fingertips? A question like this has no answer, but the traveller is already well accustomed to the situation.

From Matosinhos to Santa Cruz do Bispo is only a short hop. The traveller

15 Trás-os-Montes, a Way of the Cross

goes in search of the São Brás mountain, home to a famous sculpture of a marvellous man armed with a heavy mace, with a ferocious lion, now subdued and obedient, at his feet. Something like that demands a mountain, a wilderness, a mystery. But the traveller is wrong to romanticise like this. At the end of the day São Brás mountain was on the scale of a Nativity Crib, so well defended that it looked artificial, with its brave warrior a pathetic figure, legs nibbled by a little dog rolling at his feet begging for his tummy to be scratched. Instead of a wild and craggy country place, a caprice of nature well away from the haunts of men, the traveller encountered a piece of parkland suited to country picnics, still scattered with left-overs and old plastic bags. You know how these things are: the traveller sallies forth in the expectation that all will be his alone, and becomes offended if someone else anticipates his sights and pleasures. This bearded gentleman, who must be St Brás, is telling us he's no Hercules, whatever certain ambitiously erudite men may have intended. He welcomes his many visitors here, being the patron saint of happiness, and instead of baring his teeth, the lion looks sideways at his master like a setter awaiting the hunter's signal to be off. There are wine stains on St Brás' head and shoulders: pilgrims aren't selfish, they offer their saint the best they have, something to warm the blood and raise a smile. On consideration, the traveller is forced to confront his own selfishness,

he wanted the statue to himself, or at most for only a select few, and he found a common saint who partakes of cheap wine and a placid lion who proffers his strong back to any young girl wanting to take a break between dances. Where should one look for a more harmonious scene? Humbled by the lesson, the traveller leaves the Man of the Mace to his struggle against time and the elements that are destroying him and continues on to Azurara, a land which lent its name to a chronicler who was probably never born there, just like our friend Damião, a reputed native of Góis, who was actually born in Alenquer. The parish church of Azurara stands close beside the main road, so the traveller had no excuse for not visiting it, other than that the sacristan had vanished without leaving any indication of where a key might be found. The traveller despairs, he's not travelling in order for this to happen, but the parish church is a military fortress without breachable entry. He has to content himself with looking at it from outside, something not without its charms, and vowing to return.

In Vila do Conde, only a little further down the road, the traveller finds his reward. José Régio's house is also closed, so the traveller has obviously hit on the wrong day, but at least there are compensations in the sinuously snaking streets of the fishermen's quarter. In pursuing their way he comes across the hermitage of Senhor do Socorro, with its imposing chalky dome: it's a popular temple set apart from the grander liturgies, and in its atrium, if that is the correct name for such a space, the fishermen mend their nets in the tumbling sunlight. There's a general hubbub of gossip. One of the gossipers is called Delfim, a sound seaworthy name, and when the traveller approaches the wall, he can look down on the River Ave and the *Sorriso da Vida* and cannot ask for more: a river capable of flying and a boat with a name like that. The air holds a magnificent purity, without a puff of wind; matchless. The traveller bids Delfim and his companions farewell, descends to the lower town by dint of stairwells and steep alleys, ending up in the shipyard where they still build wooden boats, daring ensigns putting the secrets of the sea on view without permitting the traveller to decipher them properly. He has to remain content with scrutinising the design of the keels as they emerge from the water, and the arc of the crossbeams, inhaling the scent of serrated wood freshly planed with adzes. The traveller is under no illusion: just to learn the first letters of this alphabet, then to get to the next and the last, would take another lifetime. But although the traveller might know just a few of them, and is well able, for example, to read those inscribed upon a metal plate like a proclamation: WE LACK NEITHER WORK NOR THE WILL TO WORK. WHAT WE DEMAND ARE WORKING

CONDITIONS. This was the point at which the traveller became aware of the lengthy journey he had already made. All the way from Rio de Onor to Vila do Conde, from the collective murmur to the openly candid written word, from the tops of mountains and the depths of valleys, come rain and fog or clear skies, on Douro's terraces and in the shade of the pines, there was but a single Portuguese idiom.

Vila do Conde has much to tell us. Nonetheless, it's the one community among all the cities, towns and villages boasting a pillory mounted with a sword, a figure of justice that doesn't demand you to offer up your eyes as it doesn't have any. It is simply an arm, attached to a vertical shaft, faithful support of a missing set of scales. The traveller puzzles over the owner of the arm and what the sword was there to slice. Justice perhaps, but of an enigmatic variety. The parish church has a Manueline[7] doorway attributed to John of Castile. Its massive belfry dates from the seventeenth century. Sunk into the body of the church, it at once conceals and quenches it as it enhances it: at one and the same time it is excessive and complementary. The traveller, had he an opinion on such matters and sufficient strength in his arms, would have seized its solid weight and shoved it aside, in the manner of Giotto's *campanile*, freestanding beside the church of Santa Maria dei

16 *Vila do Conde, beached fishing boats*

Fiori in Florence. It's an idea the traveller decided to bequeath to posterity, if one day there is the money to waste on like perfectionism. Once inside, don't miss seeing the sixteenth-century "St John" who, as the patron saint, has another image set into the tympanum of the doorway, and also a sixteenth-century "Senhora da Boa Viagem", holding a lugger or something resembling a ship in her right hand. She is the fishermen's guardian, guardian to Delfim and his friends, happily still living.

The traveller then proceeds to the convent of St Clara. He takes a school-boy for his guide, a lad called João Antero who's already installed there, and with whom the traveller holds serious conversations on matters of his instruction and his teachers. The traveller still remembers the school-day torments he once suffered, as the magnificent Gothic church with its precious jewels fills him with profound compassion and avuncular affection. Other visitors are also touring the church, apparently more interested in testing the echoes than in opening their eyes. The little pupil is a sensitive soul and neglects their company in order to keep the traveller's. In the Capela dos Fundadores lie the tombs of Dom Afonso Sanches, bastard son of the king Dom Dinis, and of his wife Dona Teresa Martins. They are two genuine jewels made of stone.

The traveller cannot stay longer. If he allows himself to get carried away, he will never leave, for the church is among the most beautiful sights that his eyes have thus far seen. Farewell, Vila do Conde.

Where the River Mau ran to find its name he cannot say. No waters run beside the inhabited bank, and only a little stream passes a kilometre further down: something so insignificant doesn't deserve to be spoken ill of. And the Este, tributary of the Ave, flowing close beside it, takes its name from the cardinal point ("east"), another mystery that evinces the traveller's curiosity. But the focus of interest here is less the river than the famous church of St Christopher, dating back to the twelfth century. Said to be of a piece with the Romanesque style of the region, this would be at one and the same time both a proper and a contemptuous description. What deserves most emphasis is, once again, the striking plasticity of the medium, an expressiveness achieved by the density of the material, the graphic weight of its superimposed blocks of stone, the multiple readings this gives rise to. If St Christopher on the Mau is truly such a simple church, then simplicity must constitute a direct route to aesthetic sensitivity, with the obvious consequence of achieving that breathtaking force which suddenly and simul-taneously depresses and raises the traveller's spirits. Although its extensive restoration is obvious to the naked eye, he remains unaffected by it this

time, contrary to his usual reaction. Quite the opposite: rather than a ruin that his contemporaries who know about buildings would fail to recognise, he had before him a reworked reconstruction, successfully bringing yesterday into today. Once inside the church, the traveller felt as if he were in a time machine. And he's also a space-traveller, that goes without saying. One of the capitals, which as anyone can see reproduces scenes from the *Song of Roland,* transports the traveller with lightning speed back to Venice. In the Doge's Palace, in the corner of St Mark's Square, and well tucked away there's a porphyry statue known as *The Tetrarchs.* They are four warriors assuming a fraternal attitude, possibly of military camaraderie, yet with a subtle flavour of humanity. These tetrarchs of the River Mau are more warriors than men: in the true sense of the word they are men of arms. All in all the resemblance or, if you prefer it, the echo, is irresistible. The traveller marvels, betting that no-one else has ever made a like observation, and is well pleased with himself.

It's only with the greatest difficulty that the traveller tears himself away from the River Mau. Churches as rustic as this are few and far between, but this particular rural idyll had employed a genius to work on the tympanum, sculpting the image of a crozier, by reputation the symbol of St Augustine, and his two more minor signs, a bird with the sun for a halo over his head, and what looks like a swaddled infant holding the moon in his raised hands. The traveller would exchange the Venus de Milo, the Belvedere Apollo and every metope in the Parthenon for it. As you can well understand, the traveller is really a rustic at heart.

The day declines into twilight. The traveller leaves the River Mau behind him and sets forth down the highway: if driving were not such a risky undertaking, he would travel with his eyes closed, the better to preserve the magnificent image of that tympanum. He heads towards Junqueira where he'd heard of a monastery called San Simão, although with little hope of finding it open at dusk, and little desire of finding someone to open up for him at the relatively late hour. Nonetheless the traveller has his little obsessions, one of which is to see with his own eyes, however fleetingly or with only a passing glance, the things which really matter to him. He has already visited one Junqueira in Trás-os-Montes, and is keen to know more of this one in Minho. He was about to learn. San Simão is nothing but a Baroque façade, its two belfries standing like bulrushes, nothing special and nothing in comparison with the River Mau, which he can't get out of his mind. And the door, as he had anticipated, was locked.

Night was closing in, and the traveller was to spend it at Póvoa de Varzim,

so it was time to be getting on there. But when he did, he found the door ajar, a sign offering the site for rent, and vegetation growing along the top of the wall. The silence there was absolute. Not a soul to be seen. The world was evidently about to end or to begin. No-one can be a traveller without being curious. The door half-ajar; the silence; such a deserted spot; he'd be mad or misdirected not to exploit the situation. He pushed a little at the door, cautiously, and peered inside. In fact the wall was not a wall, but only a narrow structure resting on the entrance arch. The traveller's heart was pounding, the heart being the first organ to descry such things, and as if he had suddenly entered a dream, he entered and was suddenly within, on a wide path separating two entirely different gardens, one on his left at the foot of what had to be the old monastery, and the other on his right, segmented into tiny avenues bordered with recently-pruned boxwood. The other garden was raised a level, edged with balustrades, some trees of undistinguished appearance but here, on the lower level, seemingly constructed by gnomes so that fairies might pass by there, is the path trod by the traveller, near-intoxicated by the aroma exuded by the damp plants, perhaps even by the pruned boxwood, spikenard if this were in season, jasmine or hidden violets. The traveller finds himself trembling, he feels a lump rise in his throat, he wants someone to appear and nobody does: not even a dog barks. He takes a few more steps down the central avenue, having to hurry a little to avoid nightfall, and reaches a wide wooded place, low trees with a dense spread that makes a roof of vegetation he can almost touch with his hand. The forest floor is covered with leaves, a heavy cloak of them crunching under his feet. A light shines from another side of the monastery: one solitary lit window. The traveller feels desperate. He's not afraid yet he trembles; nobody appears to scold him yet he's almost in tears. He proceeds further, under a walled archway and, by almost the last light of day, he encounters a large orchard filled with fruiting trees with an aqueduct at the far end, paved paths, rose bowers and flowerbeds. On continuing he discovers an abandoned inn where the illuminated window must be, yes, absolutely has to be, Sleeping Beauty's suite, no doubt, she being the sole possible inhabitant of such a mysterious place. A minute and then an hour passed, only a remnant of light remained, but night doesn't dare advance, giving him time to return to the trees with their carpet of decaying leaves, the echoes of his footfalls, the minimalist garden, the scent of the earth. The traveller emerges, shutting the door as if closing it on a secret.

6. *Sebastianismo* is based on the mediaeval legend akin to our Arthurian one, of a saintly king (the fourteenth-century King Sebastian) bound to return and save his country at some unspecified future date.

7. Manueline architecture was typical of the reign of King Manuel I (1495–1521). This was Portugal's great age of discovery, and the style combines elaborate late Gothic elements with seafaring decorations such as twisted ropes of stone and the armillary sphere, a globe in stone that became the emblem of Manuel I.

Of Headaches and Other Miracles

The traveller has little clear memory of Póvoa de Varzim beyond a general sense of passing confusion, searching for the right road, buildings scattered along the beach like building blocks in a child's game and, somewhere along the way, a crazily ceramic-tiled house, a mosaic of every colour and shape in the universe. And when he reached A-Ver-o-Mar, of smooth name and contemplative aspect, it must have been his fault that he chose the wrong moment: the beach was teeming with millions of flies, swarming over strewn fish innards, gelatinous weeds and all sorts of disgusting garbage. The *cubatas*, the stone supports for the straw thatching with a collar of thick, irregular pearls, were a sight to be seen but, once seen, there was nothing further to observe. And so the traveller continued on, with a sufficient degree of self-criticism to suspect that the blame for this dissatisfaction should rest with Junqueira, at that irrecoverable hour on a November afternoon which would never return. And, since he had seen something of the world and of life, he also knew that while going to visit Aguçadoura at this hour of the morning to view the *campos-masseiras*, Sleeping Beauty's garden would be bathed in a different light and smell, someone would be sweeping up the leaves for the compost bin and, as a final indignity, the enigmatic young lady of the convent would now be ordering the maids around and shouting at the poor unfortunate who dropped the teapot. The traveller is also aware of other matters: he knows, for example, how to retain in his memory the indestructible image, forever and as long as he lives, of Sleeping Beauty's palace.

In Aguçadoura, the *campos-masseiras* produce agriculture in sterile zones. Earth, humus, fertilisers made from local vegetation, seaweed gathered from the sea, trees as protection against the winds, everything cultivated like orchards blooming in the desert – in the last analysis, those who do all this belong to the race of the shale-crushers of the Douro, the builders of terraced vineyards, all possessed of a like determination, the same urgency to eat, to raise their children, to procreate the species. The traveller takes away with him new values in weighing the labour of his fellow men, a reconsideration of what he so disliked at A-Ver-o-Mar, asking himself whether, going back

17 *Caminha, drying seaweed*

over it in his mind, it were possible to dry seaweed in the open air without attracting flies with the smell. And, thinking thus, he quickens his pace and resumes his journey to Rates.

Given how much the traveller has found to say about São Cristóvão on the River Mau, what more can he now find to say of Rates? This church is the slightly older sister of the one by the River Mau, both dating from the twelfth century, with Rates greater in grandeur and ornamental richness. The five-vaulted porch, sculpted into two interiors, boasts a Christ with an almond- or oval-shaped halo in its tympanum, flanked by two saintly person-ages, placed one and the other over two kneeling figures, something that seems remarkably unChristian to the traveller, unless the lower figures should be demoniacal representations – and not even then. The traveller will not go on to describe the church. He will, however, admit that each of the porch's capitals is a sculpted masterpiece; and that the façade, with its buttresses, flatters eyes and spirits alike. He will say that the wide interior, suffused with gloom, persuades us to believe that ultimately man needs to live among beauty. He will say that the tracery in every arch, broken in some and complete in others, down to the last pointed arc, demonstrates how diversity can become homogeneity. Finally he will say that Rates church deserves the inauguration of new pilgrimages for all those genuinely engaged in the search

for perfection. Here is a place for faith to be renewed. The traveller himself is without the least doubt that his reason for believing in the durability of beauty has just been confirmed.

From Rates the traveller moves on to Apúlia, where masseurs in Roman togas don't await him but where on this sundrenched day the water, there ahead in the sea, is too chilly to tempt his skin with its wetness, a spray which abounds to wet his eyes. The road to Fão and Ofir is an easy one, and there might well be good reasons for stopping off there, but the traveller has also been walking on mediaeval grounds and their touristic bustle weighs heavily on him, the adverts for building societies, the sign announcing a "snack bar"(an abomination which will soon put paid to the Portuguese tradition of *vinhos e petiscos* [wines and savouries], those titbits whose prices we are always honourably only charged for when it's too late) and when he reaches Esposende, he loses himself in the wide coastal avenues, wondering if any of it's worth the effort and yearning once more for mountains and clear waters. He recrosses the River Cavado, following a course along its southern bank via Vila-Seca and Gilmonde. It still remains for him to visit the celebrated city of Barcelos, but the traveller decides to defer it to a future occasion, given that the vocation of a lone wolf seems to have kindled within him. Nonetheless, what's for sure is if you flee the cares of the world, the world's cares come in search of you. In Abade de Neiva the traveller visited the combined church and tower, encountering the most lively mediaeval atmosphere ever, and when he returned to his car, he discovered a puncture. Such routine occurrences are risked by anyone travelling by road, particularly by such poor roads. He takes out the spare wheel and replaces the tyre, his mind on miracles and the pleasantness of the day with the green pine trees there below, considering how well whoever built that church pinned to that tower knew his job, and then, the work finally done, took to the road again. Thus he rolled on another couple of kilometres. The traveller was riding his Pegasus through the clouds when, suddenly, he was laid low by the sharp pains of error. Thank heavens for the instant of illumination: he had forgotten nothing less than tightening the bolts on the wheel, great traveller that he is, although he obviously lacked nothing in mechanical incompetence. He was left with just one doubt over whether the warning had come from St Christopher or from Mercury, even taking into account the dearth of motor-cars in ancient Greece where the god was invented, or in Syria, the saint's native country.

The traveller wanted to go to Quintiães but resisted the temptation. The road was terrible, and it would be a serious matter if he got another puncture

along the way. A last and lasting memory was of two lizards' heads, decorating a doorway there, looking like genuine gargoyles or cornerstones, but perhaps they were fakes: either way they showed greater dexterity than was to be had in the mending of a puncture.

Balugães is on the margins of the River Neiva, a land of great antiquity, already a settlement before the Romans even set food on its land. The traveller entered and was immediately at a crossroads. It's true that each one chooses his destiny and it was to Viana do Castelo, on the left-hand side of the river, that the traveller repaired, after pausing at the crossroads. After all, he had had to ascertain what kind of sphinx it was who climbed the nearest pine to ask her questions and sniff the breeze. In fact, at the roadside it was a man he encountered, one who always answered questions. "To get there you need to go straight ahead, only bearing left." The traveller was about to follow instructions when, suddenly, he noticed a niche in a chapel wall which happened to be beside him. The traveller, as you already know, is curious about such things. That was why he approached in the fashion of a hunter and, in hope of seeing those deliquescent images who so often inhabit Portuguese shrines again, he stumbled across a granite figurine, two green dabs for eyes, and with fingernails painted on her right hand, raised to head-level. On the stone below the traveller read: "Only the head." No sphinx – but a definite enigma.

In such situations you need recourse to the man who answers questions. "No sir. The person you see is Our Lady of the Head. Many people who suffer headaches come here to visit her." The traveller is a poor reader. The saint has the shape, features and expression of a heathen idol, whether or not she cured fainting fits, migraines or bouts of complete madness, but the traveller definitely remains fixated gazing at her, pondering whether or not to attempt the cure of his own stupidities here. The man who answers questions smiles, no doubt well used to such inner arguments. So the traveller acts cunning and turns towards the village.

Balugães is a small place. The traveller walks for a bit, then enquires where the main church is, as it's another work of Romanesque art that has to be seen, and he's provided with directions which, being accurate, cause him to wonder at their precision. The worst part of it is the street. He is obliged to go on foot, along a stony alley, between the walls of dry stonework and the props supporting the vines, but no church materialises to sustain him. He considers that such an important church should be at the heart of a place, to facilitate its vigil and offers of solace, not be displaced at such a remote distance. He reverts to asking questions, but is told he is not mistaken and

simply has to keep going straight ahead. So the traveller pretends he's back in thirteenth- or fourteenth-century Portugal, though who knows whether the lane might not be considerably older, dating back to the time of the Romans or even the Goths. At intervals he comes across stone crosses, placed where those on the Procession of the Cross, and perhaps others too, can pause, since the traveller is not well up in these matters. Imagine, then, how often devout hearts must feel oppressed at having to follow the crazy undulations of the path, whose uneven surfaces offer little to facilitate carrying the heavy weight on one's shoulders. At intervals the upper parts of the crosses along the Way are stained with green from the copper sulphate used in wine cultivation, and the traveller is well pleased with himself for having so rapidly deciphered the reason.

Only two sounds make themselves heard: that of the traveller's boots as they scrape the cobblestones, and the murmur of running water on every side as it tumbles down the slope, at intervals forming waterfalls. The sun hides behind the mountain but the air is utterly transparent: you can inhale a freshness rising from the earth and dropping from the skies, like two faces drawing closer to one another until they finally meet. The traveller is very happy. It's now a matter of indifference whether he encounters the church or not: all he wants is for the path never to end.

Here there are no more houses nor vines, only stones and running water, bracken, the path at times descending a little to again ascend a minute later, always following the slope. He comes upon an embankment, giving away to a walled atrium, and on the lower level stands the church. It still boasts the remnants of festival arches, decorated with faded paper ribbons, and alongside them a house is being built with, a little further on, a waterfall, a jet spouting into the air. Turning his back on the half-built house, the traveller finds himself alone. The old parish church of Balugães, built in the twelfth century, restored but still gorgeously beautiful, is small and almost half-buried. The door is locked, but the traveller makes no effort to contact the keeper of the keys. His sole desire is to remain there, gazing at the ancient stones and attempting to decipher the inscription brought to life with black paint, over the door lintel. It's in Latin and, to the best of the traveller's knowledge, is Portuguese. Night draws in, the air grows cooler, and time could well stop now.

Time doesn't stop. The traveller retraces his steps, striving to impress every image in his memory: huge paving stones in the road, the sound of water, vines dangling from trees, green musk on the crucifixes, reassuring thoughts that happiness exists. Not that this is the first time such a discovery has

occurred. At the crossroads he bids farewell to the man who answers questions, then sets off on the road to Viana do Castelo, to begin the climb up the broad ramp to the Chapel of Our Lady of the Apparition which clearly has a story to tell. It's the tale of the tomb of John the Dumb, a shepherd to whom Our Lady revealed herself in 1702, when he was barely twenty years old. This shepherd, according to the sayings of Brother Agostinho da Santa María, was a complete simpleton, who knew neither the Our Father nor even how to cross himself. The Abbot Custódio Ferreira treated him as an imbecile, given his apparent lack of the powers of speech and comprehension but his vision cured him of every disability. Our John the Dumb was obviously called to a great destiny. As his father, a stonemason by profession, refused to believe in the apparition proclaimed by his idiot son, it was confirmed by a miracle whereby John the Dumb fell from Barcelos bridge where the father was at work, and although he had the water-jar on his shoulder, not a drop spilt in the fall, nor were his legs damaged in the slighest.

The traveller heard tell of these wonders from the lips of the priest who turned up as he was on his way to visit the church built with alms donated by the devotees of Our Lady of the Apparition. He had already visited the tomb of John the Dumb who, if his whole body is contained there, must

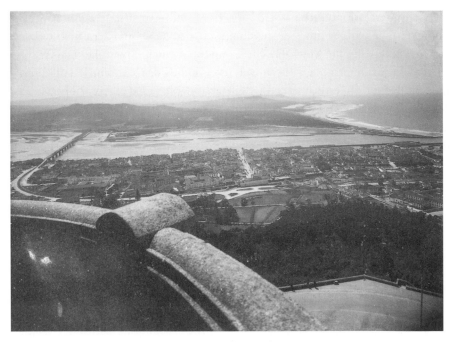

18 *Viana do Castelo*

have been of Minorcan stature. Giant candles burn in the chapel. If these were proportional to the dimensions of his miracles, the pious contributors could consider themselves well served. The traveller wished to have news of the parish church, and the priest told him that the inscription over the door, albeit incomplete, is its title of consecration. It was dedicated by three bishops who took the Roman road (of which traces still remain: might it have been the route taken by the traveller?) to the Council of Lugo. At that time, the traveller noted, it took three bishops to govern such a small church. Times when, the traveller further ruminated, the smallest sacred stone was greater than the person consecrating it. The priest shows him a stone tablet behind the altar, hidden to the eyes of those who do not know where to look, with on one side a magnificent dead Christ and on the other a representation of the Last Supper. The tablet is the best thing in the church. They then proceed to the atrium, with its story of the bell provided by the parish and which the parishioners of the old town one night attempted to steal. They came bearing chains and managed to get the bell down from its belfry, hanging loose, when their endeavours were observed. The robbers took to the mountains, but justice always catches up, however tardily. "The bell was returned to the place from whence it came," said the priest, and with that he took his leave.

The traveller was left feeling despondent. These tales of miracles, of the talking dumb, candles the height of a man, clouded the afternoon's memories for a few moments. Matters only deteriorated when on the hillside he encountered some ugly stairways and a hideous fountain, along with other mediocrities and disgraces, typified by the white stone colony representing John the Dumb, worthy of greater respect even in his unfortunate idiocy, and some sheep resembling shorn cats. Oh Balugães, Balugães, you didn't deserve any of this.

An Even Bigger House

It's a bright morning but the traveller still hasn't got out of bed. He's delaying the moment when he'll draw the curtains on the two windows in his room. He's postponing the end of the pleasure he has had since arriving at the hotel in the depths of darkness. Perhaps he also fears a degree of disappointment. Light filters through the chinks and the traveller feels a weight on his heart: "Perhaps it's cloudy . . .?" He leaps out of bed, indignant at the mere prospect of how depressing it would be to see the countryside around Santa Luzia blanketed in clouds, and reveals the first window, overlooking the sea, with a single swish. The cold morning air hits him full in the face and he feels radiant with pleasure and surprise at the watery splendours of the misty coast, a meeting-point for river and sea in a single cordon of spray from waves crashing in from the high seas onto the beaches. The other window is at right-angles to the first, the room has many corners, and – oh fine and splendid destiny – there's more countryside out there waiting. Words don't suffice to describe it nor paintings, nor music. A luminous mist suspended over the valley, the sun resplendent within it like a convector. The river, encircling numerous islands, flowing now towards the right bank, is easily distinguished from above, its liquid arms pushing into the earthy heartland and reflecting back the sky, between green fields bisected by coppery trees and dark verges. The morning smoke rises from house chimneys and greatly enhances the general beauty of a magnificent hour, against the gloriously smoky factory chimneys. The traveller is a lucky man: two windows on the world at a unique moment of light, the fresh air embracing his body. He clearly came to Viana do Castelo at the right moment, arriving as night drew in, and deciding to climb the mountain of Santa Luzia for a good night's sleep.

It's high time to head for the city. The traveller consults his notes and references in order of priority. In Praça da República there are three sixteenth-century monuments: the former Council Chamber, the almshouse, and the fountain designed and constructed by João Lopes the Elder. The Council Chamber is a solidly fortified structure, its stone façade opened up with

arches and windows, somewhat against its will, despite the candour of its open spaces; the almshouse, designed by João Lopes the Younger, has an abundance of windows in a Renaissance style unusual in our country, there for the diversion of the patients. Its twelve caryatids, six on each floor supporting the eaves, look both robust and elegant. To the weary traveller, the bench on the lower floor, from where you can look out on a city in movement while chatting with your neighbours, has definite attractions. The fountain is harmoniously placed, and built of stones in period. If the whole square had been as well devised at its edges as it is from this angle, it would be the most beautiful of Portuguese urban spaces.

The parish church, with its fourteenth-century Gothic roots, perpetuates a nostalgia for the Romanesque. It has a beautiful porch, the apostles standing in as support columns and, over it all, a gigantic rosette. Inside one can see that the different styles of architecture and decoration imposed over the centuries have failed to fuse successfully. A fire in 1806 must have made an important contribution to the composite character offered by the whole. All in all, it at least has beautiful pieces of sculpture and paintings as well as some excellent tiled panels to offer. Perhaps the best part of the church remains its position among the surrounding buildings: within this enclave a certain atmosphere is conserved, an ambience which, though it ought to be the rule, is becoming the exception.

The traveller takes a street parallel to the axis of the main square, and encounters an enormously beautiful Renaissance window which, more than any other work of art, has to be the city's true emblem. The stonework has to be worth its weight in gold, and would still remain deeply indebted to whoever worked it. Incidentally, Viana do Castelo is prodigious in its number of Manueline doors and windows, some plain and others more intricately fashioned, adding justice to the cause of showing the traveller the best of what Viana has to put on show. The museum stands out, with its entrances and exits and, although small, contains the richest and most lavish collection of Portuguese ceramics, some 1,600 pieces, which the traveller is unable to study in detail or the journey would have had to terminate there. There's more to come, for the museum is even more richly endowed: perhaps thanks to the labours, love and skill of the guide, a woodcarver by profession, the furniture it contains (of which there's a large and invaluable quantity) is in an unusual state of conservation. And as the traveller can't itemise all he sees, he merely insists on making mention of a small "Descent from the Cross", a miracle of rigour and perfection attributed to Machado de Castro and worth more than all the cribs and other carvings in which this art form

copiously abounds. You can then retire to the large sapling forking out
from the main tree in the atrium, each branch more authentic than the other,
from the Celtic period when Galicia and Minho were one.

The traveller went down to the shipyards, to which he was denied entry,
and on his way back took a look at the church of St Dominic, where the
bones of Brother Bartolomeu dos Mártires (whose biography was written
by Brother Luís de Sousa) are kept. Thus are lives entwined, including that
of Almeida Garrett, who composed the best play ever previously written in
Portugal on the theme of his biography. Maintaining a dialogue with himself
on this and like topics, the traveller took a turn to see the Palace of the Viscount
of Carreira, with its Manueline decoration and opulent airs, still known by
the same name today. He gave a parting glance to João the Elder's house and
the miniature Baroque masterpiece known as the Malheiras Chapel.

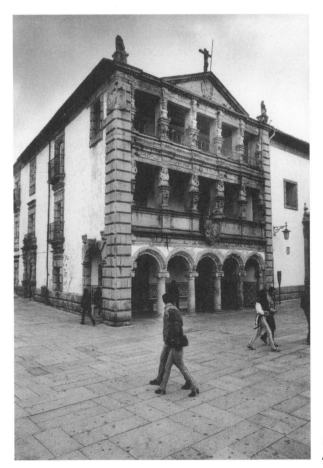

19 *Viana do Castelo, the
almshouse*

20 *Viana do Castelo, the almshouse, detail of façade*

To the Romans, the River Lima was the mythological River Lethe, which effaces memories, and which they didn't want to cross for fear of having their homeland swept away from their hearts and recollections. The road the traveller follows all along the northern borders conceals many of the most famous beauty spots, but when the traveller's profession causes him to enter a cul-de-sac, it's wiser to treat it as an opportunity and seize an alternative: set off down minor roads and follow them through and they always end in the sea. There the river materialises before our Portuguese eyes as once it did to Roman ones, and any one of us could believe themself to be a magistrate or a centurion coming from Bracara Augusta on civic or military business, a man who might suddenly feel the urge to set down the sword or the scroll of laws, and proclaim peace. The traveller pauses when the highway reaches Bertiandos; he peers through the metal grilles of its gate like a poor beggar, and his observations are repaid by the felicity of its Baroque architecture taken together with the sixteenth-century tower, which brings him to ask himself what kind of curse has befallen contemporary architecture, bereft of any kind of harmony in combining styles, witness the constant clashes between what went before and what has been constructed alongside. There's no point in asking what the rules are: one can only respond that they're well understood here in Bertiandos, even in this 300-year leap between the tower and the palace.

The traveller has to confess that he never went to Ponte de Lima. He had it within his sights, close at hand across the river, but up above and surveying him from the heights a little village called so insistently that he couldn't bring himself to resist. The most he achieved was not to go there by the most direct route, but to pause at Paredes de Coura and then yes, to descend as far as Romarigães, as the village was called. But let us not get ahead of ourselves. First we need to address the subject of this superb countryside crossed by the main road from Paredes de Coura, always climbing until it crosses the Lima plateau and the peaks of Labrujo and Rendufe. It resembles a miniature version of the highway between Vila Real and Peso da Régua, and to say this is to pay it a mark of respect. The traveller, in confronting such a breathtaking panorama, realises he has been harbouring a longing for both mountains and valleys. He now finds himself well served along the twenty kilometres of high mountains and beautiful depths of wide and cultivated lands. If it were not for his anxiety to see what the furthest curve held in store by way of horizontal and vertical sights, the traveller would have voyaged on slowly, counting the stones along the way.

He has now reached the crossroads. To one side Rubiães, to the other Romarigães. Now he's nearly arrived, the traveller is quite happy to put off meeting the person he's come to see. First he goes to Rubiães, but before reaching it he has to pay some attention to the ceaseless murmur which has been accompanying him ever since Lima Bridge, the sound of waters tumbling over hillocks and down ditches in search of a stream to flow into, a tributary to open itself to them, a river to enfold and bear them through, a sea to give them salt. The traveller remembers the arid plains of the South, dried out unless in winter the rains fall continuously, and advises the mountains and little meadows to make the most of the available water, not to waste or kill it off, tantamount to shedding blood and life.

The Romanesque church in Rubiães is closed. The atrium is virtually covered with tombstones, ranging from ancient to almost modern. The

21 *Bertiandos, a wayside cross*

traveller exchanges a few words with two men resting from their labours, sitting on the steps, then proceeds where his heart calls him.

There are three kilometres of tarmacked road crumbled away by recent rains and ending in a curve; from here on the road narrows and the traveller decides to proceed on foot. It's the right decision. The water here is fresh and clear, and the sun which scarcely makes itself felt on your face at least keeps your hands warm. As the traveller continues, he realises that the village is still a long way off and hesitates, then catches sight of two youths, boy and girl, guessing they're a couple. They're sitting on a ruined wall, and pause in their conversation. The traveller approaches them and asks: "Can you please tell me where the Chapel of Our Lady of Refuge is?" The lad and his girl look at each other, and he replies: "I don't know of any Chapel of Our Lady of Refuge. If what you're looking for is the church, it's down there in the village." The traveller knows full well what he's looking for, but he is perplexed at what he's told: "I don't mean that one. I mean the Chapel of Refuge Aquilino Ribeiro wrote about in his book;" and, having explained this much, he waited for smiles of recognition to appear on the faces of the young people. A wasted effort. The girl responds with traces of irritation at his disruption of their courtship ritual: "No, sir, we don't know what you're talking about."

The traveller felt excluded from further discussion and headed off in the direction of the village and of more fruitful questions when suddenly, as he was following a route beside a wall, he felt his heart skip a beat. He raised his eyes to a window overhung with a kind of ledge over which there was a sculpted crucifix, flanked by two amphorae with acanthus leaves, or so it seemed from below. At the same height there was a coat of arms, with coloured areas. "This has to mean something," he thought. He took a few more steps, looked up again and there it was. There was the chapel's façade, the tall belfry and the capitals. Had the traveller not been so apprehensive, he would have rebuked those two ignorant lovers with little future ahead of them if they didn't learn more about love than its earthly manifestation. But he contained himself, saying: "This *is* the chapel. Remember it, should another traveller pass this way to enquire." Distracted, the lovers mutter: "Yes, sir," and continue loving. Perhaps love is what they actually do know about .

Whoever knocked down that part of the wall knew what he was doing. It proved to be the only means by which the traveller could penetrate the adjacent property, jumping over boulders and closing in, nervous as a kid approaching a pot of jam, to peep over the other side and look down on

the façade of the Chapel of Our Lady of Refuge of which Aquilino Ribeiro spoke in his *Casa Grande de Romarigães*. The traveller doesn't suffer overmuch from modesty but in this instance decides to be governed by the circumspection due to Aquilino himself, he who most deserves to get a word in. According to him: "The whole, with the sole exception of the lower level with its simple doorway – and even here its side panels are decorated with vases in the guise of capitals between the two iron-barred windows, almost Renaissance in design – does not boast a single stone not better suited to the craft of a silversmith than to that of the stonemason. Its heterogeneity is more elaborate than the cover of an eighteenth-century volume. With its four pinnacles emerging from a bulbous base and a four-cornered pilaster, its belltower in the shape of a pavilion, it effectively resembles a pagoda with spires and capitals in symmetry with the tops of the surrounding pines and oak trees, rising up from the wasteland that recedes into the distance beneath the gushing light of the heavens." The traveller counted the pinnacles and found only two, due either to the ravages of time, or to Aquilino's relying overmuch on his failing memory.

The traveller has been to many lands, at times feeling himself to be well rewarded by what he saw, at others less so. But from Romarigães it was only possible to return with overflowing emotion. When he passed the lovers and bade them farewell, he learnt that although they didn't know the chapel's name, they knew full well that it was a heavenly place: there was after all no other reason for Adam and Eve to have selected it to meet in.

The traveller descended to Caminha, along the River Coura. On its left was the Arga Serra, a bald mountainside made incandescent by the sun, a place to harbour poems and wolves. The sierra isn't particularly high, perhaps some eight hundred metres but, its huge, bulky shape in the distance is a major disincentive to the traveller. In Caminha he visited the sixteenth-century Casa dos Pitas, defended by crenellated battlements and with beaten window mullions, checked the time against the clocktower, a residue of the old city wall, before continuing on to the parish church, a composite military bastion and place of worship where the Gothic extends into Manueline before achieving the Renaissance. Renaissance in its architectural spirit but not in its stonemasonry with a side door, where human forms in semi-relief lean over window niches and pose fresh worries of the day for the traveller, as the apostles drowse on in their Gothic dream. The town fountain is the work of one João Lopes, in all probability the same who designed and executed the one in Viana do Castelo.

There was now little time before the day drew in. The traveller followed the

22 *River Minho at Caminha*

course of the River Minho, going through Vila Nova da Cerveira without stopping, which he admits hurt, and on to Valença, as he wanted to make the best use of the light and open air. There he found the terrace wall belonging to the Pias estate, with its tilted crucifix, and further on he could almost reach out and touch the river with his hand under the tangled foliage of a vineyard. Near Monção the traveller took the main road to Pinheiros simply to see once more and just from the outside, like a humble beggar, the Palace of Brejoeira and its wide esplanade kept as inaccessible as the Himalayas, with warnings of constant police surveillance on the property. Viewing matters in those terms and given the unequal distribution of forces, the traveller felt obliged to beat a retreat. A little way on he reaped his reward, when the roadside gave way to a bright yellow plain. The sun burnt through the leaves like a crystal prism and so, without fearing further attacks from behind, the traveller could remain in contemplation of the tree for free, so long as the light held out. The first street-lamps were being lit as he drove into Monção.

The Girls of Castro Laboreiro

Monção is home and witness to the tale endlessly recounted to the children of a generation to which the traveller himself belonged, namely that of Deuladue Martins. She was a resourceful woman who, when the town was besieged and lacking basic supplies, sent the citizens to collect and cook the very last of the flour into little sweet-smelling balls which she then tossed over the ramparts with an air of grand munificence, thus – by disseminating a conviction as to the futility of continuing the siege – routing the troops of Henry II of Castile in their attempt to seize the fortress. This occurred in 1368, a period of considerable political machinations, and a time of easy belief in artificial tactics profoundly lacking in imagination. Nowadays times have changed, and Monção is the petitioner, to judge from the little altar boy at the church's entrance wearing a pious and piteous expression the better to beg and receive alms from kind souls. The traveller rather looks to recover his other sensibilities, but notes the heart-plucking imagery. He also notes the High Baroque angels either side of the high altar in the same church, and a gigantic Our Lord of the Way, theatrical and scary, in the parish church with its funeral monument to the memory of Senhora Deuladeu, an act of family veneration from a distant grandson.

The countryside around Melgaço is agreeable without particularly distinguishing itself from what is generally on view around Minho. Any one of those stubbled fields would count as a precious landscape in countries any less well endowed, but in this region eyes become exigent, not as easily satisfied with whatever comes before them. Melgaço is a small historic town, offering one more castle to enter in the traveller's ledger, and the tower of homage deserves to be seen, standing out above the cluster of houses like a father. The tower remains open and has a wrought-iron staircase. Once inside, the darkness diffuses a sense of respect. The traveller stumbles around, one foot here and the other there, scared in case a paving stone gives way or a rat appears. Natural fears, particularly since the traveller has never given himself the airs of a hero, but the flagstones are solid and rats would find nothing here to gnaw. From the top of the tower the traveller is better able

to survey the small scale of the castle, presumably because there were fewer country-dwellers in earlier times. The streets in the old part of the city are narrow and echoing. They exude an air of calm. The church looks pretty from the outside but is exaggeratedly vulgar within, with the exception of a finely executed "Santa Barbara". The priest opened the door into the sacristy to show the works there. Outside again, a shoemaker invited the traveller to observe the monkey above the side door on the north side. The monkey is not a monkey but one of those composite creatures from the Middle Ages with something of a wolf about him, but the cobbler is proud to sing the beast's praises: after all, it *is* his neighbour.

Beyond Melgaço lies Nossa Senhora da Orada [Our Lady of Prayers]. It stands at the side of the path, on a slightly higher level, and were the traveller to go by too quickly or inattentively – well, Our Lady, where would you be? The church has stood here since at least 1245, for well over seven hundred years. The traveller finds himself obliged to weigh his words. It doesn't become him to go over the top with adjectives, a plague on good style, even less so with nouns: though it has been known to occur. Yet the church of Nossa Senhora da Orada, a small and well-restored Romanesque building, is such a masterpiece of stonemasonry that words are fatally excessive because they can never match the reality. Here you need eyes not words, and photographic records or a cine-camera that can follow the play of light. Also a sense of touch, fingers able to follow the pattern of reliefs and assimilate the details which escape the eye. To involve words is to involve capitals, columns, vaulting, in other words modillions, tympanum, arch bricks, and this has to be true, as true as it is to say that a man has a head, a trunk and limbs, and to do so without understanding anything of what a man is. The traveller asks the wind where the guidebooks are to offer examples to anyone who lives at a distance to Nossa Senhora da Orada and all the Oradas who still resist the centuries and rough treatment born of ignorance or, worse still, the taste for destruction in our country. The traveller would go further: some monuments ought to be withdrawn from where they stand and are left to die, and be removed stone by stone to our major museums, maintained as buildings within buildings, far from nature's sun and wind, from the cold and lichens corroding them, yet preserved. Of course the traveller would then be accused of embalming their forms, and of course he would reply that this is the way to conserve them. It has to be wrong that so much care is given to the delicate restoration of paintings and so little to the fragility of stone.

About Nossa Senhora da Orada itself the traveller has nothing more to say than this: his eyes have witnessed it. Just as they also saw, across the road,

a rustic crucifix with a swollen-headed Christ, a little crucified man with
nothing divine about him, whom anyone would want to lend a hand at
such an awkward juncture.

The traveller now sets forth on the long climb up to Castro Laboreiro.
Melgaço is about 300 metres up; Castro Laboreiro is around about 1,100.
You cover this difference in just thirty kilometres: the climb is not particularly
steep. But it is unforgettable. The Peneda is not especially graced with forests.
Copses here and there, above all close to human habitation, but its main
characteristic is living rockface, kermes oak and scrubland. Naturally in the
lowlands there's no lack of cultivated stretches, and on these late autumn
days the land worked by man's labour has an almost feminine sweetness
in contrast to the land lower down where mountains rode bareback over
mountains, each one more bare and bald than the last. But the sierra
has a unique feature, which the traveller had never seen before the last
several kilometres and which intrigued him, inexpert as he was in travellers'
ways as soon will be revealed. The sun was at such an angle it beat on
the furthest slopes, sending out rays of light in great luminously dazzling
sunbeams. The traveller went on his way ruminating: what caused this
phenomenon? was it a sign of precious mining works? If it was just reflections
from the schist on the incline or whether – according to his facile fancies –
perhaps the earth deities were signalling to one other, concealing their morse
from prying eyes.

In the end the answer lay beside the main road he was travelling. Water
leaking from rock fissures, although not free-flowing, at least maintained a
level of humidity around the stones which, when glanced at a certain angle
by the sun, lit up like a mirror. The traveller had never seen anything like
it and, having deciphered the mystery, he continued on his way enjoying the
lustre of the rocks, which dimmed and flared according to how the main
road bent around the curves, catching the sun's varying angles. The land here
is open and empty with mountains dividing vast valleys: here no shepherd
could be heard yodelling messages from peak to peak.

Castro Laboreiro appears unannounced around a bend in the road. It has
some new houses and then the town, wearing its dark suit of old stone. It's
good to see the buttresses supporting the church walls, Romanesque remains
of primitive construction, and the castle, of great altitude, with the one
doorway left to it, the Sapo [Toad]. The traveller would give much to know
the origin of its name. He has no need of a long pause in the village, or
perhaps he needs an enormously long pause in order to realise his exploratory
ambitions: to go, for example, up to those high stones, like yoked giants

rearing up in the distance. In a sky of clearest blue there's the white trail of an aeroplane, straight and fine: not a sound and only your eyes to trace its slow passage; while, obstinately and repeatedly, the stones keep pressing up against one another.

He is about to say goodbye. Brought there simply by following the road, from the high peaks of the wide sierra still crowding the edge of his vision, now increasingly distracted by two little girls who are staring at him with a serious expression, withdrawing the attention they have hitherto been paying their doll in her long white dress.

Two little girls like no others ever seen before: and they're there busily playing in the shade of a tree in Castro Laboreiro, the little one with loose fluffy hair and the other with two plaits tied with red ribbons and both gazing seriously straight ahead. They don't smile when they see the camera, and when they raise their fresh faces so openly to him, it's hardly appropriate to smile. The traveller mentally praises the wonders of technology, that a fickle memory can be refreshed by this colourful paper rectangle, reconstructing the moment and reminding him how a skirt was made of tartan, the braids were curled, the stockings made of wool, the hair parted in the centre and – an unexpected discovery – that another doll had fallen to the floor behind them, raising her arm in a gesture of protest against not getting fully into the photo.

Fate doesn't always organise matters badly. In order to see the church of Nossa Senhora da Orada and the lasses of Castro Laboreiro, the traveller had to journey a hundred kilometres in round numbers: he now had sufficient courage to argue with anyone who said it had not been worth his while. Not to mention, to add further points in his favour, the stone giants, the mica in Melgaço, the plane crossing the skies, the watery mirrors, and this little dry-stone bridge, put there merely for the benefit of pedestrians and small herds.

The traveller returns to Melgaço, but this time the hundred kilometres nearly finishes him off and he seeks out the route to Longos Vales. Among all the beautiful names in which Portugal abounds, Longos Vales possesses a particular resonance. If you only pronounce it Looongo Vaaales you just about know all, or almost all, there is to know about it, for in these sounds you not only intimate the loveliness of the apse in the parish church, but also its modillions populated by grotesque animals and contorted human faces. The extremely narrow window which had been used as a target by children throwing stones, is prettily decorated with ramrods. When the traveller confronts these capitals he reverts to an old plan of his: to decipher the meaning of these compositions, the more complex for seeming so casual. They would doubtless reveal much of the mediaeval mind. Or, more likely, it

has by now all been decoded and explained. The traveller should take the trouble to investigate when he has the time.

At Merufe, beside a tributary leading from the River Mouro, the traveller returns to scale the banks of the River Vez, first from the north side and then from the south where you too can experience the urge to jump up and down shouting for justice at the top of your voice. There's a lot of talk of the soft bucolic attractions of the Lima, Cadavo and Minho. Yes sirs, they're all very well, all very well in their way. But the River Vez, along the Sistelo heights where the traveller joins it, and then the River Cabreiro flowing into it, are real miracles at uniting sweetness and asperity, the harmony of green sloping banks and the restless murmur of the waters, all beneath the fortunate light which both shades and defines, line by line and colour by colour, the loveliest landscape imaginable. The traveller places what his memory retains of the River Tuela beside it and has nothing more to add.

The main road lies over on the other side, but the traveller has a preference for the route which reaches Arcos de Valdevez via Gondoriz e Giela. Gondoriz church resembles a stage set overlooking the valley. It's a theatrical construction dating from the eighteenth century, an indisputably fine example of the Church Triumphant. The wayside shrine before him is cast in the same spirit, with its Rod of Aaron and a bristling red *Pietà* outlined against the sun. A few kilometres on, virtually at the gates of Arcos de Valdevez, lies Giela. Here the traveller pauses a fair while. He climbs the hillside along a well-kept path, and is only halfway up when he sees the battlements of the tower, clearly positioned in the middle of a circle of forested mountains. The traveller is aware of feeling nervous, a definite sign that he's approaching something he really wants to get to know. He comes upon a sixteenth-century palace which is, as the traveller declares now that he has it before his eyes, one of the loveliest buildings of its kind in the whole country. The tower is the earliest part, dating from the end of the sixteenth century, and it is said that it was bestowed on Fernão Anes de Lima by João I after the battle of Aljubarrota. The house, more recent in style, has a beautiful Manueline window giving onto the patio.

Neither aristocrats nor members of the bourgeoisie still make it their home. In fact no-one lives here any more. The house is used as a granary, the rickety garrets are strung with corncobs and, wherever the traveller sets foot, he finds that the floorboards creak. The little boy who becomes his companion, on the orders of his father who effectively acts as a caretaker, bounds about like a kid over the heaps of dried husks, scaring the hens then, with a display of caution, advises and warns him of the most dangerous spots.

Corncob banners stream from the roof like mainsails billowing in whatever form the wind bestows. What is left to be seen is a ruin. Outside, the harshness of the stone has its own resistance but inside the floors are at the mercy of an overabundant harvest of ears of grain and the hens have a fine roost where they wait for it to fall to them. The traveller goes on his way greatly saddened. Who will come to rescue you, Palace of Giela.

Perhaps in consequence of these unhappy musings, the traveller went through Arcos de Valdevez without stopping but, reaching Ponte da Barca, decided not to allow himself to be overwhelmed by low spirits, and set off into the Serra Soajo. He follows the River Lima, whose banks soften these high lands and skips over the pebbles in its bed. The main road soon begins its climb, departing from the river which, although not far away, becomes invisible. Reaching the T-junction at Ermelo the traveller has to choose whether to cross the river at the frontier of Soajo or to follow on to Lindoso. He decides on Lindoso. He continues climbing, counting the kilometres on this great journey of his, transporting him to his own distant lands.

Lindoso has its castle and its raised granaries, all kept securely under lock and key. Just as well. One can look out equally well from the castle and the granaries benefit from being seen from the outside as there's no reason to disturb the peace of the corncobs. The granaries are laid out like a city, the old buildings stained with lichen and inlaid with dates from the 1700s, 1800s and others more recent. But each and every one follows the traditional design, being covered by two sloping eaves, their bulk resting on beams topped with capitals, called in these regions tables or turnabouts, ingenious devices which prevent the rats from getting at the corn. In some the stone slats have given way to slabs, a sign that the days of stonemasons are long past: even the least skilled labourer can assemble a half-dozen lathes. What the traveller most regrets is not being here on a moonlit night. This city of waterless *palafitas*, a little city of houses on stilts, demands the crisscrossing shadows of night: the shade of any man wandering here would have much to learn.

The traveller resumes his route again, intending to head for Bravães, beyond Ponte da Barca, reaching it in the last moments of day, the light horizontal and tawny, the sun setting and the sky bathed in pink. Bravães is a Romanesque gateway with flowery buildings, a compendium sublimating the thematic possibilities of opencast stone, transported both from nearby and from as far away as Galicia. Façades boast bas-reliefs of bulls who have observed the passing generations, perhaps a throwback to earlier cultures,

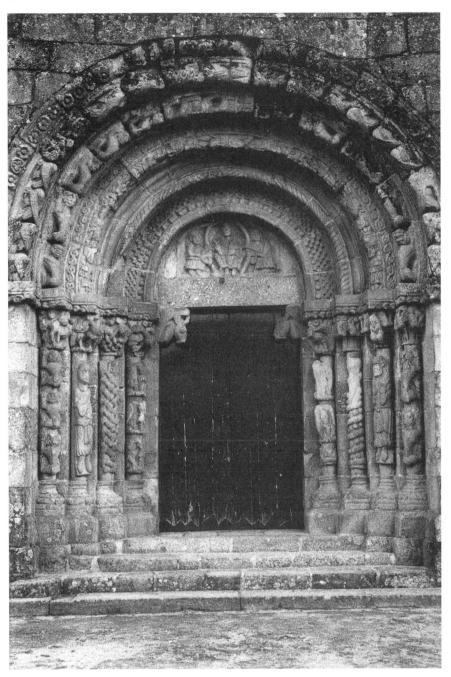

23 Bravães, *church door*

24 *Bravães country scene*

possibly of the sun and moon, so easily found in conjunction with Christian symbolism. The traveller enters the church, shadowy with evening, and can just about decipher a fresco of St Sebastian beside a triumphal arch, but what he sees perplexes him, for he has more the pious aspect of a young maiden than an officer of the Roman army. Such things evolve through numerous interpretations, what was has either ceased to be or has become something

else as, without getting into hagiography, is the case of St Sebastian who was clubbed to death in the Circus, but whom we everywhere see pierced with arrows something which, we may as well admit, appears not to offend him. Twilight fell. The Christ of the Almond Arch shot the traveller a severe look as he secretively took the Braga road, on to where new adventures awaited him.

St George Sets Forth on Horseback

Arriving at Braga the first thing the traveller does is to go and see the Fonte do Idolo. It's there at the foot of the Casa do Raio, unsigned where it stands, its gate giving onto an unlit paved area, and if you peer into the cave beyond it, you see only a large limestone puddle. So where is the fountain? The traveller descends a flight of steps and at last sees what he has come to see: damp stones, inscriptions and damaged statues. The fountain seems prehistoric although the sculptures date from later, and was dedicated to a god with a Polynesian-sounding name: Tongoenabiago. These are the teachings the traveller carefully retains. What moves him is that there was evidently a time when all the land was uncultivated, the water tumbled among the stones, and whoever came to collect it gave thanks to the god Tongo for the bounties of the siren. Nowadays we may well have cause to question the purity or otherwise of the water, but the statues continue offering their timeworn faces for as long as they are not yet utterly destroyed.

Were chronology among the traveller's vices, this would be a grand starting point: a prehistoric fountain with Latin inscriptions, but alongside these antiquities Braga offers Baroque from the period of King John, specifically in the so-called Casa do Raio [House of the Radius] and, following its name, one must take what comes to hand, without fussing over the method. The Casa do Raio is in fact a palace, one of the most precious jewels of the eighteenth century which Portugal retains. It may cause a degree of surprise to see how a style which to achieve internal harmony encountered repeated obstacles in maintaining an equilibrium between form and goal was capable, in its external design, to delight in games of curve and counter-curve, integrating them with every demand and potential of the materials used. And the blue-and-white tiles, whose rigid geometry appears to go directly contrary to the cut required by the stone, here emerge as an instrument of extreme precision and a complementary factor.

The traveller is unable to spend all the time he'd like to here. There are strings of churches in Braga, and the traveller won't make it to all of them. So he'll have to choose, partly according to the recommendations he's brought

with him, rather more according to the spontaneous impulses of the moment. One unmissable excursion, however, will be to the Cathedral. As the traveller doesn't have to obey educational priorities, he can leave you to check the minutiae and encyclopaedic detail in other accounts. Here we're talking impressions, of eyes that run over the sights, also running the risk of allowing what's essential to escape while focusing on some detail. The decorative wealth accumulated down the centuries inside Braga Cathedral has the one defect of excess through its capacity for absorbing whoever wanders in.

This was a church born with high ambitions. Unless the traveller deceives himself, Braga began by not wishing to be left behind Santiago de Compostela. Or so the first ground-plan, with its five naves, makes clear, specifying the breadth of space which the construction was eventually intended to occupy; its very position in the city centre and its religious significance reveals as much. The traveller has no documentary proof of this, but the idea occurred to him when he explored the church's interior, and he find himself obliged to give credit to his intuitions. In this confusion of styles and processes going from the Romanesque to the Baroque, by way of the Gothic and Manueline, what counts most in the traveller's book is general impressions; and what here impresses him most is the vastness of this building which, by dint of the voluntary disposition or the incompletion of its lateral buildings, breaks the rigidity of the walls which would otherwise separate it from its urban context and extends via openings, passages, access points, unless you would prefer them to be called alleyways and small squares. This serves to define a whole architectural complex which, in this single aspect, has nothing to match it in the whole of Portugal. The traveller continues counting on his intuitions but he derives no great opinions from then, still less convictions. Let each man think what he will until there is proof sufficient to convince every last one to think identically. But here and now the traveller wishes to discuss the case of Braga Cathedral.

Facing the high altarscreen, with all the aesthetic reverence due the fourteenth-century statue of Santa María de Braga, the traveller feels his spirit invaded by a vast and furious indignation. This frontal is all that remains of the altarpiece commissioned by one archbishop and mutilated by two others. The traveller is astonished and begins to think that there can be no lack of incredulity in anyone who dares to raise his hand against the integrity of a masterpiece of sculpture, and yet here were two heavy-handed archbishops with lightweight brains who would have done better to attend to the care of their souls. The traveller is not a vengeful man, but he trusts that like sins will be reckoned on high once Judgment Day comes around.

When the traveller goes into the cloister, important as a lateral extension towards the outside world, he's already aware that there are two chapels necessary for him to visit, one dedicated to San Giraldo and the other to the Gloria. At the moment they're closed, due soon to reopen.

Here, almost on the route out of the city, is the monolithic statue of St Nicholas, *edicula* and saint in a single lump of granite. He is surrounded by burning candles, a sure sign that miraculous intercessions are being petitioned, despite being somewhat set apart from the holy precinct. On the other side of the cloister lies a chapel, a building without intrinsic interest but which is guarded by four black saints, one of whom is St Benedict, of whom the traveller heard tell when a child that he ate little and grew fat, and in particular a great St George wearing a breastplate on his chest, leg-armour and helmet, his plumes fluttering in the wind and sporting the heavy moustache of a heavenly policeman. This St George has a history, a dark page in the annals of the archdiocese.

On one of the church processions (the traveller doesn't discover which, not that it would affect his understanding of the matter), St George always came forth mounted on his steed, as befits one who rides to do battle with dragons from time immemorial. On horseback with his lance raised, St George had the run of the city streets, naturally acquiescing to the supplications and military salutes while the horse, guided by the bridle, snorted with pleasure.

So it was for many years, until the unfortunate day when the horse who had to carry the saint was newly shod, since the old horseshoes were quite worn out. The procession departed, St George took up his accustomed place, when suddenly the horse came upon some tram-tracks, the ground slipped from under its hooves and it came crashing down. St George hit the pavement with a terrible crash, sowing panic and consternation. The din resounded in the ears of the crowd, causing panic among the rats who fled the saint's innards and consternation to the priests, the devout and the hangers-on who saw, there in a public place, the lack of care which the insides of their saint were deemed to have merited. Braga's Cathedral rats had nested there and none of the clergy had noticed. This occurred some thirty years ago and poor St George was so ashamed, he never took to the streets again. There he remains in the chapel, melancholy and remote from his beloved city, on which he still yearns to gaze, plumes billowing in the wind and lance at the ready. The traveller, who enjoys embellishing every tale with fresh details, fantasises that in the small hours of the night, while the city sleeps, a shadowy horse emerges bearing the saint on its back. There's no-one along the route to applaud him, but that doesn't bother St George: he has

learnt to his cost how inconsequential glory really is, and how little it is based upon.

At length the traveller decided to commence with the chapel of San Giraldo. Here the tombs are those of Count Henrique and his wife Teresa, made at the behest of Archbishop Gonçalo Pereira, ancestor of Nuno Álvares Pereira.[8] They're quite small, secreted under discreet small alcoves. The traveller asks "why does this one have a wooden cover over it?" and the reply is an amusing chapter in the history of human vanities. Pay attention, all of you.

When the Archbishop ordered the tombs to be made, it was with a hidden agenda: to keep aside one for his own remains. This was why those of Dom Henrique and Dona Teresa were laid so closely together in a single sepulchre, closer in fact in death than they had ever appeared in life. Time passed and the Archbishop still didn't die and, by dint of not dying, began to think that perhaps he had time to have his own tomb made without occupying someone else's final resting place. And so it happened, the tomb being the magnificent work of art just there, in the Gloria chapel, while that of Dona Teresa ended up covered with the piece of wood still in place today. Were there confusion during the division of the aristocratic bones, let us console ourselves with the idea that even if the count were kept company by no more than a single rib belonging to the countess, then she had her entire husband with her. As the traveller goes into the cloister, he's asking himself if the apostles and deacons lining up open-mouthed along the sides of the Archbishop's tomb, each one in his proper place, are singing the responsorial psalm or clamouring for justice. Only one of them has his mouth shut, perhaps because he already knows the truth.

You can reach the Museum of Sacred Art up this staircase. The traveller takes a guide and a guard with him, both highly necessary and both combined in a single person. Without a guide there could be no possible orientation amongst the wonders there, and without a guard there could be no permission to circulate among them. The museum is not a museum in the customary sense of the word. It's more like a giant department store, a succession of little rooms, real treasures in their own right where the traveller wanders as if blindfolded, lacking all the necessary criteria of rigorous classification under like circumstances, but with the chance to contemplate a ravishingly rich collection of works of marble and sculpture, ivory and illuminated manuscripts, wrought iron and tin, ornaments and an interminable flow of artworks of every variety. Together with his guide the traveller has the privilege to visit it all alone, and will do so again in the future, should he be granted life enough. Anyone visiting Braga without visiting the museum does

not know Braga. The traveller pronounces himself well satisfied at having uncovered this lapidary formula. It's not every day one invents something which merits the immortality of stone.

He now goes to take a turn about the town, and drop in and out of a few places. He has already seen the "Virgin of Milk" by Nicolas de Chanterenne under its canopy at the upper end of the Cathedral, and this impels him to dream on: the beautiful Virgin and Child should be secreted in a safe place before it gets too late, before her cape disintegrates altogether and the features on his face are utterly eradicated. What's happening amounts to a case of criminal neglect. The Coimbras chapel is now closed, so the traveller is prevented from joining his voice to the chorus of praise raised to this sixteenth-century building and all it contains. See it from the outside, and you take away with you impressions to fill your mind, since alongside the stone statues of SS Peter and Anthony are also a centaur and a faun, legendary evil spirits representing a very different way of life.

The Largo do Paço is very wide, paved with large flagstones, and with one of the most beautiful fountains the traveller has ever seen at its centre. The buildings form the wings of its ground and first floors: ample space there for living quarters. All the climbing up and downstairs left the traveller without time to keep a note of what he was looking at. He visits a couple of churches; examines an eighteenth-century arch; and in another unpromising neighbourhood happens upon another church (which he later discovers to have been St Victor), where he's obliged to eavesdrop on a lengthy con-versation between a young cleaning woman and a surly old man. Their conversation flowed, then rained like stones, on the subject of another woman – not present – who was so bad-tempered that even her son or daughter would be bound to share their opinion that she was someone to shun. The traveller went off to see the blue-and-white tiles, which he deemed traditional but interesting enough, and since he'd shown an above-average fascination in them the woman felt herself obliged to change her topic of conversation, to abandon the man outside and approach someone so seemingly curious, now absorbed in contemplating the altarscreen in the main chapel. The woman was so busy making up to him, possibly to cover up for having spent so long back-biting in the Lord's House, that she now proposed showing him the great collection of works in the sacristy. Just as well the traveller agreed. In the corridor, stored inside a glass case, there was a female figure all dressed in lace, wearing a fine fedora with a wide brim, also trimmed with lace, with all the airs and graces of Goya's "La Maja" – of good stock to judge from the way she held her head and her long loose hair. On her lap

she held a child who could barely be distinguished from his mass of ruffles and embroidery. "Who's this?" the traveller enquired. "Our Lady of the Forsaken on her little chair, which is how she's carried out on processions." The traveller thinks he must have misheard and persists with his question. "Yes, sir, of the Forsaken," repeated the woman. Naturally the traveller claims no expertise in hagiology but, at the end of the day, he's seen a bit of the world and a lot of Portugal, is well aware how crowded his home country is with saints, yet had never heard tell of an Our Lady of the Forsaken. Outside on the street, he still continued wondering: "Is it because she protects abandoned children and orphans?"

The traveller got his answer when he'd slept on it and remembered: in the silence of his ghostly room, amid the damask coverings of the old-fashioned hotel, illumination descended – "They mean Egipto [Egypt] not Enjeito. That young woman knows as little geography as she does Portuguese, no more than enough to curse her neighbours." And the traveller, before returning to his slumbers, was pained – as he is even now – that she was not in truth Nossa Senhora do Enjeito. To him it will forever remain a prettier and a kindlier name.

8. Nuno Álvares Pereira (1360–1431) is among the noblest personages in Portuguese history. Mediaeval chroniclers venerated his character and his work. He was the idealised knight of the Middle Ages, a military leader, victor over the Castilians at Aljubarrota in 1385. He entered the Carmelite Order in 1423 and was beatified in 1918.

Food for the Body

Day dawned for the traveller, a day for a lot of travel. First call was at the Serra do Falperra, which once rivalled the pine groves of Azambuja for the number of its assaults and robberies but which today is a bucolic spot, ideal for family picnics. Here the church of Santa María Magdalena can be seen in its infinite grace, an eighteenth-century masterpiece by the architect André Soares, who also sculpted the saint kept in a niche above the main window. Such sculptures from the hardest granite irresistibly remind the traveller of the clay models which famously also distinguished the 1700s. There would seem to be little in common between the plasticity of clay and the rigidity of stone, but perhaps the relationship is less material than spiritual, implicit in the authors' manner of tracing clothes and gestures, or in the decorative surrounds of which the façade affords a superlative example. The traveller can't get inside but isn't about to complain; it's a rare case where the objects of most loveliness are in view to all who pass by. Here no sin of avarice is being committed.

The person responsible for this sumptuous building was Archbishop Rodrigo de Moura Teles, who preached in these parts, almost always to great effect, on artistic as well as on religious topics, for a period of years at the turn of the seventeenth and eighteenth centuries. The Archbishop was a little man, barely 4 foot 6 inches tall, and so short he couldn't reach the Cathedral altar. That was why he had made the unusually elevated ceilings on display in the museum, alongside the vestments, looking as if they were sewn by a child wishing to play at saying Mass. With eight-inch heels to his slippers, the Archbishop could hardly be turned into a giant, but with the help of his mitre, together with the dignity of his position, he could feel above the common lot of mortals. But Dom Rodrigo went one better. Of all the archbishops who made Braga, he was the one who saw both furthest and highest. Even leaving aside works he undertook in the Cathedral and the church of Nossa Senhora da Madalena, he was responsible for commencing the Sanctuary of Bom Jesus de Monte, up in Tenões, although an early death deprived him of the pleasure of laying the first stone. Our

Dom Rodrigo de Moura Teles would furnish material for a psychological study: never had the compensation mechanism functioned so blatantly as in the person of this diminutive archbishop who knew only how to create on a grand scale.

Bom Jesus and Sameiro attracts the devout and pleasure-seekers in equal measure. The traveller went out of pleasure. It boasts open countryside, fresh air and plenty of sun, even now in November, and if there's a dearth of artistic wonders, it's rich in popular taste with the flavour of a pilgrimage, something that has rubbed off on its statues, staircases and chapels and abundantly justifies the visit. Bom Jesus wins out in terms of beautiful plasticity over Our Lady of Sameiro – there's really no comparison between them. As to which is the site of greater or lesser devotion, neither are counted on this traveller's rosary. So let the journey continue.

According to ancient chronicles, kings were acclaimed in Portugal, to the cry of: "Royal, Royal, shout for Dom Highness Whatever, King of Portugal!" Since we're now a republic without too much to complain about, let's drop the last couple of phrases, to stick with simply: "Royal! Royal!" ("Real", which also of course can mean "Real! Real!"[9] or even "Money! Money!") That should suffice. But then Real is also a small village a few kilometres from Braga. It's no different to the rest in its people and houses, but possesses something all the rest lack, both small villages and great cities: the church of San Frutuoso de Montelios.

The traveller is quite aware of what he's saying. He has visited many churches, his head is swimming with architectural riches, and this all gave him a just sense of his conviction that the rest of Portugal has nothing to offer to compare with such a treasure. It's a small building, shorn of ornamentation outside and simple within: you can visit it all in a couple of minutes. All in all, nothing else in Portugal has such a perfect harmony of scale, nor do flattened surfaces commonly speak with such eloquence. San Frutuoso de Montelios is earlier than anything the traveller has seen before, with the sole exception of some Roman remains. It must date from between Roman and Romanesque, perhaps from as far back as the Visigoth period, but is an example of how little classifications really count. If you wish to understand all you can about art, or to acknowledge the fullest extent of your ignorance, you should make the journey to this village: either way, you'll feel both recognition and gratitude to that distant people who conceived and constructed this church, a prime instance of the loveliest architecture to be found in Portugal.

Next to it, the monastery church of St Francis cuts little ice, despite its

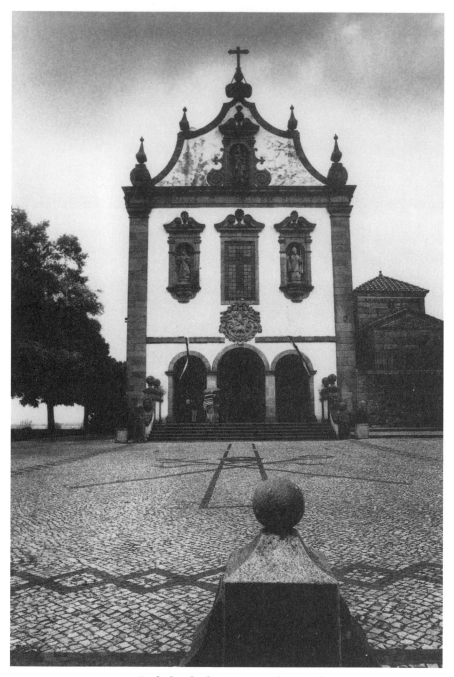

25 *Real, church of San Frutuoso de Montelios*

rigorous Renaissance style: sometimes it's the voices that come from furthest afield which whisper most closely into our ears, and into our hearts, overcoming all the flashiness and bluster. St Francis will never be more than a minor acolyte next to San Frutuoso. As to the traveller, he retires without being too sure who he is.

Happily, he is also none too sure of where he's going. In front of him lies Mire de Tibães (Minho's like that, causing you to stop at every turn along the way), an old Benedictine monastery, and an imposing edifice dwarfing the surrounding countryside, visible from many miles away. Only monks are capable of such excesses. The monastery is an utterly dejected ruin. When the traveller went into the first cloister, he assumed that restoration might be in progress: all around him were building materials, bricks, sand, signs of activity. Disappointment swiftly set in: building there was, but only that connected with the families living in the monastery's dependencies and, going from bad to worse, it always seemed to rain everywhere but in their improvised rooms. As far as he can, he does the rounds of the cold and labyrinthine corridors, where blackened portraits still hang on the walls, coated with wood-dust, the whole also covered with the smell of mould, an irrecoverable death. The traveller entered the church in low spirits: it's a giant ship, its vault a block of segmented stone. The scale is abundantly ample and rich, as ever. After the local Real delicacy, this is no dessert to savour at length.

When the traveller gets close to the Padim da Graça, he's caught out in the classic pose of hand striking forehead: although so near, he'd completely forgotten to visit the walled city of Briteiros beside Sameiro. He'll have to go there tomorrow, even if it means going back on his itinerary. He's thinking this over when a particular roadside house suddenly leaps out at him so that he has to pull up. It's neither an aristocratic nor a bourgeois stately home, nor a castle, a church, a tower or a hay barn. Just an ordinary sort of a house, with doors and windows and a low front and a high rear wall, and a rough sort of a pitched roof. Great stretches of plaster are missing, exposing the stone below. Outlined by the window stood a man with a full beard, a filthy old hat on his head, and the saddest eyes you could imagine. It was the eyes which stopped the traveller in his tracks. He must have looked extraordinary in that setting, for three or four little children also swiftly gathered round to stare with undisguised curiosity. The traveller approached the house and noticed that the man had gone out onto the main road. He found him sitting down on the kerbstone as if waiting for someone. A complete disappointment: that man wasn't waiting

for anybody. When the traveller addressed him, when he asked him the stupid questions asked at a time like this – whether he'd lived here long, whether he had children – the man removed his hat, without answering for he was unable to reply, or perhaps his muttering spoke volumes, all in sighs and grimaces. The traveller is upset, feeling he's entering a world of terrors and wants to retreat but the children start pushing him towards the house, where all is blackness, even the open window where the man first caught his attention. The walls are black with peeling plaster, as is the floor, and black the shadows where a woman seems to be seated at a sewing machine. The man cannot speak, the woman doesn't appear to have much to say either, for he's a poor madman with the airs of a Christ who departed and returned, and having thus come and gone was displeased with what went before and what he found later; the woman is his sister, working away at her machine in the gloom, sewing dusters and that's the life they both lead, that and no other. The traveller choked on a couple of words and fled. Cowardice reigns when you're confronted with like adventures.

There's no more facile and risk-free philosophy than this: comparing the splendours of nature, particularly in the area around Minho, with the condition of misery in which people find themselves, eking out their whole lives and then dying there. Just as well it isn't spring, otherwise the traveller would find a way of amusing himself by making comparisons and analogies between his own mood of melancholy and the fallen leaves in heaps by the roadside. To flee the area there's no lack of roads to take: Padim da Graça is left far behind and the man in the dirty hat returns to his window, and the traveller once again hears the dull sound of the sewing machine. The car engine gradually obliterates its disturbing sound, the kilometres tick by and Barcelos comes into view. The traveller has his duties to fulfil, each to his own.

This is the land of the magic cockerel, who crowed after it was roasted, then sired many heirs reaching a million or thereabouts in number. The story can be briefly told, and is no more miraculous than the tale of St Anthony's preaching to the fishes, nor of their listening to him. It so happened that a crime occurred in Barcelos, back in the mists of history, with no means of determining who the criminal was. Suspicions fell upon a Galician, a clear indication of how xenophobic the good people of Barcelos were, who no sooner set eyes upon him than they accused him with: "That's him!" The man was taken prisoner and sentenced to hang, and before they took him to the gallows he requested to be brought before the judge who had handed down the sentence. The said judge, arguably because he was feeling so pleased

with himself and with his upholding of justice, was in the process of giving a grand banquet where a roast capon awaited on a large trencher. The Galician returned to plead his innocence, in imminent danger of ruining the judge's digestion, not to mention that of his friends and, despairing of his cause, declared himself unable to continue trusting laws made either in heaven or on earth, saying: "I am as certain of my innocence as I am that this cockerel will crow ere I hang." The judge, who believed himself to be extremely well informed as to the nature of a stone-dead and ready-roasted capon, but had little concept of what an honourable cockerel is capable of, guffawed heartily. To keep him company, everyone else roared aloud. So they brought forth the condemned man, the feast followed behind him, but when the time arrived and the carving knife was lowered towards the roast, the capon rose from the trencher dripping gravy and scattering potatoes, fluttered to the window and from there sung out the liveliest, most defiant and ornate cock-a-doodle-do that had ever been heard in the history of Barcelos. To the judge it sounded like trumpets hailing the Day of Judgment. He rose from the table, ran to the gallows with his napkin still tied around his neck, and discovered that miraculous powers had been at work here too: the noose had sprung open, to the great amazement of all present, given the proven competence of the hangman.

The rest is common knowledge. They freed the Galician, telling him to go forth in peace, and the judge returned to the feast, which was getting cold. History has nothing to add regarding the fate of the miraculous cockerel, whether it was consumed in an act of gratitude, or whether they took it off to venerate it in a chapel until time alone consumed its bones. What is sure, thanks to the undeniable material evidence, is that its image is conserved in a sculpture at Christ's feet at the crossroads by Our Lord do Galo, and was returned to the oven in the form of its many descendants made of baked clay then exhibited in all the fairs of Minho, and in all the rich variety of colours a cockerel could or should possess.

The traveller is wholly persuaded: there is the legend to affirm it, the crossroads to consecrate it, the legions of clay cockerels to prove it. Barcelos is such an attractive town that it deserves our pardon for wishing to condemn the Galician, and our esteem for having raised the cockerel which released the fellow from his sentence. But the traveller, who's paying a visit to the Archaeological Museum (you know his penchant for old stones), is inclined to protest at other similarly unjust sentences, for example the business of labelling the pieces on show here by means of little tiles embedded in the artefacts themselves: an example of the worst affectation of folkloric

painterliness. It puts the traveller in mind of what would become of Soares dos Reis' "Desterrado" with a tile stuck in its middle, or the "Venus of Milo" with one on her chubby thigh, or again one of those uncouth Gallic warriors, like Viana's, their breastplates rippling with navy blue lettering. The traveller feels outraged. To get over it, he walks onto the bridge to take a look at the river, which on his arrival he'd barely noticed. Here the Cávado is exceptionally lovely, flowing between high banks which impose a modicum of respect from the necessities of urban life. It also boasts a water-mill which, viewed from the far bank, lends a touch of humanity to the aridity of the upper city wall, the ruins of Paço dos Condes, a more harmonious weight of stone than the parish church. Little by little the traveller's pulse drops to a calmer level. This entrance into Barcelos establishes the lousy judge of museums as the direct descendant of the one who sentenced our Galician to death.

Watching the water flow by, the traveller begins to feel thirsty, while consideration of the capon revives his appetite for food. It was definitely dinner-time. He throws himself into the quest, walking and sniffing where there's no lack of good smells, yet without doubt he must have been propelled by destiny, taken by the shoulders and pushed towards the appointed spot: to the Arantes Restaurant. The traveller went inside, sat down, requested the menu and ordered: meatballs *Sarrabulho*-style, salt-cod roasted with new potatoes, and to drink, *vinho verde*. This came endowed with the greatest virtue among wines: no traveller could have resisted it, nor in its turn was it resistant to the traveller's palate. As to the honest cod, which came garnished with exactly the right sauce and exactly the right potatoes, you could rightly describe it as excellent. But the *papas de sarrabulho*, esteemed ladies and gentlemen, the *Sarrabulho* meatballs showed that he could never hope to find nor live to eat such a tasty dish again, since it'd never be possible to repeat the human inventiveness contained in such marvellous rustic fare, with its blend of substance and delicacy, the number and fusion of flavours, all from a pig and sublimated in a hot gravy which offers sustenance to the body and solace to the soul. However much the traveller voyages the world over, he'll never cease singing the praises of those *papas de sarrabulho* he ate in Arantes.

He who lunches in such style is obliged to stay to supper. Unfortunately the traveller, after another turn about Barcelos, has to be on his way. First to the Gothic parish church, for once well restored so he could appreciate the successful blend of old and new, though what remained engraved on his memory was the adorable Santa Rosália, reclining in her niche, as fresh as her

flowery name, and so feminine that sanctity scarcely became her. In the Igreja do Terço, formerly a Benedictine convent, the traveller saw fit to applaud the eighteenth-century tiles, attributed to António de Oliveira Bernardes, recounting the life of San Bento, told all over again in lavish mouldings across the forty panels of the ceiling. The pulpit is also an object of distinction, refined by the hands of a silversmith. With its gilded poly-chrome, it is one of the rare instances where the Baroque wins the argument. It's never too late to remind ourselves that this church is also the work of the tireless Archbishop of Braga, Rodrigo de Moura Teles, the one you could measure in hand-spans.

The traveller put his nose around the door of a modest chapel, and was startled to find a St Christopher which our little Dom Rodrigo could have carried off on his shoulder without exerting himself. He further saw and was impressed by the noble houses called the Casa do Condestável, the Solar do Apoio, and spied in a high cornice in the palace belonging to the Pinheiros a member of that tribe pulling the whiskers of the Barbadao [common surnames, meaning Pine trees and Bearded Ones], but at that instant, calculating the height of the sun and the journey still remaining to him, decided he'd best take to the road again.

Manhente recalls Abade de Neiva in the relationship between its church and the towering fortress, but the twelfth-century doorway has the most elaborate sculpting and is richest in its motifs, and in the technique of its execution. In Lama you can find the Torre dos Azevedos, which the traveller didn't enter: sometimes a doorway lacks a necessary welcoming expression. He contented himself with an external review of the bevelled mullions, the Renaissance window and its air of a fortress which, at least on this occasion, was not to be taken by storm.

The road continues on to the north of Cávado, crossing what to the naked eye look like orchards, apples groves and vegetable allotments, and whether so or not, this province of Minho is so lush that now in November it looks like May and the traveller feels overwhelmed, losing himself among the greens still holding and winning out against autumn colours. Braga is now well to the south and the traveller is almost at Rendufe when, in one of his fits of penetrating enlightment, he revolutionises the study of the habits and customs of that bird we call the magpie. The magpie, as we all know, has the reputation of a thief. Investigating its nest is to uncover a hoard of glittering things, glass, fragments of crockery, anything to reflect the sunshine. So far, nothing new. Now the traveller has had occasion to observe how often these birds had intercepted the course of his journey, flaunting their

merry widow's garb as if on purpose. An instance occurred on the main road to Rendufe. On seeing the car approach, the magpie is dazzled at the prospect of carrying the shiny jalopy offering itself in its path off to its nest. It launches itself into flight, propelled by greed, but in drawing near begins to register the disproportion between its diminutive claws and the noisily gigantic cockchafer now beneath. Insulted and tearful it glides into the nearest tree to conceal its disappointment. The traveller is as sure as can be of his intuition and refuses to abandon hope that one day there will be birds of prey large enough to seize a car and its occupants, and swing them through the skies to keep company with the pieces of coloured glass. He's all the more convinced now that toy cars have been discovered in a normal-sized magpie's nest.

The traveller could not rest long on the laurels of his discovery. On reaching Rendufe he went to visit a ruined monastery, with a cloister of crude arches that's still pleasant to the eye, despite the high weeds growing all around and the tiles peeling off their wall panels, torn off either by professional thieves or by avaricious tourists, dissatisfied with simply taking their memories away with them. Groups of young children are leaving the church and the traveller assumes they must be coming from a communion or catechism class, while the priest talks to someone who's not a priest and the traveller remains somewhat offended that no-one, either child or adult, seems to be taking any notice of him, despite the resonant "good afternoons" he's wished them all, assisted by the excellent accoustics in the cloister. He entered the church, but in the way these things balance out, he found it utterly tasteless. Even the inside was in ruins, the pews falling apart and only vestiges of the organ still remaining. Certainly its size is worth mentioning, but the traveller has grown weary of Baroque proportions, as is his right even when, as here, negatively demonstrated. The day's journey is drawing to a close. The traveller has no further wish for art. He'll follow the high road running alongside the River Homem, hardly sparing a glance at the countryside. He passes Terras de Bouro, surrounded by valleys under intensive cultivation, similar to the terracing on the distant hillsides. It's an open stretch of countryside whose terraces, where any exist, are deep and often steep.

From Chamoim onwards the contours alter, sharp mountains begin to rear up, steep slopes that lack the humus to draw fertility from the water. From Covide on to São Bento de Porta Aberta, there's a vast mountain to the left resembling a wide lunar landscape. Once passed and in a transition so rapid that it turns your head, the opulence of the forest erupts in the scrub surrounding Gerês, tall trees the traveller watches as he descends

towards the reservoir at Caniçada. The evening is drawing in; night won't be long in falling; the shadows are already growing longer. This corner of the globe with its vast and serene lake, as flat as a polished mirror, and the high mountains with their huge water reserves give the traveller a sensation of peace he has never hitherto experienced. And, having regained the far side of the main road, when the day has drawn in, he turns and gazes upon the world as he believes he's justified in doing, simply because he's a human being and for no other reason at all.

9. Real (royal) was also the national unit of currency, stamped with the king's head.

Mount Everest of Lanhoso

When the traveller is far away, back in that great city he calls home, and has had a hard day, he chooses to remember the lake with its watery arms penetrating the rocky valleys, sometimes even the fertile lands and human dwellings; he'll see in his mind's eye the flanks of pine trees all reflected on that superlative surface and then, within himself, a sea of silence will form, out of which comes the murmur, as if responding in the only way possible: "I am." That nature should be capable of permitting so much to a mere traveller could only cause surprise in someone who has never been to the Caniçada lagoon. The traveller has to tell it how it is: any passer-by who merely congratulates himself by simply mentioning "I was there," or "I took that route," gets it wrong. Who could pass by without speaking the truth: "I didn't go to view it, I went to learn from it!"

The traveller reaches Gerês by way of the deep valley cutting through the countryside towards Portela do Homem. Along the way he visits some early stately homes; he visits them to learn more about the taste of those times, and while perhaps their taste wasn't flawless, he can again confirm that whoever conceived, designed and constructed them did something above average, no doubt something more than all those who sat on the chairs, ate the food and slept in their rooms. Presumably there were exceptions, but not among the prosperous and opulent merchants and industrialists from the market-places of the North, who came to stay and take the waters with their dearly beloved wives but who, sooner or later, abandoned their legitimate partners to meet their true loves in these clandestine houses. Nowadays customs have changed and mistresses are no longer content to accompany their protectors as they indulge in hydrotherapeutic cures, but what the traveller laments is that these times and customs have not been studied in order to complete the amorous history of the upper classes. The traveller realises he has become caught in these games of bedrooms and cheque-books, as he wanders beneath the tall trees, treading on damp, green mosses, hearing and seeing water skip over the pebbles. There's no-one to be seen in the park but a gardener in the far distance, sweeping up leaves, and the traveller thinks it's just as well that

nature occasionally liberates itself from a human presence, surrendering to its natural self, without graffiti'd hearts engraved on its tree trunks, asset-stripping of its daisies or collectors to deplete the ivy leaves. The traveller leaves everything undisturbed in its natural habitat and returns to his own life, which already affords him quite enough to get on with.

He reverts to climbing mountains and from their peaks can survey and bid farewell to the lagoon, pondering on how it's possible to see so much water spread before his eyes, then to continue past Vieira do Minho, which had a much prettier title when it was called Vernaria, a springlike name recalling flowers and leaves in bud: some people have all the luck, however undeserved. To the left lies the dam at Guilhofre, one he's not about to visit. His next stop is at Fonte Arcada, home to one of the oldest Romanesque churches ever built in Portugal, according to the 1067 registers. Unusually, the lamb shown on the tympanum is an adult beast, bearing solidly grown horns. The traveller thinks he gets the message: purity is compatible with strength, and it's plain that this lamb won't go to the slaughter without a struggle. The Romanesque period was a harsh one, given to following its instincts, knowledgeable as to the movements of sun and moon, as demonstrated on the side door, and highly capable of infringing the conventions of the sacristy: the Lamb of God is a ram and, if Christ expelled the traders from the temple, the ram was busy butting his horns whilst He wielded the whip.

The traveller is a little unsure as to the orthodoxy of his reflections but, on the way out of Póvoa de Lanhoso, he is assuaged by the lack of orthodoxy in the building which was leaning up against, almost hugging, a gigantic boulder that forced the road to go around it. To any local inhabitant, the stone's a good companion. It has to be a good feeling to wake up at night and know the stone is there, conscious of its presence protecting the house and its porch, like a guardian wearing moss and lichen instead of wrinkles and grey hairs.

Above it is Póvoa de Lanhoso castle. Like so many of its siblings, it sits high on a peak. The traveller climbs upwards, twisting around the curves, but suddenly finds out that there's no lack of vegetation or trees, while the verge is nothing but rough stones; strangeness turns to amazement, however, when he reaches the summit and sees the boulder appear like an enormous flagstone, with lumps and bumps here and there. Then he realises it must have come from the bowels of the earth, bursting through the fertile humus of the valley and following an impulse to reach for the skies. The traveller considers that this must be our own great Mount Everest: if we could only dig down deep enough to uncover the roots of the stone support to our high Póvoa de Lanhoso castle, the Alpine climbers would seek it out along with the kind of

mountaineers who more often go for the glories accorded to ascents in the Himalayas. The problem is that we're a poor and modest country, and that's our lot.

We're that and more besides, excellent destroyers of the best we possess. Here, for example, is a chapel open to the skies, without either doors or windows, and with frescoes illustrating the Evangelist's account of Jacob's Well, where the Samaritan woman gave water to quench Jesus Christ's burning thirst. A well is still a well, at its base the source is dirty and polluted, and the poor paintings are in a pathetic state of ruin, the young woman's right arm torn away and missing, half the water jug likewise absent, and her robes, together with Christ's, are covered with graffiti'd names, testament of humanity's ignorance in overlooking its reasons for visiting a place. The traveller doesn't know of its equivalent in all Portugal, and this one is already half-ruined. The tiling is conventional, eternal Jerusalem evoked in the distance, but nothing could fit this situation better. How long have Christ and the Samaritan woman to keep gazing at one another across the parapet of the well?

The traveller is not in a good mood when he departs. Nonetheless, he is sufficiently self-aware to suspect that his ill-humour results from an inability to reconcile two contradictory desires: that of remaining everywhere he goes with that of going everywhere he wishes. He follows the road to Briteiros, which escaped him during an earlier twist of the tour, longing to arrive there as much as he's longing to remain in Caniçada, watching the reflections of the mountains, or again in Gerês, his boots brushing through the damp ferns, or in Fonte Arcada meditating on the moon and sun, or in the chapel at Jacob's Well, waiting for someone to come and quench his thirst, or simply at the house clinging to the great rock, allowing time to pass him by: for those with the inclination, it's a perfect training in melancholy.

He's now reached the ancient citadel. No houses here, except for those rebuilt higher up, apparently with little care or concern, but the streets are still all there: at least it's easy to believe they are. If the visitor is endowed with enough imagination, he'd be attending less to where he puts his feet than transporting himself back into a time when a very different people walked those streets, no doubt greeting each other as they did so (in what-ever language) before setting off to work in the fields, or in their simple workshops, contemplating life. The streets are narrow, no two people can cross paths in them, so the traveller has to step aside to let the old man stumbling along the paving stones pass by, or the woman carrying a water jar, asking as she does: "Are you thirsty, Mister Traveller?"

Awakening from his daydream, he sees the place is in ruins, and goes to request a glass of water from the guard, whose water is scant and brought from far away, and in looking about himself, he sees the accompanying mountain range surging in waves just as the original inhabitants in ancient Briteiros must have done, if that was its real name among residents to whom we'd cause the greatest surprise once we informed them that they were living in the Iron Age.

Today the traveller will reach Oporto. He'll eat in one of those little villages hereabouts, remote from noisy conurbations. He'll avoid the main roads, since he's willing to be distracted by the side roads linking one man with his neighbours, noting the unusual names running from north to south, and knowing how there are always temptations along the way, he'll repeat each name under his breath, relishing its sound and attempting to divine its significance, then almost invariably gives up or else is overtaken by the next name, before he's succeeded in properly deciphering its predecessor. So doing, he passes Sande, Brito, Renfe, Pedome, Delães, Rebordões, and when he reaches Roriz deems it time to call a halt, drink from its fountain, and request the opening up of the church door leading into the ancient monastery, and while he waits he peers through the railings at the ruins of the cloister. There below, invisible from this angle, runs the River Vizela. Runes are carved in the most ancient stones. No doubt they have something to say, but the traveller is uncertain what it is. There are so many things for him still to learn, and so little time left to learn them in.

For example – what on earth are those oxen doing in the church porch, with their floppy dewlaps, gazing fixedly at any passer-by, our traveller or the faithful who make their pilgrimage here? What cult members are they awaiting? Are they there to remind these men how much they owe them for their effort and labour, meat and hide, their patience? San Boi was placed there to claim first dues.

Today the traveller takes it slowly. The main roads are deserted, under lengthening shadows. Now you see the sun, now you don't, sometimes it's hidden by the mountains, at others in the clouds. Then the countryside falls away, with plenty of space in the deep, wide valleys to open up major areas to cultivation. In Paços de Ferreira the traveller lost his way. There was no lack of directions: turn here, fork there, take the first on the right, the third on the left, the asphalted road and then straight ahead until you reach the school. Too much mathematics. The traveller went on, went back, repeating the question to all those he's already asked, smiling pallidly when they asked him: "Didn't you manage to find the way? But it's so easy! Look, just take

the first on the right, etc." Finally, among so many, the breathless traveller
found his fairy godmother: a tall, dark woman with deep blue eyes, the face of
a caryatid, in sum a kind of bucolic goddess of the roadside. Since goddesses
cannot make mistakes, the traveller found the San Pedro de Ferreira
monastery which, after all that, he was barred from entering. He's wasted so
long unravelling confusions between Ferreira and Paços de Ferreira, and now
has to content himself with its external glories: a Romanesque portico with
a freestanding belltower; the stylised motifs on the capitals which, in spite
of everything, are extinguished by the geometric simplicity of the architectural
vaulting with perforated petalling, like a giant embroidered border. The
traveller knocks on a nearby door. The light is on at two of the windows but
nobody appears. A dog comes as far as the railings to bark at him in a manner
the traveller finds offensive and so he departs, in humiliation.

Peaceful main roads are now a thing of the past. Only beyond Paredes was
there a resurgence of peace when the traveller went from Cete to Paço de

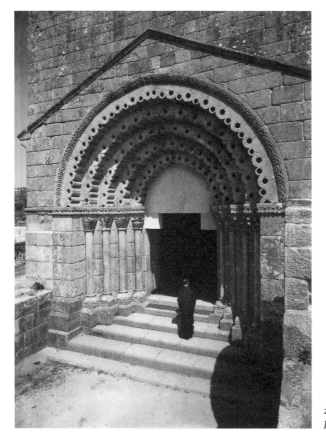

26 *Paços de Ferreira,*
Romanesque portico

Sousa. To reach Cete monastery he had to take one of those rollercoaster roads, and was greeted on his arrival by three women, each with her own idea of where the key was kept, and while they were calling in more distant neighbours who thought they'd caught the word *trave* rather than *chave* [beam not key] the traveller grew resigned. The day had both awarded and denied much. That's life. He thanked the women for their good intentions and raised voices and went on his way, his memory imprinted with the image of the strange giant on the façade protecting whatever lies concealed inside.

Humility has its rewards and in Paço de Sousa he was to receive abundant compensation. The church of San Salvador monastery is situated on a flat and wooded dip, with a stream running alongside into the River Sousa. The evening is drawing in and just as well. It's the best light to see it in, ashen over the green, the sound of rushing waters. This time the priest himself supplies the key. The traveller, were he to attend confession, would accuse himself of the darkest and murkiest envy. It's that everything about the place, devoid of any particular grandeur, renders it one of the loveliest places the traveller has ever seen. He would adore to live here, in the house to which he's been given the key in such a friendly fashion, without confiding the wicked desires bubbling in his soul. Patience. The traveller opens the church door with his own hand, but before he enters, he meets a Romanesque sun and moon, a questioning ox deep in conversation with a human figure who, hand on beard, one can tell is at a loss for an answer. Above and on either s ide they are hemmed by columns and vaulting and a large rose window, wonderful and daring in its tracery.

Inside it's just as pretty. It has a stripped-down look the traveller appreciates, so long as he shuts his eyes to the work of subsequent centuries. Here is Egas Moniz' tomb, unarguably rustic in its execution, but with a vigorous, muscular strength that overshadows the detailed refinements of High and Manueline Gothic sculptures. Perhaps another traveller would dispute this opinion. This one is deeply moved by the roughness of a chisel which would have to begin by wrestling with itself before attempting to start on something with the resistance of stone. It seems appropriate that in like struggles there were times when stone resisted being totally dominated. Cruder by far is St Peter, although created three centuries later: the work of an inspired stonemason who intended to sculpt a saint and ended up with a magnificently chiselled piece of stone.

The traveller went to return the key and offer his thanks. He cast a last glance around him, sorrowful at having to depart, but considering that here at least some things still conform to their original tradition: for a

founder, no monastery could have done better than an endowment by the felicitously-named Abbot Troicosendo Galendiz, who came here in the tenth century to select a site for the works to commence. Even out on the open road, the traveller is still repeating to himself, sounding as if he were trying to crack an almond with his teeth: "Dom Troicosendo Galendiz. Dom Troicosendo Galendiz."

Oporto is now close by. It's shortly after six when the traveller reaches the city. All the bus-stops have long queues of women. They're workers from the surrounding factories. And when the traveller again wishes to repeat the name of the founding father of Paço de Sousa he can no longer remember it.

"Beside the River They Call the Douro . . ."

The traveller is in the Cathedral square, overlooking the city. It is early morning. He came here to settle his route and choose an itinerary. The Cathedral is still shut, the episcopal palace seems remote. A cold breeze rises from the river. The traveller calibrates weather and distance, mentally tracing an encompassing arc with the square at its centre, and reckons everything he wants to see in Oporto contained within it. As a rule he doesn't bother with quite as many rigorous formalities, so he'll probably end up infringing his first rule. Fundamentally, he accepts the basic principle requiring him to note the ancient and picturesque and to disregard what's modern and banal. In observance of this rule, to travel through cities and other places ends up as conservative a pastime as visiting museums: you follow this passage here, then take a turn around this room, pause in front of this glass case or that painting for just long enough to demonstrate to any other viewers the visitor's cultural credentials, and then proceed to the next passage, exhibition room, glass case, passage. New neighbourhoods or those still under construction aren't worth even asking about, and slums are neither comfortable nor agreeable places to obtain answers on. The traveller, as anyone could tell you, has every justification in seeking out prime sites of resplendent beauty. So he does, but with the accompanying resolution that he will never forget that the world has also its fair share of ugliness and poverty.

Well satisfied with his newfound resolve, he decided to begin his descent down the Escadas das Verdades, the steps which drop sharply from behind the episcopal palace to the river. They're steep, difficult to descend and even harder to ascend. The reason for their baptismal name remained unknown to the traveller, so curious as to names and origins that only yesterday, on the main road to Sousa Palace, he'd been regaling himself with the many-syllabled Troicosendo Galendiz. People had climbed up and down these slopes since the time of Count Vímara Peres. The river still runs through the same channel squeezed between the stones of Oporto on the one and those of Gaia on the other side, and the traveller observes how the steps were worn away between the rocks, alongside the houses which looked as if they

were forcing their way out of the rockface or squeezing in amongst its outcrops. Streams of dirty water are running downhill alongside the traveller, and now, since day is risen and the morning has unfolded, women are appearing to wash in the water-tanks on the terraces while their children play round about. Long banners of washing are strung beneath the eaves, sometimes hanging as low as the first floor and the traveller feels as if he's marching down a triumphal stairway, like Radamés after the battle against the Ethiopians. Here below runs the Ribeira. The traveller passes beneath the arch of the Travessa dos Canastreiros, a great source of shade in high summer but right now a chilly corridor, and he'll wander for half the morning through the Bairro do Barredo, learning once and for all what damp, slimy streets are really like, runnels stinking of cesspits between the houses' dark entrances. He doesn't dare speak to anyone he sees. He carries a camera over his shoulder, but he doesn't use it. He feels the stare of everyone he passes stabbing him in the back, or perhaps that's just an impression, perhaps the person observing him with such curiosity is really inside himself. As the streets begin to widen the traveller looks up at the tall apartments: he's left off being Radamés and is a scholar examining the intriguing question of why the windows in this city are so broad they occupy the full width of the façades. Higher up the Rua Escura, in contrast to its name, lights up as it opens onto the flight of steps leading onto the Cathedral square and onto a popular market resembling a souk. Just as well that natural fruits and vegetables proliferate and plastics manufacturers have a firm predilection for living colour. The Rua Escura is a segment of the rainbow where every window has its share of dangling washing, arcs of the old and the new, everyone's washing together.

The traveller has taken a decision not to go from church to church as if the salvation of his soul depended on it. He'll go to St Francis, despite his own protestations against the Baroque style, which he's maintained since returning to Portugal. The highpoint of St Francis is a giant patchwork of worked gold, endlessly repeated in formulae and patterns, in copies of copies. The traveller is no authority but he can view the splendour which refuses to admit a single centimetre of bare stone and be overwhelmed by the magnificence of the spectacle, believing it has to be the best gold leaf there is in the country. He can't remember if anyone else has ever said so, but for his part, he'll swear to it: truly anybody entering must be moved to surrender to it. But one day the traveller would like to know what kind of walls the carving obscures, and what worthy stonework is condemned to blind concealment.

He makes a tour of the church, at first put ill at ease by the realistic sadism

of the altar to the Holy Martyrs of Morocco, then distracted by the sprouting genealogies of the Tree of Jesse, a mannered and theatrical sculpture reminiscent of an opera chorus. One of Christ's ancestors even wears slashed breeches, a palace figure of the seventeenth century. The traveller, gazing upon the sleeping patriarch Jesse, naturally finds phallic imagery implicit in the tree trunk protruding from his body, culminating in Jesus Christ who was born without the stain of carnality. Standing in the centre of the church the traveller is overcome, all the gold in the world rains down on him. He begs for fresh air and the woman with the keys, understanding his attack of acute claustrophobia, opens the door. As the traveller emerges, the head of another of the Martyrs of Morocco is lopped off. Just outside and behind some iron railings is the Stock Exchange. The traveller meditates a little upon the travails of this world, so many that it'd be impossible to redeem the poor beheaded martyrs even with the gold and money that's rightly theirs.

From here on he follows narrow alleys and side streets leading to the high street. In honour of the name it bears, Oporto, before all else, ultimately consists in the wide expanse open to the river, which can only be seen from the river in the narrow openings hemmed by walls, through which the traveller can lean into the fresh air and cherish the illusion that all Oporto is Ribeira. Its banks are covered with houses, houses shape the streets, and as all the ground is granite on granite, the traveller feels as though he's roving over mountain tracks. But the river reaches all the way up here. The people are not a fishing people, no nets are cast between the bridges of San Luís and Arrábida, yet traditions remain so strong that the traveller can manage to decipher fisher ancestors in a passing woman, and if they weren't fisherfolk they must have been shipwrights, riverside ships' carpenters, or people who sewed nets and sails and braided ropes, or who, higher up the hillside, gave the name of their trade to the street, Travessa dos Canastreiros, the Basketweavers' Lane. Times and trades alter, and all that's needed is a commercial advert to see the destruction of all the poetic crafts the traveller has been ticking off on his fingers. The traveller stands outside an orthopaedic shop – indicated by the opulent woman painted on a metal sign and swinging in the breeze, as innocuous in her total nudity as our mother Eve before she started having problems with intestinal hernias and ruptures.

The traveller enjoys peering into their deep entrances, so deep in fact that before reaching the counter he has time to change his mind three times as to what he's going to buy. He guesses that behind them lie orchards of fruit trees, yellow medlars for example, known as *magnorios* in these parts. The traveller will never forget the colours the houses are painted, the reddish or

yellow ochres, the deep chestnut tones. Oporto is an adventure in colour, a successful accord between granite and earth colours which he accepts, allowing as sole exception only the blue that so perfectly complements the white of the tiles.

The traveller goes into the San Benito da Vitória monastery, takes a turn around it and leaves. Its cold Benedictine style is out of keeping with the city. What's needed here is Baroque granite, taking granite as a form of exuberance, a stone which in being worked is finally restored to its natural expressiveness. The memory of the three terracotta sculptures on the façade and the Atlases supporting the organ still please the traveller. He suspects but doesn't care that he'll probably forget the rest.

There's no end to the climbing up and down. He pays a visit to San João Novo, boasting one of the first city palaces built by Nasoni. The Ethnographic Museum is here, which he takes in with a kind of greed that he cannot and would not choose to cure. The museum is well organised and well classified. On the mezzanine there's the reconstruction of a vintner's, in which only the scent of must is missing. In the upper rooms, not counting the ceramics, stone and bronze axes, paintings, popular holy images, pewter items and coins (the traveller is well aware that he's muddling periods and articles with a total lack of ceremony), there's also the truly delightful recon-struction of a country kitchen deserving at least an hour of contemplation and examination. The museum has something more to boast: toys, including a carnival giant, and marionettes with such intense powers of expression the traveller would happily have bartered the Venus of Milo for them. Had he but time, he'd add to the lesson he learnt here one from the Museum of Archaeology and Prehistory. But it'll have to keep.

More streets and stairwells, Belomonte, Taipas, and at last the traveller took his rest in Os Mártires da Pátria. He sat down and rested a while and, having recovered his strength, proceeded to the churches of the Carmelites and the Virgin of Carmen. He decided that between two such next-door neighbours there would have had to be rivalry and emulation. Comparing them side by side, the Carmen wins. If the ground floor is not particularly interesting, the others are in beautiful harmony, culminating in the fine definition given to the statues of the four Evangelists at the top. Without these, the Carmen's façade would lose much of its magnificence.

As to the interiors, after weighing up each of their component parts separately, the traveller still prefers the Carmelites. It's a church doing all it can for the Faith, whilst the Carmen simply overdoes it. It goes without saying that this all has more to do with the state of the traveller's spirits than with

any objective judgments. In sum, to go into the church of the Virgin of Carmen on that winter's day was an experience the traveller would never forget. On the left as he enters, deep in a side chapel, is Our Lord of Good Outcome beneath an apotheosis of lights, dozens upon dozens of candles, enormously powerful lamps, innumerable portraits of the recipients of benefactions, all sorts of wax ex-votos: heads, hands, feet, lit as if hot coals were burning in a violent hearth fire of white light. There are only two alternatives: either to fall on one's knees, pole-axed by the surroundings, or else withdraw. The traveller felt he was in the wrong place for him and withdrew. Old men and women of extreme venerability were seated in the pews coughing desperately one after another (it's the damp season for coughs and colds) and in the main chapel a priest is on his knees on the step, theatrically leaning his head against the corner of the altar. The traveller had never seen anything like it, and he's never stinted for churches or in giving them the respect they're due.

It's lunch-time, but his appetite has suddenly vanished. Unenthusiastically, the traveller toys with a dish of cod, drinks his vinegary *verde tinto* and, having dined, sets off down the Rua da Cedofeita to the church of the same name. He's really only doing this out of a sense of duty. It's effectively a Romanesque substitution, and the traveller is obliged to say that its restoration has been a triumph. He didn't discover what the interior was like, for a solicitous soul informed him that the church only opens for weddings on a Saturday, remaining closed the rest of the time. So he continues on to the Museu Soares dos Reis, suddenly feeling himself in need of silence and solitude. The traveller flees the world only to meet up with it in specific forms: art, harmony, proportion, and an inherited tradition which passes from hand to hand.

The Museu Soares dos Reis' hall of religious art is not particularly distinguished, but it's here the traveller wonders whether the study of imaginative sacred art could be achieved, or at least initiated. He wonders whether any such an undertaking will uncover traces of particular originality – who knows if such a thing is possible? – without falling into pseudo-mediaeval or Baroque revivalism, bestowing fresh life on an over-stylised Portuguese genre. The traveller holds to this impression while begging pardon from the shade of that grand sculptor Soares dos Reis, whose "Desterrado" [Exile] always evokes the same emotional response with its unarguably handsome Hellenic marble, so remote from the expressive force of the Ança stone carvings to which the traveller always returns. The museum is rich in paintings: the traveller singles out Frei Carlos' "Virgem do Leite", possibly

the most significant work in the place. Yet he still keeps a special corner of his heart for paintings by Henrique Pousão and Marquês de Oliveira, without intending to let his preferences in any way impugn the excellent Dórdio Gomes, Eduardo Viana or Resende. The ceramics collection is of the highest order, yet the traveller remains mindful of what he saw in Viana do Castelo, making no comparisons and according no privileges in favour of what he's now looking at. He examines the glazing on the Limoges enamels, easily granting that they are exceptional pieces, but goes no further than that. In the traveller's opinion, enamel is not an especially fetching art form.

He now heads for the Cathedral. On the way he looks in on the Clérigos, surveying the outside, thinking over what Oporto and the northern region owe to Nicolau Nasoni, considering he has been stingily rewarded by having his name on a street which ends as soon as it begins. The traveller is well aware that recognition is rarely in proportion to the debt it is intended to honour, but Oporto could have hit upon a more fitting method of acknowledging the capital influence the Italian artist had upon the actual physiognomy of the city. It's right that Ferdinand Magellan should lay claim to a whole avenue. Having navigated the world he deserves nothing less. But Nicolau Nasoni drew journeys no less hazardous on his sheets of paper: the face in which the city would see itself, no less.

How would Oporto Cathedral have looked in its earliest days? Much as a citadel, in strength and military pomp. The towers reveal as much, so huge they reach the upper bay in the rose window. Today one's eyes have become used to composite buildings, so much so that the eccentricity of a Rococo porch and the incongruity of the cupolas and tower balusters are hardly worthy of comment. Even so, Nasoni's gallery appears more than usually well integrated into the whole: this Italian, apprenticed to and educated by masters with a different language and outlook, came to learn what strange tongue was spoken far into northern Portugal and to translate it into stone. Forgive my insistence on this point: to miss it is to commit a grave offence, and to demonstrate a lack of sensitivity.

The church interior is surprising in the grandeur of its pilasters, of its pointed vaults. Conversely the well-restored cloisters dating from 1385 are small, but of an impeccable geometry, accentuating the renewed stone-work of the arches. Christ's head on the monumental cross at its centre has become mutilated by time. The features have disappeared, and lichens are attempting to etch fresh ones on its smooth surface. Next to the cloisters is an ancient cemetery. Here Jews were buried right next door to the Christian church, something to perplex the traveller who promises

himself to shed some daylight on the existence of such unlikely neighbours.

On leaving the Cathedral the traveller goes to contemplate the roofs of Barredo. He descends from the square to take a closer look, trying to visualise the streets from the raised upper levels of the house fronts and, on his way back, comes upon an unusual fountain set against the wall flanking the square. On top of it, there's a pelican in the act of pecking a beakful of flesh from its own breast. The water runs in four gutters from the upper cistern, barely emerging from the contour of the stone. The cistern is supported by the statues of two youths shown in half torso, bursting out of what looks to the traveller like the corolla of a flower. He's not too sure about this, he can only say what he sees or thinks he sees, but what's unarguable to him is the threatening expression on the faces of the women, also cut away from the waist down, propped atop columns, each one holding up an urn. The lot is a ruin. Questioning people in the vicinity, the traveller learns that this is the Fonte do Passáro, or Passarinho [Sparrow or Little Sparrow Fountain], he's no longer certain which. What no-one could explain to him was the reason for the choleric and defiant look on the women's faces, nor what their urns contained, nor even who was served by the water that once flowed here. In the pelican's breast there's a hole from which the water once ran. The pelican's three offspring, open-mouthed below, suffer an eternal thirst. Like the fountain itself right now, dirty and stained, without anyone to care for it. Should the traveller return to Oporto one of these days and look for the fountain without finding it, he'll be deeply disappointed. He'd have to say that daylight robbery had been committed, without the victim being assisted either by the proximity of the Cathedral above, or the village of Barredo, just below.

When he's ready to depart the following day, having visited a real jewel of a church dedicated to Santa Clara, with its portico where High Renaissance flourishes along with Baroque carvings, again serving to restore the traveller's good spirits, that and its sheltered and ancient patio giving onto the former convent too – when the traveller voyages forth again, he'll revisit the Pelican Fountain, gazing again upon the wild women who defy the stone that holds them prisoner, and know that there's a secret here that nobody can explain but which he'll take away from Oporto with him, as deep a mystery as the shady streets with their earth-coloured houses, as fascinating in their way as the lights which begin to emerge in the dusk in this city beside a river they call the Douro.

II

LOWLANDS BESIDE THE OCEAN

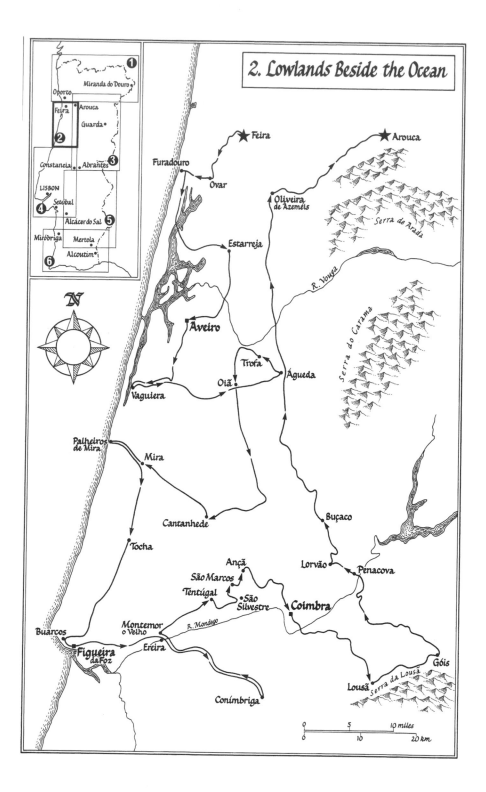

2. Lowlands Beside the Ocean

Endless Waters

The traveller heads south. He crosses the Douro at Vila Nova de Gaia, entering lands which it'd be safe to say are different, but this time he spares the fish a further sample of his sermon. They wouldn't be able to hear him preach from such a high bridge and in any case these are city fish and don't go in for homilies. Great treasures are buried beneath this bank to the left of the river: what we can see on the terraced slopes are but their visible signs, vines which on January days like these are bare of all their leaves and as black as burnt roots. On this side of the Vilanova de Gaia the wide channels descend, flowing from the trodden grapes and their must, and here subtle essences of wine are filtered, decanted and laid down in cellars where men come to guard the bottled sunlight.

Just as well they don't guard it all. On the main road to Espinho the only shade is that cast by the trees. The sky is clear, without a thread of cloud, and if the breeze were less stiff it'd be like a summer's day. The traveller didn't pause in Espinho. He saw the deserted beach at a distance, with its clashing waves, its spray seized and pulverised by the wind, and continues directly on to Esmoriz. These are minute details devoid of interest on our itinerary, but it's worth remembering that the traveller is also devoid of wings, he covers the ground like any other pedestrian, and he wouldn't be right not to mention the places he passed through. Now he's off to Feira, famous for its castle, most of all for its keep with its conical turrets which, to the traveller's eyes, give it the air of a palatial home, not in the least bellicose: merely the peaceable estate of some local landowners. It's true that the arrow-slits still exist, but even these have an explanation, assuming that the *fidalgos* whiled away some of their leisured hours in target practice in order not to lose the habit altogether. The traveller may appear disrespectful, due to a simple largely untutored manner of protecting himself against the sense of tenderness induced by those ancient stones. It's not just that Feira castle is playing with his emotions: there's also its prehistoric altar stone dedicated to a god once venerated and called upon by the amazing name of Bandevelugo-Toiraeco. As though the name of Abbot Troicosendo Galendiz

were not enough, there's also this god with a rebarbative name, who sounds like more of a tongue-twister than a suitable recipient of petitions. It's hardly odd he should have fallen into oblivion. So now the traveller continues on to Our Lady of Joy, to pray for that which was doubtless once besought of Bandevelugo-Toiraeco: peace, health and happiness.

Whether due to the invocation of the one or the other god, the wind dropped. The traveller leaves Feira castle by way of its shady, tree-lined boulevards, inhaling the consolation of the fresh air, to take a look at the church in the convent of the Holy Spirit. It hardly proves worth his while. The best it can offer to engrave on his memory is its geographical position, erected at the top of a steep slope as if presiding over all it surveys. Having taken a look, the traveller proceeds to Ovar, where lunch and the museum await him. Whatever he ate was forgotten a day later, but not that *vinho verde* with the name of Castelões, grown on the fortunate margins of the River Caima, sheltered by the adjacent lands of Freita and Arestal. It's a wine the traveller drank in a state of pure grace, at precisely the right temperature, lacking all sense of deference for the human physiology. Scarcely has it entered the mouth than it flows into the bloodstream, becomes absorbed as utterly as if by osmosis, bypassing the grosser processes of digestion.

Nonetheless, this was not the reason why the traveller found the museum so fascinating. Or perhaps in the end everything contributed, including the god Bandevelugo, the white wine of Castelões, and the indescribable light of the sun, but it's still true to say that Ovar Museum has a particular charm of its own. Firstly, it's not a museum, it's a storehouse for absolutely everything. In a house that was once inhabited, it's full to the brim with a mixture of the banal and the valuable, fishing nets and needlepoint, agricultural implements and African sculptures, clothes and furniture, pictures made of shells and fish scales or stitched with hair. It all blends together in a singular homogeneity: the love expended on assembling all these objects and the love with which they're conserved are equally on show.

Ovar Museum is a treasure for whoever has a global concept of culture. As for the traveller, who takes such matters to the limit, the moment has come to confess that he left a portion of his heart behind in Ovar: it's the one way he has of conveying what he felt in front of that woman's black hat made of thick felt, a round sweep from which six tassels hang suspended. No-one who hasn't seen it could imagine the charm, the wit, the irresistible femininity of what, in description, sounds like a raggedy parasol. There's no dearth of reasons to visit Ovar but the traveller, on his return, will do so because of the hat.

There are five kilometres between Ovar and Furadouro along a straight main road that looks about to run into the sea. Its beach is endless sand, with peaked dunes stretching away to the south, the light is crystal-clear which, luckily for the depths of winter, is poised just this side of unbearably bright. At this time on a summer's day you'd have to shut your eyes to the multiple reflections of sun and sea. Today the traveller can promenade along the beach and feel he's witnessing the dawn of the world.

It's a solemn moment. Lower down over there is the Aveiro estuary, forty kilometres of coastline, twenty kilometres inland, firm ground and water encircling every shape an island could ever come in, or isthmuses, or peninsulas, every colour the river or the sea could ever command. The traveller's prayers have served him well: no wind, a perfect light, the estuary's infinite waters an unmoving lake. It's the kingdom of the Vouga, but the traveller must be careful not to forget the useful web of rivers, streams and little tributaries running from the Serras of Freita, Arestal and Caramulo into the sea, some condescending to join the Vouga, others opening up their own passage, making a route into the estuary on their own account. Repeating some of their names, from north to south following this hand-span of waters, we have: Antuã, Ínsua, Caima, Mau, Alfusquiero, Águeda, Cértima, Levira, Boco, beside all the names they've been given by those who live or were born alongside them. Were this a period of summery relaxation the roads would be crammed with traffic, the beaches with bathers, and the waters with sail or motor boats departing. But today, despite the beautiful sun and open skies, it's still midwinter with not the faintest whiff of spring in the air. The traveller would like to believe that he's the estuary's only guest, apart from the men and other creatures indigenous to its natural habitat. Which is why (since every silver lining accompanies a cloud) the salt pans are deserted, the seaweed-gathering boats silent and their traders absent. Only the wide lagoon and its silent blue respiration remain. What the traveller cannot see he imagines, another motive for his travels. Today the estuary has a highly appropriate name: it's called solitude, and it communicates with the traveller, talks uninterruptedly, chatting about the waters and the muddy algae, the fishes swimming between the two waters beneath its surface ripples. The traveller understands it's attempting to express the inexpressible, that no words are capable of conveying what a drop of water consists in, still less a living body or a sea and a land as wide as a heart. The traveller looks up and sees an albatross. *It* knows the estuary. It sees it from on high, its dangling feet disturb the polished surface as it dives among the weeds and fishes. It's a hunter, a navigator, explorer. It lives there

27 *Aveiro salt pans*

and simultaneously it's a gull and a lagoon, as the lagoon is a boat, a man, a sky and this deep commotion allowing itself to be calmed.

The traveller crosses into the region of Murtosa and notes, firstly with no more than a vague impression then with a conscious process of observation, that all the houses including the bungalows, the humblest one-storey cottages you can scarcely glimpse between the trees and behind walls, have a palatial air about them. From which derives their lineage, which is what he rapidly discovers (or thinks he does), thus confirming the bounty of small causes in the attainment of great results. First comes proportion, colour, context, the comfort of surrounding space, but most of all the working of that red clay, with its little pinnacles, turrets and vaults positioned along the the length of the eaves on every roof. It's a style which starts and ends in this one region, with at least some degree of harmony and consistency. A countryside in which nothing is accidental, everything more or less at sea level, there's always something to hit the traveller between the eyes. The traveller doesn't get to see more than the Casa da Praça in Estarreja, painted a torturous salmon colour, prejudicial to any appreciation of its proportions. He turns southwards again, crossing Salreu and Angeja, until at last he reaches the Vouga in its proper incarnation as a river. There in front, beyond these sandy lands, is Aveiro, which was a tiny village of fishing folk in the tenth century, governed by the Countess Mumadona Dias. Even then the salt pans and the seaweed were being exploited, and it costs nothing to imagine how in another ten centuries some of these lands will still have produced nothing apart from salt.

The traveller reckons up the day and doesn't find it lacking: a personal god of his own, a matchless hat, wine for an island of love, the intoxicating waters of the estuary. Nonetheless he retires to sleep under a cloud of ill omen: the sun, well before sundown, is in hiding behind a damp fog hovering over the sea. A fog which meant that, a day later, the sky was obscured by an ashen veil, while the climate turned cold and crisp. It's time to line up all wise reflections on the instability of time and fortunes, then to comfort oneself with the succession of days, militating against each and every one turning out badly. Even yesterday, for example, he saw how the heavens cosset their favourite travellers. The estuary, seen beneath the sun's rays, was a royal gift. And it's good for the traveller to continue on without the conviction that life is a bed of roses.

Going to Aveiro Museum is an adventure on its own. Like everywhere, it has its opening and closing hours, but if the traveller came unfortunate into the world, he could tell you how he waited an infinity at its entrance, like a

poor man at the convent gate waiting for his dose of slimy soup, served up late. And when he mentions the convent gate, he's taking none of that poetic licence that amounts to a mere literary abuse, but is using the term specifically. Of course tugging on the bell pull is not without its charms, nor is hearing the clapper deep within, or again waiting until the sister porter, in other words the museum director, comes to open up. He'd do wrong to deny it. Since the servant was in the depths of the monastery, it was a long way to walk to the door, made even worse by waiting visitors. So he had no recourse but to wait there patiently, until someone appeared. The traveller had an appointment, but had no option to do more than check the time and raise his hand to the bell pull, requesting his crust of bread.

It was in Aveiro Museum the traveller set down the weapons with which, in less respectful times, he had struggled against the Baroque. No overwhelming conversion took place, and tomorrow he'll no doubt fall into further fresh and unfounded excesses, but for now his eyes have been opened to understanding. Whoever organises and maintains Aveiro Museum knows their business. So does the guide accompanying the traveller: he doesn't restrict himself to the traditional litanies, but attracts attention by entering into discussion, commenting intelligently. The traveller learns as he goes along, asking lots of questions to show off what a good pupil he is.

Of the two thousand pieces on display he can hardly mention more than ten. He scarcely dares even to address the architecture and decoration of the place as a whole. He saves a few words of description for the cloisters, looking feminine with their blue-and-white tiled benches where the nuns whiled away the afternoons, chatting about subjects sacred and profane, mingling confidences in with their praying. Not that the traveller had ever witnessed it, but he guessed as much. He considers the nuns as fortunate creatures, beneficiaries of all the beauty gathered on their walls and lining the corridors with Renaissance decorations. The traveller is equally ignorant on the subject of what food was served up on the large kitchen tables, but he still retains an image of beauty in the tiles covering the refectory walls, its low wooden roof, and the impeccable proportions of the whole. He's less impressed by the grave of Santa Joana Princesa, without doubt a work of refinement, all of inlaid marble and ordered colours, but you've already seen how the traveller's sensibilities direct him towards other types of work and material. In compensation he rewards himself with the ingenuities and anachronisms of the paintings covering the walls of what today is known as the sanctuary room, in particular the one showing the princess receiving Afonso V on his return from Arzila: behind her, in the close formation of

a guard of honour, is a company of busbied grenadiers, whilst the King appears dressed in the mode and style of a *fidalgo* more given to palaces than battles. Nonetheless, the point where courtliness truly touches total incongruity is in the portrait of Princess Joana by Pachini, giving her the expression and adornments of a Pompadour and converting the Child Jesus, who's sitting on her lap, into the least celestial of figures, so much so that the halo becomes confused with his ash-blond hair. Not that the saint plays second fiddle, all adorned with plumes and decorated with gold and precious stones. Fortunately for her, it's the other portrait, from the fifteenth century, lovely in its substance, rigorous in its plasticity, which shows a princess of melancholy and Portuguese demeanour.

The traveller needs to make more than a mention of the presumably Italian fifteenth-century "Senhora da Madressilva" with its tiles and fine columns framing the painting of "St Dominic", also that of the beautifully refined "Holy Family" by Machado de Castro, a work of a purity to redeem the conventionality of its poses. At least it should, but doesn't quite. Many magnificent pieces demand return visits, to be studied in tranquillity and with slow absorption. The traveller will simply make mention of the Christ crucified situated, if his memory doesn't deceive him, in the gallery choir stalls, to the rear of the nave. It's a strange figure, bald or apparently so. He isn't even wearing a crown of thorns: perhaps it had come off. Surprise is only increased by the sight of his anatomy, which has nothing ugly about it: it's not the body we're used to for it has none of the emaciation usually accentuated by the collapse of the trunk and extremities of the body; nor is he a Rubensesque athlete; neither does he show the mortifications of punished flesh, for example so favoured by El Greco. He's just a man, a poor man of medium height, whose frame knows nothing of classical proportions. His legs are short, his back must have borne heavy weights and his face is the most human the traveller has ever set his eyes on during his lengthy peregrination. Set up high, he lets his head drop and offers up his face. And from each of a half-dozen vantage points you can see a half-dozen different expressions, regardless of whether you do so gradually or brusquely and suddenly. All in all, if the viewer makes his way around slowly, taking up one position after the next without pausing for too long, following a geometric polygon, he'll be able to see how the face becomes successively young, mature and aged, as though every aspect of him is reaching to achieve serenity, were such a thing possible. Who is this Christ whom no-one talks about? The guide tells us he seems to have been made in Burgos, by Arab converts to Christianity: this could explain the anatomy of someone of a

different race, and exotic face. If the sculptor were *mudéjar,* he had evidently preferred to model Christ on his own body, rather than go out and look for models from another culture, which could only painfully be assimilated. This image of Christ, in the traveller's eyes, expresses this anguish.

Next to the museum stands the Cathedral or the church of St Dominic. In front of it is a crucifix, a worm-eaten piece from the Manueline Gothic period, with the sections of the cross screwed inwards, neatly held in place where they're run through by the cruel nails, either a solution the sculptor discovered to disguise his laziness, or else an indication of his supreme artfulness to prevent the feet from protruding in relation to the vertical plane of the hanging body. The church is a must, there's no lack of reasons for doing so, but the traveller has come in search of daintier dishes, and looks around distractedly, only paying attention to the limestone retablos. From there he went on to the Misericordia, where a magnificent *"Ecce Homo"* can hardly be viewed through the reflections of the glass case enclosing it. The visitor has become such a museum *habitué,* so used to clearly displayed images that he wishes that "Behold the Man" were rather less difficult to behold.

While the traveller's busy working up an appetite for lunch, something surfaces out of an obscure corner of his memory. He had eaten a fish soup in Aveiro many years ago which yet remains stored in the tastebuds on his tongue and in the recesses of his nostrils. Desirous to learn whether miracles can be repeated, he goes in search of the Palhuça, as the food mansion where the apparition occurred was called. But there's no longer any Palhuça, perhaps Palhuça has gone to cook for the angels, or perhaps for the Princess, St Joana, up above the ashen skies. The traveller hangs his head in defeat, and goes elsewhere for his meal. He didn't fare badly, but neither the soup nor the traveller were the same as at the Palhuça: after all, many years had gone by.

It was evening and he was anxious to take a look at the estuary without the sunlight on it. He saw leaden waters, razed lands, everything dissolving in the air's humidity, and all in all, despite such melancholy and the dark colour of the sea beating upon the jetties at the sandbar, the traveller is contented with his lot: one day of sun, another of mist, a bit of each helps to make the man.

He descended the coast as far as Vagueira, going through Vagos en route to Vista Alegre. He has no wish to discuss the Fabric Museum, and has no more to say of it than that man's handiwork unarguably deserves a different order of art, another invention, not the repetition or recondite researching of excessive decorative forms and solutions. What proved most worth his while

was the church of Our Lady of Penha, just next door, less for its tomb of
Bishop Manuel de Moura, sculpted by Laprade, nor even for its giant Tree
of Jesse which takes up the entire roof, but for the murals in its sacristy:
Mary Magdalene bidding farewell to the vices and baubles of the world to
take refuge like a true repentant, dishevelled and ugly, in a cave that not
even an animal claimed as its own. Pachini turned her into a doll, while this
other painter showed her a like lack of respect: thus is the world.

At Home with the Marquess of Marialva

It rained overnight. Who would have thought it, only two days earlier, with the sun high in the sky, that the weather could turn so ugly. You could be forgiven for thinking that the traveller's spirits were dropping, perhaps you might want to send him home, but you'd be more than half wrong: this traveller is a man to withstand every enemy, preferring cold to heat, loathing fog only because it prevents him from seeing things. He makes his meteorological reflections on the road to Águeda whilst observing the countryside. The main road skirts the hillsides, and from their heights it's possible to look down on the flooded plains, fields of rice, orchards of luxuriant green. Perhaps the fog hovering over the tree tops emanates from the puddles' exhalations. All in all, it's a beautiful day.

The traveller went first to Trofa, a small village out of the reach of the main road running between Águeda and Albergaria-a-Velha. No-one in a hurry would be drawn to noticing the careful signpost showing the way, or, if he registered seeing it a little further on, he'd forget what he saw, unless he happened to move in the circles of paint-and-stone-lovers. Should he not as yet count himself among them, let Trofa provide the occasion of his conversion.

For there he finds the chapel of Lemos, inside the parish church dedicated to San Salvador. The traveller had scarcely entered when he felt that he was witnessing one of the greatest moments of his vocation as a roadrunner. It's not a question of the monumental nature of the church, or an unusually impressive conjunction of space and material. Rather, it has to do with a row of graves overhung by four arches, this and nothing else. The traveller corrects himself: all of this. Here lies the knightly Diogo de Lemos, who first built the pantheon. No-one knows the sculptor of his recumbent form. Some say it was Hodart, while others deny or doubt it. The sculpture could not be made more beautiful by our knowing whose hand held the chisel, but the traveller would have been pleased to discover his initials carved on its flat, foreshortened surface – just some written record of his name, however adulterated in its Portuguese version, like Hodart becoming Odarte. The

traveller knows he has to leave, but goes on his way with this query in mind, while also taking along a useless certainty to keep it company: how strange for the sculptor to leave behind nothing but a tomb for Diogo de Lemos, a work which by definition doesn't belong to him.

The traveller retraces his steps to Águeda and visits Santa Eulalia, high above the congestion of the city centre. You reach it via steep and narrow streets, and if the church interior has no masterpieces in store, we must at least note the presence of Coimbra's Renaissance School in the Chapel of the Sacrament with its magnificent altarpiece. There is also a rather later "Deposition from the Cross", conventional but sufficiently dramatic for the traveller to be moved, evoking his knowledge based on past experience, of the unrelieved anguish of those who mourn their dear departed, so much less than He who, weeping or not, Himself went and died.

The traveller's not having the best of days. He wishes that the culture which formed him, above all its art, at least in its most refined forms of expression, were created in the breast of a religious institution. But religion preaches more about its concerns for eternal life than of the joys of this transient existence, which has its own right to be full and happy. The Catholic religion desires that mortification, fasts, and hair shirts be the order of the day, an attitude which, if attenuated today, still continues offering but feeble resistance to temptation. Catholicism is a joyless thing, the only jubilations permitted being either celestial and contemplative or mystical and ecstatic. The traveller is in search of a human art, its desire to triumph over death expressed in elevated or suspended stone, in traces of colour and design, and finds them in churches, in what little remains of the monasteries, and in the museums which ultimately find themselves nourished by either. He looks for art wherever he finds it, examining the churches and chapels, approaching their sepulchres, and everywhere arrives at the same questions: what is this? who made it? what did he intend? what fear or courage did he demonstrate? what dream was here postponed, to be realised another day? And were someone to insinuate to the traveller that he might have selected another venue for such happy philosophisings, he'd reply that all venues are equally suitable and that the church dedicated to Santa Eulalia, in the selfsame Águeda which in earlier and better times was called Ágata, has the same beneficent effect as the Queimada dolmen or Lindoso's raised granaries.

In this state of mind it's possible to comprehend why the traveller prefers to seek out small and quiet places where he can listen to the sound of his own questions, even though he may get no answer. He'll cross Oliveira do Bairro, but will go first to Oiã, across the River Certima. The church is very

new, only some eighty years having elapsed since its consecration and the commencement of its active life, but whoever built it had an undeniably sound head on his shoulders, and a sensitive heart in his body. Inside it are housed various magnificent altarpieces of worked gold from the Convent of Santa Ana at Coimbra, from where the pews also came, but what most impressed the traveller was the collection of these seventeenth-century paintings which enrich and distinguish the church. It contains a half-dozen excellent altarpieces, with an observable unity of style and manufacture, clearly all by the same hand, a none-too-skilled hand too, as witnessed by the repetitiousness of their features. But the sincerity of these little pictures, the pleasure to be divined in their execution, warm the cockles of the traveller's soul, and are translated into a smile in front of a St Sebastian with blond hair and beard, who obviously cannot believe whatever's happening to him. Had the traveller time and minimal competence, he'd conduct a study of all the Sebastians who swamp Portugal, the tough guys and those with effeminate gestures alike. The conclusions would no doubt be interesting. The traveller leaves asking his buttons if more of the arts couldn't be collected in albums, on ordinary postcards, those small popular pleasures, veritable lessons in taste and aesthetics. No, his buttons reply, and that was the traveller's last hope gone, since he wasn't hanging around for answers from the other side.

He didn't stop in Mamarrosa. He gave its outside aspect his approval, and if he's not dreaming, if he were really there and nowhere else, he went to visit the minute cemetery alongside the church, so minute that only a single conclusion can be deduced, that few people in Mamarrosa actually die. Still heading southwards, the traveller goes on through Samel, Campanas, Pocariça. The region has no surprises: called Bairrada, it's peaceful and has little variation. Today is a day without surprises.

In fact there are two, right there in Cantanhede. Taking them chronologically, the first is the parish church. It's on a large main square, and pleasant to look at from the outside, but then the traveller vacillates, wondering whether he should prioritise the exigencies of the spirit or the alarm calls of his stomach but, since he's now so near, he goes inside. He remembers having read in Fernão Lopes that it was here in Cantanhede that King Pedro the Cruel pronounced himself married to Inês de Castro. Those were times in which it sufficed for the king to say that he was married for the scribe to immediately produce a certificate. Were such a thing to happen nowadays, witnesses would at once be summoned, along with sealed papers and identity cards; the civil registry would be onto the case;

and the king would have to remarry according to *their* protocol.

Jean de Rouen came to this church, one of those sixteenth-century miracles which occurred in Portugal in the shape of a sculptor. The others were Nicolas de Chanterenne and our friend Hodart. They all came from their native France to ruffle the persistent ossification of the Romanesque, a Gothic rigidity which leads the traveller to consider that no harm could possibly have been done to us in receiving guests of such calibre. Many came, and none more productive than Nasoni, along with an abundance of others who were simply the instruments of poor art. The Chapel of the Sacrament, with its tombs of some members of the Meneses family, is a precious place, designed more like a painting than a three-dimensional arrangement. The traveller is driven to explain himself better: the chapel is architecture, the images are sculpture, but it all engenders a painterly impression, and the traveller has the sensation of being inside a picture. Other Renaissance altarpieces are in the Chapel of Mercy and as a final point, although one without great importance, the arcades dividing the lateral naves from the central body of the church are admirably cast.

But the traveller made mention of two surprises and this is but the first. Let us move on to the second. Outside it's raining, something it's been threatening to do all morning, so obviously this comes as no surprise. Catching sight of a well-endowed passer-by the traveller asked the best place for a poor soul to nourish his body. The answer didn't come in circumlocutions, but the respondent looked him up and down before informing him: "Go to the Marquess of Marialva." That Cantanhede could boast its very own Marquess of Marialva was something the traveller would only come to understand later. Nowadays people merely accumulate fortunes, in earlier times they accumulated fortunes and titles. This Marquess of Marialva, sixth in the line of succession, was simultaneously the eighth Count of Cantanhede. The traveller had no desire to go into biographical details, since what mattered most at that particular point in time was for him to quell his stomach. So he set off for the Marquess of Marialva. There he'll remain seated next to a window watching the falling rain, until the arrival of an oven-baked cod which still lingers in his memory, a wine of strong character, and some little cream tarts served in their natural burnt little tin cups washed down by spirits in an ice-encrusted bottle, and an aristocratic coffee. The traveller is so well satisfied that he would like to congratulate the restaurant owner under the honorary title of Marquess of Marialva or Count of Cantanhede. And these are not merely the effusions of wine and liqueur but of natural gratitude. The traveller settled his bill, and left with the feeling that he was still in their debt.

It's another sixteen kilometres from Cantanhede to Mira as the crow flies. The traveller is once more seeking out the sea to discover whether the famous *palheiros*[10] still exist, or whether they persist only in the memories of the old folk still living down there. Naturally anyone would say that it's a long way to go in pursuit of such a small item, but the traveller is orientated by his own compass, and doesn't do too badly by it either.

As you enter Palheiros de Mira the village looks just like any other along the sea coast: wide streets, low houses, a little piece of coastline perpendicular to the sea walk, as though a dyke had been erected along the line of the beach. But let's not get complicated: it's nothing more than the natural line of a primitive dune that once defended the population and their fields. The sky is now clear of heavy clouds and at times there are even glimpses of a watery sun. The traveller doesn't see the *palheiros* which give the village its name, and is feeling severely frustrated, but he approaches to ask an ancient man who's absorbed in gazing out to sea: "Please can you tell me where the *palheiros* are?" The old man smiles, he must be confusing this traveller with all the others who come and ask the same question, and politely replies: "They don't exist any more. Nowadays there are only ordinary houses. There are only two or three left over there." The traveller thanks him, and sets off in the direction indicated. There the *palheiros* survive, huge barracks made of wooden slats blackened by the wind and the sea, a few already stripped bare to the workings of their construction, the inner skin and supporting beams exposed to the gaze. A few are still inhabited, others have lost their roofs to the wind. It won't be long before nothing will remain beyond a photographic record. But were his eyes not otherwise distracted, the passer-by would have spotted a relationship between these houses and those being built today, in the verandah roofs and in the dark tones of weathered wood. The traveller has no idea who the architect is, and doesn't enter the houses to see if their inner matches their outer aspect, but he accords them his praise. It's not every day you meet people who so well understand the use of space, colour and ambience, the relationship between this and the whole. The use of support pillars from the *palheiros* has been transferred to new materials, employed today according to the criteria of older times.

The traveller returned to Mira where he didn't stop, but instead crossed the River Corujeira flowing to Barrinha and when he reached Tocha, he found a wide, pale rainbow shimmering in the atmosphere, giving him to understand he must go and see the famous little temple which serves as the Lady Chapel in the parish church. It was built by a Spaniard who

28 *Palheiros de Mira, a house on stilts*

29 *Palheiros beach*

dedicated it to his compatriot, Our Lady of Atocha, if she would only cure him. The Spaniard recovered, fulfilled his promise, and Atocha became Tocha, as it's easier to say. The circular temple is odd, as artificial as one of those buildings in a Rococo-style garden but, for all its columns, the cupola and lintels, and beams which look as if they have nothing to support, it has an ambience all its own straight out of an opera set. And its eighteenth-century tiles are not without interest. By the time the traveller departed, the rainbow had vanished: it must have hidden itself in order not to have to deliver on its promises.

The day was ending when the traveller reached the Buarcos highlands. It seems something of an exaggeration to describe them thus, since there's only a hill two hundred metres high, but as it rapidly rises from sea level it gains in both stature and grandeur. So let's admit it, it's a beautiful walk. The main road continues twisting on to the Serra da Boa Viagem, then descends, revealing the grand panoramas of the plains foreshortened by the setting sun. The day is drawing to a pleasant close.

The traveller is to sleep in Figueira da Foz and when he decides to visit its museum the following morning, he finds its doors barred: there's a power cut, and the supply is taking a while to restore. And since his petrol tank was also empty, he'd still be in Figueira da Foz today had the garage attendant not employed the strength of his arm to practise the virtue of mercy and afford drink to the needy.

10. Little wooden houses on stilts.

Not Every Ruin is a Roman Ruin

If there's one thing the traveller values it's knowing the meaning of names, not that this necessarily means going along with every line he's spun. Like the one about Maiorca, a name supposedly derived from a dispute between local inhabitants (who at the time either came from somewhere nameless, or a place everyone has forgotten about) and those of Montemor-o-Velho, a little further on. They claim the residents of Montemor, to irritate the rest and draw attention to the superior height of their lands, threw down the challenge, repeating: "Monte mor. Monte mor," [the higher mountain] so those from Maiorca, lacking arguments of greater weight, answered back: "Maior cá. Maior cá," [higher still here]. On balance it's a simple matter: remove any accent, slur the words, and there you have Maiorca established for evermore. The traveller quite rightly doesn't credit a word of it.

In any case, he has no wish to stoke the flames. Before going to Montemor-o-Velho he has to cross the Mondego and behave like someone who knows nothing of the imaginary quarrel. He looks, or rather stops looking, to other imaginings since the only thing he wants is to see Ereira with his own eyes, the place where Afonso Duarte, among the greatest of Portuguese poets this century – nowadays so incomprehensibly forgotten – was born and lived. Ereira is a place so close to water that, what with the Mondego flooding, and the River Arunca passing so near by, it regularly reaches the houses, as familiarly as old friends greeting one another. It must have been on a day like this that Afonso Duarte wrote:

> There's nothing but sea in my country.
> No land to offer bread:
> Hunger is killing me
> With the sweet illusion
> Of fruits like the sun.

The traveller was also born in puddly lowlands, he knows what floods are but still, when he rereads Afonso Duarte, he takes seriously his references to the rising waters in four measured lines:

Things go ill for the lyric poet
Things go ill if I pontificate
But where there are rich and poor
Problems beset the land.

Farewell Ereira. Until forever, Afonso Duarte.

The traveller has no particular reason to go to Soure, but from here it's an easy ride to Conímbriga. Today seems to be consecrated to illustrious ruins, for example those left behind by the Romans. According to popular tradition, there are three main historical reference points: the periods of the Afonsinos, the Moors and the Romans. The first serve to illustrate, paradoxically, what's most ancient of all, or perhaps most imprecise and almost mythical; the second (despite the lack of abundant material evidence) is a rich source for legend; and the third, which offered no legends of any kind, finds confirmation in a solid bridge, flagged pavements, and instils respect for the harsh laws stamped on them by the march of legionaries. The Romans find little sympathy from those on whom they bestowed their Latin language.

To tell the truth, when the traveller wanders amid such magnificence – and here it's easy to tell what magnificence is – he feels somewhat apart, as if he were seeing, caressing almost, the remains of an utterly alien civilisation and culture. It's conceivable that this impression derives from visualising the Romans installed here, entirely lords of their forum, of their water fountains, parading in their togas and tunics, visiting the baths before wandering into the surrounding hills, today covered in olive groves, apparently an ingenious and domineering people, suffering certain hunger and acid jealousy. Viewed thus, Conímbriga must have been an islet of advanced civilisation surrounded by a sea of drowning people. Possibly the traveller may be committing a grave injury to the person whom this same civilisation finished by rooting here, but this is the only explanation to be found for the sense of unease that always overwhelms him when confronted by Rome and all its works, and inexorably returns to prey upon him here in Conímbriga. It has to be said that, come what may, Conímbriga's ruins have a subtle monumentality which gradually impresses itself upon our consciousness, not even the bulky mass of the city walls can disturb the particular ambience of the place. In fact, ruins have a whole aesthetic of their own. Intact, Conímbriga would be beautiful. Reduced to what we see of her today, this beauty has adapted itself to necessity. The traveller doesn't believe that anything better could have

30 *Conímbriga, Roman baths*

happened to these stones, to these wonderful mosaics, than that they should intermittently still be covered and so conserved by the sand.

He took several slow turns about the place, listened carefully to the guide's lectures then, once alone, unexpectedly came across three human skeletons under a pane of glass, Roman remains gazing up at our Portuguese sky, foggy at this hour of the day, from the bottom of their pit. The traveller hesitates whether or not to persist in cultivating his dislikes: at the end of the day, Conímbriga was invaded, sacked and partly destroyed by the Swabians, a people who, in the last analysis, were either drowning in the sea of which mention was earlier made, or else were coming down here to drown others with their bare hands. Life is profoundly complicated, a thought given little polish and still less originality, so the traveller decides to set aside resentments of which he's scarcely aware, and surrender to a justified sense of piety towards his poor bones, fed and formed by the fruits of his native Portuguese soil and to which he'll pay his dues by returning.

So now let's move on to Montemor-o-Velho. You can see the castle from a long way away, it crowns the whole elevation on which it was raised and gives the strong impression of a military machine, as much for its position above the land as for the quantity of the square and cylindrical towers reinforcing its walls. The traveller has no desire to dream up castles in Spain since he already has them in Portugal, and this one will always stand out among the large number already populating his memory. All in all it's quite possible that the traveller, to whom a taste in literature is hardly alien, is allowing himself to be influenced by factors which have nothing whatever to do with the castle, for example the fact that our good city of Montemor-o-Velho was the birthplace of Fernão Mendes Pinto,[11] and of Jorge de Montemor, author of *Diana*. The traveller's well aware of his own position in this line as the third of three writers, right at the end, but by allowing his imagination free rein, he finds himself delighting in the idea that each in turn entered through that very same door in Santa María de Alcáçova for his baptism: the *picaro* Fernão, the amorous Jorge and now the traveller, on shanks's pony, with more salt in his saliva than was conducive to his salvation, but as inquisitive as Fernão, as sensitive as Jorge. But let's leave this fantasy be and get back to our buildings and paintings. Santa María de Alcáçova has three naves, but the arches are so wide and the pillars so slender that it has more the air of a drawing room, decorated with false beams. It contains a Renaissance altarscreen, presumed to be from the work-shop of Jean de Rouen, a furnisher of fine pieces of furniture which exhaust every style, including Santa Luzia and Santa Apolónia, and a Gothic "Virgem

31 *Conímbriga , Roman mosaic*

da Expectação" by Master Pero, resting her left hand on her swelling belly. It's a beautiful and unforgettable image.

The traveller went out onto the terrace and, judging from the height of the sun, (being in a mediaeval castle, this appears the best timepiece to rely on), he observes that it must now be about time to eat. In any case, this is what his stomach has already been telling him for some time. So he went into the town and stopped as close as possible to the Igreja da Misericordia, right on the waterside. Its proximity would be the more laudable but for the fact that, at high tide, the river does actually come into the church. The traveller has no idea what happens on such occasions, or whether the saints are obliged to lift the hems of their garments in order not to get wet, but what he does know is that in writing these words, which seem almost disrespectful, he is disguising his indignation at what he feels to be a lack of respect due to precious works of art, condemned to death by indifference and neglect. The traveller is bound to admit that he's not going on about ecclesiastical images out of a desire to fall and pray at their feet, but because he wishes to see them protected as works of art produced by man's genius. When, over the main door, he spies Our Lady of Mercy garlanded with parasitic weeds

whose roots eat away at the stone joints, and gazes upon and is moved by the sight, he also employs a form of prayer: love lost in admiration.

Nonetheless, likes and dislikes do not start and end with Montemor-o-Velho. He continues on from there to the Convent of Our Lady of the Angels, sees that the door there is closed, but isn't too concerned because a good neighbour advises him that the key's in the charge of another good neighbour, a little further on. The traveller has grown accustomed to hammering on the doors of local residents, feeling increasingly like a mendicant who takes pride in his office. It requires patience to wait a little whilst the key lady finishes her meal. Had he not by now eaten, he could have invited himself in, since the smell coming from inside the house could have raised the entire valley of Josafat. The traveller descended the street, sat down on the little dividing wall beside the atrium, and waited. The key lady didn't take long to arrive, still chewing on her last mouthful and with the creaking common to obstinate locks the door opened.

The traveller at once comprehended that he was in a place of profound reverence. Portugal contains many things of beauty, and if you can't conclude as much from this account, the fault must lie in a failure of communication, but the Convent of Our Lady of the Angels needs no greater praise than the sudden intake of breath which hits us as we enter. Its inhalation derives from two causes: firstly from the ineffable loveliness gathered and harmoniously joined in this place; and secondly from the ruined condition in which it is to be found, cracked and stained with damp, and with green slime invading everything. The traveller is distressed, asking himself how things could have come to such a pass, then asks the key lady the same question since she both loves her convent and finds it in this state of abandon, but as she has no answers, the two of them are left staring at the ceiling, the walls, not to mention the cloisters, which are falling to bits. The traveller makes an effort not to see the bruises and blemishes, and the beauty of the church is such that he succeeds.

In Portugal there's a lot of talk of the Romanesque, Manueline and Baroque styles. We discuss the Renaissance less. Perhaps this is because it all arrived from abroad, perhaps because it had no national development on our soil. Such subtleties are of little interest in Montemor-o-Velho: what we have before us, here in the Chapel of the Deposition, there in that of the Annunciation, are Renaissance masterpieces which would be hailed as such in Italy, birthplace of the Renaissance. And talking of Italy, the traveller thinks ironically of how, had the Italians a church like this they'd guard it like gold, maintain it in tip-top condition, while the Portuguese would travel to

it from far and near, lamenting that something so rare should belong to a foreign country.

This tomb belongs to Diogo de Azambuja. That's his surname, yet he was born in Montemor-o-Velho. A young man is depicted upon its sepulchral arch, his head supported by two intricately-embroidered pillows, but the stone slab covers an eighty-six-year-old man, that being the number of years Diogo de Azambuja had to his name when he died. This old man chose the image to accompany him for all eternity, and had the luck to find the sculptor to invent it for him: Diogo Pires, o Moço (the Youth). There too green lichen has insinuated itself, but at least it helps to accentuate its volume, enliven cavities and design curves. The prone statue of Diogo de Azambuja is full of life. It deserves to be.

The traveller has no desire to leave. He chats to the key lady since they are now old friends. But there's nothing to be done, he has so far still to go. He visits the upper part of the convent, surveys the frescoes on the walls of the church's high choir stalls, ingenuously and delicately painted as they are, a stunning "Birth of the Virgin" surrounded by flowers and sparrows, and sorrowfully returns to the high road until he can come back another day. Conímbriga is luckier: it's a Roman ruin. This is a Portuguese ruin, and nobody visits it: a ruin is clearly as noted as a prophet in his own country. It's true that sometimes we rush and attempt to set a disaster to rights, but always when it's too late. Try telling it, for example, to that Dona Margarida de Melo e Pina, also there in the church, who died in the Inquisition's jails following seventeen years' unbroken imprisonment. She was innocent.

There's no way of getting lost going to Tentúgal. All you have to do is go straight ahead towards Coimbra. The road goes round a bend and there you are. In Portugal there's no lack of communities that seem to have been left behind by time, helping the years pass without moving a stone from here to there and despite it all, we sense they have a warm inner life, you can hear their hearts beating. Either the traveller has committed a grave injustice, or that's what's going on in Tentúgal. The streets are full of people; cars pass; even a noisy tractor on tow; and the shops are open. Yet the impression given by Tentúgal is that of a town which has refused to collude in the decline into which it's fallen after a past filled with noble splendour, retaining a sort of fallen aristocratic reluctance to accept new times and values. Tentúgal shut its doors and windows, arming itself with ancient disdain, and left the streets and squares for intruders and ghosts to inhabit. From this derives the fact that its urban atmosphere is much more intriguing than the contents

of its sacred places, not that these are wholly devoid of interest. The traveller vows to come back here one of these days to further the examination of its particular ambience. Also, and he's now confessing to the cardinal sin of greed, out of longing to check if the divine cakes there taste as delicious as those he ate in Torre dos Sinos, propped up against a wall and using his left hand as a plate in order not to risk losing a crumb.

Coimbra is close at hand, he can already smell the city air, but first he has to go to San Silvestre and San Marcos: they are anyway on the road and are well worth a stop. The parish church of San Silvestre contains many highly valuable images, and the traveller's prayers are that they may long remain so. San Marcos' convent is planted in a spacious plot of ground with huge trees at the edges, the key kept in a pleasant house on its left. The traveller was ill at ease in Montemor-o-Velho, when he was chatting with the woman still chewing over her last mouthful as she brought him the key to the Convent of Our Lady of the Angels. In San Marcos it's a surly youth who appears, hardly bothering to reply to the traveller's polite "good afternoon", and as soon as he's opened the door he clears off and doesn't return. Patience. Contrary to the experience at Our Lady of the Angels, San Marcos is clean and polished but – that's just the way things are – the traveller encounters in himself a certain nostalgia for abandoned ruins and observes that its immaculate order is uncongenial to him. The traveller is unfair and inconsequential. San Marcos is very lovely. It has magnificent tombs, in such great quantity they resemble a pantheon. It scarcely resembles a funerary shrine, and its most precious jewel is undoubtedly the altarscreen in its main chapel: the work of that prodigious sculptor Nicolas de Chanterenne. In any case, the traveller would like to know to whom it owes the delicate polychrome figurines populating its niches and corners: it's as though Chanterenne left an entire thing of beauty here, and the painter added exactly what was needed, arithmetic which might appear erroneous, but the traveller is convinced that it's comprehensible.

At last it seems as if the day is over. Yet the traveller still continues on to Ançã, the place which gave its name to the soft stone it bestowed on its sculptors. If now the quarries are exhausted, it's not something he'd be aware of, riveted as he is, going on his way to the sound of a small guitar, drums and bagpipes. A heavy mist is drawing in when he goes to visit the parish church which is dark, well positioned and with more than enough assets to display. The view of the church forecourt opens out onto the River Ançã flowing below. The traveller stares at the cobbled street running beside the church: it is paved with stone fragments carved with letters, remains of

gravestones. One could say that here only the stones benefited from the dead.

So now the traveller goes on his way to Coimbra. The weather has turned nasty. He hopes it's not about to rain.

11. Fernão Mendes Pinto (1509–1583). He wrote *Peregrinação*, among the most astounding travel books in world literature. He was the first European to visit Japan and visited nearly all of the Far East. He left us accounts of his journeys, adventures and predictions, laced with the picaresque style of the Castilian Baroque.

4

Coimbra Climbs, Coimbra Falls

It rained. As evening fell the skies opened and rain fell in torrents. But your traveller isn't the sort to be discouraged by the first downpour, nor the second or third, along the way. He retains a hardy rural resistance from the time of his childhood and adolescence when, amazingly, he didn't differentiate between rain and sun, neither from moonlight, nor any from a flight of kites. After all it's true that the morning can still sweep across wide bands of blue sky, and bathed in this light the traveller climbed the Couraça de Lisboa, a thorny wayside by which many lost aspirations for degrees and doctorates have fallen. To the traveller it's not a route to be regularly recommended, least of all to anyone heavy on their legs or short of breath, yet he, while it might not suit his heart condition, always feels himself obliged to find new paths off the beaten track, ones with minimum traffic and maximum life. The Couraça de Lisboa doesn't have fine monuments to offer. It is simply, as we said, a steep path, well situated for a view of Coimbra, that provincial town with two hats to wear: one of them its own, and the other on top, filled with knowledge and some immaterial prodigies. Had the traveller time, he'd seek out the plain, ordinary Coimbra, ignoring the university at its summit, and visit the houses along the Couraça de Lisboa, potter along the little streets leading to them and, by talking with the people, overcome the unthinking defensiveness of those who assume a mask over their normal features.

But the traveller hasn't come here to join in such risky posturings. He's merely a traveller, a man passing through, a man who, in passing, looks and in that rapid passing and looking which cannot but be superficial, is bound to find among his memories signs of currents beneath the surface. These may also be risky, but err more on the side of intuition. This is Coimbra University from which Portugal has derived much of benefit, but equally where something unpleasant is going on. The traveller isn't going to go inside, he'll remain in ignorance of what the Sala dos Actos Grandes looks like, or the interior of the Capela de San Miguel. Sometimes the traveller is a timid man. Seeing himself there, in the Patio das Escolas, surrounded on all sides by Sciences, he doesn't dare go and knock on doors, begging for a syllogism

as for alms, or for a safe conduct to the Registry. Such cowardice confirms his deep conviction that the university is not synonymous with Coimbra, and so he confines himself to a turn about the Patio das Escolas, with little appetite for the statues of Justice and Fortitude which Laprade mounted in the Via Latina, somewhat greater satisfaction as he stands before the Manueline entrance to the Capela de San Miguel; and, having entered through the Porta Ferrea, he decides to leave by the same door. He departs routed, vanquished, disappointed in himself for having dared so little, a traveller who'd walked over mountains and valleys, yet here, in this seat of wisdom, he circles the outside walls as if hiding from wolves. He's in this state of despair when he sees some students, a lad and a couple of girls, showering loud and colourful language on a fourth, who leaves with arm raised and fist clenched. And the young paladin, accompanied by his ladies, and from a safe distance, yells his intention of doing something to the other fellow, something the traveller's chaste ears refused to retain. Hardly a pretty interlude, but true. As ever, the traveller, who has arrived so disenchanted, discovers greater pleasure in his own company.

The Casa dos Melos lies far down the hill. It's a privileged sixteenth-century building, better suited to being a fortress than a Faculty of Pharmacy, where today students are being taught simple and compound chemistry. The traveller is none too sure of the scientific rigour of these words so, lest he

32 *Coimbra university*

be approached to provide an account of them, he sets off again towards the
New Cathedral.

As a single finger gives a giant away, so a façade betrays the Jesuits. Great
cultivator of the scholastic, supreme definer of what's *distinguished*, the
Jesuits brought to architecture their particular form of intellectual rational-
ism, dominating more fanciful cults by interweaving themselves into their
convolutions. The façade of the New Cathedral is like a theatrical backdrop,
not because of exuberant scenarios, which in fact it lacks, but for the opposite
reason: its neutrality and sense of distance. You could put on a Greek tragedy
or a cloak-and-dagger play in front of a façade like this. It could adapt to
anything, this Jesuit style defined by an impersonal elegance. Such matters,
although they do not feature in the traveller's dreams, can be found upon
the church's façade and interior. If we return to the façade we'll soon see
how everything else is kept in the same spirit, including the belltowers; these
are somewhat set back, but draw the perspective towards themselves. Built
at a later epoch, the towers prove the traveller right.

The New Cathedral offers no dearth of points of interest. With its high
altar of gold filigree and branching columns it is monumentally opulent. In
addition, all the chapels are well served with altarscreens, the most outstand-
ing of which is one dedicated to St Thomas of Vila-Nova, an exceptional piece
of work. The church is not especially rich in fine paintings, any more than
are a great many Portuguese churches. Maybe the traveller was really observ-
ing his own preference for a bit of warmth in those cold walls, the nakedness
of the pillars or the emptiness of its spaces. Its marble was worked to be
merely marble. In the traveller's opinion, few stones have less to recommend
them, although he'll be called a barbarian for suggesting it. Fundamentally
the traveller goes for the Romanesque, which turns stone of whatever kind
to art – rudimentary maybe, but never niggardly.

Perhaps due to the chastisement of heaven or the heresies he'd been
contemplating, the traveller, on his way to the Machado de Castro Museum,
is caught in the first downpour. Just as well it isn't far. He goes inside, shakes
himself off, and reciprocates the broad smiles of the staff, happy to see him
arrive. Not that he knows them, but they're people who enjoy showing off
the valuables they're providing a home to and the traveller is their only guest,
at least for the duration of his visit. It's true we're still in January, a long
way from the high tourist season, but it's a shame to meet guides with no-one
to guide, or works of art without eyes to value them. The traveller decides
to be selfish: "So much the better, all for my eyes alone." Truly, a gift for his
eyes to feast on. The Machado de Castro Museum has the richest collection

of mediaeval statuary in all Portugal, going by what's on public display. Meaning that statues, according to the degree of proximity permitted by museum displays, end up losing their individuality and forming a kind of huge gallery of characters with blurred features. Of course this is an exaggeration, but the traveller wanted to see each single piece on its own, with space all around it, in order that his eyes, engaged in studying an angel, wouldn't become captivated by a saint. These are matters of detail that only create discomfort when confronted by a treasure of immeasurable artistic value. It's not a matter of multiplying the value of the works, but of the pleasures of looking to his heart's content.

What has the traveller to say of what he's seen? To which sculpture, or image, which piece, could he award pride of place? He could hazard a half-dozen, offending any left off the list. What of this fifteenth-century statue of a prostrate Christ, mysteriously smiling, apparently certain that he will rise from the dead. The traveller is not about to start discussing the Resurrection, as he prefers to see the expression of fallen men who are about to get up, smiling in the conviction that they will rise, than those who come after them, and cannot do so. He prefers to see the permanence of hope etched here, lips parted in a living smile, and it's appropriate that he now remembers the boat he saw in Vila do Conde with just the same name. It's the "Senhora do O", fourteenth-century, from the hand of the Portuguese genius known as Master Pero, who inspires the traveller with the desire to write his biography. This *Senhora* is in an advanced state of pregnancy, divining the pulse of the new human being within her with the shell she holds in her hand while, her head gently inclined, she gazes out at us stony-eyed. There too is the angel who came from Porto Cathedral, heavy and Romanesque, and the "Black Christ", which the traveller obviously admires, but which he refuses to place ahead of the crucified man in Aveiro Museum. And, moving on from one century to the next, there are also the redoubtable "Apostles" by Hodart, another modeller of men who created the companions who attended the Last Supper, bringing with them, in the very clay of which they're made, an ardent mass of human emotion: rage, just anger, ire. These apostles are combatants, guerrilla fighters who have come to seat themselves at the plotters' table and, at the moment when Hodart appeared, had reached the most animated pitch of their discussion as to whether they were about to save the world or to wait for it to achieve its own salvation. They were at that precise point, and haven't reached a decision yet.

Since Coimbra had been the hub from which the Portuguese Renaissance radiated, it is hardly surprising its initiators are represented here, Nicolas

de Chanterenne and Jean de Rouen, whom the traveller had already
encountered on other occasions along his itinerary. Go and see the spectac-
ular – the traveller dislikes this word, but cannot find a better alternative –
Treasury Chapel by Jean de Rouen, and de Chanterenne's "Virgin of the
Annunciation", among the loveliest sculptures ever seen. The traveller still
hasn't reached the end and, as regards paintings, would only mention the
Master of Sardoal and a few of the Flemish School, not many more, since
the museum's strength doesn't lie in its paintings. Precious metals and orna-
ments are always magnets attracting attention, which goes on to focus upon
the ceramics, a pleasure to the eyes.

Now he's about to descend to the depths. He abandons the upper areas
where, to cap it all, it's again raining, and follows his guide (who's no Virgil,
even though the traveller's no Dante either) through galleries scantily lit from
the crypt doorway. The traveller, occasionally wearying of marble, as he's
already demonstrated candour in admitting, now stumbles across a rough and
crudely chiselled stone. He runs his hands over it with sensual pleasure,
feeling its rugged grain with his fingertips, and it takes no more to make this
traveller happy. The succession of arches is like an infinite reflection, and the
atmosphere becomes so dense and mysterious that the traveller wouldn't be
surprised to see his own self emerge at the far end. Fortunately this isn't what
happened. The guard would have been worried had he heard the traveller
talking to himself, even if he were doing no more than deploring Agrippina's
wounded lip. The traveller has come all the way down when he has to
climb up again, and when the street begins to descend once more to the Old
Cathedral so does the rain; it overflows the gutters and, as one idea follows
another, the traveller remembers how the waters of Minho ran down the
hard shoulders beside the street, how small the world is, all its memories
jumbled together in the minimal space inside the traveller's head. Suddenly
the rain stops. The traveller can furl his umbrella before going into the Old
Cathedral, perturbed at the sight of two men undertaking a dangerous repair,
tilted at the top of some high ladders leaning against the church walls, pulling
out the weeds growing in the cracks between the stones. Since the street
itself was so steep, the ladder was propped up to maintain its verticality, and
the prop consisted in some small, unstable pebbles. In the end, there was
no disaster, but a common-or-garden ladder had given sterling service.

Assuming the traveller enjoys the Romanesque as much as he says he does,
he can find more than enough satisfaction in the Old Cathedral since, by
general consensus, this is the loveliest building in that style in all Portugal.
So it is. The traveller is brought up short by the strength and robustness of

its basic components and the beauty of elements added over succeeding centuries, like the Porta Especiosa, while, on entering, he was struck by the solid enormity of its pillars, the vaulting of the high dome over its central nave. He recognises he is within a logical, complete construction, without a blemish on its essential geometry. Beauty has found its home. The traveller persists in his weaknesses and has the courage to own up to them: without in any way detracting from what the Old Cathedral of Coimbra is and has, he knows himself to be most profoundly moved when among the little rustic Romanesque churches of the North, at times almost stripped bare, eaten away on all sides, outdoors and in, often as worn as a rounded boulder, but always so near and dear to his heart he can feel the stone beating. Here in the Old Cathedral of Coimbra the architect introduced an element which is logically missing from those poor churches and to which the traveller is deeply sensitive: the triforium, a gallery on reinforced columns running above the lateral naves and among the loveliest inventions of the Romanesque style. And it's the triforium which redresses the balance and sends the traveller forth on the path of righteousness that the Old Cathedral is owed. He leaves remembering that here, on this flight of steps and on hot summer nights, there's a tradition of singing *fado*. Rightly so. But it's not a bad place either for listening to Johann Sebastian Bach. For example.

It's lunch-time, and it could be a comforting experience. The traveller has no reason to complain. He went to Nicola's, and was waited on by one of those rare waiters who respect their profession and ensure its respect through every gesture, word and a sense of dignity. All this accompanied a tender and succulent beefsteak, and all combined to afford the traveller a meal fit for a king. That accomplished, he went to Santa Cruz. It was raining as if by divine rule, but today the divinity shouldn't have ruled for so much rain. A few locals were sheltering beneath the triumphal arch, among them two market women holding a conversation that would have been thought loose whatever the circumstances. The traveller doesn't count himself among those who believe that walls have ears or feelings, and took the discussion as a double and simultaneous confession, like many others that had been doubtless overheard by the side of this arch. The doorway itself was by any account a collective work: it bears the traces of the hands of Diogo de Castilho, Nicolas de Chanterenne, Jean de Rouen and Marcos Pires without even alluding to the masons who left their work unsigned. The work of constructing the tombs of Kings Afonso Henriques and Sancho I was also collective: Diogo de Castilho again and Chanterenne again, and because all was not to be revealed, a further anonymous mason who came down through

history as the Master of the Kings' Graves, an over-obvious epithet if ever there was one.

What caused the traveller the biggest shock was to find Afonso Henriques buried here, since only a few days ago he'd bade him farewell at the doorway to the Castle of Guimarães, along with his horse, the pair of them severely exhausted. He gathers his thoughts, mingling them with more serious matters, confronting first Afonso and then Sancho, the one who conquered and the other who populated, seeing them entombed beneath those magnificent Gothic arches and decides in his traveller's heart that many have here reposed and been celebrated ever since the twelfth century when they battled and laboured that Portugal be both won and lost. Were we to raise the slabs over the tombs, we'd see a veritable anthill of men and women, some of whom would be those who quarried this very stone, who transported and worked it and sat on it to have their dinner, eating what their wives prepared for them, and if the traveller doesn't insert a full stop at this point, he'll end up relating the history of Portugal.

On the left as you enter is the pulpit. Much stone and magnificent stonework by Jean de Rouen. This pulpit is so precious that from its summit the preachers didn't even have to preach: parishioners would be enlightened simply by looking at the doctors of the Church sculpted there, as secure in the mysteries of their Faith as in the secrets of Art.

The tiles covering the nave walls are equally beautiful, but our tiles can only be absorbed in homeopathic doses: if the traveller abuses this rule, he turns dizzy. Just as well that in Santa Cruz church you can go straight from the historic tiles of the nave to the floor designs in the sacristy. Here you can also find some beautiful paintings: Vasco Fernandes' "Pentecostes"; Cristovão de Figueiredo's "Crucifixion" and "Ecce Homo". The traveller leaves feeling comforted, walking the length of the pews, and decides at the end that Santa Cruz is indeed beautiful. When he leaves the women are no longer there, some other citizens are now sheltering beneath the arch, an eighteenth-century work by Brother João do Couto.

The traveller goes out in pouring rain. He goes to visit the Casa do Navio, then returns to Alta, and can't visit Coimbra without looking at the Casa de Sub-Ripas, so worm-eaten, sadly for us and for it, and the Torre de Anto, where António Nobre lived out his final and true Castilian vocation. The traveller doesn't know whether anyone lives there today. He could have checked it out, but it didn't occur to him. Once outside, he was the only living person to brave the rain falling in torrents. He turns off downhill, goes into the Jardim da Manga, which now resembles a pond, and sets off

to admire the little temple, so reminiscent of the church at Tocha.

These diversions are delaying him. The traveller reckons up swiftly and decides he'll go to Santa Clara, and, even though it's raining cats and dogs over the Mondego, that's where he goes. Below him is Choupal, where he won't be going: he feels amphibian, yet still has a degree of difficulty coping with gills.

Santa Clara-a-Velha can be seen clearly at a distance, but after a bend in the road he follows a built-up route, and the monastery vanishes. Eventually it reappears, an abandoned building, worse still, a complete ruin, and it makes his heart ache to see such a wreck beneath the heavy rains which keep on falling. Once inside there's a wrought iron staircase, it seems right to climb it, at least in order to find shelter, and when he's found it he can close his umbrella and bid good afternoon to the guard who's deaf but lip-reads or responds if you shout loudly enough and, thus sorted, the traveller surveys the wide arches, the vaults, then the sky through the cracks in the walls. Santa-Clara-a-Velha was a women's convent, and there's a particularly female atmosphere in its melancholy church, or maybe that's what the traveller thinks because that's what he knows.

The guide wants to chat. Nobody had visited the place the whole day long, so the traveller was clearly sent by Providence. The traveller falls silent. He hides behind a feigned attentiveness when, for the millionth time, he hears the story of the subterranean passages linking this convent to others and Santa Clara-a-Velha to the Jardim da Manga then, halfway along, beneath the floor, there's a room with a stone table and benches all around it, and they say the walls are covered with tiles as the guard was told by a stonemason who was busy about his work when he came across it. The mason died as the result of an accident a while back, so the guide couldn't get any further information. Apart from that, it's still raining heavily . . .

He's attempting to go, on foot, to Santa Clara. But the cascades falling from on high seem to require a salmon's flippers. The traveller's a mere human being. He crosses over the bridge, and when he looks back upriver, he considers how sheltered he would be in that subterranean room, gazing on the tiles that so delight the eye – so long as they're not there in excess – and a terrible suspicion occurs to him: in that very room, when the museum is shut for the night, Hodart's "Apostles" gather to continue their plotting. Who's to say whether the entrance to the subterranean room isn't in the little church of Jean de Rouen?

A Castle Fit for Hamlet

Fortunately the traveller's not one to catch colds. But when he awoke next day the morning was already half-gone, so perhaps he was worn out by so much climbing up and down. He took a turn around the narrow and crowded streets in the lower part of the city, made one more pilgrimage along the steep slopes of the upper city, gazed upon the Mondego and, whether he wished to or no, he departed Coimbra. Strictly speaking, leaving Coimbra when, like the traveller, you take the main road for Beira, means following the riverbank, until the said road forks either to Penacova or to Lousa. Until this point the place names are still evocative of Coimbra: like Calhabé or Carvalhosa. Seen from the north of the river it could be said that Coimbra lies between Mondego and Mondego.

The traveller travels with no clear idea as to his destination. He feels equally claimed by the Mondego riverbank as by that of the Ceira. He refrained from tossing a coin, and decided for himself: Ceira won. But men are made in such a manner as to regret being unable simultaneously to climb the steep slopes of the Lousã Serra and to skirt those of the Buçaco. In order not to travel divided between being here and there, for that's the worst division of all, he made a vow, on arriving at Penacova, to at least go down the Mondego to the Foz do Caneiro. Having thus concluded his deliberations, his doubts were allayed and he was free to pay attention to the countryside.

There's nothing to take you aback about this countryside. The skies are low, almost grazing the mountain tops that are just becoming tinged with pink one after the other, back to back, and with little serious effort or conviction. From the road the river is almost out of sight, just a glimpse of it here and there, but not enough to afford the continuous company apparently promised by the map. Fortunately it's not raining, or only intermittently, as single droplets fall without substantially adding to the quagmires left by yesterday's flood. The traveller crosses the Ceira at the Foz de Arouce, and from there it's no distance to Lousã. As his goal was the castle he didn't stop at the town, which is no sooner seen than admired, and continued on his way. It's a regret he'll need to remedy some day.

33 *Beira Baixa, donkeys*

As of now, yes ladies and gentlemen, the serra deserves its highflown name. The traveller isn't about to climb up to Santo António da Neve or to Coentral as he lacks a necessary trust in the roads, but he sees their peaks in the distance, and even here, lower down, on a track that leads only to the castle, the valleys fall abruptly away. The slopes are covered with trees, there's plenty of undergrowth, which is why, given the curtain folds multiplied by the curves, the castle suddenly emerges. The traveller had somehow managed to forget about it, then here it was.

This castle is a diminutive one and, had it been magnified, it would have been all wrong. It occupies a bump on the mountain's spine, unexpectedly the lowest in the region. Mention the word castle and you think of heights, dominating all it surveys, but here it's necessary to revise one's assumptions. No doubt he'll deem that Lousã castle is, from the standpoint of its setting in the landscape, among the most beautiful sights in Portugal. Its particular situation, in the centre of a circle of higher mountains, paradoxically renders the sensation of height all the more imposing. It is precisely the proximity of its hanging borders which affords the traveller a near-anguished impression of perilous balance as he enters the castle and approaches the tower. He had felt the same way as he reached the end of the mountain range and heard, from the valley's depths, the roaring of invisible waters from the river

far beneath, squeezed between the walls of rock. It's a windy day, the mass of surrounding branches are shaking, and the traveller is none too secure on top of the cylindrical tower which he has finally reached. He's inside it when, amid the defiant romantic crosswinds and tempests, suddenly a marvellous idea occurs to him: in this place, this familiar castle, in the centre of this circle of mountains threatening to descend on it one of these days, Hamlet lived and tormented himself, and it was here, standing on the slope descending towards the river, where he asked his unanswerable question; and if none of this really happened at the very least the traveller is convinced that there's no more suitable setting on earth for a Shakespearean drama mingling punishment, prophecies of doom and grandeur. It's a natural stage set that has no need of finishing touches, and its dramatic gloom couldn't be made any more theatrical. Built of shale, Lousã Castle had poorly resisted the alternate hammering of the sun, rain, hail, wind, or perhaps the traveller's disappointment lay in seeing it suffer extreme dilapidation in its most exposed areas, even on the restored walls. Nonetheless slate has one advantage: if one tile falls, it can easily be replaced by another.

The traveller returned to the main road, his imagination fired with grandiose projects for films and plays but, happily and swiftly, he became distracted by the tall mountain on his right, en route to Góis. It's best, he decides, to leave things as they are, set the stories aside, for the castle doesn't need a Hamlet to work its way into impressionable hearts. In any case not even Ophelia could continue placidly singing beneath the waters of her pebbled bed, poor thing.

Góis can be seen from above, but the road has so many curves that the village nearly disappears from view, and you imagine you've overshot it, since the way into it is tight, a near-complete hairpin bend at the bottom of the valley. The curve brings him back to the Ceira, a beautiful river when it comes into view, if evasive.

At Góis the traveller wants to visit the tomb of King Luís da Silveira attributed, by those in the know, to Hodart. It could be in doubt, however. If Coimbra's "Apostles" are by Hodart, and they are, his convulsed men whose arteries pulse to the form given by clay have nothing whatever, as far as the traveller can see, in common with this kneeling horseman. We know full well how substance determines form, and how the plasticity of clay gives it a more sharply-defined expressive value than can be obtained from stone, yet he admits the attribution only with substantial reservations. In spite of everything, the traveller is still inclined to acknowledge the kneeling figure as a masterpiece, however wrong its classification may be. And the arch,

clearly not by the same hand, is resplendent with magnificent Renaissance ornamentation. Góis is a remote place, but this tomb rewards the journey. Then in a side chapel the traveller discovered an unusual representation of the Holy Trinity with the Virgin, the figures arranged upon a cloud, lifted and transported through the air by angels, harnessing the tips of the divine personages' garments to tow them along, if you'll pardon such an expression. The inventor and creator of this religious image knew full well that clouds were not to be trusted, that on the merest whim they dissolve into rain, something of which the traveller has had abundant evidence and once again fleeting confirmation, as he leaves the parish church.

The River Ceira plays hide-and-seek with the main road. We believed it to be at a distance and here it reappears in Vila Nova, this time to bid us farewell. The road to Penacova continually climbs up and down, a tangle of curves, reaching its pitch of delirium just by the Mondego, confronted by the uneven stretch outside Rebordosa. This is the point at which the traveller decides to abandon any attempt at reaching Foz do Caneiro. Since he has to get to Lorvão, he'll need to content himself with the four kilometres between Penacova and Rebordosa. Here he meets the bridge, then the climb to Penacova, a name which divulges a supreme ability to reconcile a contradiction, pacifically uniting the concept of height (pena) with that of depth (cova). Something you only come to understand by verifying the constructions halfway up: what comes from above is seen from below; what comes from below can be seen from above. Nothing easier. Also, nothing colder. The traveller lunches in a freezing, smoky local inn. He doesn't put his nose out of doors, and still he's shivering. The waitress, bundled up in numerous wraps, has a scarlet and streaming nose. The whole resembles a polar scenario. And although the meal is excellent, it takes no more than the trip from kitchen to table for it to chill.

The traveller departs in the blackest of moods. And if a black mood can be further blackened, just imagine how he felt when he discovered that the garage was shut and wouldn't be open until three o'clock. In these circumstances, patience is the only virtue worth practising. He went to the parish church and spent twice as long as it warranted, then to the heights to survey the Mondego Valley, studying the mountains and searching for some aspect to differentiate them from the previous hundred he'd already viewed, and to justify such lengthy contemplation. The Penacovenses should have been well satisfied with this traveller who seemed so pleased with their countryside, to the point of not abandoning the bannister of the mirador, even beneath teeming rain. A man has to air his blackest moods or burst.

At last three o'clock struck. He could now proceed to Lorvão. These roads are the dead ends of the world. Were the skies to clear and the sun beam down, perhaps the countryside would become pleasanter, but the traveller doubts it. Everything in these parts has a serious demeanour, severe even, and a little disturbing. The trees so very dark, the slopes almost vertical, the main road dangerous. The traveller decides to pause and get the measure of the silence, and he does. It makes you feel better to listen to the distant murmur of the rain falling on the trees, watching a near-transparent haze drift across the valleys. The traveller is at peace.

He didn't see much of Lorvão. His head was full of fantasies, and for that he had only himself to blame. Nothing at all remains of its original ninth-century buildings. And only a few capitals still remain from the twelfth century. Those of the sixteenth and seventeenth century are hardly impressive. What stands out from the rest is the church, dating from the eighteenth century, although this is not the century the traveller most esteems but one which in certain instances he may even undervalue. To come to Lorvão dreaming of a monastery fitting the Romanesque model and the surrounding countryside is to guarantee disappointment. The church is large, tall, imposing but cold in its architecture, with a drawing-pen tracery and clumsy curves. And the three giant angels' heads crowding the pediment over the main chapel are, according to the traveller's feeble lights, in the most vulgar taste. However the choir, in spite of the rest, is a thing of beauty, its railings of mingled bronze and iron, with beautiful eighteenth-century pews. So here he makes use of the opportunity to affirm that the eighteenth century, however poor its understanding of the possibilities of stone, knew how to work wood as only rarely before, or as rarely thereafter. The seventeenth-century cloisters are also lovely, typical of the Coimbra Renaissance. And if the traveller is capable of forever remembering what he so appreciated, he should also take note of the good paintings in the church too.

The Buçaco Serra, as seen from the main road along which the traveller is driving, doesn't impinge on his brain. And since the route he follows accompanies nearly all the southwest range, the curves aren't too unbearable, nor the inclines over-excessive. In discussing Buçaco, one mustn't assume this is a serra like any other, for at one extreme there's a fabulous wood which the traveller is now about to enter. In it lies the Palace Hotel, which demands our immediate attention. Let's take a look at it, in order to pass on to more serious matters. Because, and without question, this neoManueline building has no claim to seriousness, it's pure neoRenaissance, conceived by an Italian architect and scenery-painter in the twilight of the nineteenth century, when

imperial Portuguese consciences were aflame and it was deemed appropriate
to seal them into either good or bad sixteenth-century moulds. And if the
Palace is a Palace, there only for the few, if Buçaco is far away, out of his
grasp, the same process was applied to the construction of Rossio Station in
Lisbon, sticking a Manueline façade also onto its frontage, and in order for
the illusion to be the more complete, an image of King Sebastian, vanquished
in Alcácer Quibir, yet still the absolute monarch of many imaginations. The
traveller's not upset nor indisposed, these thoughts are not the product of
poor digestion nor intellectual acidity. But he has the right to dislike the
Palace Hotel, even though he recognises the stone is well chiselled; its rooms
and dining halls are well decorated; and its chairs comfy – everything, in
fact, is there for the purposes of comfort. The Palace Hotel would, the
traveller thinks, fit the dream-come-true of a North American millionaire
who, being unable to take the building to Boston brick by brick, turned up
here to give full rein to his greed. Nonetheless, it seems that the traveller is
deceived even in this: many of the foreigners who seek shelter under its
Manueline roofs set off early every morning for the woods surrounding
the hotel, returning only at meal-times. The traveller's beginning to believe
that good taste is not altogether lost in our world and, this being so, he need
do nothing more than follow the example of the most advanced nations:
head for the woods.

Buçaco forest absolves the combined sins of Manini and the traveller
and then, if it is possible to absolve the sins of the world, all those of Jorge
Colaço who made the tiles, and of Costa Motas, both uncle and nephew, who
carved the sculptures. Buçaco is king of a vegetable kingdom. Here water is
a slave, as are the animals hiding or wandering in the undergrowth. The
traveller goes for a walk. He surrenders without making conditions, and
has nothing but dumb surprise to express in the face of its explosion of
tree-trunks, and rich variety of leaves, branches, spongy mosses clinging to
stones and crawling over trees, and when you follow them with your eyes,
you confront a thicket of tall branches, so dense it's impossible to find where
one part starts and another ends. Buçaco forest demands a whole vocabulary
which, once spoken, tells us that there's everything still left to say. You don't
describe Buçaco forest. The best thing is to lose yourself in it, as the traveller
did in that incomparable January period, when the humidity of the air
joins with that of the earth, and the only sound is of footfalls upon dried
leaves. This cedar is really ancient, planted in 1644, and today has become a
pensioner requiring steel supports in order not to fall unguardedly sideways.
Before it the traveller makes an act of contrition and declares at the top of his

voice: "Were I a tree, nobody would drag me away from here either." But the traveller is a man, has legs to walk with and many walks yet ahead of him. He goes on his way extremely sad. He carries the forest in his memory, yet cannot reach out and touch it with his hands when far away, since not eyes alone can do justice to it, for here all the senses are required, and even these may prove inadequate. The traveller vows only to stop looking when asleep. After Buçaco, the deluge. He took to the road, passing through Anadia and continuing on through Boialvo, a B-road, crossing Águeda, and were it earlier he'd probably forget his promise to revisit Trofa, and when he reaches Oliveira de Azeméis it's already darkest night. By now there's a wind blowing strong enough to change the earth's orbit. The traveller wearily ascends the hotel steps. Even at its entrance, malign forces attempted to strike the final blow: on the fifth floor there's a hairdresser who announces her services as *houte-caiffeur*. Tell me, ladies and gentlemen, what would have become of the traveller, were it not for the Buçaco forest.

At the Mountain's Gateway

O n waking up the next morning, the traveller foresees a disastrous day. If it was raining in Coimbra, in Oliveira de Azeméis it was bucketing down. All the way to the Vale de Cambra, it was impossible to see further than twenty metres down the road ahead. But gradually the weather started to lift, and he could begin to see what had formerly been lost to sight: sweeping countryside, mountainous but with wide, open valleys, its slopes all cut into deep green terraces, protected by slate walls. Its roads were as narrow and cultivated as the tracks of a country estate. On either side lay extensive swathes of trees, almost all eucalyptus, whose customary funereal, livid colour was happily dampened by the rain and the general humidity of the atmosphere. When he reached Arouca the skies were again clear. It had to be one of those typical coincidences, or a prodigy rendered commonplace by the town that, truth to tell, three gorgeous girls – tall, slender, who seemed to belong to some other time either in the past or the future – walked by together at the instant of his arrival. The traveller watched them recede into the distance, envying the meteorological fortunes of Arouca, and went to visit the monastery.

Here, speed is distinctly not of the essence. Firstly, there's the church. Although not of particular note from an architectural point of view, it is still more interesting than Lorvão, which in some respects it resembles. But the pews are magnificent, as well in their substance as in the rigour of their execution. The eighteenth-century carpenters who carved them demonstrated what could be achieved by the extreme precision of their handiwork and a sense of harmonious design. Over the pews sumptuous Baroque-style mouldings frame a set of religious paintings which, while conforming to the conventions of their type, merit attention.

In addition there is an eighteenth-century organ, of which you need to know it has 24 registers and 1,352 voices including, for those concerned with details, a battle bugle, a trumpet royal, the deep tones of rough seas with their stormy notes, the sound of a bass drum, of a flock of canaries, along with echoes, clarinets, flutes, piccolos, horns and an inexhaustible etcetera.

The organ is silent for the time being, but now the guide is about to reveal that inside this tomb of ebony, silver and bronze, there is the mummified – not to say uncorrupted – corpse of the Beata Mafalda, also called in these parts the saintly Queen Mafalda. The body is diminutively child-like, and the wax coating over its face and hands conceals the truth of its death. It could be said of this St Mafalda that she is doubtless far more beautiful now, with her precious little face, that she was in life during the barbarous thirteenth century. The lucky punter with an eye on the jackpot had no concern with appearances when he had a larger-than-life statue made of the saint; it was set apart in the cloisters, away from the community of arts deserving of their name, for in truth the statue didn't deserve any more fortunate fate.

The museum is up on the first floor, and has many riches to show, both in sculpture and painting. Here is the much talked-about fifteenth-century St Peter, valiant enough even to travel to foreign parts – he is known across the world through photographs. But he has to be seen in close-up, his face is that of a robust man, the mouth characterised by a deep and quiet sensuality, his hand clasping his book, the other holding up the key, his cloak wrapped around him and his tunic raised over his right leg in graceful folds, likewise his tilted head, with its burgeoning beard and curly locks. Another superbly beautiful image is that of the "Virgin of the Annunciation", her hands crossed on her breast, kneeling in surrender. And there are some wonderful Gothic sculptures in wood representing saints.

The painting collection is also excellent, and while the traveller is notably unsympathetic to eighteenth-century conventions, he finds the decorative garlands intriguing, as he does the sequence illustrating the miracle performed by Blessed Mafalda, whose direct and supernatural intervention (of which there was ample witness) extinguished a fire that had broken out in her convent. But what really captures a visitor's eyes are the eight fifteenth-century canvases depicting scenes from the Passion. They are, or seem to be, of popular origin, and the traveller suspects that perhaps they derive from somewhere beyond our borders, from Hispanic Valencia rather than from here in the immediate locality. I can neither offer proof nor swear to my assertion, but it seems to me true.

All this is very lovely and of great artistic merit: the tapestries, the Mannerist "St Thomas" by Diogo Teixeira, the popular ex-votos continually putting the traveller's honour to the test, the volumes of illuminated parchment, the silver plate, and if all these items are randomly listed, without criteria or any kind of formal judgment, it's because the traveller has a clear conscience in that it is only through seeing that you learn to see, while never

34 *Arouca monastery*

forgetting that seeing requires its own apprenticeship. In any case this is exactly what the traveller is hotly pursuing: ways of learning to see, learning to hear, learning to speak.

The visit is over. If he can, the traveller will return again one day to the monastery at Arouca. He's already out on the street, the doors slammed shut behind his back, the guide setting off to lunch. The traveller will do the same and then, spreading his map out on the table, confirm that he's at the gateway to the mountains. Having finished his coffee, he pays the bill and slings his bag over his shoulder. Onwards with life.

III

SOFT-STONE BEIRAS, BE PATIENT

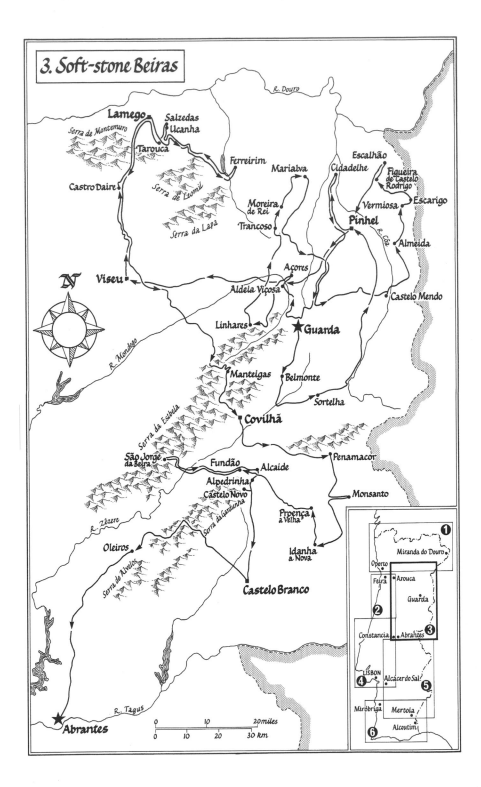

3. Soft-stone Beiras

R. Douro

Lamego
Salzedas
Ucanha
Serra de Montemuro
Tarouca
Ferreirim
Marialva
Escalhão
Cidadelhe
Figueira de Castelo Rodrigo
Escarigo
Castro Daire
Serra de Leomil
Moreira de Rei
Vermiosa
Serra da Lapa
Trancoso
Pinhel
R. Côa
Almeida
Viseu
Açores
Aldeia Viçosa
Castelo Mendo
R. Mondego
Linhares
Guarda
Manteigas
Belmonte
Sortelha
Serra da Estrela
Covilhã
São Jorge da Beira
Fundão
Alcaide
Penamacor
Alpedrinha
Castelo Novo
Monsanto
R. Zêzere
Proença a Velha
Oleiros
Serra da Gardunha
Idanha a Nova
Serra de Alvelos
Castelo Branco
R. Tagus
Abrantes

N

0 10 20 miles
0 10 20 30 km

Miranda do Douro ①
Oporto
Feira Arouca
Guarda ②
Constancia Abrantes ③
LISBON ④ Alcácer do Sal ⑤
Miróbriga Mertola
Alcoutim ⑥

The Man Who Could Not Forget

If the traveller were to set himself a test, he would fail it. A test as a traveller, of course – any other kind, he might pass or fail. But to reach Guarda after one o'clock on a Saturday night in the month of March, which is high season for snow in these mountains, and to trust that the patron saint of travellers would provide him with a hotel room, is sheer incompetence. At the first place he was turned away, at the next they did not open up, further on he was told not even to bother ringing the bell. He went back to the first hotel – how could it be possible there was not so much as a single room free in such a huge building? But there was not. It was perishingly cold outside. The traveller could have begged them to let him settle down on a sofa in the lobby until morning when one of the rooms became free, but he has his pride and so decided that his lack of foresight deserved to be punished, and tried to get to sleep in his car. He did not succeed. Wrapped in whatever he could press into service as protective clothing, nibbling at crackers to ease his night-time hunger and to try at least to warm up his teeth, he considered himself the most wretched creature in the Universe through all the long hours of his personal Arctic winter. The first light of dawn was struggling into the sky, and the cold had become even more intense, when the traveller found himself faced with a terrible dilemma: either to suffer humiliation by finally asking for shelter in the warm hotel lobby, or to be humiliated by early risers pressing round his car windows to see if it was a man or a block of ice inside. He chose the softer option, and do not judge him too harshly for it. When at long last a noisy group of Spaniards who had won their own battle of Aljubarrota left the hotel early in the morning, freeing up a room, the traveller sank into the hottest water in the world, and then in between the sheets. He slept deeply for three hours, had lunch, and went to see the city.

The day deserves the description of glorious. There is not a cloud in the sky, the sun is shining, the cold is invigorating. Where the night saw an unhappy traveller, the day sees a contented one. Sceptics will say that this is simply because he had slept and eaten, but then sceptics were born purely to spoil the simple pleasures of life, like this one of crossing the square, buying the

previous day's newspaper and noticing that the young girls of Guarda are pretty, well built, and look you in the eye. The traveller stores them in his memory alongside those of Arouca, and continues on his way until he comes across the museum, and goes in.

There are others that are richer, better organised, that follow the basic rules of museology more strictly. But given the limitations of the space, and with such a wide variety of collections, the traveller has to appreciate what is on offer, and does so. For example, this Romanesque "Our Lady of Consolation" from the twelfth century, carved from the same stone as the niche it is exhibited in (and which reminds the traveller of the St Nicholas in Braga), or this sturdy, rosy Baroque "Saviour of the World", with a high bare forehead, the body clad only in a loincloth and a short red cape thrown over his shoulders, or the alms chests for souls in purgatory, or the small, hefty crowned Virgin, with an Infant Jesus whose face is an exact likeness of hers, or the seventeenth-century triptych showing St Anton, St Anthony and a bishop, or a painting by Brother Carlos, an "Adoration", which in one corner has a reference to the village of Açores, a place that the traveller will visit without fail. Or the magnificent collection of arms, the Roman and Portuguese artefacts, the weights and measures, the carvings, and also some notable paintings from the nineteenth and twentieth centuries. Also of note are some mementos of the poet Augusto Gil, who spent his childhood in Guarda. All in all, the Museum of Guarda is well worth a visit. It's almost a family affair, which perhaps explains why it has a heart.

Before seeing the Cathedral, the traveller decided to take in the Misericordia church, but there was a service going on, and in such cases he prefers to be discreet. So he left, and went instead to St Vincent's church, where he spent some time appreciating the eighteenth-century tiles lining the nave. Their design is not especially beautiful, or perhaps is too conventionally so, but their frames are imaginative, they are monumentally ornate, and the colouring is sensitively done. The length of time the traveller took to gaze at them must have aroused the suspicions of two old ladies from the neighbourhood: they stared at him far from charitably, which must have upset St Vincent, who even had a crow bring him a crust of bread when he was starving.

As he has started down this route, the traveller continues along the narrow streets leading to the main square where the statue to Dom Sancho I stands. They are quiet, narrow streets empty of people at this time of day, but in one of them the traveller saw something he had never seen before: an Alsatian wolfhound staring out at him from a shopfront next to a pile of

cardboard boxes. The dog does not bark, merely looks; perhaps he is guarding his master's possessions and knows that no harm will come to him from this particular traveller. Guarda is a city of tiny mysteries. Why for example are its double-glazed windows lined with flowery wallpaper that make it impossible to see either in or out? What is the point of the windows being transparent? What are these inaccessible gardens meant to look out on?

There is the Cathedral at last. The traveller starts his visit on the north side, with its wide steps and Gothic doorway, above which rise one after another the forms that correspond in the interior to the side nave and the central nave, and the flying buttresses resting on their supports. The Cathedral is squat and solid at its base, even though higher up the features are more graceful, and if one looks at the façade face on, it looks like a fortress, with towers that are castles crowned with pinnacles. And since the entire building, except for the rear, is in an open space, this impression of size is accentuated. The traveller is beginning to like Guarda.

He goes in by the north door and is immediately caught up in the airy Gothic interior. The nave is deserted, the traveller can take all the time he likes, the pious old ladies from St Vincent will not be casting their suspicious eyes on him here – more than likely, the saint has given them a good talking-to. Here is the great altarpiece in the chancel, with almost a hundred sculpted figures on four levels depicting scenes from the Bible. This is also said to be the work of Jean of Rouen. If this Anca stone were hard instead of soft, our sixteenth century would never have seen such a wealth of statues, altarpieces, figures and figurines. But a very different, hard stone is to be found in the Pinas family chapel: this Gothic Bishop's head rests on his left hand while his right arm is stretched along his body in a final, irredeemable gesture of abandonment. The body is tilted slightly towards us, to show that it is a man reclining there, and not a prone statue. There is a difference, and it is no small one.

The traveller walks slowly down the three naves, peers up at two high windows or apertures the reason for which he cannot discern, but as the light they give is so favourable, it would be churlish to find fault with them. He has no desire to leave, perhaps because he feels at peace in this solitude. He sits on a stone step, can see in close-up the twisted strands of the columns, can think about the skill of the construction, the vaulting, the calculated distribution of weight in the upper structures: in short, he has learnt a lesson without a master. Guarda Cathedral is no finer than other similar buildings, but since here the time was ideally suited to the place, the traveller was more able to enjoy it.

From there he went to the Blacksmiths' Tower. He wanted to see the surrounding countryside from the top, to have the sensation of being at over a thousand metres' altitude. The day is still bright, but there's a thin cloud on the horizon that is enough to hide all that could be seen in the distance. The traveller knows that the Serra da Estrela is over there, and beyond it the Serra da Marofa, and beyond that the Serra Malcata. He cannot see them, but knows they are there waiting for him: that is what is special about mountains, they never go to Mohammed. Evening is drawing in, the sun has sunk low in the sky, and it is time to return to the hotel. He slept very little that morning, after the freezing night out, and he is longing to stretch out his weary limbs.

So the traveller dozed in his room and then, when it was time, went down to have dinner. By now the hotel has been freed of the Spanish invasion and all the Portuguese tourists have returned to their hearths and homes, so the dining-room is agreeably peaceful, reduced in size by means of a thick curtain that makes it seem cosy. The temperature outside has fallen considerably, and the traveller shudders to think what his fate might be were it not for his room and his hot bath; that sort of thing happens only to improvident or novice travellers, not to a veteran like him. He is busy poking fun at himself in this way when the head waiter comes over with a menu and a smile on his face. He is a short, stocky man. They exchange the usual courtesies, and it seems as though nothing more will occur than the arrival of the food and the wine, with coffee to follow. But two things happen. The first is that the food is excellent. The traveller had sensed it at lunch, but he must still have been affected by his freezing night, and did not pay particular attention. Now however, at his leisure, and with his tastebuds refreshed from the horrible experience of chewing on crackers in the lonely Arctic night, he can confirm that the cooking is excellent. First-rate. The second thing to happen is that the conversation between him and the head waiter blossoms. He explains in two or three words who he is and what he is doing; in two or three more the waiter gives the essential details about himself, and then they find they need many more to tell the stories they have embarked on.

Senhor Guerra (for that is his name) says: "I'm from Cidadelhe, a village in the district of Pinhel. Are you thinking of going there too?" The traveller replies truthfully: "I intended to. I'd like to see it. What's the road like?" "The road is bad. It's at the ends of the earth. But it used to be worse." The waiter paused then repeated: "Much worse". No-one can call themselves a traveller if they do not have intuition. This one sensed there was more to the story, and threw out a line that did not even need to be baited: "I can imagine."

"Perhaps you can. What I can't do is remain indifferent when I hear that places like mine are condemned to disappear." "Who told you that?" "The mayor of Pinhel, years ago. They're condemned, he said." "So you like it there?" "A lot." "Do you still have family there?" "Just one sister. I used to have another one, but she died."

The traveller senses he is getting close and searches for the question that might open the treasure-chest, but in the end it opens on its own account, and shows it contains a story common enough in condemned places like Cidadelhe: "My other sister died when she was seven. I was nine at the time. She had the croup, and it was getting worse all the time. It's twenty-five kilometres from Cidadelhe to Pinhel, and in those days it was nothing more than a stony track. The doctor never came to the village. So my mother asked to borrow a mule, and the three of us set out across the hills." "Did you get there?" "We didn't even get halfway. My little sister died. We turned back for home, with her in my mother's arms on the mule. I walked along behind, in tears." The traveller can feel a lump in his throat. He is in a hotel dining-room, this man is the head waiter, and he is telling him part of his life. There are two more waiters close by who can hear the story. The traveller says: "Poor child. To die like that, because there was no medical help." "My sister died because there was no doctor and because there was no road." The traveller understands: "You've never been able to get it out of your mind, have you?" "I'll never forget it as long as I live." There is a silence, the dinner is over, and the traveller says: "I'm going to Cidadelhe tomorrow. Would you like to come with me, Senhor Guerra? Can you come? Show me where you are from." The man's eyes are still damp. "It will be a great pleasure." "That's settled then. Tomorrow morning I'll go to Belmonte and Sortelha, and we'll set out after lunch, if you agree."

The traveller returns to his room. He spreads out his big map on the bed and looks for Pinhel. There it is, and the road which heads off into the hills. At some point in this space a seven-year-old girl died; then the traveller finds Cidadelhe, on the heights, between the Rivers Coa and Massueime, it really is the ends of the earth, the end of life. If there is no-one to remember.

Bread, Cheese and Wine in Cidadelhe

The prima donna assoluta is the opera singer who only sings the principal roles, whose name is always first on the billboards. In general, she is capricious, impulsive, fickle. The traveller hopes that this absolute spring which has come early will not have the same defects, or will only show them later. On the plus side, he has already enjoyed two bright, magnificent days, the day before and this one. He descends the valley that begins on the outskirts of Guarda heading south, then follows the River Gaia. It is a rolling landscape, with farmland that is already showing green: the winter is really over.

Near Belmonte stands the Centum Cellas or Centum Coeli, the most mysterious monument in all these Portuguese lands. Nobody knows what this twenty-metre-high structure was originally: some maintain it was a temple, others that it was a prison, or an inn, a belltower, or a watchtower. There seems to be no reason for an inn here; if it were a watchtower it need not have been so elaborate; it could only have been a prison of very advanced ideas, because the windows and doors are so large; it might have been a temple; the problem is that we are always quick to put that label on anything we come across. The traveller feels that the answer must lie in the land around the monument: it is scarcely credible that it should have been built on its own, as a whim. So the reply probably lies under the ploughed fields, but unless it is possible to guarantee a serious, methodical excavation, with sufficient money and protection, it is better to leave Centum Cellas in peace. We have already ruined enough in Portugal with our lack of care, persistence, or respect.

Belmonte is the home of Pedro Álvares Cabral, who landed in Brazil in 1500 and whose portrait can apparently be found as a medallion in the monastery cloister of the Jeronomite brothers. It may or may not be him, because who can tell with these portraits of bearded, helmeted figures, but what is for sure is that here in Belmonte Castle the young Pedro Álvares must have played and learnt his first lessons as a man, as here lie the ruins of the house of his father, Fernão Cabral. Pedro Álvares did not have such a

bad life: to judge by the remains, it must have been a magnificent place. The same can be said of the double Manueline window in the walls facing the setting sun. The walls themselves are extensive, surrounding a large area that the traveller would like to see kept clean and swept. Children from the local primary school are playing there, and their two teachers, who are hardly any older than they, are joining in as well. The traveller likes to see happy scenes like this, and leaves with a wish that neither the dark-haired nor the blonde teacher lose their temper if one of their charges cannot remember what nine times seven is.

Close by, in a small courtyard, is the old parish church. The traveller enters unawares, and before he has gone three steps comes to a halt in amazement. It is one of the most beautiful sights he has ever seen. To say it is Romanesque but also transitional Gothic would be to say everything and nothing. What is most impressive is how all the forms are balanced, and how bare all the stonework is, apart from its irregular joints. It is like the interior of a body, and far more beautiful than one could expect on entering. The eyes immediately fix on the unadorned chapel formed by four arches, standing out from the triumphal arch, along one wall of which is a sculpted group showing the Virgin with the dead Christ stretched out on her lap, his bearded face turned towards us, the wound in his side. She is not looking at anything, him or us. Their heads have been repainted several times, but the beauty of the whole, fashioned from hard granite, is quite sublime. Belmonte offers the traveller one of the most moving aesthetic experiences in his whole life.

This *Pietà* is the outstanding work here, but mention should also be made of the capitals of the nearby columns, of an arch in the main chapel, and the frescoes on the far wall. And if the traveller accepts these smaller pleasures after having enjoyed the main delight, in the sacristy there is a Holy Trinity with an Eternal Father with enormous staring eyes, and in the nave some Renaissance tombs, coldly executed, as well as an athletic, effeminate St Sebastian, with long hair cascading onto his shoulders and a gesture of mannered elegance. See all this, but before leaving the church go and stand in front of the *Pietà* again, and keep it in your eyes and in your memory, because you do not come across works such as this every day.

The traveller goes from Belmonte to Sortelha by roads that are poor and through landscapes that are worthy of admiration. To enter Sortelha is to enter the Middle Ages. When the traveller says this he does not mean it in the same way as he would on entering the church in Belmonte for example. What gives Sortelha its mediaeval appearance are the huge, thick surrounding walls, the rough, steeply inclined streets, and on its outcrop of rock, the castle,

last refuge of the besieged – last and probably vain hope. To anyone who had breached the cyclopean walls below, this tiny fortress must have seemed almost a joke.

What is no joke is the accusation painted in well-formed letters on the rim of a fountain: ATTENTION! THIS WATER IS UNSAFE DUE TO THE LACK OF CARE OF THE MUNICIPAL AND HEALTH AUTHORITIES. The traveller was pleased – not of course at seeing the inhabitants of Sortelha going short of water – but because someone had taken the trouble to get a paintpot and a brush and had written for all to see that the authorities do not do what they should, when they should, and where they should. That was the case in Sortelha, and the traveller can testify to it, because he wished to drink from the fountain and could not.

The traveller moves on to Sabugal hoping to see the eighteenth-century ex-votos, but he did not find a single one. They were supposed to be in the chapel of the Nossa Senhora da Graça, but the old man who came up with the key had no idea where they were. The church is a new construction in spectacularly bad taste, apart from the Pentecost scene portrayed on wooden panels in the sacristy. The lively painted figures of the Virgin and the Apostles are very expressive. But a doubt tugs at the traveller's mind: if this is Pentecost, why are there twelve apostles? Is Judas shown simply to balance the composition? Or did the craftsman who carved the work take it upon himself to grant Judas a pardon, as only artists can do?

The traveller has an appointment this afternoon. He is going to Cidadelhe. To save time, he has lunch in Sabugal, and from what little he can see, it seems to be a noisy little town where everyone is either going to or coming back from market. Afterwards, he heads straight for Guarda, leaving out Pousafoles do Bispo, which he would have liked to visit to see what remains of land once owned by blacksmiths and to see the Manueline window that apparently still exists there. But the traveller cannot see absolutely everything, and even so he is far more privileged than most others who cannot explore at such leisure. So Pousafoles do Bispo will stand as a symbol of the unreachable that escapes us all. The traveller soon feels ashamed of this metaphysics when he wonders what has become of the descendants of those blacksmiths of Pousafoles. He blushed, fell silent, then went to the hotel to find Senhor Guerra of Cidadelhe, who was waiting for him.

As already mentioned, it is twenty-five kilometres from Pinhel to Cidadelhe. Add to this the forty between Guarda and Pinhel. That is plenty for a good chat, and it is well known that nobody talks as much as two people who do not know each other well but find they are travelling together. Before long

they are exchanging confidences, speaking about their lives far more than one usually does, and discovering how well two people can get on simply by talking to each other, when there is no attempt made to fool the other by being insincere, which would be intolerable in a situation like this. The traveller became friends with the head waiter, he listened and spoke, asked and answered, and the two of them had a fine journey. In Pêra do Moço they passed a dolmen, and Guerra, knowing the reason for the traveller's journey, pointed it out to him. But this is not the kind of dolmen the traveller likes, it has no secrets or sense of mystery, it is simply there by the roadside in the middle of a field, he has no desire to get out and take a closer look. The traveller has seen dolmens on his journey, but he does not talk of them in order not to confuse his memory of the one in Queimada where he heard a heart beating. At the time, he thought it was his own. Now, so far from it in distance and in time, he is not so sure.

They have left Pinhel behind, the road has become nothing more than a track, and beyond Azevo the landscape is one of bare hills, cultivated as high up as possible. There are small fields: the deepest green are rye, the others wheat. Lower down potatoes and other vegetables are grown. This is a subsistence economy, people eat what they plant and grow.

Cidadelhe really is at the ends of the earth. The village stands on a rocky outcrop between two rivers. The traveller pulls up, gets out of his car with his companion. Within a couple of minutes they are surrounded by half a dozen little children, and to his surprise the traveller discovers that they are all goodlooking: a small, roundfaced sample of humanity that it is a pleasure to see. The chapel of St Sebastian is close by, so too is the school. The traveller is in his guide's hands, and if the first visit is to the school, then so be it. There are not many pupils. The teacher explains what the traveller already knows: the population of the village has dwindled, until there are hardly more than a hundred inhabitants. One of the little girls is staring at him: she cannot be called pretty, but her look is the sweetest thing in the world. And the traveller discovers that it is here that the school satchels of his own childhood have ended up: the city's leftovers for Cidadelhe.

The chapel was closed, but now it is open. Above the door in the porch protecting the entrance, there is a local mannerist painting depicting the Calvary. Although the porch keeps off the rain and the sun, it can do nothing about the wind and the cold, so it is a miracle the painting is so well preserved. Guerra strikes up a conversation with two old women, asks for the village news and tells them about himself and his family, then says: "This gentleman would like to see the pallium." The traveller is busy looking

at the painting, but from their silence he can sense an air of tension. One of the women replies: "That's impossible. The pallium isn't here. It's being mended." This was followed by low murmurings, a stealthy conference in the subdued manner of these people.

The traveller went inside the chapel, and found himself face to face with the most extraordinary St Sebastian he had ever seen. It was obviously a recent creation, with bright pink colours freshly varnished, and the dark shadow of a beard. The saint has an arrow through his heart, and yet he is smiling. But what is extraordinary is the size of his ears, real fans, to use the popular Portuguese expression. The power of faith must indeed be great if believers can keep a straight face when confronted with this comical saint. And the proof of this great power is shown by the fact that four women are already praying inside the recently-opened chapel. And the only smile to be seen is that of the saint.

The roof panels in the chapel depict scenes from the life of Christ in a lively rustic style. Apart from the effects of age that can be seen in some of the mouldings, the paintings are generally in good shape. They only need some filling-in to conserve them properly. As they are leaving, Guerra comes up, and the traveller asks him: "Well, Guerra my friend, what about the pallium?" "The pallium," Guerra replies, embarrassed: "it's being mended." And the chorus of old women, grown so large the traveller cannot even count them, repeats: "Yes, it's being mended." "So it can't be seen?" "No, no, it can't."

The pallium (the traveller already knew this, and had it confirmed by his companion) is the glory of Cidadelhe. To go to Cidadelhe and not see the pallium would be like going to Rome and not seeing the Pope. The traveller has been to Rome, and did not see the Pope, and was not particularly concerned about it. But he is concerned about Cidadelhe. However, what cannot be cured must be endured. Take heart and press on.

The village is entirely of stone. The houses are of stone, and so are the streets. The landscape is of stone. A lot of the dwellings are empty, many walls have collapsed. Where people used to live, now weeds grow. Guerra points out the house he was born in, the threshold where his mother felt the birth pangs, another house they lived in later on, almost entirely hidden under a huge *barroco*, the name they give in the Beiras to the boulders that are strewn all over these mountains. The traveller is delighted by some doorways that are sculpted or have decorative bas-reliefs: a bird settled on the head of a winged angel, between two animals that could be lions, dogs or wingless griffins, a tree spreading over two castles above a geometrical pattern of

fleurs-de-lys and garlands. The traveller is looking at them in delight when Guerra says: "Let's go and see the Citizen." "What might that be?" the traveller wants to know. Guerra does not want to tell him yet: "Come on."

They set off down stony lanes. In a house along the way lives Guerra's sister, Laura by name, and his brother-in-law is there too. He is busy cleaning out the cowshed, and has dirty hands, so he does not come over, but greets them and smiles. Laura asks: "Have you seen the pallium?" Visibly uncomfortable, Guerra replies: "It's being mended. We can't see it." The two of them go off to one side, and another secret debate takes place. The traveller smiles and thinks: "There must be something behind this." And as they are walking up towards a church tower he has seen rising in the distance above the rooftops, he sees Laura heading off quickly down another street, as if she is on a mission. Strange business.

"Here's the Citizen," Guerra says. The traveller sees a small arch next to the church tower, with on one pillar the roughly sculpted figure of a man standing on a half-sphere. On the other pillar can be read in large letters: "The year 1656". The traveller wants to know more and asks: "Who is this figure?" Nobody knows. For generations, the Citizen has belonged to Cidadelhe, he is a kind of lay patron saint, a tutelary god, fought over by the lower village (where the traveller is now) and As Eiras, the upper village, where the traveller first arrived. Apparently there was a time when the verbal disputes erupted into real fights, but historical sense prevailed in the end, because the Citizen has his roots at this end of the village. The traveller reflects on the strange love that links a village so lacking in material wealth to this badly sculpted, time-worn stone showing a human figure so roughly carved his arms are barely distinguishable, and becomes confused when he realises it is in fact easy to understand if we simply follow the essential paths, this stone, this man, this harsh landscape. He further reflects that one has to be careful in dealing with these simple things, one has to let them be and let them become what they may, not to push them, simply to be with them, and he looks again at this Citizen and at the happiness on the face of his new friend called José António Guerra, the man who has decided to keep all this in his memory. "What is known about the history of the Citizen?" the traveller asks. "Not a lot. It was found no-one knows when in some stones over there (he gestures down towards the invisible banks of the River Coa) and it's always been in the village." "Why is it called the Citizen?" "I don't know. Perhaps because this is Cidadelhe."

That's a good enough reason, the traveller thinks. He is about to go into the parish church nearby, when he realises that he and José António Guerra are

not alone. Out of nowhere, three of the old women from the St Sebastian chapel have appeared, and despite being so aged and careworn, they are smiling. The best of Cidadelhe church is its ceiling, where the wooden panels are an educational treat showing the saints, all done in a more thoughtful manner than those in the St Sebastian chapel. The traveller despairs at not knowing who painted all this, what imaginary world existed inside this church, what was said between painter and priest, how the people of the village judged his work when they came to see how it was progressing, what prayers were said to this celestial host, and why. As the traveller reads out the names of the saints, there are gasps from the old women accompanying him: they cannot read, and they are discovering for the first time which saint is being portrayed: "St Matthew, St Helen, St John, St Jerome, St Anthony, St Teresa of Jesus, St Apollonia, St Joseph." The paintings are from the sixteenth century, and make a precious catalogue of saints, who hopefully are powerful enough to be able to afford their protection.

This is how a journey should be. To pause, to look. The traveller's face shows how moved he is. He leaves the church with José António Guerra, and climbs with him to the top of a hill that is the highest part of Cidadelhe. The birds are singing, the two men gaze out over the hills, taking in all there is to be seen from this vantage point. "I've liked it up here since I was a child," his companion says. The traveller does not reply. He is thinking of his own childhood, of his mature years, of this village and other villages, and he wanders off. Each of them is in their own world, and with all this world.

"Time for something to eat," Guerra says. "Let's go to my sister's house." They take the same street back down, and there is the Citizen still standing guard. They stop off at a small bar to drink a glass of rosy red wine: it is acid, but from an honest grape. Then they climb the front door steps to the house: "Come in. Make yourself at home," Laura says from the threshold. Her voice is gentle, her face is calm, and there cannot be two more limpid eyes in the whole world. Bread, wine, and cheese are on the table. It is a big round loaf of bread; to cut it Laura has to hold it against her chest, and her dark housewife's blouse becomes coated with a white sprinkling of flour, which she shakes off without thinking. The traveller notices everything, that is his duty, even when he does not understand he has to notice and record what he sees. Guerra asks: "D'you know the saying about bread, cheese and wine?" "No, I don't." "It goes like this: bread has eyes, cheese has no eyes, wine goes to the eyes. That's what they say here, anyway." The traveller is not sure that these three attributes are universal, but in Cidadelhe he not only accepts them, but is incapable of believing they could be any different.

The meal is over, it is time to go. The traveller says goodbye affectionately and starts to walk down the street. Guerra is still talking to his sister, who says to him: "They're waiting for you in As Eiras." What can she mean, he wonders. It does not take long to find out. As they draw near the St Sebastian chapel, he can see the same aged women and other younger ones waiting outside. "It's the pallium," Guerra says. The women slowly open a big box, pulling out something wrapped in a white cloth. Then all together, with each of them carrying out their movements as if they were performing a ritual, they begin the seemingly unending process of unfolding the huge pallium of crimson velvet, bordered in gold, silver and silk, with its bold central motif showing the monstrance being held by two angels, and all around them flowers, filigree work, tin discs, a splendour beyond description. The traveller is amazed. He wants to see it better, and touches the incredible softness of the velvet. He reads an embroidered inscription: "Cidadelhe, 1707". This is the treasure that the women in black guard and defend so jealously, even when it is so hard for them to guard and defend life itself.

On the way back to Guarda, at nightfall, the traveller commented: "So the pallium wasn't being mended after all." "No. They wanted to be sure first of all that you were a good person." The traveller was pleased that in Cidadelhe they judged him a good person, and that night dreamt of the pallium.

How Malva Got its Name

In order to able to visit the region at his leisure, the traveller set up camp in Guarda. Today he is to take the Viseu road as far as Celorico da Beira, from where he will make his detours and return to his starting point. The day is like its closest kin: beautiful. The traveller deserves as much: he has had more than his share of mists and rain, although he is not complaining and sometimes even misses them. Yet it would be a shame if the weather were to spoil today: he would not be able to appreciate the long, wide valley of the River Mondego at the start of its great curve north around the mountains of the Serra da Estrela before it travels through lower land out to the sea. The River Mondego seemed certain to flow into the Duero, but found that the heights of Açores and Velosa and the mountain of Celorico stood in its way, and so chose instead to become the longest of the rivers born in Portugal. Some human destinies are no different.

The traveller starts his trip in Aldeia Viçosa, only recently renamed because its inhabitants were ashamed it was called Porco and asked for it to be changed. A bad idea. Aldeia Viçosa sounds like a tourist complex, whereas Porco had been handed down through the generations since the days when wild boar roamed these hills and to kill one was a matter of rejoicing and a chance to improve one's diet. To change the village's name was an act of ingratitude. Still, the traveller has his own business to mind, and so he looks at the lush landscapes around the river and sees how far down he has come. But then he starts back up again, and notices the farmhouses dotted about the valley: it has taken a lot of hard work to turn this into a garden. The road is very narrow, with tall trees on either side; there are gateways to estates, glimpses of imposing façades. All of a sudden he rounds a bend and finds himself in Aldeia Viçosa.

At first sight, the parish church is disconcerting. In a region so full of Romanesque and Baroque buildings, to find a neoclassical church in this ancient village of Porco is astonishing. Inside the church, though, there are glimpses of earlier times, such as the sixteenth-century tomb of Estévão de Matos, who died in 1562, and of his wife Isabel Gil, who came to join her

husband at a date no-one thought necessary to add. Other sights worth seeing in the church: a fine panel, also sixteenth-century, depicting the Virgin and Child with angel musicians, and in the curved roof of the main chapel, paintings showing the four doctors of the Church, two on either side, painted huge against an ornamental background of foliage and vegetation. Another pleasant surprise Aldeia Viçosa has to offer in addition to its neoclassical façade. There are also some noteworthy statues, above all the beautiful sixteenth-century St Laurence carved in wood.

The traveller returns to the main highway only to leave it again soon after to follow a country lane which according to the map is the road to Açores. If this is a road, then the traveller is a falcon: if he has to take such care in dry weather, what can it be like when there is rain and mud? The way into Açores crosses the old fair ground, whose size is out of proportion to the current importance of the village. In times gone by, Açores was a market town, and what the traveller calls the fair ground was also the place where the pilgrims to Our Lady of Açores made their camp. The building over there, with the pillory in front of it, used to be the town hall. It has been spoilt – doors have been opened where there should have been plain walls – but even so it is a joy to behold. Açores gives the sense of being badly abandoned, and in that way reminds the traveller of Tentugal: the same silence, the same emptiness: even its proportions are somewhat similar. The traveller suspects that in its day it must have been renowned throughout all this part of Beira.

The church door is Baroque, but inside there are traces of an earlier construction, including an inscription to a Visigoth princess who died in the seventh century. But the great fascination in the church, because of its novelty in Portugal, are the paintings representing local events and legends. The traveller already has two village women accompanying him, and they take it upon themselves to relate the life and miracles of Our Lady of Açores. To begin with, the name. This is not an island in the Atlantic, but Beira rock, solid enough to make the Mondego change its course, and yet it is called Açores. This hawk-like name came from the miracle that took place one terrible day when a page of the King of León let the royal falcon loose and was condemned to have his hand chopped off. In his anguish, he called out to the Virgin, who saw to it that the bird flew back. The two women are already taking turns to tell the traveller about the second miracle, in which the Virgin appeared during a battle between the Portuguese and the army of León, and then the third, concerning the resurrection of the son of a king who came here on a pilgrimage, and the fourth and last, which involved the

rescue of a cow whose life was in danger, to the great sorrow and possible economic loss of its owner. Our Lady of Açores must have performed other deeds, but unfortunately they were not recorded for posterity by any naive hand. The two women are upset at how neglected everything is, the traveller is upset that they are right to have cause for complaint.

He still wanted to reach Velosa, which was only two kilometres away, in order to see the tumulus of a Goth princess, Suintiliuba – have you ever heard such a marvellous name? But he was worried about the state of the road, and did not have the nerve. So he returned to the highway, through Celorico da Beira, where he did not bother to stop. He was aiming for Linhares, on the road to Coimbra. As long as there is no possibility of taking a wrong turn, the traveller does not do so. But as he is returning to Linhares, he turns where he should not have done, and before he knows it, is climbing up tracks so steep that even goats would probably refuse to take them. Up and up he goes, turning first in one direction then in another, with things getting worse all the time. Finally he comes to a fork in the road, and has no idea which way to go. To his right, the road descends into a dark pine wood and appears to be swallowed up. It might be better to go left, but the traveller does not want to risk it. He gets out of the car and walks on a few paces until suddenly, thanks no doubt to the intervention of Our Lady of Açores (and sure enough, a hawk is circling in the sky above), a man appears. But first the traveller should explain that from here Linhares and its gigantic castle are perfectly visible, and for some unknown reason remind him of Mycenae. So Linhares is there, but how on earth is he to reach it? The man replies: "Take this track. When you reach a clump of rock-roses, that's the main road." "The main road? Which main road?" "The one to Linhares. Isn't that what you wanted?" "But I came from another direction." "You came from Quintas. What astonishes me is that you got this far." The traveller is also astonished, but it is not something to feel proud of. The accomplished traveller is one who only takes bad roads when there is no choice, or when he is forced to abandon the good ones. He is not someone who takes the first track that presents itself to him, without checking it out.

Linhares is fertile earth. As soon as he arrives, the traveller befriends the man in charge of the works going on at the Misericordia church, who is the local mason and willing opener of all doors. The traveller has a first-rate guide. These are the banners of the Misericordia church: the one depicting the Ascension of the Virgin is particularly fine. And here, in the middle of the street, is a stone platform or forum that used to have a roof but now

does not. This was where the town council met: they sat on these benches and discussed the town's affairs out loud, in sight of the townspeople, who could hear everything through the open windows. Those were simple times, but this practice convinces the traveller they were good ones too: in those days there were no massive doors or velvet seats, and perhaps when it rained the session was interrupted so that public and passers-by could shelter under the canopy.

The sixteenth century was a great age for building. The traveller has noticed that in this region as in others he has seen, most of the ancient civic buildings date from that century. This is true of the palace in front of him now, with its huge window open onto the street, its airy lateral columns, its shapely lintel. He will never live here, but it pleases him to imagine that it must be good to see the landscape around Linhares from inside, with the Cabeça Alta rising more than 1,200 metres in the distance. His guide waits patiently while he is concluding these random thoughts, then takes him to the parish church, which boasts the splendid panels attributed to Vasco Fernandes which feature an Annunciation, an Adoration of the Kings, and a Descent from the Cross. Equally attractive is the arch over the side door, with its two wonderful archivolts, decorated on the outside with geometrical designs and on the inside with different patterns that show its Romanesque origin. From left to right these show a six-pointed star inside a circle, a cross, a chequerboard design, a sword on which what looks like a bird has alighted (could the hawk of the miracle have ended up here?) and finally a human figure with arm raised. The tympanum is plain.

The castle must have been enormous. This is obvious from the two huge granite corner towers, the height of the walls, and the whole fortress-like atmosphere that still exists inside. It needed to be huge, because in the days of the wars against the Saracens, this was a forward post for the Portuguese. That was in the reign of Dom Dinis, of whom the traveller will have occasion to speak again soon. Who knows whether it was not in this castle that inspiration came to the poet-king, as he looked out on the pinewoods below: "Oh flowers, oh the flowers of green pine." Well, the traveller himself is inspired today, but he must not overstay his welcome, because this visit is in the mason's lunch-hour, so it is time for him to say goodbye and leave Linhares, which from afar looked so like Mycenae and took him so long to reach it could well have been the Greek city.

He returns to the main highway, this time by the correct road, and as he drives towards Celorico da Beira spots the turning for Quintas and admonishes himself again. He speeds through Celorico again without stopping,

aiming to reach Trancoso in time for lunch. The road passes through moderately high hills, with boulders or *barrocos* as they are called here dotted about them. They stand singly or in groups, one boulder on top of another in what seems like an unstable balance, but which only a sizeable explosive charge could shift. Ton is piled upon ton of rock, and the traveller asks himself the typically innocent question: "How can they have got like that?"

Trancoso is not quite as he had imagined it. He was expecting a town with mediaeval architecture, surrounded by walls, an atmosphere of ancient history. The walls are there, the history is ancient enough, and yet the traveller feels rejected. He ate an unremarkable meal, saw and even enjoyed some of the monuments, but came to a conclusion that he puts in this way: "One of us has not understood the other." To be fair, the traveller suspects that it is he who has not understood Trancoso. But he did like St Peter's church, with its tomb of Bandarra the shoemaker prophet,[12] and since he knew beforehand that on the site of the St Bartholomew's chapel, in a church which no longer exists, Dom Dinis and Isabel of Aragon were married, it occurred to him that history, especially imagined history, brings things together very aptly, since in this same spot there lived a shoemaker who could tell the future, and a king and queen who produced roses from bread. The traveller also enjoyed seeing the Nossa Senhora da Fresta church and the poorly preserved mural paintings inside. He also wished to see the church of St Lucia, and went there, but all he saw were fences, dust and scattered stones: from top to bottom, everything was in the process of being restored. Time to move on.

The traveller had only one reason for going to Moreira do Rei, seven kilometres north of Trancoso: to see with his own eyes the measurements cut into the stone of its church door columns: the elbow, the arm, the foot. This was an effective system: anyone who wanted to know the correct measurements so that he could not cheat or be cheated, could come and check his rule against these standards. Then he could go to the market, buy his cloth or rope, and return home in the knowledge he had the right measure. Moreira is a royal town because Dom Sancho II stayed here on his way into exile in Toledo in 1246; out of all the lands around here, some of them far more important, this was where he was given shelter, perhaps for only one night – so end the glories of this world. So too the glories and the miseries of this world ended for those buried around the church in tombs dug in the hard rock, at random it seems, but all of them with their heads towards the walls of the building, as if calling for a final blessing.

The traveller continues northwards along the main road to the east of the

River Teja. He is surprised to find this name here, because these are not lands that the Tagus flows through and where its female companion the Teja, like a good wife, should be found. He passes through Pai Penela and then Meda and Longroiva, where there is nothing much to detain him, and takes the road heading southwards from Vila Nova de Foz Coa. The route is now through flat, level land which in fact is a plateau. There is plenty to please the eyes, but the traveller knows that Marialva will have more to offer, since the attractions of this plain are those offered by any inhabited, well-ordered land. While the traveller is not a tourist who is fetched and carried everywhere, on this journey he only has time to investigate art and history, aware that if he can make the links and choose his words carefully enough, it will be clear that he is always talking about human beings, those who in the past raised as new the stones that now are old; those who today repeat the time-honoured gestures of construction and learn to create new ones. And of course it is for the reader to decide whether or not the traveller succeeds in this.

Marialva was once called Malva. At first, the traveller thought this must be the shortened form of a woman's name, María Alva. Even now, he cannot bring himself to accept that it was so named by a king of León, Fernando Magno. Clearly His Majesty did not come here from León to make sure that the name Malva suited this mountain. He must have heard from some friar or other who passed this way and having seen lots of malvas (mallows) decided they were characteristic of the region, without noticing, as a narrow-minded monk, that in a house that today stands in ruins, lived the most beautiful girl of these parts, who was called María Alva – or so the traveller argues, to justify and defend his thesis. He must be forgiven this kind of flight of fancy, because woe betide any traveller who does not have them: all he will see are silent stones and indifferent landscapes.

No-one could accuse the castle of being silent or indifferent. Nor the old town, nor the streets climbing steeply up to the fortress, nor the people living there. As the traveller climbs, they wish him good afternoon with gentle voices. There are women sewing on their doorsteps, a few children playing. The sun is on this side of the mountain, and strikes the walls of the castle with a powerful light. It is mid-afternoon, and there is no wind. He enters the castle – soon old Brígida will be there to tell him where the gunpowder store is, but for now he is on his own, discovering something which from this day on will remain in his mind as the castle with the most perfect atmosphere, the one most inhabited by invisible presences, the enchanted realm, to put it in two words. In this space containing both the well and the pillory, divided between light and shade, a whispering silence descends. There are ruined

dwellings, the keep, the courtyard, the dungeon, other places no longer identifiable, and it is this complex of ruined buildings, and the mystery that unites them, the present memory of all those who lived here, that suddenly moves the traveller, brings a lump to his throat and tears to his eyes. Do not conclude from this that he is a romantic, but rather that he is a very lucky man: lucky to have been here on this day, at this moment, to have come in alone and to have been left alone, and to have had the sensitivity to grasp and hold the presence of the past, of history, of the men and women who lived, loved, worked, suffered and died in this castle. In the castle of Marialva, the traveller felt a great responsibility. For a minute, and so intensely it became unbearable, he saw himself as the meeting point of past and future. May whoever is reading these lines feel the same thing, and then tell me how it felt.

Malva, María Alva, Marialva. The traveller spent almost all the rest of the afternoon roaming among its stones and streets. Old Alfredo Brígida appeared to point out, as if they were secrets, the gunpowder store, the engraved stone at the castle entrance, the ship's prow formed by one of the towers. Then he took him to the village to show him other ancient things, people's faces, the church of Santiago, the tombs cut directly into the rock as in Moreira de Rei. The sun is setting. The castle is glowing with light on one side, is submerged in cindery darkness on the other. The traveller is on his own again, he climbs the streets once more, and by now is an old acquaintance of the inhabitants: "Hello; back again, are you?" He goes into the castle again, into its darkest corners, as if hoping to hear some kind of revelation, some final explanation.

He has to leave, finally. He is out on the plain again, with the sun shining level with his eyes. Something has grown inside him since his visit to Marialva Castle. Or perhaps the castle is going with him, and makes him seem bigger than before. Anything can happen on journeys like this.

He makes his way back slowly. He drives through Póvoa do Concelho with the last of the daylight, gets a glimpse of the Casa do Alpendre, and by the time he reaches Guarda it is night. It is time to have dinner. And since man cannot live by castles alone, nor from the tears that well up in his eyes, he would like to mention here the splendid *chouriçada a moda da Guarda* that he ate. And with it, a small protest and a wish: that this chouriçada become known as *ao modo* da Guarda, in good plain Portuguese. The traveller can accept that Malva becomes Marialva, but not that the dish is called *moda* and not modo, as it should be. Modes are for fashion, modo is the Portuguese way.

12. Gonçalo Eanes Bandarra, a shoemaker from Trancoso who lived in the sixteenth century, made prophecies of biblical inspiration which said that Portugal would one day be free from Spain and have its own king. Bandarra was imprisoned by the Inquisition, and died in jail. In the next century, during the struggle for independence from Spain, his prophecies became famous throughout Portugal.

A Grain of Corn Away from Being Lisbon

The traveller is a river-hopper. Solely in this part of his journey, on the way to Vilar Formoso he crosses a tributary of the River Noemi, the Las Cabras River, the River Pínzio, the Las Cabras once more (a river pushed northwards as the Mondego was pushed south), and meanders for a while along the banks of the Los Gaiteiros and the River Coa. This is without taking into account the thousand smaller streams he crosses which, depending on the weather, are either dry or wet. As this is March, there is water everwhere, the riverbanks are flourishing, today there are more clouds in the sky, but they are high and light, there is nothing to fear from them.

The first stop today is Castelo Mendo. Seen from afar it is a fortress, a place surrounded by walls, with two towers at its main entrance. From close up, it is all that, but also there is a great neglect, the melancholy of a dead city. Town, city, village. It is not easy to classify somewhere that is all these things at once. The traveller took a rapid look round. He went to the old court-building, which is being restored and where only the thick porch columns are worthy of note. He went into the church and came out again, saw the tall pillory, and on this occasion did not feel like talking to anyone. There were some old people seated in their doorways, but they gave off such an air of sadness that the traveller felt uneasy. He left, noting the wild boar on the coat of arms guarding the main gate in the walls, and continued on his way. A little further on, he could not visit Castelo Bom, as he had planned. Sometimes his own lucidity depresses him: he looks at himself from outside, critically – here you are, on a journey, and life can be so hard.

Between Vilar Formoso and Almeida there is nothing to see. Flat lands that give the impression of being abandoned. This must be wrong though, because it is unbelievable that such vast expanses should not be cultivated. But this part of the Beiras seems deserted, perhaps because it was border land, always being invaded.

Almeida is its fortress. The polygonal design of the fortifications, the outline of the forts, the line of the ditches, could best be seen from the air. But even from the ground the traveller gets a good impression of the whole

by walking round the walls and estimating their height. They are built for other times, other wars. People fought close to the ground, and although bombs were lobbed through the air, they were not powerful enough to destroy the arches of the gates. Those were wars of ants. Today, Almeida is as much a museum piece as a halberd or an harquebus. And the town itself, with its sober, calm air, only serves to accentuate this feeling of distance.

Now the traveller heads for Vermiosa. He wants to reach the frontier with Spain, to see what it is like here. The fields are big, coloured green and earth-brown, and stand out from afar. Vermiosa does not stand out though: its streets are dirty, there are few people around, it gives the impression there is no-one behind its doors or windows. What saved Vermiosa was the bewitching scent of a mimosa on the hillside, giving off what seemed like the essence of nature. The traveller climbed to the church, and no adult or child came to ask him for news of the world or to tell him about the village. He was all alone visiting the interior of the building, constructed on arches like the huge ribs of a whale, and then went to see the sacristy, where he appreciated the unusual octagonal roof paintings.

Then he made another mistake, and did not go straight to Escarigo, the next town. Instead he took a long detour and went through Almofala, which did not have much to offer, apart from a cross just outside it on the road the pilgrims used to take on their way to Santiago de Compostela. This monument is made up of a series of crosses on top of each other, decorated with the typical pilgrims' scallop shell and other liturgical motifs. There are also the remains of a Roman temple, later modified and inhabited by monks, on a knoll at some distance from the main road, but the traveller did not get out to look. All this is before Almofala, close to the bridge across the River Aguiar. Later, the traveller regretted not having left his car: it went against his custom of putting his hand on each stone to be sure what it was made of. The eyes are all very well, but they cannot reach everything.

When he reached Escarigo, he had a long struggle. Not to get into the town, of course. There were no barriers, and if there had been, they would have been on the Spanish side; but they did not even ask to see his papers. It was plain however that this was international territory. Three Spaniards from the village of La Bouza were in town, talking to the Portuguese in a tongue that was neither theirs nor ours, but seemed like one of those languages especially made up to poke fun at foreigners. Nor was it hard to ask the magic question: "Can you tell me where the church is?" Sometimes there is no need to ask, because one can see the belltower, the steeple, the spire, the roof, or whatever else the top standing out above all that is below is called. But in Escarigo,

which is full of ups and downs, it is worthwhile asking, if you don't want to waste time.

The church is shut. No need to panic, this has happened before. He goes and knocks on a nearby door, explains what he wants, he is directed to another house. In this one, no living soul responds. The traveller returns to the first place: the person he saw is no longer there, and he almost believes he dreamt the whole thing. He is standing there wondering about it, when the providential child who cannot hide the truth passes by. The traveller asks him, and almost gets his answer: that is, he does not get it first time around, but finally does. If anyone thinks this is rather complicated, here is the dialogue that took place: "Please, is this where the church key is kept?" "Yes, sir, but it's not here at the moment." This from the woman who came to the door. The traveller looked thunderstruck and returned to the attack: "If it's not here, where is it? I've come from far away, I heard how beautiful the church of Escarigo is, and you mean to say I have to leave again without seeing it?" The woman replied: "That's a shame, but the key isn't here. There's another one in that house over there." The traveller obediently follows the direction she is pointing in, and sees a tall two-storey house about two hundred metres away. To get there, he will have to go down one street and up another, but the traveller does not baulk at such challenges. He is already halfway down the first street when he hears someone calling out behind him. It's the same woman. "Sir, sir, come back here." He climbs back up the street, thinking he is about to receive some more precise information, but to his surprise he sees the woman is coming down towards him with key in hand to show him the church. There are times when the traveller has to accept the world as it is. Here is a woman who knew from the outset that she had the key, and yet denied it and sent him off to find another one which, if it existed, was about two hundred metres away, and then called him back, just as if nothing had happened, as if the traveller had only just arrived and asked: "Do you have the church key?" "Yes, sir, I do." I defy anyone to understand that woman.

Now there are two of them. They make peace without ever having declared war, and are the best of friends. The church boasts a Baroque altarscreen that is among the finest the traveller has seen. If it were all in the standard banal gold colour, it would not merit more than a glance from anyone who was not a specialist. But the polychrome effect of the sculpture, with its red, blue and gold, its touches of green and pink, is so harmonious that one could spend an hour looking at it without growing tired. Four pelicans hold up the throne, and the door of the tabernacle shows a triumphant Christ surrounded

by angels and scrollwork. And the angels bearing torches kneeling beside the altar, decorated with huge flowers and palm fronds, are a wonderful example of popular art. One of the figures is a very famous St George, who has neither sword nor lance, but is trampling on the head of a snake-like dragon. In a side chapel there are columns with two very beautiful angels' heads in high relief. The traveller also admires the roof of the main chapel, but his gaze is more drawn to two small panels which adorn another altarpiece. These show an Annunciation and a Visit of the Virgin to St Anne of such pure design and knowledgeable composition, even though naive, that the traveller does not regret having come such a long way and to have had such a struggle to find the elusive key. Now here he is in conversation with a damaged St Sebastian in the sacristy, perhaps the first one he has felt any affection for.

The two women have gone back to their daily lives. The traveller walks across the village, says hello to a young girl. She replies, an old woman joins in, and before long the three of them are talking about hidden treasures. The old woman was saying that in days gone by, when there were wars against the Spaniards, the well-off people in Escarigo used to hide their money in holes in the ground among the rocks, marking the place with drawings of a cat for example. "But if the Spaniards stayed for a long time, the vegetation grew, so that when the people finally went to recover their hidden money, they couldn't find the cat. There's hidden treasure all around here." As the younger generation always does, the young girl smiled a dubious smile. But the old woman insisted: "Escarigo is not much to look at now. But it used to be a real city, it was the capital of the region." Then the young girl took up the conversation again, still smiling, but now with a smile anticipating the effect she was going to produce: "Around here they even say that Escarigo was a grain of corn away from being Lisbon." The traveller smiled too, and said goodbye, reflecting on the importance of a single grain of corn, which weighs so little, and is of so little importance, but which had meant that in the end Escarigo was Escarigo.

He went through Almofala once more, and further on noted a cross marking the spot where a border guard had died – it must have been something to do with smugglers, who have always abounded in this frontier region. It is not far to Figueira de Castelo Rodrigo, but first the traveller has to see the convent of Our Lady of Aguiar, or rather the church that is all that remains of it. The church is as cold as all heavily restored buildings are, made worse in this case because the interior is completely bare. This unadorned Gothic is rapidly done with, but in the sacristy there is a marble Nossa Senora de Aguiar, with traces of gold, blue and red paint which is

worth seeing. The Virgin is crowned, and in her left hand holds a broken wheel. The attendant, not a great one for attributions, calls it a machine-gun, and it was with this weapon that the Senhora de Aguiar is said to have helped defeat the Spaniards in a battle which cannot have been Aljubarrota. Anyway, it is hard to believe that someone with such a soft face and gentle gestures would have been capable of firing such a deadly hail of bullets at people who are always as dedicated as the Portuguese in their devotion to the Virgin.

The traveller had lunch in Figueira de Castelo Rodrigo. Afterwards he went to see the parish church, worth the visit for the angel musicians around the main altar and above all for the arch in the choir, made up of S-shaped stones, and considered unique in the whole country. The construction is a real Columbus' egg: each part encloses the next one, so that the whole is kept firm and stable by the simple force of gravity. Of course, the wedge-shaped insertions also help in this, but the arch here gives an impression of strength not found elsewhere. It's strange that the technique has not spread.

Castelo Rodrigo is on a hilltop close by, but the traveller is heading first to Escalhão on the Barca de Alva. He was expecting an out-of-the-way village, but finds instead a good-sized town, with broad streets and lofty trees in the main square. The parish church key is in the prior's house, and the traveller is given it without any of the Herculean labours he had to undertake in Escarigo. The traveller cannot enter the sacristy, where it is said that there are some fine frescoes, but is able to visit the church at his leisure, which makes the day worthwhile. It is an ample sixteenth-century building, with a fair number of interesting artworks. There's a small Baroque group in which the angels' heads serve as pedestals for the Virgin and St Anne, who are depicted as two friendly neighbours having a conversation, each one seated on her own bench, dressed in swathes of decorative clothing. And a St Peter, whose doleful face shows just how much remorse he is feeling in his soul, while at his feet stands the cock, crowing away as if his life depended on it, painted with a naturalism that brings a smile to the face. But the most magnificent thing in Escalhao church are the two Flemish – or Flemish-inspired – bas-reliefs, painted in dark hues, and showing the ascent to Calvary (with in the background Christ being scourged) and the Entombment. The treatment of the folds of the shroud in this is admirable, as are the composition of the figures and the serene, absorbed expression on the faces in both of the reliefs. Three medallions on the side of the tomb show human figures: the two end ones are bearded men, while the one in the middle shows a child or a woman. And as the traveller is always attracted by mysteries, even when he cannot solve them, he leaves the church wondering why there is that half-hidden face

behind the winding sheet in which the Christ is being lowered into the tomb. Once the body was lowered, we would know who it was. But we have arrived too soon to find out.

The traveller returns along the way he came and finally climbs to Castelo Rodrigo. As he does so, he can see the Marofa mountain and all the wild landscape around it. Seen from afar, with its cylindrical towers, Castelo Rodrigo looks like the Spanish city of Avila. The traveller, who has seen posters and photographs of Avila on many of his journeys, is surprised the Portuguese officials cannot do the same for the walls of this town. This and more sombre reflections still occur to him as he enters the walls and sees the melancholy streets with their houses in ruins or abandoned by those who once lived here. It may be true that mountain cities are bound to lose vigour as their inhabitants head down for an easier life and more possibilities of work in the valleys, but what is harder to understand is that people can look on indifferently while what is merely depressed is allowed to die, instead of making an effort to find fresh stimuli and energy to help renew them. One day we'll find a balance to life, but by then it will be too late to recover all that has been lost in the meantime.

At this hour, on this day in March, Castelo Rodrigo is deserted. The traveller has seen barely half a dozen people, all of them elderly: women sewing in their doorways, men staring out ahead of them, as if they were suddenly lost. The man showing him round drags along a lame leg, and endlessly repeats the same refrain that he has obviously not properly understood: this is his worst way to earn a living, and he is not up to it. The traveller travels, but does not go in search of dark thoughts; and yet they come to him here, they hover over Castelo Rodrigo: desolation, infinite sadness.

This is the church of the Reclamador, which despite appearances has nothing to do with protesting. Reclamador is simply the local version of Rocamadour, a French pilgrimage site, the abbey where it is said the relics of St Amadour are to be found, and where there is a church – or so they say – which contains the famous Durandal, the sword belonging to Roland, paladin and nobleman of France. The stories have come down through many centuries. This church was founded between the twelfth and thirteenth centuries, and although little remains from that period, the building gives off a Romanesque atmosphere as strong or even stronger than the traveller felt in Belmonte. This low building, curled up like a crypt and equally mysterious, has resisted everything added to it in later years. And if the church contained no other ornaments than its stone St Sebastian and its ingenuous

wooden St James, they would make the climb to Castelo Rodrigo worthwhile.

It's as if the town had been struck by plague. Its coat of arms has the royal arms upside down – a punishment, apparently, for the townspeople having sided with Doña Beatriz of Castile against Don John I. And not even the fact that a later generation showed its patriotism by setting fire to Cristóvão de Moura's palace was enough to win them pardon for the earlier error: the royal arms were upside down, and they stayed that way. Castelo Rodrigo needs to take stock of its own arms and to fight for its life: that is the advice the traveller leaves it, the only thing he can offer.

It was the same as when he had left Marialva. When one is deeply affected by something, one looks inside oneself and scarcely notices the landscape and all there is to be seen. But the traveller did visit Vilar Turpim to see the Gothic church and Dom António de Aguilar's funeral chapel. He would have got a better view but for the enormous statue of the Easter week Christ in front of it, which meant he had to risk life and limb to find a proper perspective. The fraternity could have found a worthier place that did not spoil the worth of the rest. Dom António inside the chapel will not mind, of course. But those outside do.

5

New Temptations of the Devil

Without meaning any disrespect to Fornos de Algodres or Mangualde, the day leading to Viseu was uneventful. If he can, the traveller will return one day to these and other doors he has left unopened by the wayside. He can only hope they don't call him to account for today's lack of interest.

He had a long-held memory of a special rice dish of the region that stirred his appetite, especially as he was due to arrive just in time to eat. Which in the end he did, but only to find something unmemorable in a place he would prefer not to mention. Mishaps like this are bound to happen to those who travel, and are no reason for taking a dislike to the places they occur in. But it seemed he was tempting fate when he got to the Grão Vasco Museum and found it alternately lit then plunged into darkness, because of problems with the electricity. There was work, alterations, repairs, being carried out on the first floor and, despite everything, he had to be grateful for the attendant who went with him, switching the light on in front of him and off behind him, so that there would not be an overload and the whole system blow the fuses, which did in fact happen once or twice despite all the precautions. Eating badly and then seeing badly. No wonder the traveller departed in such a bad mood.

The Grão Vasco Museum is in the old Bishop's palace known as Três Escalões or Three Steps. I mention this not from any great topographical scruple, but because it is right to know the beautiful names some things have, like this building, which is as beautiful inside as it is out, with its massive shape and the ecclesiastical decoration of the lower rooms. The eighteenth-century decorators had a good sense of colour and design, even when they had to accept the strict conventions imposed by the Church. Some Baroque and Rococo flourishes managed in spite of everything to insinuate themselves into these ceilings, which are a delight to the eyes.

If the museum is called the Grão Vasco, let's see the Great Vasco. Everyone goes to look at his St Peter, and so does the traveller. He wishes to state here however that he has never understood the chorus of praise this painting elicits, and still does not. Doubtless it's an impressive panel, and it's true that

the robes of the apostle are magnificently treated, but to the traveller these are external virtues, and can be found also in the side panels and in the predellas. It might be said that this is more than enough, to which the traveller would merely reply that the best of this St Peter lies not where it is usually sought, and leave it at that, if anyone is interested.

Despite this, he would like to make it clear that he has no quarrel with Vasco Fernandes, as is shown by the high esteem in which he holds the panels of the Life of Christ from the Cathedral. These are fourteen scenes painted with a sincerity and expressive talent rare in the artworks of his day. Here Vasco Fernandes takes every opportunity he can to show he is a landscape painter. It is plain that he could look at distances and see how to integrate them into the composition of his painting, but the observer can also easily isolate the landscapes and realise how valuable they are in their own right.

In order to view the panels, the traveller had to step over some youngsters sitting on the ground while they were instructed in the religious message the paintings contained, thankfully by a teacher who did not conceal the value of the painting in her need to catechise. And since catechising some-times prefers to make use of dreadful artistic examples, let this lesson from Viseu stand as an example of a good teaching method.

The remaining exhibits in the museum would need a detailed and lengthy description. The traveller would simply like to point out the excellent collection of paintings by Columbano, the great number of paintings by water-colour and naturalist artists, two canvases by Eduardo Viana, some ancient sculptures and panels from the sixteenth and seventeenth centuries; in short, there's a lot to see. Always providing, of course, that the light doesn't fail.

To reach the Cathedral, all he need do is cross the square, but the traveller wants first of all to give his eyes a rest, to let them gaze at ordinary things: houses, the few passers-by, the streets with their enticing names: Arbol Street, Chão do Mestre, Escura and Direita Streets, Formosa Street, Gonçalinho Street, and Paz Street which, with its peaceful name, wins his vote. This is the old part of Viseu, which the traveller walks round slowly, with the strange impression that he is no longer in this century. This must be something subjective, because the old town is not so extensive as to sustain the illusion of having returned to the reign of Dom Duarte, whose statue he passes, and even less to the time of Viriato, whose bronze image stands guard outside what was once a Roman cellar. If the traveller does not take care, he'll end up a Visigoth.

And here at last is the cupola of the knots, an extravagance due either to the architect who proposed the idea or to the Bishop who required it: the traveller is not really concerned who was responsible. He is such an admirer of lines justified by necessity that he cannot see the reason for these imitation knots. It is taking the sixteenth-century love of ropes too far to make them into Manueline decoration. The traveller has no doubt that any tourist would be bowled over by them, and he asks of his coat buttons exactly what it is that would bowl the tourist over. As on other occasions, his buttons gave no reply.

Here comes someone he could ask. It's the Cathedral guide, a talkative sort who fusses about, rushes around, allows no doubts or questions, and frogmarches the traveller from church to cloister, cloister to sacristy, sacristy to treasury, from treasury to street, all the while making jokes and puns: he opens a window and says "Alfama", opens another and says heaven knows what, trying to point out similarities with other places in Portugal and elsewhere in the world, goodness gracious, what kind of guide is this? As a result, the traveller couldn't ask a thing, and cannot remember what he heard, but making an effort he drags something out of his memory, dusts it off, as follows: the eighteenth-century tiles in the passageway to the sacristy, those inside it, the tall choir and its sculptings, the Renaissance floor in the cloister, the Romanesque-Gothic door recently discovered, the Moorish roof on the Calvary chapel. It must be a good memory to have resisted such a guide.

The Cathedral treasury brought out all the guide's worst gossip. The traveller has no wish to bear grudges, but one day he'll have to return to see what he was barely allowed to glance at, not because of any physical problem this time, but due to being bemused by this hopeless charlatan. The next time he hopes either it will be a different guide, or if it is the same one, that he keeps his mouth shut. He plunges again into his outraged memory, and brings up the confused images of a San Rafael and San Tobias, attributed to Machado de Castro, the rich Limoges chests, and a general impression, a vague idea that the Cathedral treasury contains a collection of valuable items harmoniously displayed. The traveller would not mind learning the rigmarole and becoming a museum guide here himself. He would have at least one virtue, even if he lacked more important ones: he would not crack any jokes.

The traveller left Viseu the next day. In a bad mood. He slept badly because his bed was uncomfortable, he was cold because the heating didn't work, yet he paid as if everything had been fine and had worked. It's obviously only

an advantage to be called Grão Vasco if you can paint. But the road to Castro
Daire is very beautiful. As he passes through hills and woods, the traveller
becomes reconciled with the world: there's no chance of the Cathedral
guide turning up, because he was careful not to tell him the direction he was
headed in. Now he's driving down towards the River Vouga, its clear waters
coursing down towards the sea, although before they reach it they will flow
into a huge estuary where the traveller vaguely remembers something being
left, perhaps a boat on a sandbank, the flight of a seagull, a line of mist in
the distance – but the land he is in now is, as he has said, all wooded hills.
The road turns bends, rises a little, then descends, and thanks to this the
traveller realises that it's uncommon to have the real feeling as here that one
is surrounded by hills: they are neither too far away nor too close up, we
can see them, they can see us.

The traveller is musing on discoveries such as these, and suddenly realises
he has a river alongside him. This is the River Mel, a mountain spring
frothing over stones in between green terraces and perched houses, with trees
higher up, and above them on the skyline boulders that stand out from the
bright blue sky. This River Mel is a beautiful place in the Beiras, a beautiful
place anywhere in the world. The traveller believes he knows something
about rivers: the Tagus here, the Duero there, the Mondego that bathes
Coimbra, the Seine flowing through Paris, the Tiber through Rome, and then
there is this river with its sweet name, *mel* or honey, the beauty of flowing
water, vegetation protected by walls of slate. If he could, the traveller would
sit here until nightfall.

But this region spoils him for choice. Where there was the River Mel,
now there is the even deeper ravine of the Paiva, sunk in a circle of mountains
that the road continues round until it reaches Castro Daire at the top. Its
inhabitants may lack for many things in life, but they will not lack beauty
as long as this river is cascading down in front of their eyes, or they can lift
them to the hills opposite. The traveller is looking for the chapel at Paiva,
but is so absorbed that he follows the road down to the riverbank, well
beyond what he is looking for. In Pinheiro he is told: "It's back up there," and
looking back, the bends of the river almost make it seem as though it's on the
far bank. He turns round, finds the steep track up to a narrow terrace, and
continues on foot.

He hears the sound of running water once more. The traveller walks along
gaily, on his right an almost vertical rock wall, whose summit he cannot see,
while on his left the ground falls away gently down to the river, which is also
invisible. The chapel comes into view on the upstream side. It's so small that

at first it looks like a house where a family might live. What the traveller knows about it is that it was founded in the twelfth century by a friar of the Premonstratensian Order, called Brother Robert. The traveller, who has learnt that in its early days the order was an austere one and did not even permit its friars to eat meat, can imagine how hard it must be to live in this remote part of the world and have to endure such abstinence and cold weather so ill-equipped. Eight centuries have gone by, and there are still people who suffer from the cold and rarely taste meat, but with no promise of reaching heaven.

The mediaeval masons always left their mark in the masonry of the churches they built, distinctive signs that are impossible to identify now. Usually you can pick out one here, one there – any traveller with sufficient imagination can picture the scene: the mason patiently tracing his own signature, carefully tapping with his chisel to make sure the line is just right, a final flourish. But the chapel at Paiva is literally covered with these signs, which leads the traveller to wonder: can they really simply be distinguishing marks made by the stonemason? And if so, why were so many of them employed on this building, which is of no great size? Might all this not be another language, another way of communicating? This is probably mere speculation, idle questions, but it would not be the first time that a modest traveller, simply by looking and seeing, stumbles on some important discovery. It would be amusing.

The traveller went back to Castro Daire, on and up out of the valley, and then found himself on the other side of the Montemuro range. Here the landscape was totally different – arid, strewn with *barroco* boulders, scrubland, the ashen bones of the hills laid bare. As if the face of the world had changed in half a dozen kilometres.

Sometimes the traveller feels the mild temptation to do this journey on foot, knapsack on his back, stout stick in hand, water canteen on his hip. These are simply memories of adolescence, nothing more. But if he had, he would have found other names to include, and would have said that from the chapel at Paiva he climbed to Picão, from there to Moura Morta, or to Gralheira and Panchorra, or to Bustelo, Alhões and Tendais – all places he in fact never visited. As it is, his car journey includes another good crop of names, from Mezio to Bigorne, Magueija, Penude, and at the culmination of this stage, São Martinho de Mouros.

The traveller is looking for the parish church. It is to one side of the road, facing the valley, and standing there as it does, braving the winds, it is easy to see that it was built more as a fortress than as a church. Its solid door and

sturdy wooden bars would defeat any Moors who attacked it, as Fernando Magno, King of León, did in fact defeat them here in 1057, still almost a hundred years before Portugal came into existence. Proof that this church was designed as much to be a fortress as a house of prayer lies in the plain, thick, buttressed walls with only narrow window openings. And the tower, set back from the vertical line of the walls, must have been a lookout post, open to the four cardinal points. In order to see it, and even then not in its entirety, the traveller had to walk back to the far side of the village square. Definitely a tower to be taken seriously.

The traveller has never seen a church like it. The overall rigidity of its Romanesque conception left a lot of room for invention. To place such a tower on top, and then resolve the structural problems that this created, to reconcile the solutions of this particular challenge with the whole, and to make the final outcome aesthetically pleasing (so that today we find it so magnificent) suggests that the master mason had a lot more tricks up his sleeve than was normal among the builders of his day. Then when the traveller entered the church, he was amazed to discover how they had supported the tower: on a series of columns just inside the entrance, making a kind of internal atrium that creates a unique effect. The church can boast few real works of art. Two panels with scenes from the life of St Martin, an enormous figure of Christ, and little besides, apart from some naive holy paintings busy gathering dust and cobwebs high on one wall. The traveller was scandalised at this neglect. If in São Martinho de Mouros they don't know how to look after such fine examples of rustic images, then they should hand them over to a museum, which would take care of them. As he leaves the church, the traveller will tell a woman, a chance passer-by in this lonely desert, of how indignant he is at this and other things, couching his anger in terms of advice, because abandoned as they are, the images are within easy reach of greedy fingers. Only the traveller knows what an effort it cost him to resist the fresh temptation of the devil when he visited him in the empty church. He gave the poor woman such a fright that nowadays there's probably a high wall around the church that people can only enter after a thorough examination of their conscience, and can leave only after having their baggage checked.

And there are other temptations in São Martinho de Mouros. They would not all fit into the chapel at Paiva, but came down here, brought by the prayers of the friars, or rather the materialisation of the earthly dreams of the Augustinians who preached the mortification of the flesh on the banks of this beautiful river. In the altarpieces, the female body is depicted with an

athletic opulence that is almost Rubensesque. There is no hiding or disguising their breasts: they are round, shapely, thrust forward and brightly coloured so that there can be no doubt about the morality in heaven: it's plain at last that there are angels of both sexes, and the age-old, absurd question is resolved. The body is glorified. The figures may exist only from the waist up, but the temptation is absolute.

All of which gives the traveller pause for melancholy reflection as he approaches Lamego. His mood is so obviously opportune that the sky decides to join in too, and is soon covered with heavy, ash-grey clouds. Soon afterwards, a light drizzle that hardly even touches the ground starts to fall, a veil of gauzy mist that covers the hills, sometimes visible, more often not. There must be great confusion up among the stars, because a little further on the sun comes out again, and in Lamego itself there's no sign that it has rained or is about to. The traveller found lodging then went out into the street again.

Lamego is a small, quiet, peaceful town with kind and friendly people. When the traveller enquires where the church of Almacave is, not one but three people offer to tell him – and fortunately, they all coincide in their information. The traveller already knew part of it, and it had saddened him: its museum is not open to the public, as it has been undergoing repairs for over a year. And as he is feeling sad, he decides to leave the Cathedral for the next morning, and to clear the clouds from his soul by visiting the top end of town, Almacave, which is on his way. It turned out to be a good idea, not so much for the marvellous art he saw, as that was only average, but for the marvel of a middle-aged man, obviously the worse for wear from drink, who came up to him and asked: "Are you from here?" The traveller could see at once who he was dealing with, or thought he could, so he replied patiently: "No, I'm just visiting." "That's what I thought; but tell me, have you already found a hotel? I saw you walking along with such a long face I thought you must be looking for somewhere to stay." The traveller replies: "I've already got a room. There are other reasons for my long face." "Why don't you come and sleep at my place then? There's a clean room, and a warm and comfortable bed – my wife makes sure of that." "Thanks a lot, but as I said, I already have a room in a hotel." "You're making a mistake. It would save you money and you'd be in a friendly house." At this point the man paused, looked hard at the traveller and said, "I know I'm drunk; wine loosens my tongue, but the invitation is a sincere one." "I'm sure it is," the traveller replied, "and I thank you for it. To come to Lamego and find someone who offers me a roof over my head without

knowing me is incredible." The man clung on to a lamp-post and simply said: "I believe in God." The traveller weighed up the importance of this declaration and replied: "Some people believe; others don't; that doesn't matter, so long as they get on as people." "So long as they can," the man echoed him. Then, after thinking this over for a while, he added: "It's not important. There are some who don't believe who are better than others who do." So saying, he held out his hand to the traveller. This happened in Lamego, and the drunk then carried on down the street. As for the traveller, he made his way up it, with as clear a head as he could muster.

King of Cards

It rained during the night; not the meagre drizzle of the previous afternoon, but a real honest-to-goodness downpour. But the next morning was clear and sunny. Perhaps that was why the traveller did not spend long inside the Cathedral. He liked the discreet Manueline façade, and the disposition of the porticos, which were imposing without being overwhelming, but the architecture inside seemed to him cold. If, as is said, it was Nasoni who oversaw this project, it must have been one of his off days. What is striking, in the traveller's view, is the rich decoration of the cupolas, and their tapering design, and the truly magnificent polychrome effects in the biblical scenes represented. There is a small, quiet cloister that seems more suited to the murmur of young girls' voices than to any dramatic religious meditations.

The traveller then went to the shrine of Nossa Senhora dos Remédios. This reminded him of the Bom Jesus church in Braga, although there were many differences. What was similar were the tall, wide steps up to the church, with at the top the promise, or at least the hope, of salvation. The rocaille exterior is worthy enough, but the blue and white stucco inside must weary anyone who has not come in search of the remedies offered by Nossa Senhora. What the traveller really appreciated was the theatrical alignment of the porticos at the lower end of the staircase. Here, the statues of imaginary kings on pedestals reminded him from the side of the figures of the prophets carved by Aleijadinho in Congonhas do Campo, in Brazil. Not that the traveller can pride himself on having been to see them, but photographs have made them world-famous, and you have to make an effort not to have seen them.

But what he is sad about not seeing, even for a minute, is the "Creation of the Animals" by Vasco Fernandes, in the Lamego Museum. He would have loved to see that marvellous white horse which is lacking only the sharp spiral horn to be a unicorn. It's possible that God Almighty may finish the job one day, when we're not looking. As he sets out for Ferreirim, the traveller promises himself he will return to Lamego: it was here he met a man who offered him a roof over his head, and he is sure he will meet the unicorn. The one is no more uncommon than the other.

Ferreirim lies in a valley near the headwaters of the River Varosa. It has its own gentle beauty, with line after line of trees and narrow footpaths leading off among them, as though the landscape were a series of transparencies that change as the traveller advances through them. The same feeling dominates throughout the entire journey to Ucanha, Salzedas, Tarouca and São João de Tarouca, in what is one of the most beautiful regions the traveller has experienced, with above all a rare harmony between the land and agriculture, human dwellings and the natural habitat. There is every good reason to go to Ferreirim, but in general just one is enough: to see the paintings in the parish church. These are eight panels painted by Cristóvão de Figueiredo, assisted by Gregório Lopes and García Fernandes, usually known collectively as the Masters of Ferreirim. That is what has brought the traveller here. He arrived, found the church locked, and tried a door to one side. Fortunately, someone appeared: a man in a brightly-coloured woollen shirt and rustic trousers. "Yes, I can show it you." He disappeared back inside, took far too long for the impatient traveller, but finally re-appeared with the key in hand. They entered the church by a side door, with no ceremony. "Take all the time you wish." The traveller tours the nave, lingering in his contemplation of the admirable panels, the only problem being they are placed far too high up. As he moves around, he talks with his companion, who is obviously well informed on the church's treasures. It's a pleasure to meet a holder of the keys of this sort. They continue talking animatedly about the Renaissance tomb and the remains of an arch embedded in one of the church walls. The traveller has not only been accumulating bitter experiences of theft since leaving Miranda do Douro, but has had to struggle with his own temptations, and so uses some pretext or other to make a serious accusation: "Sometimes it's the priests who are to blame. They sell valuable images – ones that are invaluable in artistic terms, simply to buy all these kitsch, modern horrors that fill our churches." The traveller is right about these monstrosities, his companion agrees, but when it comes to the priests: "Don't believe it. It's much more that there are some young sacristans who want to get rid of the old images in return for five hundred miserable escudos. By the time the priest tries to sort it out, it's too late."

At this, the traveller's heart skipped a beat, but he decided not to attach any importance to it. He finished looking round the church, and when they got outside the keeper of the key wanted to show him the remains of the arch that had begun their debate. As they got to talking again, he said: "I always had my doubts that this was an entrance. The other day the Bishop of Porto was here, and when I was explaining my position, he said to me: 'Look,

father . . .'" The traveller did not hear the rest. His heart had been right. The keeper of the key was the priest of Ferreirim. He had been forced to listen, with evangelical patience, to the traveller's tirade about true or rumoured misdealings in holy images. So the guide's artistic knowledge had its explanation. Everything had its explanation, but nothing was said. The traveller said goodbye, leaving a contribution to the upkeep of the church in an attempt to erase the slight to the good father, and taking with him the suggestion that he visit the nearby village of Ucanha. Just think – no tonsure, no priestly garb of any description. If things carry on like this, one day the traveller is going to run into St Peter himself with his keys, and won't recognise him.

Ucanha is but a step away. It is on the right bank of the River Varosa, spreading partly onto the far bank, and just next to the river is the tower for which it is renowned. It's an unusual sight in Portugal. The angular roof, high balconies supported on modillions, the twin windows, the low arch of the entrance, the general heaviness of the construction are not usually found in mediaeval Portuguese buildings. Anyone travelling through Italy would not

35 *Ucanha, the tower*

be surprised to find a tower of this sort. But in Portugal it comes as a shock. From down below, the traveller falls in love with the remarkable statue of a crowned Virgin, with the Infant Jesus in her lap, protected by an iron canopy. He gives thanks to the misunderstood priest at Ferreirim who advised him to come here. This is a region that values its own, as can be seen from the plaque here that commemorates the fact that it is the birthplace of Leite de Vasconcelos, one of Portugal's foremost ethnographers, philosophers and archaeologists, some of whose works are still fundamental. Leite de Vasconcelos left Ucanha before he was eighteen, with only basic schooling and a little French and Latin. To the traveller's mind, he also took with him advice he heard in the shadow of this tower, beneath the sonorous arch over the river, as he stroked the rough stones with his hands: seek out your roots.

The traveller enters Salzedas in search of its convent, and it is the convent which blocks his path. The traveller comes to a halt in the shade of a building so huge it climbs to the heavens, or at least so it seems to him. He's never seen such a tall church. This is probably the reaction of his eyes after the pleasure they took in the surprising way the tower at Ucanha achieved its harmony despite its weighty construction, but the traveller must accept what he finds, and try to understand why it is so. This is what he does in Salzedas, although in the end he saw very little, and in fact there was little to see, apart from the paintings attributed to Vasco Fernandes. If he did linger awhile, it was because of a wedding. The bride and groom, the priest marrying them, and all their guests still made only a tiny group in the huge nave of the church. The traveller's footsteps hardly even raised an echo, the priest's voice vanished into thin air; what noise there was came from children playing outside.

As we have seen, the traveller likes to daydream. While he was watching the couple getting married, he began to imagine a different kind of wedding: two people who came here on their own, walked up the aisle without saying a word, and did not need any priest to bless them. They were attracted simply by this huge arched space; they knelt down or not as the case might be, prayed or not and then, giving each other their hands, they left the church married. And it would be the same if they had gone up a hill and come down again, declaring themselves a couple. The traveller loses himself in this silly kind of supposition, and in doing so finds that when he returns to reality, the ceremony is over and he's all alone. He hears the sound of engines revving up outside; the children are shouting more loudly than ever; it must be raining rice over the happy couple, and here he is, sad and lonely because no-one has invited him to the wedding, even though he is full of such good ideas.

By the time he leaves the church, the square in front is deserted. The bridal

couple has gone, the children have gone; there's nothing more to be hoped for from Salzedas. But he's mistaken. He is just rounding the sprawling building that used to be the monastery, and passes by an arch giving onto some open ground, when out of the corner of his eye he catches a fleeting glimpse of a statue or person on the top of a wall. He stops and retraces his steps, looks up discreetly – he's hardly going to ask the person, if person it be: "What are you doing up there?" and finally sees that it is a statue. The statue of a king, to judge by the crown, of a Portuguese king, to judge by the five divisions visible on the shield he's wearing on his right hip, although badly damaged. This unknown Portuguese king is in full armour, with greaves, knee guards, breastplate, and coat of mail – but he's also wearing a lace ruff and pleated sleeves. He obviously dressed up for his portrait, and looks down from his pedestal with a friendly smile, as though after having reigned for a short while he's glad to stay where he is forever, because after losing his feet in heaven knows what exploit, he's now securely fastened by his stumps. He looks like a king from a pack of cards, and so he is in fact. The traveller asks some women passing by, who weren't invited to the wedding either, how long this regal figure has been there. "Forever," is the reply he was expecting and got. And it's the right one. For a butterfly born with the morning and dying before dusk, night does not exist; for anyone who has met this king of cards, the honest reply is "forever".

The traveller is in no great hurry to leave this region. He crisscrosses the main roads, passes through Ucanha a second time, and heads for Tarouca. Here he rather loses his way, and has to backtrack, confused perhaps by the tall mountain he can see looming in front of him, which he can't find on his maps: is it Montemuro, is it Leomil? Finally he stumbles across what he is looking for: the church of St Peter. He goes to look at the Manueline tomb, which is lacework in stone, with a filigree of columns and patterns, but surprisingly without any reclining figure – usually the dead patrons were only too keen to show it was they who had paid for the work. St Peter's is a Romanesque church, but to the traveller's mind is not outstanding. Perhaps it is simply that travel not only broadens the mind but makes it more demanding. Or perhaps the traveller is simply tired.

If he was, he recovered in São João de Tarouca. But before turning to its artistic treasures, the traveller has to mention something that happened when he rounded the last bend of the main road and came face to face with an earlier period of his life. It's just his memory playing tricks on him, he tells himself. But the traveller doesn't believe in tricks of the memory. Memory comes from seeing something and having it fixed in the mind. It might not

be a conscious memory, it may require an effort to bring it back, but the moment that this recollection can be "read" once more, that is what we will see, more or less precisely, and what we see is what we saw before. Everything we remember in this way is true, there are no tricks. The image may be confused, like the pieces of a jigsaw puzzle, but it is potentially possible to reconstruct it down to the smallest detail, the shortest line, the least-defined tone. The day mankind is capable of searching through all the images in its memory and classifying them, there will be no more talk of it playing tricks, although it may well be that we defend ourselves from this total recall by inventing false forgettings.

In spite of which, the traveller knows he has never been here before, knows he has never visited São João de Tarouca, has never crossed this tiny bridge, never seen these hollowed-out grassy riverbanks or the ruined building in front of him, or the arches of the aqueduct (and now, as he writes, he is not sure he has seen them this time either), this short incline leading firstly up to the church door, then down again to the town.

So if it is true that memory does not play tricks, and yet the traveller swears he has never been here before, then it must be that souls do transmigrate, that metempsychosis exists. The very same traveller who is standing here now, but in another body from whom he has inherited this memory in addition to all of his own. The traveller can insist that all of this is nonsense, that a dead brain is an empty one, that memories do not float on the wind to see who will pick them up, that even the collective unconscious is based on real recollections, and so on. And yet, knowing full well what he has to say "no" to, he is unable to discover just what he should say "yes" to. What he does know, beyond a shadow of doubt, is that he has already seen this image of São João de Tarouca: he must have dreamt it once, as he has dreamt of so many other landscapes for which he has so far not found any correspondence in the real world, perhaps simply because he has not visited everywhere. To say this would be to say that dreams, uncontrolled thought, the unconscious stream of images in the brain, can foresee external reality. This is a dangerous path for the traveller to take. In any case, it might well be that the soldier whose job it is to clean out the barrels of the cannons dreams of the way the cannon fires: here is the breech, here the piston.

The traveller loses himself in useless speculation once again. The problem is, he is given time to do so. The church door is locked, a young kid goes to fetch the key, and obviously is in no hurry. The traveller tries not to think any further about his conviction that he has seen this before, and starts talking to the twelve-year-old girl who is to accompany him. He learns about some

attempted robberies, and the way the church bell is rung to bring out the townspeople and chase off the would-be thief. The story is a true and moving one. For the first time in the entire journey, the village idiot joins in the conversation, and when he asks for some money, the traveller gives him some. The girl protests that he'll spend it on wine, and that when he's drunk he hits his mother, who throws him out of the house, and so it goes on. The traveller is caught up in his desire to see works of art: for him paintings, images, fine stonework, are everything, when all of a sudden life grips him by the arm and says: "Don't forget me." Embarrassed, the traveller replies: "But you are art as well." To which she replies: "Yes, but don't forget the village idiot."

Now at last the boy with the key appears. They all go into the church: the traveller, the twelve-year-old girl, three more kids. The traveller is afraid the visit will turn into bedlam, but he is wrong. The children are on their best behaviour, escorting him round; or perhaps they are keeping their eye on him, ready to run to the bellrope and summon the whole town. Whatever the truth of the matter, the fact is there was never a better-behaved group of children than those he met in São João de Tarouca.

In places like this, historic periods come and go like tides. The Romanesque period came in, and built the church; the Gothic arrived and added to it; if there was a Renaissance, it flowed over the church as well; the Baroque age did its damage; if the waves had enough strength and power of seduction as they swept in and out, they all left their highwater mark. So in this church we can see the carved, gilded pews, the painted tiles telling the legend of the foundation of the monastery, paintings by Gaspar Vaz, others attributed to Vasco Fernandes or to Cristóvão de Figueiredo. Here is a fourteenth-century angel, a Virgin in painted granite with the Christ Child on her shoulder from the same period. And here in the sacristy small wooden sculptures polished by time and use.

The tides all came and left their marks. As the traveller stands in the church's three airy naves, he can hear the waves of time and the voices of the men they brought with them, their chisels on the stone, the sawing and banging of nails in wood. He is carried on the crest of the centuries, and as it is his turn now to land on the beach, he comes to a halt in amazement in front of the sarcophagus to Pedro de Barcelos. This is a huge tumulus, with on top the reclining figure of what looks like a gigantic St Christopher who, tired of carrying the world around on his shoulders, has lain down to rest. Made from roughly hewn granite, this sepulchre to King Dinis' bastard son is one of the most impressive things the traveller has seen and experienced: inside this, the body of a real person would be as small as a boat on the sea, or a bird

in the sky. One of the sides of the sarcophagus has a bas-relief of a wild boar hunt. This seems odd to the traveller. Like all the nobles of his time, Dom Pedro de Barcelos would naturally have gone hunting, riding up hill and down dale in his pursuit of the prey. But the count's reputation, here in the Beiras where he spent the latter part of his life, was based on something very different. He was the compiler of the Livro de Linhagens, possibly also a songbook, probably a general chronicle of Spain; but instead of a great man of letters, the traveller is faced with this truculent giant, this bloodthirsty hunter. There's more than enough material here for a discussion of incongruities, but as the traveller is busy pointing out the mote in another's eye, he realises he should start with the beam in his own: it would be a poorer world if a poet were merely a poet, and everyone were exclusively what they seem to be. So Dom Pedro de Barcelos was quite right when he wanted to include among the scenes from his life those bright, fresh mornings when he was hunting boar on his lands at Paços de Lalim.

The traveller's visit was at an end. He wanted to give some money to the little twelve-year-old who had shown him round, but she wouldn't hear of it, and told him to give it to the younger ones. This is a day full of lessons to be learnt. The traveller thanks the girl as if she were an adult, looks at the landscape one final time to convince himself he has seen it before, and then the first seeds of doubt come into his mind: he cannot remember having seen the little girl.

By the time he reached Moimenta da Beira, it would have been too late for lunch, but for the good will of the owner. He ate an excellent steak with onions, something rare nowadays in Portugal, and if he did not look any further in the village, it was because his eyes were still full of São João de Tarouca. The road between Moimenta and São Pedro das Águias filled them again. Astonishment would scarcely be a strong enough word to describe it. No words in fact could do justice to the ineffable nature of its hills and ledges, the gentle transparency of the air, and then beyond Paço, when the road nears the River Tavora, the wooded slopes with their rocky outcrops. When he reaches Granjinha, he is completely confused because the name of São Pedro das Águias suggested heights where eagles lived, but instead he is embarking on a descent that drops further and further through tiny villages, and seems never to end. The traveller is almost made giddy by so much beauty, and when he does finally come to a halt, in the vast silence he can hear the rush of invisible water over rocks, and before him stands St Peter's chapel, and then he understands why it is called "das Águias", because in truth only eagles could overcome the vertigo of the towering peaks all around.

The traveller approaches the chapel. The first mystery is why anyone decided to build a church in such an out-of-the-way spot, lost among forests and mountains. There may be a road here today, but what were roads like in the twelfth century? How did they get the stone here? Or did they use the stone from the mountainside they dug into to build the chapel's foundations? And the second mystery is why Dom Gosendo Alvariz – if he really was the chapel's founder – chose to align it so that there is so little space between its façade and the rock face, just enough for a small supporting arch – although it's not clear to the traveller whether it is supporting the chapel, which doesn't appear to need it, or the rockface, which has not budged an inch in eight centuries. Was the tradition of aligning the façade of a church with the setting sun so strong in those days? São Pedro das Águias is a jewel that time has been nibbling and gnawing at on all sides. There have been other destructive fingers, but the real destroyer has been time: the wind that must whistle through these gorges, the beating rain, the scorching sun. In another two hundred years all that will be left of this suffering ruin will be a heap of random stones, vague inscriptions, indistinct shapes, blurred images in relief that future travellers will not be able to identify. This traveller has had his share of emotions: Rates, Rio Mau, Real and other places already mentioned in this book. But São Pedro das Águias fills him with a sense of tenderness, a wish to put his arms round its walls, to stay leaning his head against them, as if flesh could defend stone and defeat time.

It's mid-afternoon, he has plenty of time. But today the traveller decides he's had his fill of beauty. He doesn't want any new image to displace that of São Pedro das Águias. If he could, he would keep his eyes shut for the whole journey from here to Guarda, where he is to spend the night. He had to keep them open, of course, but however hard he tries, he can't remember a thing of what he saw. But in Guarda there is another mystery for him to solve.

Highs and Lows

The traveller is heading for the heights, which by definition must be the Estrela mountains. Yesterday was clear, bright, and sunny; today the sun is covered by low cloud and those in the know say it will stay that way the whole day. Despite this, he decides not to give the mountains a miss. If in Trás-os-Montes he could travel through fog and pouring rain, here he is not going to let a few clouds stand in his way, all the more so as it is now spring. It may be he will find himself in the mountains without being able to see them, but he puts his faith in the fact that one of those ermine gods who used to be worshipped in Lusitania and are now asleep, such as Endovélico, might awaken from their centuries-old slumber and open some gaps in the clouds for him to see their ancient kingdoms.

The traveller decides not to follow the highway through Belmonte. If he is determined to head for the heights, he should get used to them immediately. So he travels along the Vale de Estrela to Valhelas, and the horizon is always in view. Except when, as often happens, the road is very narrow. In these regions, there isn't a soul on it. But it is true beyond a doubt that the clouds are low. Up beyond the next bend, there's a line of pine trees whose trunks appear cut in two: the tree tops are barely visible, and if the traveller is not careful, the clouds would come right in through his car window. But the god he has invoked must be present, because by the time he reaches the bend, the clouds have dispersed, and the road is clear. It's too soon though to cry victory. The cloud, or bank of fog, or thick mist has simply withdrawn a little higher, and is lying in wait for him at the next peak, to leap down on the road again. The traveller is beginning to think it might not be worth the effort of travelling all round the mountains as he had planned, passing through Sabugueiro, Seia, São Romão, Lagoa Comprida and finally La Torre, then descending through the Penhas da Saúde to end the day in Covilhã. When he reaches Manteigas, he decides to ask for fresh advice. He's told: "We don't recommend it. It's not that the road is dangerous, but you won't see anything of the mountains. There's no problem with visibility on the road, but it's almost impossible to see the landscape." The traveller politely thanks

them for this information – that's the way we're taught to behave, to thank people even when we're told something unpleasant – and bends over his maps and guidebooks again. He calculates distances, measures contours, and decides to follow the River Zézere, passing first through the Poço do Inferno, which should be close enough not to be invisible, then take the road up to Penhas da Saúde. When the gods fail a traveller, he has to use his native wit.

If this is the Poço do Inferno, the Pit of Hell, we need to strictly revise some of the notions of hell we have inherited. Although these roaring waters cascading down might suggest hellish punishment, if there are no clouds beyond the ones draped around these rocky summits, then the traveller can see no reason why a condemned soul should not spend eternity gazing at this rushing waterfall, perhaps with the hope that every century or so a ray of sunlight might bring a sparkle to the foamy waters and caress his head in a kind of pardon. And if the soul in torment were eventually given a full pardon, then a similar pit should be provided in heaven, with its name changed accordingly. The traveller then takes the main road up along the river. He is making poor time: he had planned to sweep through the whole mountain range today, but will not manage even half of what he had intended. All journeys have their problems. But also their rewards, such as arriving at Nave de Santo António and finding the sky completely free of clouds. It seems that the gods are careful to clean out their lofty dwellings, but leave mere mortals to grope around down below, even when all they want is to get a glimpse of the landscape. The traveller feels hard done by. He heads for Covilhã and soon finds himself surrounded by cloud again. He decides to make the best of his situation: surely no traveller can have gazed so intensely at these fluffy white masses; or stopped at the roadside to feel himself immersed in them; or climbed out to sit under some pine trees and stare at the invisible valley, the great white sea. This is the right philosophy: everything is a journey. What can be seen and what is hidden; what can be touched and what can only be guessed at; the roar of cascading water and this fine blanket covering the hills. The traveller no longer feels hard done by. He rejoins the highway at peace with himself, and comes down from the heights to Covilhã. The mountains stand on high, but today they will not be seen.

The Town of Stone

When he was young, the traveller possessed a gift he has since lost: he could fly. But as this was something that set him apart from the rest of humanity, he only practised this art in the secret hours of sleep. He would steal out of his window in the early hours and fly high above houses and gardens until, this being a magic power, night suddenly became bright day, thus correcting the only flaw in his adventure. The traveller had to wait many years for this gift to be restored to him, perhaps only for one night, and then thanks to a last-minute dispensation by Endovélico who, unable to carry out the miracle of lifting the fog in the physical world, did so in the traveller's dreams. When he awoke, the traveller could remember he had flown over the Estrela mountains, but since dreams are said to be fickle, he prefers not to say what exactly he saw, in order to avoid the embarrassment of having no-one believe him.

He opened the window – or rather, pulled back the curtain and rubbed off the condensation that had formed there during the night, and looked out. The mountains were covered with clouds that looked even lower than those of the previous day; there was nothing to be done. The traveller could not put reality to the test to see if it fitted in with the reality he dreamt. So he resigned himself to the idea that today he had to stay away from the heights, and started off by paying a visit to Covilhã, a town only halfway up a hillside. He saw the church of St Francis which has a magnificent portico, but little else of interest except for the pointed arches of two door-ways and the sixteenth-century burial chapels. The tomb effigies are fair enough examples of their kind, if a trifle cold, but the whole benefits from the half-light that covers this entire part of the church. From there the traveller went to look at the outside of St Martin's chapel. This has been recently restored, and time has not yet blended in the new stones with the older ones, lent them that colour of weather-beaten skin they have from all the years of sun and wind. It's an extremely plain Romanesque chapel, a house where the faithful can congregate that does not have any great aesthetic pretensions. But whoever designed the small window over the

main doorway knew all about space and how to use it to the best advantage.

The traveller decided to go from Covilhã to Capinha. He had no special reason for going there, apart from seeing the Roman way, which is a spur off the main one from Egitânia to Centum Cellae. In those days, Capinha was known as Talabra, a name which suggests it must be a close cousin of the towns called Talavera in Spain, unless all this is linguistic fantasy on the part of the traveller, who is not always as erudite as he may sometimes appear. Anyway, Capinha is a pleasant village where it's easy to find what you're looking for. No sooner did the traveller step out of his car and ask the first passer-by where the Roman road might be, but he found himself accompanied, and being given explanations the whole while: "You have to go up here, cross these fields, and there it is." The passer-by happened to be the village priest, a young, open-minded man with whom the traveller had a long and interesting conversation which this is not the place to go into, although here is where it started. On his way back from seeing the Roman road, the traveller ran into a former Lisbon taxi driver, who wanted to show him Capinha's fountains, which date probably from the eighteenth century. The taxi driver was an enthusiastic politician, someone with a great love of his own land, both this village where he was born and the country we all share. The traveller considers himself a rich man: wherever he goes, he makes friends.

Next, the traveller crosses the River Meimoa and carries on to Penamacor through lands that seem deserted, with rolling hills and sparse vegetation stretching to the horizon. It's a melancholy landscape, or perhaps not even that: simply an indifferent one, neither untamed nature resisting man's encroachments, nor the bountiful kind of nature that has already succumbed. In Penamacor, the traveller had lunch to the sound of disco music in a restaurant done out in "rustic" style. Neither the music nor the decor fit in with those eating there, but they do not seem to mind. The thumping beat of the disco music doesn't seem to offend the family from Benquerença (the two oldest women in the party have astonishingly beautiful faces) and the traveller himself has grown used to even worse musical pollution. As for the food itself, it was neither here nor there.

Nowhere as much as in the church of Misericordia in Penamacor did the traveller feel that the Manueline style was simply a decorative technique. The almost complete lack of depth to the portal, combined with the thin external columns that launch the archivolt and end above in a domed shape that has something oriental about it, accentuate and justify this impression. And yet there is no denying the harmony between the diverse elements of the portal: the fretwork, the rosettes and other stonework patterns show a

truly original conception. Up above, the castle remains half-hidden, and the traveller decides not to insist, especially when a dog the size of a lion and with a growl to match is obviously determined he shall not pass, even though he has never done anyone any harm. The traveller did manage to visit the Paços do Concelho, but preferred to walk round the lower part of the town. He admired the arabesques on the columns at the parish church, and then said his goodbyes.

The road now leads to Monsanto. The landscape does not change much, except that beyond Aranhas and Salvador the hills of Penha García begin, and to the southeast the similar ones of Monfortinho. The traveller heads south: he has his goal, and no-one is going to divert him from it. Some places are for going through, others are for going to – and Monsanto is definitely one of the latter. A national myth, the innocent model for a definition of Portugal poisoned by a paternalist, conservative rural idyll (the traveller is averse to adjectives, but uses them when he has to), Monsanto is both more and less than what he was expecting. He was looking for slate roofs and found red Mediterranean tiles; he imagined narrow, winding dark streets that would be slippery in this wet weather, but all that is winding is not dark, and what is dark manages to be picturesque. Tourism has been here and whispered in someone's ear: "Smarten up." Monsanto did what it could. Compared to many mountain villages or those in the higher Beiras, Monsanto is a dusty place, at least going by what the eyes can see . As the traveller has already said: travelling should mean arriving. In Coimbra, he felt like going into the houses and saying: "Let's not talk about the University." Here, in the same but different way, he would say: "Let's not talk about Monsanto."

For now, he is not much interested in churches. If he comes across one, he won't refuse to look at it, but he's not going to go out of his way to list images, archivolts, aisles or capitals. He is looking for another kind of stone, the kind that has never seen a chisel, or if it has, still bears the scars proudly. He won't be in Monsanto long enough to know how much of the stone has entered its people; but he thinks he will be able to understand what they gave to stone. To judge the former, he would have to stay; for the latter, he can move on.

He heads for the summit. Between the last house and the walls of the castle there is an almost untouched realm of huge boulders, the *barrocos* again, vast empty spaces which could fit a whole city of rocks, and above all these, four huge boulders, one of them almost completely buried in the ground, which serves as a base for two others at its ends, and balanced on top an almost perfect sphere, like a satellite fallen to earth. The traveller thought he

36 *Monsanto, rocks*

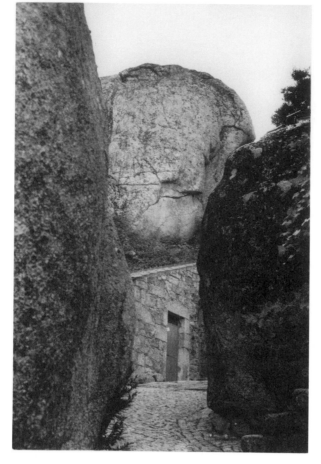

had seen all there was to see regarding stones. That was before he came to Monsanto.

It's strange. There are no houses up here, and yet he could swear he hears signs of life, whispers, breathing. If this were at night, he would be scared, but the daylight bolsters his flagging courage. But the noises are not human. Behind the boulders there are stone pigsties – here it seems, even pigs have castles. Unfortunately for them though they are not unassailable, and when their day comes, no amount of ditches and barbicans will save them from slaughter.

These sties are built to last. Dating from heaven knows when, they have properly built supports, and a circular shelter covered in earth with grass growing from it. Looking at them, the traveller cannot help but reflect that if the insides were cleaned up and fresh straw spread, they would be palaces

compared to the shanty towns around our big cities. And that even in Monsanto there must have been a time when human comfort was little better than that of these pigs.

The traveller has already said he was not particularly looking for churches. But now he stumbles across one, although it has nothing more to offer him than four bare walls and is roofless. This is the chapel of St Michael. It's set in a hollow, in the midst of boulders all the same colour that seem to form their own chapels. The traveller hesitates: should he head first for the castle, which is on his right, or for the ruined temple, on the left? He decides on the latter. He walks down a rock-strewn path. The chapel porch is plain and deep; the chapel itself is on a lower level than the threshold. To enter it is like entering a crypt; this feeling must have been even more intense when the chapel had a roof and the only light came from candles or through the small high window. Now the nave is open to the skies. Grass grows on the earthern floor and on fragments of sculpted stone. The traveller has already accumulated a long list of ruins, but this chapel, despite being so obviously another one, somehow resists being categorised as such. It's as though the chapel of St Michael has nothing missing. It was built as a place of worship, and functioned as such, but this was its true destiny, to be simply four walls exposed to rain and sun, to be covered in moss and lichens, silence and

38 Monsanto, pigsties

solitude. On the northern wall there are two empty niches, and on the ground the tombs have lost their lids and are half full of water. To the east is the mountainside and as far as the eye can see, the valley of the River Ponsul and the slopes of Monfortinho. The traveller is happy. He has never felt in less of a hurry. He sits on the edge of one of the tombs, touches the chill, fresh water with his fingertips and just for a second believes he can unravel all the secrets of the universe. This is an illusion that grips him only very occasionally, so don't think too harshly of him.

Now it's the castle's turn. The gate is in one corner surrounded by massive walls with arrow-slits protecting the way in. Above the castle walls rise other walls: the boulders that are the true defence of this mountain, the indestructible shoulders of a fortress that men simply had to cover with pads of walls.

39 *Monsanto, castle walls*

Inside he feels pure astonishment. A comparison with the Cyclops is obvious, and the way they gathered heaps of boulders either because they enjoyed doing so, or to try to sink Ulysses' ship. But there's no ship here, and little pleasure, so the traveller is left unable to make comparisons, can simply assess his own almost unbearable disarray faced with these stones that emerge from the ground like bones, huge skulls, granite knuckles. He climbs to the top of the highest wall, and it is only here that he can feel a breeze, a cold wind from the north; and it is perhaps this which brings tears to his eyes.

What kind of people lived in this castle? What men, what women could bear the weight of these walls, what words were shouted from tower to tower, or whispered on these staircases or at the rim of the well? This is the stronghold of Gualdim Pais, with his iron-shod feet and his pride as a master Templar. These walls are where ordinary people fought off assaults, wounded and bleeding. The traveller wants to hear explanations but only finds questions: Why this? What is it for? Can it simply be for me, a traveller, to be here today? Can things have such a flimsy reason for being? Or is that the only reason they have?

He leaves the castle and walks back down the hillside to the village. Old men and women are sitting at their doorsteps, in the Portuguese way. They too are part of the reason. Take a man, take a stone, man, stone, stone, man, if there were time to take them and tell all their stories, to tell them and to listen, to listen and tell, once you've learned their common tongue, the essential I, the essential you, buried beneath all the tons of history and of culture, so that just like the boulders in the castle, the entire body of Portugal would emerge from the ground. Oh, the traveller dreams and dreams, but never gets beyond that, and soon the dreams are forgotten, as they are now when he leaves the hills and looks back up at Monsanto, all solitude, wind and silence.

When a landscape is beautiful, it's good to take one's time. But this, seen from close up, would not detain even the most polite of travellers. Yet this one, who is not bound by the demands of politeness, goes as slowly as if he were dragging along one of the huge boulders from Monsanto, or were caught up in all the recollections from the past that he imagined. He finds it hard to get through Medelim: people come up and ask him what on earth is that weight he's dragging along – all this is just in his mind, of course, but it could be true. After all, it is true that in his dreams he did fly.

This used to be Egitânia, and is now Idanha-a-Velha. Egitânia seems to be Visigoth, and thus posterior to the Latin Igaeditania; not that this matters much to the traveller, except that it reminds him that the past of these lands is

longer than the roads leading to them. This village has come from so far in the past it has got lost in the journey; perhaps it is still being guided by the sundial presented to it in 16BC by Q. Jalius Augirinus, of whom nothing more is known. Idanha-a-Velha's streets are wide, but so bare and empty that the traveller feels he's in a lunar landscape. He goes in search of the palaeo-Christian basilica or Visigoth Cathedral, and comes up against a wire fence surrounding a ruin. This is it.

He looks for a gap in the fence, and spots one a bit further on, where it comes up against a wall jutting out from the ruin. It looks as though some excavations have been carried out here, because the foundations are exposed, but everything is covered in weeds and the basilica itself is a jumble of stones, some of them meaningless, others that are perhaps very significant, peeping out from the undergrowth and brambles. The traveller tries to make out the different shapes: all he can identify is half a column. For someone who has come so far, this is little reward. But lower down to the left of the main doorway and separated from the rest, he can see the baptistery. It's under a roughly-built wooden shed that is open to the winds.

What's to be done with such neglect? Damp and slimy lichen is eating away at the baptismal fonts: the larger one, presumably for adults, and these other two tiny ones, with lips on the side that look like seats, that must have been for children. The traveller feels as crumpled as a piece of old newspaper stuffed in the toe of a shoe. This may seem a complicated comparison, but the traveller's state of mind is complicated in the face of this crime of abandonment, of absurd lack of care: he feels indignant, sad, ashamed, he doesn't want to believe what he is seeing. This shack, hardly worthy of keeping tools or bags of cement in, is all there is to protect a precious relic that is some fourteen or fifteen centuries old. This is how Portugal takes care of its heritage. As he climbs back through the fence, the traveller almost cuts himself. He goes to look at the Roman arch which gives onto the River Pônsul, and it is so well restored, so solid in its assembled blocks, that he finds it hard to understand why there is so much care on the one hand, and so little on the other.

The traveller looks up at the sun to see how high it is, and decides it's time to be on his way. He drives down through Alcafozes, then turns west towards Idanha-a-Nova, which despite its name is also pretty venerable. Yet compared to its older sister, it's a mere stripling: it was founded in 1187 by Gualdim Pais in the reign of Sancho I. All that remains of the castle from those days are ruins; the traveller has had quite enough of them for one day, thanks to Monsanto, so does not go to visit them. What he remembers of the village

are a cluster of houses built on a ravine, and beyond them the palace of
the Marquess of Graciosa, which is indeed gracious, but little else. As he
is leaving the village, a wall blocks his way, forcing him to stop. It's a low
wall that gives two clues as to what it is: first, with a heart pierced by an
arrow painted on it, and second, by a plaque which announces for all to
see: "Lovers' Wall". The lovers of Idanha-a-Nova are well looked after: when
they're wandering aimlessly around, all they have to do is to come here:
two hearts will always beat as one if the spot for them to meet is so well
signposted.

The traveller still had a long way to go, so he went on to Proença-a-Velha.
He did not expect to find much there. He chatted with some women busy
knitting in low chairs by a sheltering wall, then went to see what the village
had to offer. The church square in Proença-a-Velha is large enough to hold
dances, if such a mix of the sacred and profane is permitted in regions like
this. The traveller did not ask. Instead, he preferred to admire the late
afternoon gazing down towards the River Torto, which is invisible but easy
to imagine, and then spent a long while leaning back against a wall that
perhaps deserved the label more than the other one, because from behind it
there wafted the most exquisite perfume of flowers the traveller has ever
inhaled. Compared to this, the acacia at Vermiosa was nothing more than
a cheap eau-de-cologne.

He goes straight on to Fundão. The day is drawing to a close. After Vale
de Prazeres he is in the Cova da Beira. The land here is both fertile and, at
this hour of the day, very beautiful. It is shrouded in a light mist that, rather
than restricting visibility, dilutes it. It's impossible to tell if the shreds of
mist are floating down from the sky or rising from the flat earth. Woods and
fields alternate on either side of the road. It's a landscape from an Old Master
painting: perhaps it was from here that Vasco Fernandes took his palette,
the mist, and that feminine softness that makes the traveller yawn and
stretch, with Monsanto long forgotten.

The Ghost of José Júnior

Night is cold in this hollow where Fundão lies. But that wasn't the only reason why the traveller slept badly. In this region – not close by, but close enough for his presence to be felt – walks the ghost of José Júnior. The only ghost the traveller believes in. Because of him, the traveller will visit São Jorge da Beira, a village high in the fastnesses of the Serra da Estrela. He did not know José Júnior, had never even seen his face, but once, many years earlier, he had written about him. He did this in response to a newspaper article about a tragedy that unfortunately is not uncommon in Portugal, about a man who fell victim to that strange sort of ferocity seemingly reserved for village idiots or drunks, those unfortunates who cannot defend themselves.

In those days, the traveller wrote for a newspaper which in fact is published in this very town of Fundão. So, moved more by passion than by reason, he wrote an article or chronicle that was finally published. In it he began by evoking a verse by the Brazilian poet Carlos Drummond de Andrade, then turned to some moral considerations about the fate of many Josés in this world, of those who "have reached the limit of their endurance, are cowering at bay from the pack, lacking the strength for one last – though mortal – charge". And he went on: "Another José appears in front of the desk I am writing at. He doesn't have a face, only a vague shape, one that shakes as if in non-stop pain. I don't know any more about his family or his name than that he is called José Júnior, and that he lives in São Jorge da Beira. He's young, gets drunk, and is treated as if he were stupid. A few people make fun of him, and some children play tricks on him, throw stones at him from afar. Or if they did not do that, they surrounded him with that sudden cruelty children are capable of, and José Júnior, blind drunk, fell and broke his leg – or perhaps not – and ended up in hospital." And the article went on: "I'm writing these lines many miles away; I have no idea who José Júnior is, and would find it hard to place São Jorge da Beira on a map. But these names are merely one instance of a general phenomenon: our disdain if not hatred for our fellow man, this kind of epidemic madness that here, there

and everywhere prefers easy victims. I'm writing these lines in an afternoon where there are clouds in the sky the colour of morning; out of my window I can glimpse the Tagus, where slow boats are taking people and goods back and forth. All this seems as peaceful and harmonious as two turtle doves perched on a railing cooing at each other. Oh, how this precious life always slips from our grasp, this soft afternoon that will not be the same tomorrow, that will never be what it is now! And all the while, José Júnior is in hospital, or if he has already been discharged, is dragging his broken leg along the cold streets of São Jorge da Beira. There's a tavern, there's burning, annihilating wine, oblivion in the bottom of a glass, and shining like a diamond, drunkenness that offers victory as long as it lasts. Life returns to its source. Does it have to? Does mankind have to kill José Júnior? Does it have to?"

That was how the article ended, but life did not return to its source: José Júnior died in hospital. Now the traveller feels he has an appointment with his ghost. His maps have already shown him where to find São Jorge da Beira, and he will go there, although he bears no recriminations and would not know against whom to make them. All he wants to do is to see the streets where this incident happened, to be, if only for a split second, José Júnior. He is well aware that all this is idealising someone else's suffering, but he is doing it sincerely, and no-one can ask more than that.

But there's still a long way to go before that. Every region occupies its own time and space. Let's look first of all at Fundão, where we are now – or rather, let's see what we can of Fundão in the time available to us. The high altar of the parish church for example, with its golden altarpiece, and especially the painted panels of the ceiling, done by artisans or a minor school of artists. The traveller thinks it is high time to pay more attention to these secondary works, to look for the signs they offer of a little – or greater – originality. Besides the major painters, whether or not they are identified, there is room for these lesser works, which are not always second-hand, or mere copies. Portugal is full of minor works which would reward greater study: that's the traveller's opinion at least. Also worth seeing is the cross in the Capela de Nossa Senhora da Luz, which might be called the Crucifixion of Two Sorrows: on the one hand, the crucified Christ, on the other side, his mother.

Next he drives to Paul, and then on to Ourondo, where the hills begin again. In Paul, the painted roof of the parish church is interesting. It's a conventional enough trompe-l'oeil work, but to find it here in the heart of the Beiras is as surprising as the famous Surrealist meeting of a sewing machine and an umbrella on an operating table. These architectural tricks belong in palaces, not in modest churches like this one, where a young teacher is trying

to control a group of youths who are going from station to station of the Cross reciting the appropriate prayers. The visitor's entry and wandering gaze upsets the catechism: the flock of faithful stare at him full of curiosity, and are slow and hesitant in their religious responses. Before he can cause even more chaos, the traveller withdraws.

He would have stayed a long while in Ourondo, had there been any recent confirmation of the old legend that gold used to be scooped up here by the handful, thus giving the town its name. It's not that the traveller dreams obsessively of striking it rich, but it had never occurred to him one might be able to stumble across gold like that, either under the open sky or in a mine; if that were the case, he would dig these hills and pan these rivers as assiduously as any prospector. For now, though, he has to pay full attention, because willy-nilly the road starts to climb, with crags on one side and a steep drop on the other. He's in among vast pinewoods, with above them a completely white sky, one single cloud without beginning or end. It's not raining. Far down below him flows the River Porsim. If every positive had its balancing negative, there must be a River Pornão somewhere around here. According to the map, there isn't one, perhaps thus confirming the name of the other. More seriously, the traveller is thinking again of José Júnior when suddenly up above the natural crags there appear two mountains, one the colour of cinders, the other a burnt ochre. Neither of them has so much as a blade of grass on it, or shows the branch of any tree, nor even a rock like one of the many that overhang the route. These are the waste heaps from the La Panasqueira mines, separated according to their composition and colour; two huge masses that loom over the landscape and progressively swallow it up from the outside just as the earth inside is being dug away. To the unwary, these twin peaks come as a great shock, especially as from a distance there is nothing to betray the fact that there are mineworkings here. It's only further on, close to the village, that the entrance tunnels can be spotted on the mountainside. And there is a whitish mud that seems almost liquid, on both sides of the road.

The traveller does not go into the mine, but sees an image of a damp, sticky hell where the condemned are forced to work up to their knees in mud. That's not the reality, of course, but it won't be much better.

São Jorge da Beira is three kilometres further on. The road goes round a bend, doubles back the other way, and suddenly the whole village appears in front of you, climbing the hillside as if it were determined to conquer it, but lacked the energy after the first impulse. This was where José Júnior lived. It's a quiet backwater, so far from the rest of the world that the road leading

here goes no further. It seems impossible to the traveller that along these cobbled streets, staggering up these slate steps and beneath these rough roof tiles there should have lived a man attacked with words and stones, hopelessly drunk, or drunkenly hopeless, which is not the same thing, without anyone coming to his aid to separate the weak from the strong, the hunted from the hunters. Or perhaps someone did come, but that was not enough. A helping hand can damage if it is withdrawn. There probably was someone who spoke wise words to José Júnior and warned off his persecutors. There was probably also someone who bought José Júnior a few drinks then had a good laugh at him. In a place so lacking in everything, it would be silly not to enjoy this free entertainment, the public fool. But voluntary amnesia is a fine thing: the traveller asked three people if they had known José Júnior, but none of them remembered him. That should come as no surprise: when we can't bear to live with our remorse, we forget it. That is why the traveller would suggest that on the corner of one of these beautiful streets, or even of one of the dark alleyways, a plaque should be put up, with half a dozen simple words that merely say, for example: José Júnior Street, a son of this village. And when other travellers asked its meaning, the parish council could send someone to explain who José Júnior was, and why a street is named after him.

This particular traveller did not meet the ghost. São Jorge da Beira continued on its own tranquil way in among its pinewoods and ravines under an endless white sky. Tomorrow perhaps it will snow here, or further up in the mountains, where the traveller will not be going. José Júnior will not have gone far from here either. Possibly that is why the traveller did not meet his ghost. Being a ghost, he could escape. And of course, ghosts don't drink. And, if they exist, they surely must make fun of us.

The traveller went back the way he had come. He had lunch in Fundão, went to look at Chafariz das Oito Bicas, and then on to the nearby village of Donas. All the important things to see here are off to one side, which makes the visit that much easier. In the parish church some women were busy washing the floor and did not seem pleased to see an intruder. They eyed him suspiciously as though he were a works inspector come to fill in their time sheets. Yet the traveller knows they do not get paid for their work, but do it for the greater glory of the church or for their souls' salvation. The main church had little to offer him, so he went on to the side chapel, the Capela do Pancas, with its fine Manueline decoration. Another good example of Manueline architecture is the Casa do Paço. This belonged to the family of Cardinal Jorge da Costa, the famous Alpedrinha, who lived to be over a hundred and is buried in a magnificent tomb in Rome. The Cardinal was

ambitious. He liked money, luxury, and power. He had all three. He was a
prelate in Évora, Archbishop in Lisbon, a cardinal *de nomine*. Then after
he went to Rome in 1479, from where he never returned, dying there in 1508,
he was rewarded with the titles of Bishop of Albanense, Bishop of Tusculum,
then Bishop of Oporto and of Santa Rufina. And he became Archbishop
of Braga without once leaving Rome. The traveller is disturbed, wondering
how it is possible for the evangelical tree to give so much earthly fruit, but
consoles himself with the thought that it was not the hands of Alpedrinha
or his proud relatives which raised this wonderful Casa do Paço from the
earth of Donas. The traveller imagines that the women scrubbing the church
floor are descendants of the workmen who built these walls and fashioned
the stones of the door and windows. Someone should tell them.

From Donas to Alcaide it's a short step, easily taken. The beauty of the road
makes it seem even shorter, despite the sights along the way, which include
two level crossings and a bridge. The church of St Peter was locked, but
the sacristan, a friendly old man, came rushing up to open it. You may think
the traveller is joking, but it is worth the trip to Alcaide just to see how
this man opens a door, the way such a simple act can be so ceremonious. The
church is broad, and the eight granite pillars supporting the roof give it a
rather stern appearance, but not cold. The Romanesque arch to the mortuary
chapel is splendid – it has just been uncovered during restoration after being
hidden since the seventeenth century. From the same period is a painting of
St Anne, who is shown teaching the young Virgin Mary to read. It's not a
work of great artistic value, and would hardly be worth mentioning were it
not for the fact that the composition of the central figure somehow reminds
the traveller of the profane figure of Juliet's nurse, from the play by William
Shakespeare. There must be as many of these nurses as there are actresses
who have played her: thin and fat, short and tall, blonde or brunette: but
for the traveller, the nurse who dandled the young Juliet Capulet on her knee,
and then saw herself caught up in so much heartache, is this plump figure,
so simple and maternal, whose charge seems intent on undoing her bonnet
while she is showing her the book of the future, and is naturally frightened
at what she can see. After the traveller has gone, St Anne must be telling
Juliet Capulet a story to amuse her: "Once upon a time . . ."

To the west is the Serra da Gardunha, ending in Cova da Beira. The
traveller has to climb round it, and suddenly he is confronted by a cloud from
the Serra de Estrela which has come all this way; worse still, it brings mist
and rain with it, when down in the valley all the traveller had seen was a
slightly covered sky. This must be very local weather, because even before the

traveller reaches Alpedrinha the clouds have gone, the mist has lifted, and it's no longer raining.

The Cardinal was born in Alpedrinha. His coat of arms is over the doorway to the Capela do Leão, also know as St Catherine's chapel. The traveller should have got here earlier. Although still in the distance, the storm in the hills has already dimmed the daylight. The air is still clear, but he has many more miles to cover and for this reason, and also because Alpedrinha seems deserted, he contents himself with simply walking along its streets to get some sense of its decay, of a way of life that refuses to adapt. It's a purely subjective feeling of course, perhaps due to the fact that there is nobody around, all the doors are closed, not even the curtains twitch as he passes by. Yet in front of the parish church there is a group of young girls who must have just finished school, and the curiosity and irony obvious in the way they look at this stranger in their midst leaves him feeling disconcerted.

At the top of the village is the fountain of King John V. The traveller would like to see this spouting sovereign, if it's not lèse-majesté to call it that, and when he gets there he has to confess it is a very imposing construction: it seems almost impossible that a single jet of water should have required so much carved and sculpted stone. Not all water has such good fortune. This water comes from among bushes and rocks high in the mountains, cascades down, and before it ran freely into the River Alpreade, the royal architects directed it into a series of basins, channels and steps, where the limpid water is less important than the imperial crown. The traveller looks down at all this ostentation, and smiles at the irreverence of some children who are leaping over the stones while a woman's voice calls out, "Be careful." But there is a time for everything. The traveller's amusement turns to impatience because he wants there to be silence over this sleeping town; he does not want it to wake up to the noisy children playing or their mother shouting, but only to someone walking through it as he is. The games went on endlessly, and so did the mother's plaintive call, so finally the traveller left and went to visit the ruins of the palace, the cannon and urns at the entrance, the windows – some of them locked, others staring blindly up at the milky sky. He walked on down to the main road and from there looked back up at the town. A very strange place indeed. The road passes by at the bottom and cuts it in two, but even so it's as if it were between two walls that hide everything behind them. There are many hidden villages, but Alpedrinha is a complete secret.

Wet ashes fall from the sky. The whole landscape becomes mysterious. It seems as though night is about to fall, but it doesn't: the daylight continues as if whoever is hauling it off had paused just long enough to allow the traveller

to reach Castelo Novo. It's a favour the traveller will owe until his dying day. At this time of day, with this miraculous light, there can be nothing like it in the world. The road describes a broad curve around the flat meadows of the River Alpreade. Put like that, it seems almost nothing: it's impossible to do justice to the mist floating over the fields, the trees on the slopes of the Gardunha hills in the distance, and above all the light, this indefinable light that is what mostly remains of his journey: the traveller cannot properly describe it. The traveller admits he cannot, would not know how to.

Castelo Novo is one of the most moving experiences the traveller has had. Perhaps he will go back there one day, perhaps he won't, perhaps he'll deliberately avoid it because some things cannot be repeated. Castelo Novo, like Alpedrinha, is built on a mountainside. If you continued on up you would soon arrive at the summit of Gardunha. The traveller has no need to repeat his description of the time of day, the light, the damp air. He simply asks that all this be not forgotten while he is busy climbing the steep streets, past the simple houses and the palaces like this one from the seventeenth century, with its portico, its balcony, the deep archway leading to the yard. Hard to imagine a more harmonious construction. So there is the light, the hour, as if held in suspense in time and in the sky: the traveller will be able to see Castelo Novo.

Here is the Casa da Câmara, the town hall, a Romanesque building from the reign of Dom Dinis. The traveller is about to protest at the fountain put there by Dom John V, but restrains himself when he sees that in fact the Romanesque succeeded in absorbing the Baroque, or perhaps that the Baroque was tamed by the Romanesque, which was there first. Together with the Manueline column, there are three periods here: the thirteenth, sixteenth and eighteenth centuries. The men who built them knew how to work in stone, and to respect space, whether close by or far away: if this had not been the case, the three would have had huge and irreconcilable architectural battles.

The traveller asks an old woman on her doorstep where the wine trough is. The old woman is deaf, but understands if she is spoken to loudly and directly. When she understands the question, she smiles and the traveller is amazed, because although her teeth are false, the smile is so genuine and she is obviously so pleased to be smiling that he feels like hugging her and asking her to do it again. He heard her directions, but must have misunderstood, because he gets lost on the way. He asks some youngsters, but they have no idea – young people know other things. So he asks again, and is told: "Go down this street to the square. There's a shop on the corner, they'll tell you

there where it is." So the traveller walks down the street, finds the square and the shop, and repeats his question to the shopkeeper. He's a short man, with rather more hair than the traveller, and slightly older too. He comes out from behind his counter, and is the personification of goodness: he wants to show the traveller the way himself, so the two of them leave the shop deep in conversation. The man's eyes fill with tears when he talks of his region. They turn into a street slightly higher up, and there is the wine trough or *lagariça*: there was really no need for him to leave his shop, but that's the way he is, and the way this region is. As they stand above the trough, a scallop shell scooped out of the rock, he explains to the traveller: "In olden times they used it to tread grapes in: you can see the spout that took the liquid down to that tank." The traveller can imagine the men from the village in bare feet and with their trousers rolled up to the knees, treading the grapes, shouting comments to the women passing by, with that jovial carefree feeling that wine gives, even when it is not fermented. If there is another such wine trough in Portugal, the traveller does not know of it. There may well be one, though: we are still a long way from knowing all the riches we possess.

The traveller has already introduced himself, and now his guide does the same: José Pereira Duarte. He has light-coloured eyes and is a caring man, a man who reads. He is smaller than the traveller, but looks at him as if he were a long-lost friend. His only concern is that his wife is ill in bed: "Otherwise, I'd be delighted for you to come home for a while." The traveller would also like to stay for a while in Castelo Novo, but it is not to be. They climb down from the wine trough, say goodbye in the square with a genuinely warm embrace, as genuine as the old woman's smile – and it seems she has also stayed waiting on her doorstep to say goodbye to him as well. This may be another dream: such goodheartedness is impossible; whoever does not believe it should pay a visit to Castelo Novo.

Mist, ashes over a green landscape, a grey twilight which is finally drawing to an end. By the time the traveller reaches the main road to Castelo Branco, it's night. It's understandable: there was no more need for light.

"Hic Est Chorus"

In Castelo Branco all roads lead to the garden of the Bishop's Palace. There's no risk therefore in the traveller dawdling or getting lost, in going first for example up to the castle, which is a bare ruin. It's here he encounters his first disappointment: the church of Santa María is closed and fenced off, so there is no way he can visit the tomb of the poet João Ruiz de Castelo Branco, whose statue stands down below in the Largo do Municipio. The traveller, who is prone to these sentimental weaknesses, had been hoping to recite at the tombstone those marvellous verses which since the sixteenth century have been resounding, oblivious to time, with the pain of lovers parting:

> My lady, these eyes depart
> With so much sadness from thee
> That there's never been, dear heart
> Anyone so sad as me . . .

but the traveller was prevented from fulfilling his sentimental pilgrimage by a strong fence all round the church. Apparently, some archaeological remains were found here, and while it is being decided whether or not to excavate, all visitors are being kept out. This fence isn't as penetrable as the one in Idanha-a-Velha, and even if it were, there doesn't seem to be any way into the church.

The traveller walks through the old town down the Rua dos Peleiteros, and to make up for his disappointment murmurs to himself:

> So weary and so tearful
> So sorrowful from parting
> A thousand times more fearful
> Of living than of dying.

Some literary reputations are based on a very small amount of work, and this is the case of João Ruiz (or Rodrigues) de Castelo Branco, who even though he was responsible for little more than these few verses, will be remembered as long as the Portuguese language survives. A man comes into this world, takes a couple of turns, and departs it, but that is all that's needed to create

and give form to this expression of individual sensibility which then becomes part of our collective experience.

It was in this reflective frame of mind that the traveller found himself confronted by the Cathedral, which does not know what to do with the inexpressive façade that was foisted upon it. And inside it is obvious that those charged with the mission of beautifying this temple to St Michael did not put themselves out very much; we can only hope that in his magnanimity the archangel will forgive them their oversight. A lot more forgiveness will be needed, for Bishop Dom Vicente's pride for example, after the way he has had his coat of arms sculpted over the sacristy door: put briefly, this is nothing more than a delirium of stone. Christ's only emblem was a rugged cross, but his bishops are going to enter heaven carting with them heraldic puzzles it will take an eternity to solve.

This part of the town is so provincial, or at any rate so much at one with its province, if that first word seems in any way pejorative, that the traveller finds it hard to believe that close by these streets and quiet avenues are signs of the feverish, agitated world of today, as the saying goes. This impression stays with him throughout his visit.

Shortly afterwards he's nearing the palace garden. Here is the crucifix of St John, with stone like lacework, hollowed out in filigree, with not a smooth surface to be seen anywhere. It's a triumph of curves, scrolls, flourishes. But this crucifix seems lost in a large corner square; it seems out-of-place with all that's around it, as though it had been transplanted here without much thought. And yet as far as the traveller can tell, it's always been here. It's just that at some moment or other, the crucifix became detached from the rest of the square; it was spurned or did the spurning.

The traveller passes by the garden, but does not intend to go in yet. He goes first of all to the museum, where he wants to see the good archaeological display, the reconstruction of cave paintings from the valley of the Tagus including the Herculean figure of a hunter carrying a deer on his shoulders, and the much more recent delicate Roman statuette. The traveller is moved by the representation of the goddess Trebaruna, to whom Leite de Vasconcelos dedicated such dreadful verses and such sincere love; and notes the famous case of the ancient pair of Siamese twins, realistically illustrated on a tombstone that unfortunately is damaged. The museum at Castelo Branco is not of the first rank, but gives a lot of pleasure. The San António attributed to Francisco Henriques is magnificent: the saint's face is that of a simple man, and he holds the book the holy child is reading, not daring to touch him. His face, with its rough stubble of beard, is contemplative, the eyelids half-closed;

and it is plain that this rustic friar is not the splendid orator who converted the fishes, and that his simplicity is not affected in the slightest by the sumptuous background of the panel, with its porphyry column and flowery tapestry. In this sixteenth-century painting the traveller also notes the Angel of the Annunciation coming in through a window made to measure for him, more of a humming bird than a messenger, and this raises two divergent thoughts in his mind. First, that it would be interesting to study the mosaics depicted not only in these sixteenth-century paintings but in the periods before and after the golden age of our arts. He thinks this would provide valuable information about the chronology, similarity of motives and reciprocal influences between the painters' and mosaic-makers' studios. He is sure that not all the information to be gleaned from these mosaics has been exhausted by Almada Negreiros' discoveries about their disposition in the panels at San Vicente de Fora. His second thought might not please those who are sticklers for religious orthodoxy. It concerns how frequently these Annunciations show the Virgin's bedroom, either beneath a low arch, as in this case, or behind heavy, drawn-back curtains. It's true that by this time Mary was already married to Joseph, but since this descendant from the Holy Spirit is supposed to be immaterial, the bed is usually deemed unnecessary, unless the painter insists on reminding us that normally this is where the sons of men are conceived. Satisfied with these two original thoughts, the traveller moved on to the ethnographical section, where he admired the antiquity of the electoral urns, the absurd machine that selected numbers for military service, and the earliest examples of looms for weaving. Nearby there are some wonderful examples of the region's quilts, while from behind a curtain he can hear the voices of apprentices learning to sew them; afterwards he was sorry he did not say hello to them. In another room there are banners of the Misericordia, but they have been repainted so often it is difficult to tell what they were like originally.

The traveller entered the museum on the ground floor, but leaves by the staircase from the first floor, in the way most befitting an archbishop. Now it is time to visit the garden. Whereas Monsanto was the town of stone, here is a gallery of illustrious figures: angelical, apostolic, real, symbolic – but all of them intimately portrayed, close at hand, in the gaps between the shaped box trees. The traveller thinks there cannot be another garden like this in the whole world. If there is, then this is a remarkable copy; if not, then it's worth a lot of praise. The only drawback he can find is that it is not somewhere to rest or to read a book – anyone entering it should bear that in mind. When the bishops came in here, they doubtless brought their servants with them,

and they in turn brought stools for their masters to rest and pray on, but nowadays the common traveller who visits the garden can look round it as much as he or she likes, but will have only the ground or the steps of the staircases to sit on. The statues are remarkable, not so much for their artistic value, which is debatable, but for the ingenuity they show, the display of a learned plastic vocabulary. Here are the kings of Portugal, like those of a pack of cards, and here too is the patriotic gesture that meant the kings of Spain were portrayed alongside them on a smaller scale – since they could not be ignored entirely, they were shrunk. Alongside them are the symbolic statues: Faith, Hope and Charity; Spring and the other seasons; and here in a corner facing the wall, Death. The visitors don't like this particular statue, of course. They stick chewing gum in its empty eye sockets, put cigarettes between its lips. These insults probably mean little to Death. It knows that there is a time for everything.

The traveller finished his tour, counting all the apostles, looking at the pond shining like an altarcloth in the muddy garden. Back in the town square, he is disappointed to find that the statue to João Ruiz has nothing in common with his verses: he is simply a stuffed shirt dressed like country nobles of his day, not someone who was capable of writing:

> The sad are so sad to leave
> So hopeless in their goodbyes
> That no-one could ever believe
> The sadness in their eyes.

The traveller also takes his leave. He is neither sad nor particularly happy, merely worried about the rainclouds gathering in the north. His journey is going to be a wet one. It is at this point that the stern hand of history grasps his shoulder, and wakes him from the kind of stupor he has been in since arriving in Castelo Branco. "The person whose bones are buried in the church of Santa María," this voice tells him, "the person whose statue stands in the square, is not the poet, my dear friend, but Amaro Lusitano, a doctor, who shared the same name as the poet but never wrote a line of verse in his life." Annoyed, the traveller pulls up, seizes this irritating voice by the arm, and throws him out of the car. Then he continues on his way, murmuring the immortal words of João Ruiz de Castelo Branco, the bones and statue of poetry.

And in a further effort to be truthful, it has to be said that the traveller seems always to choose the worst roads. Now he rejects the main road on his right that would lead him straight to Abrantes, and chooses instead to

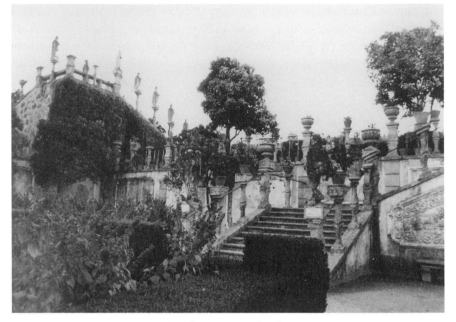

40 *Castelo Branco, Jardim do Paço*

head for the heights of the Moradal and the Serra Vermelha, where all the clouds and storms of this fickle spring have apparently congregated. Until he reaches Foz Giraldo, the rain is only a threat. But from there to Oleiros, it is pouring down, and at the summit of the Serra do Moradal he could swear it is streaming straight out of the clouds, because it has none of that delayed effect it usually has. The road is a solitary one: tens of kilometres without a soul, just mountain on mountain: how can such a small country be so big?

In Oleiros, the traveller enjoyed the images to be found in the parish church, even those which have been sadly repainted, like the stone statue of the Virgin carrying a bunch of flowers in her hand, which has been covered in gold paint. The same has been done to the carvings. But the church is well worth the visit, to see not only the things that have escaped this repainting mania, but also the decorated ceiling and the tiles in the mortuary chapel.

Oleiros is between two mountain ranges: Alvelos, to the southeast, and Vermelha, to the northwest. Between them flows the River Sertã, which here is a rushing torrent. The traveller has a goal in mind: he wants to reach Álvaro, which can only be done from this side, after first climbing the Vermelha range. In comparison with other ranges, it's not very high or very extensive. But it has its own special grandeur, due perhaps to its ruggedness,

its almost disturbing solitude, its dramatic ravines and slopes covered in heather, from whose colour it perhaps gets its name. The low clouds help underline this sense of an untouched world, in which all the elements have still to be separated out, and where man can only enter with slow and deliberate steps in order not to disturb these first moments of creation.

The traveller did not get far on his descent towards Álvaro. Roadworks had made the surface more like a sea of mud than a road for cars. The rain seemed to have eased off a bit, or at least that was what the traveller was trying to tell himself. But the driver of one of the diggers, snug in his cabin, told him: "If you carry on, you'll have problems." If the traveller had had a dove with him, he could have sent a message on ahead to Álvaro, but this not being the case, he had no other choice than to turn back and head along the crest of the mountain range. Once again, heather everywhere, deep, dark ravines, the only thing missing were highwaymen.

The rain had stopped by the time he reached the Sertã valley. The roads down here are narrow and rough like ant trails. While it may well be that in terms of the world, the traveller is no larger than an ant, he would still have preferred a little more space, a little less loose stone, fewer potholes; anyone travelling this route is hardly going to believe that apshalt and concrete have been invented. And since misfortune never comes alone, the traveller made a mistake and passed by Sardoal, without coming across anything to compensate for the error. However, he pushed on and finally reached Abrantes after nightfall.

Abrantes is the gateway to the South. From his hotel window, the traveller can see the River Tagus and, as he recognises its broad sweep, he is afraid he will not be able to convey how much he loves it and the lands it flows through. But that is a task for later. Now he has to head for the coast, and visit places he has left behind until now. And so he sits contented with the almost cloudless evening, and stares out thoughtfully at the plains of Southern Portugal.

Of Abrantes it is said: "Everything is as it ever was, headquarters in Abrantes". The traveller is no connoisseur of military headquarters, but if everything in Abrantes were really like it had always been, then artistically speaking it would be a very different matter. Buildings have been torn down on all sides, and what has replaced them is in no way an improvement. The same happens all over Portugal, but it's more noticeable here in Abrantes because it was such a historical crossroads, and now little remains to tell the story. And there are still things unfinished, like the missing tower on St Vincent's church, or the two towers of St John the Baptist's, which must be

for reasons of financial exhaustion. The traveller could not enter St Vincent's, but he walked round it carefully, enjoying the simple flying buttresses on its lateral walls and smiling at the tiny belltower that takes the place of the missing one. Since there was no more to see there, he went on to St John the Baptist's. This church is in one corner of an elevated square that rather overwhelms it, but does give it an intimate air. The traveller did not particularly like the Philippine architecture – so called because it was under Philip II that the church was reconstructed – because it seemed to him that the Ionic columns were out of place, a late Renaissance idea that was unconvincing. He also found the three pulpits incongruous, as it was hard to imagine why so many were needed when a single sermon preached here would be more than enough to fill the entire church. Anyway, these are mysteries of the church that the traveller did not care to delve into.

If this were all there was to Abrantes, nothing would be lost by not entering it, except out of politeness or from a need to rest. But Abrantes can also boast, in the Misericordia church, the admirable panels painted by – or attributed to – Gregório Lopes, full of the refined figures typical of all his work, even the most religious. The models – or the way of looking – of the Master of Abrantes were very different, to judge by the panel thought to be by him in the Santa María do Castelo church. The Virgin Mary in this Adoration of the Magi is clearly a countrywoman who is presenting her son – a future shepherd – to other country people who are thinly disguised beneath their regal robes.

And this is what more than justifies a visit to Abrantes: the church of Santa María do Castelo, and the Dom Lopo de Almeida Museum set up here fifty years ago. The church nave is not vast, nor is the mseum, but it has a superb collection. On his journey, the traveller always tries to find someone he can talk to, ask questions of, but does not always receive his just desserts. This is not the case in Abrantes: here, the museum attendant loves what he is watching over, it's his pride and joy, he talks of each object as if it were a close relative of his. Soon there is no telling who is the guide and who is the visitor, they are simply two friends, and both of them admire the splendid sculpture of the Holy Trinity, the work of one M.P., who was an imaginative genius, the Roman statues, and the illuminated manuscripts kept in the sacristy. The attendant shows him, with touching delicacy, the letter N from a tiny missal, and his finger points out the flourishes, the scrolls, the brightness of the colours, as if he were pointing out his own heart.

The two of them carry on conversing as they walk along a passageway leading up to the choir, but suddenly the traveller stops and cannot go any

further until he has properly admired and fully savoured the wonderful wooden plaque, with a simple floral surround, that shows in its undecorated centre the three unnecessary but moving words: "Hic est chorus"– here is the choir. These steps could not be leading anywhere else, there's no danger that the bodies or souls climbing them might get lost, and yet someone felt the need to point out this precise spot. The attendant smiles and nods, perhaps it had not occurred to him before, and from now on he will point it out, as he does with the letter N in the missal. These are more letters, after all. When the traveller reaches the choir, he understands everything. On the far wall is a frieze from another church's altarpiece. It shows two angels carved in dark wood, raising their body, arm and doubtless their voice in jubilation: that explains "hic est chorus", spreading throughout the church. These angels have made their own journey, they are exultant. Jubilation. "These are truly jubilant angels," the traveller hears someone murmur beside him.

The attendant accompanies him back to the entrance, and from the door-way points out the stone from where, according to tradition, Nuno Álvares Pereira climbed onto his mule and set out for Aljubarrota. The traveller is headed in the same direction, and it's high time he got started.

IV

FROM MONDEGO TO SADO,
STOPPING ALL THE WHILE

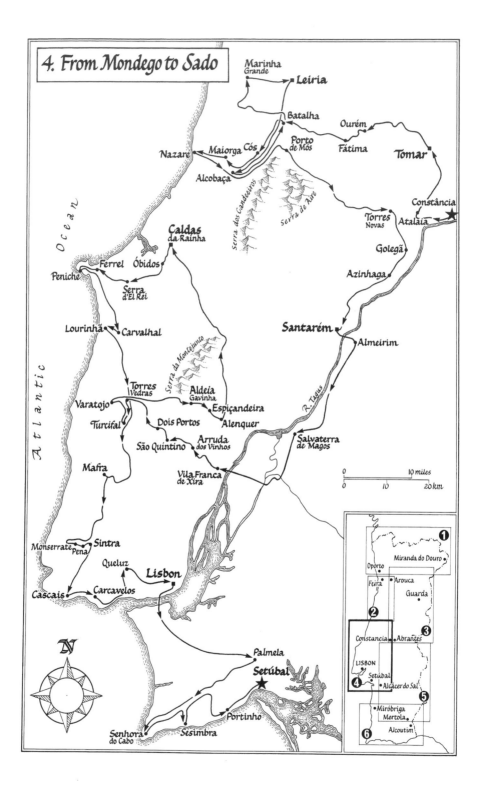

4. From Mondego to Sado

Marinha Grande
Leiria
Batalha
Ourém
Porto de Mós
Fátima
Tomar
Maiorga Cós
Nazaré
Alcobaça
Serra dos Candeeiros
Serra de Aire
Constância
Torres Novas
Atalaia
Golegã
Caldas da Rainha
Azinhaga
Ferrel Óbidos
Peniche
Serra d'El Rei
Santarém
Lourinhã Carvalhal
Almeirim
Serra da Montejunto
Torres Vedras
Aldeia Gavinha
Varatojo
Espiçandeira
Turcifal
Dois Portos
Alenquer
São Quintino
Arruda dos Vinhos
Salvaterra de Magos
Mafra
Vila Franca de Xira
R. Tagus

0 _____ 10 miles
0 ___ 10 ___ 20 km

Monserrate **Sintra**
Pena
Queluz
Lisbon
Cascais Carcavelos

Palmela
Setúbal
Portinho
Senhora do Cabo
Sesimbra

Ocean
Atlantic

N

① Miranda do Douro
Oporto
Arouca
Feira
Guarda
② Constancia Abrantes ③
LISBON
Setúbal
④ Alcácer do Sal ⑤
Miróbriga
Mertola
⑥ Alcoutim

One Island, Two Islands

The traveller would like to continue along the bank of the River Tagus, but the highway heads away from it, and it is only beyond Montalvo that the road finds its way back – and this time to not one, but two rivers. This is Constância the beautiful, even more so when seen from the far side of the river, in its magnificent amphitheatre, with its houses clambering up towards the parish church of Nossa Senhora dos Milagres. To reach it, the traveller needs strong legs and a good pair of lungs. But this fine spring weather fills the path with the overpowering scent of roses, so that he does not even feel the effects of the steep climb.

The statues inside recall certain Baroque Italian churches, and this effect is strangely reinforced by the roof painting, by José Malhoa, which shows Nossa Senhora da Boa Viagem blessing the union of the rivers Zêzere and Tagus, and is far less realist than the traveller's school lessons had led him to believe. Malhoa was certainly influenced by the statues he saw around him. The traveller enjoyed the seventeenth-century bas-reliefs brought from the chapel of St Anne, especially the fresh way that the usually solemn Baptism of Christ is treated: while it shows in the foreground the conventional scene, in the background it depicts an earlier moment: that is, when St John the Baptist is taking his boots off and Christ is lifting his tunic over his head, leaving him naked from the waist down, although here naturally enough his body is concealed to preserve the necessary modesty. The whole composition is full of grace – two young men going for a bathe on a hot afternoon, shown plainly with great simplicity of gesture and with a great zest for life.

The traveller walked back down to the river in search of refreshment in the Flor do Tejo, a small restaurant with a roof of cane and greenery, but the child of the house, only four months old, had a bad stomach-ache and did not stop wailing, so the traveller decided instead to visit the house of the poet Camões, which is a little further on. It is known as his house, which could equally well be true or not. The traveller, who is a native of this river, likes to imagine that Luís Vaz de Camões strolled in between the ancestors of these

willows, lovesick for Catarina. Would it really be any great historical solecism to reconstruct this house like a sixteenth-century mansion and to put the poet's works in it, and so to recreate the village of Punhete? Surely it is no worse than to say: "In this tomb lie the bones of Luís de Camões" as the visitors to the Jeronomites' church in Lisbon do. Constância has as much right to its Camões as anyone does. And the traveller must confess that, with his own eyes, he saw the shade of Luís Vaz de Camões descending the Escadinhas do Tem-te Bem as if he intended to compose a few poems by the riverside.

When at the castle of Abrantes the traveller admitted knowing little about military strongholds, he was attempting to disguise his complete ignorance of military affairs, but now, seeing the castle of Almourol on the far side of the river, where some soldiers are larking about or reading comics in an olive grove, he cannot help but feel that this fortress cannot have been of much use to Gualdim Pais or those who came after him. What did this castle defend? Even if there are no crossing places upstream or downstream, the Moors could easily have got across in boats, as the north bank is clear of vegetation; and a properly laid siege, which prevented those inside the castle from coming down to the river to fish, would have ended their resistance as soon as they ran out of flour for their cakes. Yet here stands the castle, a triumph of stone and strength, thereby proclaiming there was a need for it. So the traveller admits he must be wrong, with the reservation that it was probably the need for shelter more than any precise military objective which led to all the battles over it with broadswords and longbows. The land on the far side of the river is flat and empty, leaving room to the imagination. So the traveller chose not to cross: castles are always better seen from the outside, and Almourol more than any other.

He is not able to visit the church at Tancos, which is surrounded by houses and low walls in a style that announces the Ribatejo region, but he enjoys what remains of the Renaissance spirit of the building: the niches on the façade, a Nossa Senhora da Misericórdia that mercifully has been preserved, and the decorative side doors, one of which bears the date 1685 over the lintel.

Continuing on in this direction, the traveller only has to cross the hills of the Aire and the dos Candeeiros ranges to reach the sea. He will reach it all in good time, but for now, after visiting Atalaia, he turns back the way he came and crosses the bridge over the Zêzere once more, then heads upstream and returns to the river at Castelo do Bode. All this toing and froing is necessary if only because it enables him to visit the remarkable church of

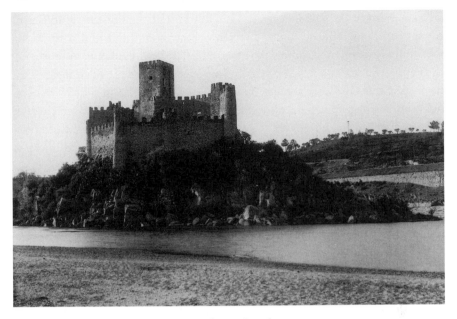

41 *Almourol castle*

Atalaia, with its façade that probably influenced the one at São Vicente de Abrantes, and the fine decorative tiles in its interior. Built at the edge of the village, which fortunately has respected the site as it has grown, the church, and its three real and five apparent naves, is a fascinating construction. It almost makes the traveller feel like playing hide-and-seek behind the huge arches, so pleased is he to discover that architecture has the power of itself to make a man happy.

He does not have the space to record everything that pleased him. So in passing he will mention only the fan vaulting of the main chapel, the imposing Baroque sepulchre on its left, and the image of a Virgin from the fourteenth century, said to be by the elder Diogo Pires, and with that done will have eyes only for the wonderful tiles, above all – ah, above all – for the polychrome panels on the rafters of the central nave. These depict biblical scenes: the Creation, Original Sin, the Expulsion from Eden, Cain and Abel, the Flood, the Entry of the Animals into the Ark. They are imaginative and pleasing in their design, particularly the one showing the Flood, with its rough, heavy ark tossed by the waves. Their intense blues and oranges light up the whole church ceiling; the faithful must often have lifted their eyes to them when the lessons they taught were taken to heart, just as they do now, when we most admire these panels as an almost unequalled work of popular

art. It is hard to leave this remarkable church, with its "broad-shouldered" façade which succeeds in hiding the heavy buttresses that support the body of the building. But needs must, and so on to the River Zêzere.

The highway follows the riverbank for three kilometres. Then it starts to climb, and a league later reaches the dam. This is Castelo do Bode. The dam is full in early spring, forming a huge inland sea that stretches into all the surrounding valleys. The traveller is as ignorant about hydraulic engineering as he is about military matters. He is therefore entitled to be astounded that this wall of concrete, however massive it is, however expertly its foundations and submerged structures have been calculated, is able to withstand the pressure of such an enormous mass of water stretching thirty kilometres in a straight line, without any intermediate barrages. Yet the traveller does have one redeeming feature: he is capable of admiring everything he is incapable of doing.

It's not far from here to Tomar, so the traveller decides to turn off at Beberriqueira and to travel through the woods on this side of the dam until he reaches the village of Serra. The detour is very restful to his eyes, offering him as it does extensive views of the cool woods, light softly filtered through the branches: this too is enough to make the traveller happy.

Making his way down to the waterside once more, he has opposite him the island of Lombo, which is like Almourol but smaller, and with no castle, only a small building in among trees, and a serviceable jetty that is too far away to distinguish properly. The traveller supposes that before the dam existed, it was not an island but a hilly promontory jutting out from one bank of the river. That is of little importance, of course, but the traveller likes to amuse himself with this kind of speculation. Now he is in a boat travelling across the clear, deep green waters to the island, and the further he leaves the shore behind, the more he feels freed of care, of timetables, even of his own desire to travel. He's leaving the world behind, entering Nirvana, floating down the River Lethe of forgetfulness. And when he sets foot on the island he can't get it out of his mind what a boon it would be to stay here for two or twenty days, with bed, board and lodging, until the outside world or inside concerns tugged at his ear and reminded him he could not avoid his obligations any longer.

But his stay did not last two hours. This landscape of water and mountains, this Swiss lake, this haven of peace is beyond human measure. It is too overwhelming. So he returns to earth, this time in a rapid launch with an outboard motor, and this too he finds pleasant: the waters flowing past on both sides, the roar of the engine; the visit to Lombo was a short one, but well worth it.

He enters Tomar at the opposite end to the Castle of the Knights Templar, sorts out his lodging and uses the time remaining in the day to visit the church of St John the Baptist and the synagogue. The Manueline portal of the church is made all the more beautiful by the bareness of the stone. The belltower is a heavy mass that refuses to integrate with the rest of the simple exterior. It has its own worth, and tells you so.

The church of St John the Baptist is vast, with three naves of soaring ogival arches. The central nave is highest, but the light coming in from the round window in the façade and the side windows is not enough to penetrate the gloom that encroaches on everything at this time of day. With time and patience though, the traveller can appreciate the panels by Gregório Lopes. This fine painter must have had an excellent studio working under him, and have been a good instructor: this is obvious from the unity of conception in these and other panels, the delicacy of the decorative elements, the easy transition of colour and line from composition to composition. The Beheading, with its theatrical figures, shows a real sense of drama in the halberds crossed diagonally over their heads.

The pulpit, which is meant to be by the same hand as built the porch, reminds the traveller of Santa Cruz de Coimbra both in its individual elements and in its overall design. It's the work more of a goldsmith than a stonemason. The traveller admires it, but is not overwhelmed. As he has already said, he thinks that the invisible boundary – which, being invisible, is all too often crossed – beyond which stone still keeps its essential nature, its density and weight, is all-important. In his humble opinion, stone should not be fashioned like stucco; and yet, as he does not have any fixed ideas, he is ready to accept all and every exception to this rule, and to defend them with the same enthusiasm that he employs in his defence of sculpting as against filigree work, chisel rather than scalpel.

He regretted being unable to see the Baptism of Christ in the baptistery. The grille is closed, and however much the traveller tries, he cannot make out anything more than the wine jugs of the left-hand panel depicting the Wedding at Cana. Both baptism and temptation are out of sight.

The sun is already sinking behind the castle. The traveller moves on to the synagogue, where the door is opened by a tall old man who might be Jewish but does not show it from the way he speaks. He is clutching an old, worn and greasy tome, and tells the story of the building as best he can. The synagogue is simple and harmonious in its design, with a high vaulted ceiling resting on four slender but precise columns and corbelled walls. One curious detail is the large water jugs stuck in the plaster at each corner in order to help the

acoustics by increasing the resonance. The traveller gives them a standard test, which as usual does not prove much. The builders of the Greek theatre at Epidaurus knew a lot more about the science of making oneself heard.

That evening, he had dinner at the Beira-Rio restaurant. He ate a magnificent, historic steak, with a taste that, having passed through all the subtleties of its sauce, had returned to the essential savour of meat, and stays forever in the palate's memory. And since good fortune never comes alone, the traveller was served by a serious-looking waiter who when he smiled had the happiest face in the world – and he smiled a lot. The city of Tomar should pin its highest award or commendation on this man's chest. In return, it would get one of his smiles, and would be amply rewarded.

Arts of Water and Fire

The traveller wakes up the next day and opens his bedroom window. He wants to be able to enjoy the freshness of the trees round the Mouchão, its tall poplars and green-and-white birches. Whoever transformed the sandbank that this was in the last century into this cool oasis also deserves a medal. As you can see, the traveller is in a mood to recompense everyone he thinks deserves it.

The monastery is at the top end of town, and must be visited. But the traveller devotes his first attention of the day to a close exmination of the water wheel that is so near at hand that passers-by usually ignore it, perhaps thinking it is merely decorative or is simply some children's plaything that has been set to one side. Yet as a piece of carpentry, it is one of the finest machines the traveller has seen. It is known as the "Moors' wheel", as is common in Portugal when we don't have any other explanation for something, but in fact experts say it dates from Roman times. The traveller does not know exactly when it was built, but finds it hard to credit that it has been a wheel since the fourth or fifth century. Far more important than determining whether it is Moorish or late Roman seems to him to be when it stopped functioning, and all the art and science of its use. Everybody has their favourite things: the traveller delights in these functional instruments, small works of art bearing the marks of those who used them.

The path up to the monastery is a pleasant one, with plenty of shady trees. To the right, a small avenue leads to the church of Nossa Senhora da Conceição, which the traveller would very much like to visit in order to see whether as is claimed, a Renaissance style can remain warm and inviting when it is mixed with the kind of classical purity he has always found cold. But he will not be able to do so on this occasion: the church is only open on Sundays, and the traveller cannot camp outside waiting until then.

The entry into the castle walls is by a path which follows the hill round to the entrance on the eastern side. The traveller walks up in a relaxed mood, indifferent to the flowerbeds and fine gravel of the path. He is not radically opposed to them, but if asked his opinion, he would do it differently:

to his mind, there should be some common ground between packaging and content. When two things are adjacent to each other, they should respect one another's qualities. These thoughts might seem out of place here outside a castle, but the traveller is simply putting into words the thoughts that arise as he sees things, as everyone does who pays attention to the workings of his own mind.

Here is the portal by John of Castile, one of the most magnificent works of art in Portugal. Strictly speaking, a sculpture, this gateway, or even a simple painting, cannot be explained in words. It is not even enough to look, since the eyes also have to learn to read shapes. Nothing can be translated in this way. A sonnet by Camões cannot be rendered in stone. All one can do faced with this portal is to look, identify the different elements according to the knowledge one has, and try to fill in the gaps in this knowledge – but each traveller has to do this for himself, one person cannot do the seeing and explaining for anyone else. A guide would be a help, provided they were not like this one, whose boredom and lack of interest is as insulting to the interested visitor as it is to the things to be seen in the castle. But the traveller must be kind: after all, the man is here every day, looking at the same stones, hearing the same remarks, having to give the same replies to the same questions, giving the same information; even if he were a saint, a model of virtue and patience, he would be unable to avoid a certain weariness in repeating the same words all the time, in coming and going as he does, seeing all those faces. So the guide is forgiven in the light of such terrible suffering.

The Convent at Tomar is the portal, the Manueline church, the *Charola* or Templars' oratory, the great window, and the cloister. And everything else. What most impresses the traveller is the *Charola*, because of its antiquity, of course, because of its exotic octagonal shape, but above all because he can see in it the perfect expression of the idea of sanctuary, a secret place that can be visited but is not on display, a central point that is the focus for believers and around which the lesser attractions are laid out. So the *Charola* is at one and the same time a radiant sun and the navel of the world.

But every sun sets, and navels wither away. Time is gnawing at the *Charola* with its sharp, ruthless teeth. There is a general air of decrepitude that comes from both age and neglect. One of the most precious artistic jewels of Portugal is in decay, being snuffed out. Either it gets help soon, or we will hear the usual chorus of lament when it's too late. When he hears the traveller's complaint, the guide forgets about being aloof for a moment, and explains that the damage to the lower parts – the crumbling walls, the paint

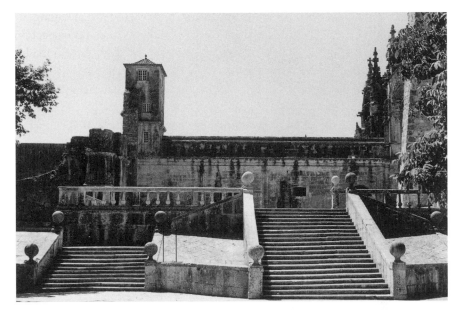

42 *Tomar, Convento de Cristo*

and plaster that has come off – are chiefly due to the large numbers of weddings that take place in here. "Everybody wants to get married here. The guests come and lean against the pillars, climb up them to get a better view, and then amuse themselves pulling off bits of painted plaster to have as keepsakes." The traveller is appalled, but soon hits on the answer: "Then they should ban weddings here." The guide must have heard that solution a hundred thousand times. He shrugs and doesn't say a word. So it's not boredom on his face, it's discouragement.

The cloister seems dry and cold to the traveller. To put it another way: just as Diogo de Torralva, the creator of this project, did not identify with the Manueline, and still less with the Romanesque or Gothic styles, so the traveller, who is faced with the product of this succession of historical styles and tastes, can say that this Roman neoclassical style is not to his taste either, and if he is obliged to say why, he will say it is because it seems to him dry and cold. Of course, this is subjective. But so be it. The traveller has a right to be subjective, otherwise there would be no point in travelling – travel surely is the confrontation of the subjective with the outside world. Let's not get carried away then: it's not a complete rejection, it's simply not a complete acceptance. And the traveller admits to being conquered by one thing in Dom John III's cloister: the doors at ground level, where the windows

above them seem to him a triumph of straight lines and exact proportions.

Everything has already been said about the Great Window: which means probably that there is everything still to say. Don't expect any revelations from the traveller. Except for the firm conviction that the Manueline style would not be what it is if the temples in India were not what they are. Diogo de Arruda may not have been near the Indian ocean, but there's no doubt whatsoever that Portuguese ships carried artists with them, and they brought back drawings, sketches, copies: an ornamental style as dense as the Manueline could not have been created, elaborated and refined in the shade of our olive groves: it is a cultural whole discovered elsewhere and recreated here. Please forgive the traveller these rather bold conjectures.

The traveller is not bold enough, however. He lacks the courage to ransack Tomar until he can find someone who will open the door to the chapel of Nossa Senhora da Conceicão for him: he can't get the image of those cloister doors out of his mind. If Diogo de Torralva worked so long in the church, perhaps the traveller will need to review his rather free use of the terms cold and dry. Yet he lacks the courage: come back on Sunday, I can't, I have to leave, you'll just have to be patient then.

The traveller continues on towards the west. On his way he sees the aqueduct at Pegões Altos, the proof that utility and beauty are not incompatible: the series of perfectly rounded arches above more open false ones reduces the monumental nature of the construction, making it less imposing. In this way, the architect designed a false aqueduct which serves as a support to the real one carrying the water.

Ourém is high on a hill. This is the old town, set among the most abandoned lands the traveller has seen. It's well known that it is the lowlands which attract economic activity, industry and commerce, but some people still insist on living in this abandoned place, and the reasons for their insistence should be considered and respected. The death of places such as Ourém is not inevitable. It's not true to say that old stones such as these should be glanced at then left behind. The old town of Ourém has many reasons to continue to live: the outcrop it is built on, the sixteenth-century layout of its streets, the extraordinary castle perched on its sheer cliff – reasons enough and more for today's neglect not to become tomorrow's destruction. Stones should be preserved; people should be defended.

As luck would have it, the traveller took the longest way round to reach the palace. A wise choice, as he was able to see the entire town, with its deserted houses, some of them in ruins, others with the windows boarded up, the wayside shrines stripped of their images, places where even spiders go

hungry. It is only at the top of the town that the last few inhabitants were huddled, and there were some signs of life: children playing, a restaurant with silly heraldic pretensions that thankfully was closed, because the traveller was tired of all these noble hostelries and other such fantasies.

The palace, of which little more than the towers remain, is the work of giants. It may be true that Lilliputians could pile stone on stone until they built a tower reaching to the sky, but these, which do not have such a lofty aim, give the impression they could only have been built by huge arms and muscles. They must have been powerful builders to have constructed such an original fortress, with its Gothic arches and brick adornments that immediately lighten the feeling of massive solidity the whole tends to create. It seems it was built by Jews from the Maghreb, the same ones who went on to build the synagogue in Tomar and the crypt for King Afonso, which the traveller has yet to visit. He recalls the Cristo de Aveiro, probably built by Moorish hands, throws into the same pot newly converted Christians and Arabs, lets the whole lot stew, with the different traditions, new beliefs and their ensuing contradictions, and watches how new forms of art emerge, sudden changes unfortunately flung together before they are

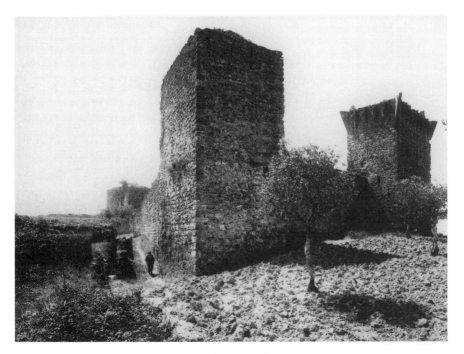

43 *Ourém castle*

properly developed. The synagogue in Tomar, in Ourém this crypt and the tomb inside, and the palace itself: if we delved deeply into the circumstances of the times, the place, and the people, where would it all end? This is the question the traveller was asking himself as he descended the steep road back down to the plain.

It takes many twists and turns to get to Fátima. There are more direct roads of course, but coming as he does from a region that is a mixture of Moorish and Jewish, it is no surprise the traveller prefers the longer route. Today, the huge esplanade is deserted. Only in the distance, in front of the Capela das Aparições, have a few people gathered; a few groups congregate then disperse. A nun carrying an open parasol appears in the traveller's line of vision as if from nowhere, and disappears just as suddenly. The traveller is a man of opinions, and here his opinion is that aesthetics have failed faith. This is no surprise, in our sceptical age. The builders of the most humble of Romanesque chapels knew they were building the house of God; nowadays they are simply carrying out a commission. The church tower seems unde- cided as to how to end, there's no measure or balance in the columns – only faith can save Fátima, not the beauty it does not possess. The traveller, an unrepentant rationalist, has been moved during this journey by more than one belief he does not share, and would like to have felt he could respond here too. But he leaves without feeling guilty about it. What he does feel is a certain indignation, pain and anger faced with the vast number of stalls which are selling – by the million – medallions, rosaries, crucifixes, tiny repre- sentations of the shrine, small and large statues of the Virgin. When all is said and done, the traveller is a very religious man: he was even scandalised in Assisi at the cold, holy trading that the friars carried out on the balconies.

The traveller has nothing against caves. He's well aware that his forebears lived in them after they had grown tired of swinging from tree to tree. And to be perfectly frank, although he would have made a poor anthropoid because of his fear of heights, he would have been an excellent Cro-Magnon, because he does not in the least suffer from claustrophobia. And to con- tinue being frank, he wonders why the natural wonder of these limestone formations, with all their possible combinations of stalactite and stalagmite, should be ruined in these caves at Fátima by the variety of lights, the shocking colours, and the background music from Wagner, in a place the Valkyries would have been hard put to find room in for their horses. Then there are the names with which the different caves have been baptised: the Crib, the Unfinished Chapel, the Wedding Cake, the Fount of Tears: how ghastly! What would the traveller have preferred? A single light that picked out the features

of the stone; no sound, apart from the natural one of dripping water; not a description – an absolute ban on hiding what something is with a name that has nothing to do with it.

So now the traveller needs a long period of just looking at landscapes. He wants to relax with the gentle hills of the region, trees that are not storm-tossed, fields that do not fight cultivation. He decides not to visit Leiria yet. He crosses the River Lis beyond Gândara dos Olivais, and heads north across the coastal plain. He meets Amor on the way, which surprises him, as love is usually to be found in more challenging surroundings. The day is bright and luminous, with already a scent of the sea. In Vicira de Leiria there is a seventeenth-century church, Santa Rita de Cássia, which he visits because it's on his way, but which deserves to be seen anyway. In front of him now is the beach at Vieira, open to the south, and beyond it the mouth of the River Lis. There are fishing boats drawn up on the beach, with long curved prows, their oars folded back as they wait for the tide to rise and the fish to teem.

Then there are the pinewoods of Leiria, those in the songs of the green pines by Dom Dinis, of the ships and caravels of the first explorers, the fragile wood that ventured across such vast distances. From Vieira to São Pedro de Muel there is a road that cuts a straight line through the woods until it finally turns towards the sea. Seen at this time of day, with its beach deserted, the waves pounding, and many of its houses boarded up to wait for summer, which will possibly not bring as beautiful weather as this, it soothes the traveller' spirit. And this atmosphere leads him to ask whether there might be a road to Marinha Grande that will allow him to savour the coastal woods for a little while longer. He's told that there is one, true enough, but it's also true that he is likely to get lost. He took the risk, did get lost, but did not lose anything in doing so. On the contrary, he gained: several kilometres of true delight, through dense woods where light fell in swathes, in torrents, in clouds, transforming the green of the trees into pulsating gold and then changing back into living sap, until the traveller was so overcome he did not know which way to look. This wood of São Pedro de Muel is beyond compare. Others may have more varieties of trees or be more imposing, but none is so worthy of being inhabited by the little people, the gnomes, fairies and elves. The traveller could swear that a sudden movement of the foliage in the wood must have been the work of an expert gnome in his red hat.

Eventually though, he has to return to the road for ordinary people. Now he's on his way to Marinha Grande, the renowned centre for the art of glass-making. Perhaps because it has devoted everything to its furnaces and chemical magic, it has little to spare for any other graces. This is an industrial

place, with a strange political atmosphere: this is plain from every wall, from the banners in the streets, from the earth itself. When the traveller asks how he might visit a glass-making factory, he finds someone to show him the way, help him get in, and accompany him on the visit.

The word factory hardly conjures up what he sees: a big shed full of holes, open to the winds, with a few other scattered whitewashed stone buildings offering slightly more protection. But the factory, the place where the glass is made, turns out to have its logic: the heat would be unbearable if these windows were closed, or any of the holes stopped up. The breeze constantly blowing in helps keep the workshop relatively cool, and – the traveller imagines – so does the glass itself. Here are the furnaces. Jets of fire are directed ceaselessly into the ovens, inside which a reddish-white liquid mass bubbles and quivers in frightening streams: it is a tiny sun from which objects capable of capturing and holding the light of the real sun will be fashioned. When the glass emerges from the furnace in a soft gleaming red ball that seems to be trying to escape from its long tube, nobody would think it will soon be transparent, diaphanous, as if the air itself had been turned to glass. But this colour is fleeting. The ball is then placed in a mould, blown and turned many times before it solidifies, and finally emerges, still gleaming and rainbow-streaked from its internal heat, in the shape of a jug, and then travels through the air, cooling all the time, to the next stage in the process. This movement is neither fast nor slow, simply measured enough to protect both the workman transporting the piece and the piece itself.

In this hot and noisy atmosphere, against old wooden walls, the workmen move as though they were following the steps of a ritual. It is a simple chain: one man takes the piece and passes it to another man, a delivery service that always follows the same route, and always returns to its point of departure.

The better to understand this chain of work, the traveller went to the workshop where the moulds that go into the ovens are made, moulds in which the fusion of the elements that make up glass takes place, not forgetting the proportion of old glass that is always added to the mixture. There's no noise here, the door is always shut, the men speak in whispers. This is where the clay is moistened and shaped, slowly, with the feet and with a deliberate precision that seems almost crazy: treading it, piling it up, treading it, piling it up, using a technique that prevents any small part of it from being drier or less worked than any other. There must be no foreign bodies in this clay: not the smallest stone nor any dirt the workmen may have brought in from outside on their shoes. The creation of the shape inside the mould, the ensuring that both halves are identical, the smoothing that is almost

polishing, is the work of a sculptor. It's an abstract task that is repeated over and over, a concrete cylinder closed on one of its two sides, but the traveller can detect not the slightest sign of boredom in the men who make these moulds, only a deep-seated love of their work, which has to be perfect because if it is not, the oven will reject it with the first flame. This is work which, in the most literal sense, is put to the test of fire.

Friars, Warriors and Fishermen

The traveller did not see much of Leiria. Whether this was his fault, chance, or unavoidable necessity, who can say?

The Cathedral probably suffers from the length of time it took to be completed (over a hundred years), which produced the inevitable fluctuations in a style that became increasingly less sure of itself from its early years onwards. Then came the 1755 earthquake, which brought down part of its front – so that in all honesty it cannot be said that the Cathedral offers any great spiritual rewards, except for strictly religious ones, of course. While the traveller was inside, peering up at the tall columns in the naves and the coffered ceilings, he could hear a ball bouncing against one of the church doors: some children were playing football in the courtyard outside, using one of the doors as the goal, and the goalkeeper was apparently not very good. The sound echoed through the empty naves like a hammer blow, but none of the scattering of people inside appeared concerned, from which the traveller concluded there was a high level of tolerance in Leiria for children's games. Thank goodness.

Although it is still early morning, it is already hot. The children are still playing as the traveller starts the tiring climb up to the castle. The countryside opens out gently in front of him, apparently without surprises, and the traveller is not expecting any. But he is wrong: the castle at Leiria is a very pleasant place for a stroll, with its wooded walks, its narrow paths, and picturesque ruins. The magnificent loggia in Dom Dinis' palace conjures up images of courtly ladies trailing their long gowns as they listen to exquisite poetry and prose whispered to them by ardent lovers. No more ardent than the embrace a boy and girl are giving each other in a corner, looking as though they are joined together from mouth to knee, as young people do. The traveller asks himself severely whether or not he is passing a moral judgment, but decides he is not, particularly when he bears in mind that the lady and her admirer would have done the same in ancient times, although not in such a public place. Seen from here, Leiria is beautiful.

Then the traveller went to visit the nearby ruins of the church of Nossa

Senhora da Pena. Nothing identifiable remains of the stones making it up in
the time of Dom Afonso Henriques. What can be seen is from the fourteenth
century, when it was rebuilt. The church is of medium size, and must once
have been a fine building. Even today, roofless and open to the winds, it has
a beauty all its own, which comes from the sense of proportion it gives,
especially against the obligatory reference of scale that the palace offers in
the background. The traveller spent some time wandering happily along
the undulating wooded paths, and then, seated on the very stone where Dona
So-and-So finally said yes to her stubborn suitor, he got out his map and
worked out his own plan of battle. He will start, yes indeed, by going to
Batalha, then pass through São Jorge e Cós, and finally sniff out Nazaré.
He will come back inland via Maiorga and Alcobaça, and end the day back
in Leiria.

The distances are not great, so the traveller can take his time. And in order
to relax all the more, he leaves the main road and takes a much smaller one
which follows the banks of the River Lis. He needs to prepare himself quietly
before facing the great monastery, the Mosteiro de Santa María da Vitória
in Alcobaça. It is simple enough to state something like this, but deep inside
himself, the traveller knows he is a lost man. Where ten thousand pages
would not suffice, one is too many. He is sorry not to be travelling by
aeroplane, so that he could say: "I couldn't see properly, we were flying too
high." But his feet are on the ground, and he's almost there, and a man
must not shirk his duty. Nuno Álvares had a much easier task – all he had
to do was defeat the Spaniards.

In fact, the traveller cannot allow himself to be intimidated by the sheer
size of the monastery or lose himself in what eventually must become a tire-
some examination of every stone, capital, ornamental flourish or statue
he comes across. Instead, he will get an overall view and be satisfied with
that and, since he is no expert but merely a curious observer, he will dare
contradict accepted and well-founded opinions, because that is what having
a pair of eyes, his own taste, and very much his own sensibility give him
licence to do. He will say for example that once he is inside the church,
the Capela do Fundador, despite the rich sculptures it contains and its
harmonious structure, arouses in him admiration rather than passion – which
is his way of expressing the sense of rejection he suddenly felt. Let's be
clear about this: the traveller has not the slightest doubt that it is worthy of
all the praise that has been heaped upon it, and he could add his own easily
enough. But since perfection is not an end in itself, and since the traveller is
the least perfect of observers, he would perhaps prefer to have found the

artist working in that ample region where triumph over the matter he is struggling with is not so complete, even though the satisfaction is equally great. This may seem a paradoxical attitude. On the one hand, he wants the artist to express himself fully, as this is the only way of getting to know who he is; on the other, he would prefer him not to be able to say everything, perhaps because this idea of everything being said is still an intermediate stage of expression. It is quite likely that certain formal lapses are in fact due to the troubling realisation that perfection empties a work of meaning.

The traveller is worried he is talking nonsense. Too bad. That's the risk that has to be taken by someone who travels and comments on what he sees. And since he is not going around simply to confirm that the sun rises in the east and sets in the west, he can risk a few subversive comments which, when all is said and done, are no more than sincere personal opinions. And this sincerity leads him to declare the simple pleasure that filled him when he first stepped into the central nave of the abbey, seeing the tall, thick columns which at first form a solid wall blocking off the rest, and then, as one advances down it, gradually open out and reveal the whole extent of the lateral naves, before closing down again. The static becomes dynamic, the dynamic pauses and gains strength from immobility. To walk the length of these naves is to experience all the impressions that the organisation of space can create. But suddenly the traveller is forced to admit that there is more to say: three swallows flew in through the main door and wheeled around the ceiling, giving off their cries. A shiver ran down his spine as he realised that this new language complements the other one: the bird adds to the nave, the cry adds to the silence.

The traveller moved on to the royal cloister. Here, the artistic merit is based on decorative rather than structural factors. Were it not for the rich sculptures of the arches, on elaborate columns which support none of the weight, this royal cloister would be scarcely any different from many others whose only ambition was to reserve a privileged space for meditation. It is the Manueline exuberance added to Gothic severity that creates its basically theatrical impact.

This is why the traveller, who always accepts he may be wrong, but seeks to be coherent with himself, declares that he was much more impressed by Dom Afonso V's cloister. It was built by Fernão de Évora, not someone of great genius, but that is not the point here. There is a workmanlike character to the Afonso V cloister, the touch of someone more used to building ordinary courtyards than luxurious palaces, and it is precisely this aspect that moves the traveller: the rustic nature of its design and construction, and the sense

of spiritual reflection it creates, when compared to the showy virtuosity of the royal cloister. Viewed as a whole, the Afonso cloister is, to the traveller's mind, more perfect. Yet he would not mind being contradicted.

When he enters the chapterhouse, he recalls the story by Alexandre Herculano that made such an impression on him at school: the old architect Afonso Domingues sitting beneath the keystone of the vault, the workmen stripping away the supports and the scaffolding, the worry that the whole thing might collapse, while outside, crowding into the doorway or the side windows, the other workmen and a few nobles, all of them wondering: "Is it going to fall?" and one or two of them certain there would be a disaster: but then as time passed and this huge stone sky stayed up, the words of Afonso Domingues: "The vault did not fall, the vault will not fall." The traveller seems to remember that his teacher took the matter lightly, as just one more lesson to impart, but now he is on the spot he sees things differently. Afonso Domingues sat here sure that his calculations were correct, but by no means sure that he would win the challenge: it is not human to foresee absolutely everything. But he offered himself as the guarantor of something that was the work of many. He won, and we all won. It is a magnificent space, the site of another battle, one which transforms inert stones into the interplay of forces that are finely matched. The traveller goes and stands under the keystone of the vault, on the very spot where Afonso Domingues sat. Many people have done the same, accepting the architect's challenge as their own. It is our trial of faith. In the chapterhouse there are two live soldiers standing guard over a dead soldier. And a dead architect who is guarding the soldiers and the traveller. There must be some way for us all to stand guard over each other.

Moving on round the outside of the chapterhouse, the traveller went to visit the mausoleum to Dom Duarte which is absurdly but definitively known as the Unfinished Chapels. Luckily, the pantheon was never completed. If it had been, we would have a vaulted ceiling over our heads, and no surprise at all. But as it is, we have a promise which will never be fulfilled and so remains a promise, and in so doing somehow manages to satisfy as much, if not more, than if it had been completed. And it is good that it is spring. In the open space above the seven chapels, swallows wheel in darting flight, crying as though furious, but in fact simply saluting the sun as they hunt for insects, or perhaps glorying in the beauty of the columns, which in uninterrupted flight raise their seven arms to hold up the sky. Forgive the traveller these sudden lyrical flourishes, however unimaginative. Sometimes a person needs to let himself go, and doesn't always know how to.

The traveller then undertakes a leisurely tour all round the monastery. He studies the main doorway, with its archivolts peopled by the figures of angels, prophets, kings, saints, martyrs, each according to their place in the hierarchy; its tympanum with Christ and the Evangelists; the statues of the apostles on figurative corbels that are true masterpieces. The traveller stands back as far as he can, tries to take in the whole building, and withdraws contented, if slightly surprised at the daring of his own conclusions.

An ingenuous traveller who believes that words have only one meaning, might think that in order to discover where the battle of Aljubarrota took place he would have to look in the village of that name. But he would be wrong. Aljubarrota is fourteen kilometres from the monastery, and is not precisely the site of the battle. It was in São Jorge, five kilometres from Batalha, that the decisive combat took place. There is not a lot to see, as is always the case on battlefields where the bones of those who died and the weapons of those defeated have not been preserved. The tomb of the Unknown Soldier is in the chapterhouse of the monastery – here all of those who fought are unknown. But the traveller pays a visit to the Ermida de São Jorge, which was built on the orders of Nuno Álvares Pereira as a thanksgiving. Little or nothing remains of what it once was. It scarcely helps us imagine what once took place here. Even the admirable fourteenth-century sculpture of St George on horseback is busy with other battles: there's always the dragon to be killed, the dragon always comes back to life; when will St George realise that it is only men who can really slay dragons?

The traveller heads for the sea, through fields that slope down to it. The village of Cós is on his way. It's a national holiday – 25 April – and it seems the people of Cós are even more disposed to celebrate than the traveller himself – they're all in the streets, enjoying the holiday and their own contentment. In Cós stands the convent of Santa María, or what's left of it. To find such a grand and artistically rich church in this out-of-the-way spot comes as a great surprise. The colour and composition of the roof are magnificent, especially the painted beam-ends, and so is the sacristy, with its blue and white tiles depicting the life of St Bernard of Clairvaux. Cós is one of the fortunate discoveries of the journey.

Another discovery is Maiorga, not for its monuments but for the musical riches it offers. The traveller barely more than passed through the town, but even so he could see at least three signs proclaiming they were the meeting places of a band, an orchestra or a musical group. And one of them, in addition to its proclaimed love of music, also had a fine Manueline doorway (may Apollo preserve it): the traveller later learnt it had been the chapel of

Espírito Santo, and subsequently an almshouse. The ancient building is keeping up its tradition: first it cared for souls, then bodies, now it's dedicated to soothing our hearing.

What has the traveller come to Nazaré for? What does he do in all the villages and towns he visits? Look and pass by, pass by and look. He's already said he's not travelling for his health, but in order to be somewhere and feel himself part of it. But in Nazaré he needs to repeat his words of caution, if he is to be pardoned his presumption: he would need to stay and be part of the village to see the fishermen put out to sea and – hopefully – all return from it; to capture the shades of the waves, the way they beat on the shore; to help push out the boats; to shout like the people here shout, and shed tears with them too; to weigh the catch and the pay he gets for it; to live and die like them. Only after he had rowed and steered the boats, could he say he was part of Nazaré. But as it is, he is merely a traveller passing through on a holiday, with no-one at sea, a gentle sea with a sun shining so brightly it dazzles, and a lot of people strolling along the esplanade by the beach, or sitting on the sea wall, and a procession of cars buzzing like bumblebees. At times like these, the traveller feels rather melancholy; he feels cut off from life behind a glass partition which distorts at the same time as it reveals. So he decides to go up to Sítio, and to look from the cliff arching south back towards the broad curve of the beach, the sea constantly foaming in, the earth constantly absorbing it. There are plenty of people up here as well. It would be fun to put together what each of them sees, all the different oceans, all the Nazarés, and conclude that they were still not enough. The traveller gets the impression he is not helping, and asks for forgiveness.

The last port of call for today is Alcobaça. He has not covered much ground, but has seen a lot. Alcobaça raises yet again the question of what came first, chicken or egg. More precisely: was Alcobaça so called because the rivers here were the Alcoa and the Baça, or was it the other way round: before the rivers had been named, did the people of the region decide to split the name of the town in two, and say: "this can be the Alcoa, and that the Baça"? Those in the know say that the name of Alcobaça comes from Helcobatie, the name of a nearby Roman settlement, but this does not resolve our anxious doubt, merely puts it further back in time: "What if in those days the rivers were called Helco and Batie?" Was Helcobatie named after them? Or was Helcobatie generously split in two so that the rivers should not remain anonymous? This may seem like a traveller's idle speculation, but it is a serious question. And it is not good enough to be given an explanation that explains nothing. Although it must also be said that it's

44 *Nazaré, the harbour*

perfectly possible to live and work in peace without ever resolving the question of Alcobaça's name.

What is most impressive about the façade of the monastery at Alcobaça is the way that the different styles integrate perfectly, especially since the more recent Baroque makes no concessions to the Gothic doorway. The fact is that the doorway's possibility of competing with the other elements is reduced by having plain, undecorated archivolts enclosed in the Baroque pillars. So the structure and the movement of the whole is Baroque in spirit, despite the two Manueline windows surrounding the rose window. The twin belltowers are the apogee of the style, and have been repeated endlessly throughout Portugal.

But once inside the church, the traveller soon forgets the Baroque exterior.

This is the realm of the Cistercians, a cool atmosphere created by strictly functional architecture, its rigour reflecting that of the monastic order. The central nave is immense. It is the longest in Portugal, and seems narrow because of the great height of the vaulted ceiling. The lateral naves only serve to increase this impression, seeming almost like corridors. The overall effect is overwhelming. The space can only be filled by large choirs and solemn prayers. The traveller feels a bit out of place, in search of his own dimension.

Here are the tombs of Pedro and Inês (see Fig. 61), the immortal lovers who await the end of the world to resume their love from the point where the "brutal assassins" cut it short, if this kind of love is tolerated in heaven. They are the tombs of a Portuguese king and a lady of his court, born in Galicia. They loved each other and had children: she was probably killed for political rather than any other reason. Their sculpted figures are wonderful, although they have unfortunately been mutilated and worn away. The magnificence of the ensemble almost compensates for this. The only complaint the traveller has is that these tombs practically hide their most important feature, as it is difficult to get more than a glimpse of the reclining figures. In Batalha, it was hard to make out the combined forms of Dom John and Dona Filipa, he offering her his hand in the image of the perfect couple: the traveller had to walk round it, feeling he was missing the most essential part. Wherever it is possible without spoiling the architectural context, tombs like these which nowadays are simply works of art and not monuments to the glory and power

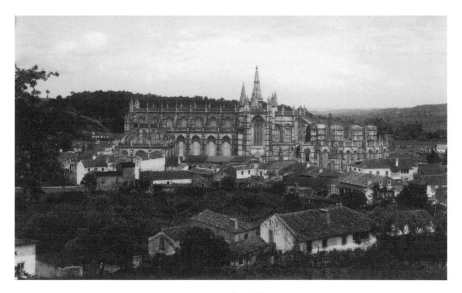

45 *Batalha abbey*

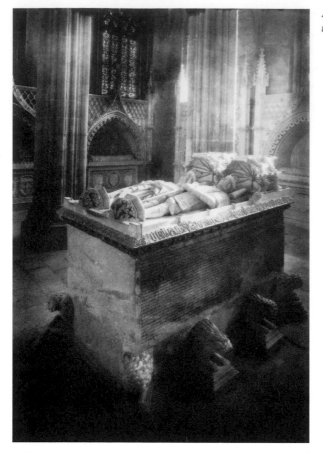

46 *Batalha abbey, royal tomb*

of the person there (or no longer there, or never were there) should be lowered and placed so that there is enough room to see them from every angle. This cannot be done, the experts will say. It should be done, the traveller will insist. And that will be that.

What the traveller should not do is repeat himself. But he cannot hide the fact that although he found the tombs of Dom Pedro and Dona Ines very beautiful, he prefers the other chapel where the thirteenth-century tomb of Dona Beatriz de Gusmão is to be found. This is a life-size coffer, surrounded by roughly sculptured faces with the most dramatic expressions, although somewhat stereotyped.

The altarscreen of the Death of St Bernard is dramatic too, but in this case because of the parlous state of its worn and split ceramics. Even so, it is a masterpiece. The figures have a presence that perhaps only clay can give them, as it is so much closer to our human frailty than stone. Or at

least, that is what we are taught. The traveller would have liked to go through the sacristy to the chapel containing the Baroque reliquary of Brother Constantino of San Paio. He had to make do with looking at the doorway to the sacristy, with its exotic Manueline foliage by the sculptor John of Castile. This makes the traveller wonder about his own taste: admirable the doorway may be, he thinks, but isn't it perhaps too admirable? It's as though the doorway had a mouth and was saying: "Here I am, admire me." The traveller has never liked being given orders.

What remained in his mind of the cloister was the contradiction between the weight of the lower range of arches and the airiness of the upper one. They represent two ages, two ways of working stone, two techniques, two scientific approaches to the resistance of matter. But he was also impressed by the capitals, which did combine the solid and the delicate.

The traveller visited the kitchen and the refectory along with a noisy group of Spanish schoolgirls. These are two huge halls on a similar scale to the rest of the monastery. The traveller's attention was caught by the constantly running water in the kitchen, he stood under the vast chimney with eyes and mouth wide open, and when he went into the refectory could not help but imagine it full of friars waiting in a disciplined fashion for their meagre food, then the scraping of bowls, the big white water pitchers, their chewing and swallowing stimulated by their appetite, the appetite stimulated by work in the monastery gardens, and finally after the last prayers had been said, everyone filing out for a digestive stroll round the cloister: give us this day our daily bread, o Lord.

How time flies. They are soon going to close the monastery. The Spanish schoolgirls have already left in their coach, where can they be headed for? The traveller pauses for a moment in front of the Cathedral, and gazes out at the square in front of him, the houses beyond, the castle high above them. The village grew up in the shade of the abbey. Now it has a life of its own. But the shadow still reaches out, or perhaps the traveller is just being deceived by a trick of the light as the sun sets.

The Oldest House

Early the next morning, the traveller left Leiria. There was a certain
solemnity to his departure, due not so much to the fact that his journey
was to include several places of historical or artistic merit, but because, after
visiting so many grand houses, the time had come to visit the oldest one. But
let's not get ahead of ourselves: the first stop on the route is Porto de Mós.

This is a luminous, pretty town, with white house fronts, that is clustered
around its castle. This monument is more than enough for the traveller.
The Count of Ourém's palace attracts from afar, with its gleaming tall
cone-shaped turrets, the vast opening of its main gate, the surprise it and the
similar ones at Feira and Ourém offer in the Portuguese landscape. In fact,
they could be its mother and father, if chronology shows that neither of them
are its offspring. In the end, the castle at Porto de Mós is more like the one
at Ourém. The hand of Dom Afonso is plain here – that strange character
who lies in the crypt of the town church and whose emblem – two winches –
puts him closer to engineers than his birth and heraldry might suggest. There
can be no doubt about it though: Dom Afonso, Count of Ourém, was noble
and pure of blood. It is hard to see him breaking with his class. Yet he would
make an interesting study: a man of culture, widely travelled, and yet a lover
of such strange architectures. The traveller would not be in the least surprised
if, scratching beneath the surface a little, there were traces of heresy in him.

The road twists and turns up to Casais do Livramento, on the north side of
the Mendiga hills, through a rolling landscape with few trees. Further on is
the de Aire mountain range, with its twin peaks to the east and west. The road
then descends into a valley, down towards the plains of the River Tagus.
It's hot. When the traveller enters Torres Novas, he takes time off to look at
the Almonda River, with its shady willow trees, the tall plumes of its ashes
and poplars. There's the island in midstream, with its benches and its
pergolas, its launches: it's a shame he does not have more time. As the town
grew, it respected the river's space: it did not crowd it out by building right
next to its banks – unless of course it was the river that kept it at bay with
its flooding during its impetuous youth. Whatever the case, the two grew up

side by side, close together, but not jostling each other. The traveller made
a quick tour of the town's churches, but found nothing of particular interest
in them (it should be remembered that the day before he had seen the wonders
of Santa María de Vitória and Santa María de Alcobaça), and then decided
to fill in the time till lunch with a visit to the Carlos Reis Museum. First
though he went to look at the river from the town bridge, but could scarcely
believe it was a river, the waters were so dirty, and full of flecks of foam,
and bits of rubbish. It looked so dead that the traveller withdrew feeling sad
and depressed.

But the museum is a charming jumble. Although there is a greater selection,
and it has more valuable works, it reminds the traveller of the one at Ovar
because of its range and the way the most disparate objects are shown
alongside each other. Right next to (but please do not take the expression
too literally) an extraordinary fifteenth-century image of the Virgin of the
O, there are models of oil and wine presses; the most delicate lacework sits
side by side with a twelfth-century helmet, a fine Roman glass jar reflects
panels attributed to the Master of San Quintino, and finally, not to say that
absolutely everything has its real or imagined twin, here is a statue of a weary
Eros, a lovely little figure of a boy who, worn out by all the battles of love,
fell asleep twenty centuries ago and never woke again. The traveller asks if
the museum is well attended, and the knowledgeable young girl who acts
as guide gives him the expected answer that it is not; so the two of them
sit there glumly for a while, staring at the modest rooms that deserve a
better fate. Outside, in the open air, there are lots of fragments of columns,
mouldings, tablets. There are several children playing in among them, and
although this can do their aesthetic education no harm, the same cannot be
said of the stones which are so inviting to climb, but every time a boot scrapes
against a Roman letter, a flake of history disappears. The traveller walks
down from the hill where the museum is situated, asks about somewhere
to eat, and is so well rewarded that he can say without fear of contradiction
that it was in Torres Novas that he ate and fully enjoyed the most wonderful
roast goat he has ever tasted. Not being an expert, he cannot tell how such
a masterpiece of the culinary art was achieved, but he trusts his palate, which
is something of an infallible expert in these matters, if such a thing exists.

He returned to the road. No need to consult the map. This region is full of
the names of an extended family which contains the places themselves, the
people who live or have lived in them, trees, insects, maize and melon fields,
olive groves, the corn stubble, signs of suffering and want. These are names
the traveller has known since he was born: Riachos, Brogueira, Alcorochel,

Golegã. This latter remains for the traveller the most secretive of all Portugal's towns, even when it opens up for its famous fair. The traveller never felt at home in this flat place, in these endless streets always full of clouds of dust; even today, now that he is a man who has grown up as much as he ever will, he is still the little boy frightened by this name of Golegã because in those days it was linked to the paying of taxes, the court of justice, to the death of an uncle who had his head staved in.

But these are personal details. The traveller's aim is rather to point out things of general interest, especially anything to do with art. So he goes to visit Golegã's church, which is surely the finest example of Manueline architecture in the countryside. The portal is the work of Diogo Boitaca. The way it soars vertically almost to the round upper window shows how the exuberant decorative Manueline style can integrate itself into a smooth frontage like this. The overall harmony is helped by the two turrets which define the central body of the façade: in this case, the structural supported the ornamental. The church has much to recommend it, but for the traveller the most remarkable thing is the proud yet humble declaration that stone angels hold up at the entrance on scrolls, which reads: "I am a reminder of the one who built me." Was it Diogo Boitaca who had these words inscribed? Or a mason at odds with the man giving him orders? Nobody knows. Only the words remain, and they could serve as an epitaph for everything man has made: even though usually they are invisible, any proper traveller should be able to read them everywhere, as proof that he is looking closely at the world and at those who live in it.

This is Campo da Golegã. Men and the river built this ground on either side of the highway. They made it flat so that they could see each other, although the river is concealed among willows until it's time for it to continue its work, or to destroy what is there, in which case men would also have to share the blame. The road is straight: there are no hills to avoid, or valleys to overcome, so it is an almost perfect straight line to the other river, whose name is the Almonda. A long time ago, the traveller used to like to travel along here, across the marsh Paul do Boquilobo, although to travel is hardly the right expression, as he used to mess about in boats in the channels, slide around in the mud, anything but travel directly. He had his own very special way of getting across the part of the marsh that had trees on it: he would swing from branch to branch of the willows, a couple of yards above the deep mud – or perhaps not so high, but certainly too high for his own good. He would go for great distances like this, until he reached the trees where the channels could be seen from, and never once

fell in. Even today he has no idea what would have happened if he had.

The traveller will not give another sermon to the fishes from this bridge. The Almonda is a river of dead water: everything in it is rotten. As a child, he swam in this pool, and if the water was never as clear as that of the mountain streams, it was only because of the mud it carried along, and that was welcome because it fertilised the fields. Nowadays, the waters are poisoned, as he had already noticed in Torres Novas. The traveller did not come here to mourn a dead river, but he must at least announce that it is dead.

Now he really does come to the oldest house. The road continues between tall, old plane trees, with on one side the Quinta de Santa Inês, and on the other the Quinta de São João, and then the first houses of the village. This is known locally as the Cabo das Casas. And it was near here, in Azinhaga, that the traveller was born. To show that he has not come here for merely selfish or sentimental reasons, he goes to visit the chapel of San José, which has fine blue and white tiles, and delightfully decorated ceilings. As a child, the traveller was frightened of this place: there was a story that one night a huge beam appeared, blocking the road in front of the chapel, and nobody knew where it had come from. When a man returning home tried to climb over it, he found he couldn't, because something kept tugging at his leg, and when all of a sudden he heard a voice saying: "Nobody can cross here", he took fright and ran away. The sceptics in the village said the man was drunk, but when he was a boy the traveller could never accept that, as it took away all the place's mystery and dread.

The traveller will not stop here. The oldest house is deserted now. He still has a few uncles and some vague cousins in the village, but finds the idea of an individual's past melancholy: all things considered, it is only our collective past that is inspiring. Nor is there any point in visiting the river again: it's not even a clean death. Further down, where it joins the Tagus, it does look a lot cleaner, but that is only because it runs over a flat sandy bottom. The place there is called Rabo dos Cágados, or "tadpoles' tail" and it is a perfect description, even more so on the map the traveller is looking at, not to get his bearings, but to remember everything better. All the names here are enchanted, like secret passwords that usher him in to the discovery of the world: Cerrada Grande, Lagareira, Olival da Palha, Divisões, Salvador, Olival Basto, Arneiro, Cholda, Olival d'El-Rei, Moitas. This first home of the traveller belongs to everyone. And that's all there is to say.

Santarém is a strange city. Whether its inhabitants are out in the streets or in their houses, it always seems closed. There does not seem to be any link between the old town and the new neighbourhoods: each of them is in its own

place, turning its back on the other. Once again, the traveller admits this is his personal view, but the facts – or rather the lack of them – confirm that it's true: nothing can happen in Santarém. It's like another Sleeping Beauty castle, without the sleeping beauty.

But Santarém has the Portas do Sol to open out the view. Or should have, the traveller reflects. Because to him, the wonderful panorama, the view over the river and the fields of Almeirim and Alpiarça only serve to increase the feeling of isolation, of distance, almost of absence that Santarém conveys. Yet it only takes a single chimney to humanise, to bring sudden warmth to this closed city: on his way to the Portas do Sol, walking down an alleyway that he could have passed by a thousand times without looking, a chimney-piece suddenly reveals the figure of a woman baring her breasts – strange, disk-shaped elemental forms – the like of which the traveller has not seen anywhere else.

This makes the visit to the town more relaxed. But he won't visit the Museum of São João de Alpalhão, because it's closed today (there's nothing wrong in that, today is the day it's meant to be closed). Instead there's the church of Graça. Modern restoration has given the building an unwelcome coldness. The new stone is encrusted on the old, and the two do not mix. Yet the rose window is well worth seeing, as is the portico, pure flamboyant Gothic, obviously based on Batalha but without the latter's rich columns and archivolts. The floor of the nave is well below street level, and this produces an effect seldom found in Portuguese churches. There are many commemorative panels, memorials and tombstones, among them that of Pedro Álvares Cabral, the discoverer of Brazil. The traveller moved on to the church of Marvila: a fine Manueline doorway, and interesting seventeenth-century tiles. As there was a Mass being said, he looked around as best he could and left quietly, so as not to disturb them. Close by is the church of Misericórdia, with its span of highly decorated columns: it has three open naves, which in fact form a large hall covered by a dome supported on tall columns.

Today the traveller is happy with overall impressions, and is not concerned about details. Yet he spent a good deal of time in the church of the Seminário Patriarcal, which he entered by a hidden side door without anyone realising. This church is a good example of all the elements of Jesuit taste: theatricality, lush decoration, fine materials, a sense of stage management. Here religion is an opera to the divine, the place for a great orchestral sermon, a lecture theatre for a seminary. The traveller admires the huge painted ceiling, so vast it seems the sky has been covered with fantastic architecture and festoons of flowers in order to greet the Virgin Mary and her host of angels. The effect

is magnificent: the Jesuit painters knew what they wanted and knew how to achieve it. Sculptures, gleaming white Carrara marble, inlaid panels cover the chapels from floor to ceiling. From the east to the coast, the traveller finds himself thinking à propos of nothing, the River Almonda is dead.

The afternoon turns cool. The traveller crosses the garden, admires the sturdy trees, and now comes face to face with the best that Santarém has to offer, and has laboriously restored: the convent of St Francis. Or to be more precise: what's left of it. It is a ruin: the pulverised remains of a giant's body that is searching desperately to put itself together again, and keeps finding bits and pieces of other giants: fragments here and there, chunks of wall, bits of columns, fallen capitals, some of them Gothic, others Manueline, still others from the Renaissance. But inside, the church of St Francis is most definitely Gothic, from the fourteenth century. Even in ruins as it is, with planks over holes in the ground, piles of earth on the floor, scaffolding, gaps in the roof the sky is visible through, its cloister full of recovered fragments nearly all of which will be impossible to piece together. This chaotic jumble conveys to the traveller an unheard story of calculated forms, of spiritual force which does not seek to leave the earth, or only enough to be able to stand upright rather than to sprout wings that would be useless for the work needing to be done here below. In the opinion of the traveller – and when he has an opinion, he says so – this ruin should only be restored sufficiently to ensure it is conserved. It is and should stay a ruin. Ruins are always more eloquent than any restored building. On the day that this church opens its new doors to the public, as they say, it will lose its greatest strength: that of bearing witness. No-one will stop to wonder beneath its portal, unless in a casual way, if it was here that King John II was crowned. The present has more than enough places in which to speak to the future. This is the voice of the past. Better to be silent in this cloister, at the edge of this empty tomb, stumbling on the dust of centuries: silence is as vital as speech.

So Near and Yet so Far

Facing Santarém is Almeirim. The past here is only a distant memory. A favourite place for royalty in the fifteenth and sixteenth centuries, the chosen altar for imperial weddings: even the most ingenuous of travellers might expect to find here plentiful reminders of its former glories. Not so much as a stone. It looks like a town born yesterday, with no history apart from the anonymous one of work, which exists everywhere. The traveller, who deals with everything in its time and place, cannot find any trace of art worth mentioning, except for the palace of the Marquesses of Alorna, and that is nothing out of the ordinary.

The route is an easy one, following the path of several waterways: the Tagus, the Alpiarça canal, the Muge, and then further south shortly before Benavente, the wider River Sorraia. In Salvaterra de Magos, the traveller went to visit the chapel in the royal palace, a strange building which goes against the normal proportions of spatial relations. The most attractive work in the chapel is the sixteenth-century *Pietà*, which shows Christ stretched on the Virgin's lap. He lies there rigid, his arms flung out, and the work as a whole reminds one of the *Pietà* at Belmonte. The sculpture in the chapel is made of wood, but apart from the Virgin's bent back, there are few signs that the sculptor was able to resolve the problems posed by the material. The earlier artist at Belmonte was working with granite, but he managed to convey a sense of drama through the form of the sculpture which the paint simply respected, whereas here the rather crude painting attempts to express an emotion lacking in the sculpture itself.

Today was a day of bridges and pontoons. Take the one at Vila Franca de Xira, which is pleasant despite its twisted supports. It was almost ruined the day it was inaugurated, if the story the traveller heard at the time is to be believed. Here it is in a few words: in honour of the visiting President with his pair of scissors, mounted horsemen were placed all along the bridge. At a signal, they all began to make their horses dance, which they did with such a regular rhythm that the whole structure started to vibrate, giving everyone a nasty shock. And since it was impossible to explain to the horses that they

should not all follow the same rhythm, they had to come to a halt to let the bridge – and the engineers – stop shaking. The President then cut the ribbon, made it safely to the other side, and the bridge did not collapse. The horses twitched their ears, annoyed at this lack of human foresight.

This region is heavily populated: the villages run into each other, almost touching. Here the unknown begins. This is a figure of speech, of course, because the capital Lisbon is close by, but how else to describe a part of the country which is hardly ever visited precisely because it is so close? So near and yet so far, as they say, and the unknown is what is under our nose. This leisurely traveller would like to ask all the people of Lisbon who set out on side roads, high roads and motorways in pursuit of happiness why they don't look here for the pleasures that journeys can offer, in places with names such as Arruda dos Vinhos, Sobral de Monte Agraço, São Quintino, Dois Portos, Torres Vedras, to mention only the ones he has visited.

And even more striking than the villages is this calm beauty of the countryside, a land of farmers, vineyards, orchards, market gardens, a constantly undulating landscape where everything is hill or valley. The land is female, soft as a body giving itself, and warm on this April day. The roadside ditches are full of vegetation, and the budding rows of vines make a strange geometry in this illogical homeland of ours. There's not an inch of earth that the hoe has not penetrated since the first Mustafa came to live here under the protection of the armies of the Prophet, and after him a long line of descendants, with different names and a different faith, in the shadow of their new lords, but as mistrustful as ever. The traveller is visiting a garden that has no need to smell of roses.

In Arruda dos Vinhos he came across a church which, despite the ordinariness of its plain façade, could boast a fine Manueline portico whose harmony came from the balance between decoration and structure. The traveller wondered why he was so surprised at this, and concluded that as he was in such a different kind of countryside he had also unconsciously been expecting the architecture to be different as well. Such are the mysteries of the mind, which this is not the place to examine. The church interior is also harmonious, with its slender columns coming together in sturdy shafts, and fine tiles showing scenes from the lives of the saints.

The hills here, especially in places protected from the winds, abound in large farmhouses, half of them used for work, half for living in. They are simple in style, like peasant palaces, but so much part of the landscape that any modern construction seems like a tasteless act of aggression alongside them, aggression against both their neighbours and the traveller, who has

grown used to their harmonious tunes. Many of these farmhouses look neglected: either their owners do not live there, or only live in part of them, or their new owners have not bothered with their upkeep. To do so would cost a fortune, and who knows whether farming the land provides enough wealth to do so. However that may be, the farmers surely cannot go far: these big houses stand out like trigonometric points, reference points on a journey that always returns to the same spot and the same tasks: ploughing, sowing, planting, fertilising, weeding, harvesting, the same beginning and the same end, the true everlasting movement which needed no inventor because it was invented by necessity.

The road to São Quintino starts from a hidden dip in a bend on the main road, then splits in a fork which means the traveller will either find what he is looking for or, if he gets it wrong, nevertheless is sure to find something else instead. There's no risk of getting lost, as there is in the mountains: everything here is close by, but the succession of hills, with their seemingly endless slopes and valleys, does strange things to perspective, gives a new sense of distance. Just when it seems you can stretch out and touch São Quintino church, it disappears, plays hide-and-seek; we are twenty metres from it and yet we still cannot see it.

Not to see it would be a shame. The church at São Quintino deserves a direct bus service and an expert guide, someone who could talk knowledge-ably about tiles and architecture, about the Manueline and the Renaissance, about its exterior and its harmonious interior. This church, on its hillside open to the horizons, is a little-known jewel. And, talking of guides, he should be accompanied by the woman whom the traveller met in a field nearby and who showed him round the church. This woman is the voice of a sincere love of things, someone without great knowledge, which is often anyway only a label stuck on the true face of beauty, but someone whose every word expressed an almost painful tenderness, the sort that binds human beings to the apparent rigidity and indifference of inert objects. Sometimes this woman repeats phrases gleaned by chance from more learned visitors: these echoes of other voices gain fresh meaning when she speaks – they are blooms of what is perhaps an exact science in her human, ingenuous soil, fertile for any crop.

An inscription in a pillar dates the portal to the year 1530. With only a little knowledge, it becomes immediately evident that the doorway contains both Renaissance and Manueline elements. The traveller probably has little more than this basic knowledge, but he has acquired the useful habit of reflecting on things, and in this case his reflection tells him that the symbiosis

between the two styles has not reached its full development – one of the styles (the Renaissance) being imported in its entirety, while the other (the Manueline) although flourishing in Portugal, had even more distant roots, and was nourished by a different culture. Both are exotic, as were the Romanesque and the Gothic – two international styles as well, but ones created in a period that was more open, less canonical in its judgments. If they had appeared in the sixteenth century, their development would undoubtedly have been hampered by the ideological repression that then held sway. So the mix between Renaissance and Manueline was a fluttering of wings that never really got airborne.

To take just one example. It is well known that the artistic vocabulary of the Renaissance included the use – and overuse – of the mask, in other words the human face altered by subtle or gross distortions. This was employed for decorative effect on pillars, entablatures, pediments, everywhere that decoration could help architectural transposition. Here in São Quintino, as in many other places in Portugal, the mask can be seen, or indeed was meant to be seen, as a worrying or threatening element. The mask becomes grotesque. Intended or not, this threat is obvious from the popular terminology used to describe the triple mask which looks out over the incongruous landscape: "the face with three noses". There are other fantastic shapes from the Renaissance in the portal, but none of them as rich in added meanings or in possible futures as this one.

The pleasant surprises continue inside. The arches fanning out from their columns, as in Arruda dos Vinhos. But the finest work is the eighteenth-century tiles, in the panel covering the side walls, and in the entrance with its diamond-point pattern. In spite of all the other tiles he has seen, the traveller will not easily forget the effect of these. And the baptistery, on the left of the entrance, is a perfect and private place of initiation, sheltering the baptismal secret for parents, godparents and guests.

São Quintino is not rich in imagery. Yet the traveller was fascinated by a painting in the sacristy which is undoubtedly of the Virgin and Child, but neither of them has a halo, and the child is not the usual babe-in-arms, but is five or six years old, and has a wry, innocent smile which is much older. The artist was not sufficiently in control of all the anatomical details: the Virgin's body is lost in her robes, the Child's right arm is far too short, and his head is awkwardly done: but the intense expression in their gazes compensates for the weaknesses in the composition, which also has much of interest in the colours used and the draughtsmanship. It may not be a very valuable painting, but the traveller liked it, perhaps because its figurative

clarity gave it a mysterious air, or because its apparent simplicity raised further questions. There are many more "faces with three noses" than one might think.

Then the traveller went to Dois Portos, but not to catch a boat. Up on the hill the church was closed, and only the priest could authorise it being opened. The traveller had a lengthy conversation at the priest's house door, but it must have been one of those days when he looks like a bandit, because however much interest and urgency he put into his request, the maid (if that is what she was, rather than a relative) politely but firmly refused, her politeness concealing her fear that this intruder might be the villain she obviously took him for. For his part, the traveller regretted not having been able to see the Moorish ceiling or the sixteenth-century St Peter. If the sick person whom the priest had gone to visit did receive some spiritual comfort, then the traveller can accept his disappointment. But if the church keys did not close the door to death, then everyone was the loser: the priest for his journey, the sick person for their life, and the traveller his moment of pleasure.

From here on to Torres Vedras, the road follows the River Sizandro and the railway line, which it crosses sometimes as a bridge, sometimes as a level crossing. The landscape is uninterruptedly beautiful and gentle. Torres Vedras is on the edge of the great geological upheavals of this part of Extremadura. To the west and northwest, the land slopes very gradually down to the coast, but to the east and northeast rise the first hills that lead step by step up to the heights of Montejunto.

It was in these hills, from the River Tagus by the valley of Bucelas up to São Pedro da Cadeira, that the English general Arthur Wellesley, who was now Viscount Wellington and later became the Duke, had the line of fortifications known as the Torres Vedras built. It was here that the advance of the French army commanded by Masséna was halted in 1810. Despite being defeated at the battle of Buçaco on 27 September, the French succeeded in flanking the Allied army and advanced south. After a swift tactical retreat, and while Masséna was busy occupying Coimbra, Wellington's troops waited for the French behind the lines of the Torres Vedras. With the first few skirmishes, Masséna understood that his forces would not be sufficient to attack the fortifications he was facing. He had fewer than 50,000 soldiers under his command whereas the allies – made up of English, Portuguese and Spanish troops – could muster almost 130,000 men. On 15 November, the French withdrew to Santarém, and from there to Spain, with the allies in hot pursuit. The Napoleonic empire had begun to lose its grip on the Iberian peninsula.

In Torres Vedras, the traveller began by having a look at the Fonte dos Canos. It is just by the roadside, and it would have been rude not to stop. The fourteenth-century builders must have held water in high esteem to dress it up like this, with well-designed ogival arches, capitals that go beyond structural necessity, and imaginative gargoyles. But there was no water: perhaps the spring has dried up or, when it was connected to the public water supply, perhaps nobody took the trouble to redirect it to its natural outlet. The traveller regrets this: a fountain without water is sadder than a ruin.

Further on he visits the church of St Peter, which also has an impressive portal combining Manueline and Renaissance elements. It is a fine piece of stonework, but São Quintino, either because of its intrinsic merits or because the traveller saw it first, stays more in the memory. There are many things to admire in the interior too: the decoration of the arches furthest away from the main door, the green and white tiles and other more recent ones, either carpet-style or diamond-shaped; the sixteenth-century sepulchre, whose Renaissance tomb is encased in a Manueline superstructure; and the blue-and-white tiled panels in the chapel to the Senhora da Boa Hora, protector of women who have just given birth.

Since evening is drawing in, the traveller wishes to have a last look at the region he has come through. He climbs up to the castle, admires as far as he can see, and since the church of Santa María do Castelo is nearby, decides it would be a shame not to see it. Parts of the original Romanesque church from the twelfth century are still visible, and the interior is also interesting. From below, in the gathering gloom, the traveller tries to make out the details of the Resurrection in the choir, which seems a noteworthy painting. Situated high in the town, in the midst of the old walls, the church is completely silent; there aren't even any birds singing outside. The traveller notices a side door, pushes it open, and finds himself in a small room empty of furniture or any decoration. He takes three steps forward, and, looking round as he advances, gets a tremendous shock: he thinks he has seen an enormous face spying on him through a crack in the door to another room. Before he's even asked, he confesses it: he was frightened. But when it comes down to it, he's a man: if there is no-one around to impress with his courage, he'll have to prove it to himself.

He went over to the mysterious door and flung it open. Kneeling on the brick floor was a huge St Joseph made of papier mâché; his clothes in tatters, the white hair, beard, moustache and eyebrows of an old man, but with a young-looking skin. It was a figure from a Christmas crib, of course. The traveller went down two steps into the room, and spotted the other figures:

an athletic Jesus in his manger, and the most fashionable Virgin imaginable, dark, with long hair, blue eye shadow, eyelashes with mascara, the eyebrows outlined in pencil, full, heart-shaped lips. The girl who was the model for such a Virgin would be offended if she knew how she had scared the traveller through the crack in the door. In fact, it wasn't her; it had been St Joseph who had looked so suspicious. But even now, the traveller wonders what on earth he would have felt if he had glimpsed such a beautiful creature and had thought she was real flesh and blood. He is convinced he was sinning in his thoughts. So he had rather not think any further.

6

Captain Bonina

It was in Torres Vedras that for the first time the traveller was entrusted with the keys to the house, and so, in a manner of speaking, came of age. Normally, the hotel door is locked at such and such an hour, and then what is a guest supposed to do? Ring the bell? Clap hands and call for the night porter? Nothing of the kind. All he has to do is put his hand in his pocket and take out the key he has been given, then simply go in as if into his own home. He doesn't have to apologise to any poor porter who stumbles out of the dark, roused from the sleep of the just. To the traveller it seemed like an excellent idea.

The next morning he had to choose what he should see, and decided on the Convento da Graça and the town museum. He was not disappointed. In the convent is a room covered with curious tiles that show episodes of the life of San Gonçalo de Lagos, who was prior here at the time of his death in 1422. His tomb is also here, but he must not be a great miracle-worker because there are no obvious signs of any great devotion to him. The traveller always likes this kind of saint: they made all their efforts here on earth, overcoming who knows what temptations, and then in heaven did not receive any special powers. From time to time they perform a small miracle, just so they won't lose their place. They must be on the back benches of any conclave of saints; they vote when they have to, and are happy with that.

On either side of the main chapel are two female saints, with imposing robes and the haughty attitude of two mother superiors. They are obviously in a conspicuous place, but the traveller wonders why they are not on altars: here, they are easily accessible to any believer, who can approach them like a friend they've met by chance, but the ceremony of prayer must suffer to some extent. The sixteenth-century paintings in another of the chapels are magnificent, as are the tiles showing scenes from the Passion in the Senhor dos Passos chapel. And while I'm talking of tiles, I should also mention those in the cloister, which depict the life of Brother Aleixo de Meneses, who did not become a saint, but edified the monks as they strolled round. As he was leaving, the traveller said hello to three women hard at work with mops and

buckets, and they replied with such warmth that he went on his way as if he had been thrice blessed.

The town museum is not rich, but makes a good display of what it has. This includes several interesting panels from the region's workshops; the traveller's words of praise for them were well received by the young attendant who accompanied him. The most remarkable work is a wooden sculpture, probably of Spanish origin, depicting the dead Christ. It is almost lifesize, realistic in style and succeeds in avoiding the theatrical. This makes it one of the most beautiful works of its kind, which is uncommon, because if there is an area of religious sculpture where banality usually prevails, it is precisely in this sort of portrayal. So the Christ of Torres Vedras is doubly praiseworthy.

The traveller finally set out on the road, still grateful for the blessing that the mop wielders had given him, although he was soon to realise that their radius of protection was dangerously small. It so happened that in Turcifal he saw a tall church perched high above several flights of steps, another test for his leg power. As the sight caught his attention, he set out on the habitual search for a key. A kind woman behind a shop counter sent her young son with him to fetch it from a street nearby. The traveller should take the opportunity to confess that he is not much good at chatting with children. He proved this once again in Turcifal. The poor boy had been taken away from his games and told to go with this stranger, so the least the traveller could have done was to strike up a conversation. But he failed. All he asked was one question, which the boy quite rightly disdained to answer, and that was that. Just as well the house was not far away.

Or rather, would that it had been a long way off, and that the traveller had got tired of the idea and changed his mind. "Here we are," the boy said. The traveller called once, twice and finally at his third attempt, a suspicious crack appeared in the door, and the frowning face of an old woman: "What do you want?" The traveller tells the usual story: he's come a long way, he'd like to visit the church, it would be doing him a great favour, and so on. The crack in the door replied: "I don't have the authority. I can't give out the key. Go and ask the priest." How offputting can you get! The traveller insists, he is told this was where the key is, but he hasn't finished his sentence before the door is slammed in his face. This is the first time it has happened to him. Turcifal has no right to treat him like this. The traveller goes to calm his indignation with a coffee, which at this time of the morning will probably only give him heartburn, and begins to wonder if it is worth going to see the priest or whether it would not be better simply to leave

Turcifal altogether. He is already mentally rehearsing the theatrical gesture of shaking the dust of the town from his feet when he reaches its edge, but then he remembers how polite the first woman he met had been, and the litle boy's help, so he goes in search of the priest. What a surprise! The old woman is already there, gesticulating wildly as she tells her story to the priest's housekeeper – or relative, perhaps – and, when she sees the traveller approach, backs away fearfully, as if he were the devil incarnate. "What can I have done?" the traveller wonders. Nothing of course, and everything eventually gets explained. While showing the church to other visitors, the poor woman has twice been the victim of attacks (that was the word she used) by Jehovah's Witnesses, bent on committing who knows what outrages or sacrilegious acts. Once (according to her) one of them even put his hands round her throat. So it was all a mistake. The traveller had been taken for a Jehovah's Witness, and is lucky she was not someone worse. Eventually, all three of them went to visit the church, which in the end was not worth half as much trouble as it had caused. The most remarkable thing was that the old woman turned out to be something of an experienced traveller in Europe. When her husband was alive, they had visited nearly all the countries in Western Europe (and at the word "Western" she had opened her eyes wide, for some reason), especially Italy. She had been to Rome, Venice, Florence – the traveller was astonished: this sour old woman from Turcifal, in her shawl and scarf, a woman living in a poor back street, was a seasoned traveller. The two of them made it up, but the traveller is convinced to this day that to her he was really a Jehovah's Witness operating in disguise.

She seemed really to have cast a spell on his day. That's the only explanation the traveller can find for having to go all round São Pedro da Cadeira, fascinated by how it got its name, and yet found the Cátela chapel closed for repairs, and St Peter's church firmly locked. No hope of seeing the first; despair at the second, because the sad news he was given was that the sacristan was working in his garden and it would be a job to go and fetch him. The traveller knows when he is beaten. He thanked his informant for her trouble, and went on his way. He consoled himself with the thought that the next village, Varatojo, was close enough to Torres Vedras to be within the radius of the blessings he had received earlier in the day.

And so it turned out. Once he had got beyond Ponte do Rol, he could see the huge mass of the convent of St Anthony in the distance. At first it did not appear very promising, with a façade full of ordinary-looking windows, and the traveller began to worry, but then he remembered that the devil can't be waiting behind every door – even he must take some time

off once in a while. And so it proved: in Varatojo everything was fine.

Since the traveller was approaching the convent from the other direction, and not from Torres Vedras, he came up behind it, which was more interesting. He looked up at the tall façade, searched for a door and went in through a low opening that led along a dark passageway to a second door, and beyond that an airy courtyard. Not a sound to be heard. The traveller was hesitating as to whether or not to go on, when suddenly a stout man in a wing-collared shirt appeared. The traveller was expecting to be asked what he was doing there, but the other man simply returned his greeting, so the traveller was the one who muttered: "I'd like to visit . . .". All the other man replied was: "Of course . . ." before leaving the building, climbing into a car parked outside, and driving off. The traveller was intrigued: "Who could he have been?" He didn't look like a priest, but the traveller has been kicking himself since he made that mistake in Ferreirim, he's not going to be caught out again. Everything is quiet again. Emboldened by the permission he has been given, the traveller ventures further in. The first thing he sees are some steps leading to a corridor with creaking wooden floorboards lined by doors that are so low that even the smallest of adults would have to stoop to enter. These are the monks' cells. The traveller is reminded of Assisi (the old woman of Turcifal is not the only one to have visited Italy); both are Franciscan monasteries, so it is not so strange that they should be similar.

Beyond the courtyard where the traveller began his visit is the cloister. It is of the sort the traveller likes: simple, small, discreet. As this is spring, there are no lack of flowers or bees. An old tree trunk is entwined round one of the columns, and the traveller is amazed that the embrace of the wood has not disturbed the arches and brought everything crashing down. When he looks up to see what damage has been done, he finds another surprise: the roof is painted with a motif that's repeated over and over: a water-wheel, the emblem of Afonso V. It's odd: it seems the mediaeval aristocracy took as their personal symbols these images of mechanical objects, tools used by ordinary people, and therefore ignoble: this wheel, the Count of Ourém's winches, the fishing net chosen by Queen Leonor, and all the others the traveller has yet to discover. It would be interesting to look into the reasons for these choices: what moral or spiritual – in other words, ideological – thinking was behind them?

Next he comes to a Manueline portal. In any other place, he would pay it more attention, but not here at the convent of Varatojo. At that moment a figure passes in silence across the far side of the cloister, one of the friars. He did not look, or say a word, simply hurried by: what duties could be calling

him? Later, the traveller even doubted that he had seen him. Or rather, he did
not exactly doubt it, but was unable to work out which door the friar had
appeared from and which he had entered; this caused him problems almost
immediately, as he could not find his own way into the church.

Soon enough he is in the chapterhouse, which gives onto the cloister. Its
width, length and height are of perfect proportions. The eighteenth-century
tiles are excellent. There are paintings of friars above the stonework, and the
traveller goes from one to another, without paying them too much attention,
as they are not very well done, until suddenly he comes to a halt, filled with an
inexplicable joy. In front of him there is a fine portrayal of Brother António
das Chagas, a man known in the outside world as António da Fonseca
Soares. He was a captain in a regiment at Setúbal, killed a man before he was
twenty, afterwards lived a dissolute life in Brazil given over to many love
affairs, until the crime of his youth was pardoned. He subsequently lived
through more adventures and further worldly temptations, and finally entered
the order of St Francis as a novice. In short, a man of flesh-and-blood who
brought his military vigour and knowledge of ambushes and guerrilla tactics
to religion; he was a renowned preacher who sometimes even roused his
congregation by flinging his crucifix at them from the pulpit, a last, violent
argument to convince the faithful, as they prostrated themselves on the tiles
of the church sighing and shouting back at him. He was known as Captain
Bonina, and since he had no flesh-and-blood enemies to confront while
preaching, he used to punch and pummel himself with such violence that his
spiritual director eventually advised him to moderate this self-punishment.

All this is very Baroque, and at odds with the traveller's stated taste, but
this Brother António das Chagas, born in Vidigueira in 1631, and who died
here in Varatojo in 1682, was a full-blooded man of his time, and therefore
excessive, a writer in the style of Góngora, both lyrical and obscene, someone
who put passion into everything he did. Towards the end of his life he suffered
from dizzy spells and continuous nose bleeds. He called this complaint by
the erudite term of "epistaxis" and used to boldly declare: "Epistaxis is
a reminder of how your honour must accept everything that comes from
God, whether good or bad. Epistaxis falls from the head to the breast, and
signifies that what comes from God comes from our head and should be
kept by your honour in his heart, as the breast has no more room for it".
Who could possibly resist a man who argues in this way? Even if his portrait
were not well done, the traveller would be fascinated by it. But, as I have
already said, the painting is excellent, worthy of a place of honour in any
museum. The traveller is glad he came to Varatojo. The little friar, as he was

known, died in one of these cells. As death came near, he asked his companion to open the window for him so that he could see the heavens. He did not see the landscape or the sun that had shone on his adventures. All he saw was the vast, final night he was about to enter.

The traveller left the chapterhouse quite moved. Happy and moved. The life of a man is the most important thing there is. And this man, who went down roads the traveller is unlikely ever to tread, came to the same crossroads the traveller will have to face, sure he had lived a good life in a way the traveller would like to be able to say for himself. There are more than enough roads. Not all of them lead to the same Rome.

The traveller wants to enter the church proper. He opens every door he sees, and after lifting many latches, peering down many passageways, opening doors that lead only to more locks, he finally discovers the way in. Nobody has seen him, nobody has come to ask him what he is doing, he's completely free. There is plenty to look at, in the main nave and in the chapels: inlaid marble, altarpieces with Baroque angels and birds, edifying paintings, striking tiles. Squeezed above them is another painting, showing a pilgrim walking away into the distance, his body somehow prolonged in a slender tree that fills all the remaining space. This was the image that the traveller carried with him from among the many he saw. Who can explain that?

It's time to go. The traveller leaves the church, crosses the cloister, looks up at Captain Bonina one last time ("To perish in the attempt, or go on to victory" was his motto) and as he walks down the hill thinks that should he ever become a monk, he will come and knock on the door of this monastery at Varatojo.

Lisbon is further down, for anyone who is north of it, but before going there, the traveller has to visit some parts he has passed through quickly but should not leave out. Unfortunately, this consideration is not always rewarded, as was the case in Merceana and Aldeia Galega, where he could only see the churches from outside (the Manueline portal at Aldeia Galega looked magnificent), and also in Meca, where all he could see was the outside pulpit used for blessing the cattle, which had no particular artistic merit.

Aldeia Gavinha offered both goodness and kindness. The traveller had gone to find someone to open the church for him (he could write a treatise on the different ways of asking for church keys); this caused a bit of a commotion in the family as they were on the point of going out, but one of the men said he would help, and not only went with the traveller to get the key but then accompanied him to the church and gave him explanations about the paintings and the church in general. They were in the midst of this when two

women who had been about to go out also arrived, God bless them, simply to see if they could be of service in any way to the stranger. To say that the church of Nossa Senhora da Madalena is worth a visit would be not to do it justice. The blue and yellow tiles are outstanding; when he saw the baptistery covered in them, the traveller almost wished he were a baby again so that he could be baptised there. The image of the patron saint of the church, brought inside after spending many years in a niche on the façade, is intriguing. Her eyes are lowered, closed, if the traveller's eyes were not deceiving him. Either she is like that to concentrate better on important things, or she is refusing to see the outside world, which would be a shame, as it contains many good things, as Brother António das Chagas could tell her.

This is where Palmira Bastos, the last great actress of the nineteenth century, was born. Here is the square named after her, the house where she was born. The traveller who, as we have seen, is nothing if not fertile in ideas, wondered why her ruined birthplace had not been turned into a theatre museum, housing portraits of Palmira, her personal effects, her costumes, posters and so on – all the usual exhibits. As the traveller expected, nobody could answer the question. If they had done so, he would not have had the opportunity to repeat the question. So here it is.

The traveller has not spoken for some time of the landscape but it is very similar to what he has been admiring since Arruda dos Vinhos and Torres Vedras. It should be mentioned that the traveller jumped across almost to the coast, but now he is back at his starting point. Espiçandeira is on the right bank of the River Alenquer; it's a tranquil, introspective kind of place with low houses and a triangular main square. The church, dedicated to St Sebastian, is protected behind a grille that also shelters a small garden. Facing onto the road, a door with Renaissance decoration seems a little threatening, its message to passers-by being that life is short, and nothing more. The traveller agrees, but finds that the warning on the door is at odds with what the interior of the church promises by way of immortality.

San Sebastião de Espiçandeira remained in the traveller's memory for its tiles (all this region is supremely rich in them), for a heterogeneous row of images over the treasure in the sacristy, and above all, for the impressive tomb of a seventeenth-century nobleman, a roughly hewn portrait of him in armour with his sword by his side. The rough quality of the stonework recalls the tomb of Dom Pedro de Barcelos in São João de Tarouca. In this way, two distant regions are brought close by a visit: the best kind of neighbourliness.

You reach Alenquer almost without realising it. There's a final bend, and you are in the village. This is very different from the approach via the highway

from the north; from there, the village is set high up as if it was a Christmas crib. And it is high up, as the traveller learns to his cost, when he toils up to the convent of St Francis. Nobody could tell nowadays that this was the first Franciscan convent built in Portugal, back in the year 1222. Only the Gothic door remains from that period, and there is a sixteenth-century cloister and a Manueline portal in the chapterhouse. All the rest dates from after the 1755 earthquake, which destroyed almost everything.

A smiling, rather distracted nun shows the traveller round; she always gives firm answers to his questions, but her mind seems elsewhere. Be that as it may, it is she who points out to him the sundial which tradition says was given to the convent by Damião de Góis.[13] The traveller had not forgotten that Damião de Góis was born and died in Alenquer, but to hear his name spoken by the ingenuous lips of a nun who went on smiling all the while as she had been recommended to do to receive her tip, made the traveller feel uneasy, as if she had been talking about a relative or close friend of his. The traveller visited the top floor of the cloister, where the nun wanted him to see the chapel dedicated to Dona Sancha, the founder of the convent, which did not seem to him particularly special. Two patients from the old people's home were there, waiting for death: one of them sitting on a bench staring at the altar, the other outside in the freer air, perhaps listening to the birdsong. The cemetery was just next door. "That's where the little saint is buried," the nun said. The traveller nodded respectfully, but thought: "Yes, Damião de Góis." He knows it's not true, this is the last place Damião de Góis would be buried.

What the traveller could not swear is that he might not be in the church of St Peter, a hundred metres away, because the bones of the dead undergo all kinds of indignity. It seems certain though that the mutilated stone head in the wall above a Latin inscription written by Damião de Góis himself is a portrait of the humanist. The lower half of his face is missing, but it is easy to see that when the portrait was done, he was a sturdy old man of the Renaissance, as his cap, his hairstyle and his intrepid look testify. Alenquer saw the birth of Damião de Góis and saw his death. Some say he died of a fall, others that he was killed by his servants, either to steal his possessions or under orders from obscure forces. There is no way of knowing. From down below, the traveller salutes Damião de Góis, a free spirit, martyr of the Inquisition. And without really understanding what might link two such different men, he thinks that Damião de Góis might also have written those words from António das Chagas: "To perish in the attempt, or go on to victory." Victory or death: a cry that comes from far in the past and reverberates still.

13. Damião de Góis (1502–1574). A Portuguese humanist who was friends with Luther, Melanchthon, Luís Vives, Dürer (who painted his portrait) and above all, Erasmus. The Inquisition put him through a cruel trial, after which he died in mysterious circumstances.

The Name in the Map

The traveller did not stop between Alenquer and Caldas da Rainha. Apart from Ota, Cercal and Sancheira Grande, it seemed the road itself was deliberately avoiding human habitation: a rough-and-ready road, a road of few words, like a woodland animal. But this suited the traveller, who spent the entire journey thinking of Brother António das Chagas and Damião de Góis, in other words, thinking about Portugal.

Mornings in Caldas are for going to the market. The traveller went, but did not buy anything. The market in Caldas is for domestic goods, that's its only attraction. The tourists who come here so excitedly, camera at the ready, are mistaken if they think the bustle of the stallholders is going to offer them any rare curio or collector's item. More often than not, they move on disappointed. There's no need for them to travel so far to see people buying and selling.

It is the town garden that has the most to offer. Intimate and airy at the same time, the garden at Caldas da Rainha is, if you'll forgive the cliché, a peaceful spot. The traveller sits on a few benches, strolls down the tree-lined avenues, glances at the mostly realistic statues, some of them well done, and then goes into the museum. There are lots of paintings, not all of them outstanding: Columbano, Silva Porto, the Marquis of Oliveira, for whom the traveller can only repeat his great esteem, Abel Manta, António Soares, Dórdio Gomes, and a few others. Also of course, José Malhoa: he was an excellent portraitist as well as an open-air painter. Just look at the portrait of Laura Sauvinet, or Paul da Outra Banda. Or if you want a terrible indict-ment, look beneath the brilliant surfaces and brightness of As Promesas until you see what it is really saying. These women who keep their vows by dragging themselves along through the scorching dust are the cruel but truthful image of a people who for centuries always paid their own debts and others' demands on top. The only doubt the traveller has is whether José Malhoa himself knew what he was painting. In the end, it doesn't matter: if truth comes from the mouths of children, who do not know how to distinguish it from lies, it can also come from the brushes of a painter who believes he is simply painting a picture.

The other thing to be seen in Caldas are the ceramics. The traveller confesses to a great love for these creations in clay, and indeed so great is his affection that he must control it or risk praising everything indiscriminately. He is no expert, but knows the work of María dos Cacos, Manuel Mafra, the Alves Cunhas, the Elias, Bordalo Pinheiro, and Costa Mota Sobrinho, not to mention all the anonymous potters who did not sign their pieces, but made magnificent ones nevertheless. If the traveller started mentioning every ceramic shop in Caldas, it would take him all day; better to keep quiet, and continue the journey.

But he does not set off again at once, because first he has to go and visit the church of Nossa Senhora do Pópulo, classified as "preManueline" by those in the know, though the traveller would personally prefer to know how it was classified by the architects who built it in 1485, some ten years before Dom Manuel was crowned king. The traveller does not wish to seem like the eternal grumbler, but sometimes he is annoyed by this kind of simplification. The church is very beautiful, and above the triumphal arch is a triptych attributed to Cristóvão de Figueiredo which is a great work of art. It is only a shame it is so high up. At least once a year it should be lowered to the level of common humanity: it could be called the day of St-See-the-Painting, which I'm sure would soon gain many devotees and payers of debts. The traveller listens to what his guide is telling him and, thinking they might engage in conversation about things they apparently both admire, makes a simple observation, offers an opinion of his own. What a mistake! The man becomes confused, looks at him in terror, hesitates for a second or two, then continues his flowing speech at exactly the point where he was interrupted. So the traveller grasps that the guide can only repeat the story like this, word for word, and does not dare open his mouth again. In spite of this, the traveller would have liked to say something about the lovely baptismal font, made by the same hands as those which sculpted the one now in the New Cathedral in Coimbra. Or about the Manueline doorway (yes, this one really is Manueline) to the sacristy. Or about anything that could lead to some discussion. But it was not to be. Too bad.

To go from Caldas da Rainha to Óbidos takes no time at all. The traveller does as everyone else does: he enters the town through the Porta da Vila and stands there staring in astonishment at the interior, with the oratory covered in panels of blue and white tiles, the roof painted in eighteenth-century style. Anyone who has not been told of this sight, or passes beneath the gateway head down thinking about life, or thinking ahead to the beauties awaiting him in the town, risks failing the test of awareness, especially if

he is in a car. It's not great art, of course, but it is wonderful decoration.

The traveller would have liked Óbidos to be rather less floral. Flowers, which any normal person likes to see and to smell, are in such abundance here that they should be curbed: the blinding white of the housewalls is diminished by all these masses of flowers, these torrents of greenery cascading down, tubs holding climbing shrubs of every variety, pots on every high windowsill. The traveller is aware that most of the visitors like this, and is not saying they have no taste; all he is doing is giving his opinion, as this is his journey. He knows he'll probably be told that no-one had ever dared commit such heresy before, and willingly accepts his role as pioneer.

Yet Óbidos deserves all the other praise it has received. It may be that its inhabitants live a rather artifical life. Since it is an obligatory place for tourists to visit and stay, it's all been arranged so that it will come out well in not just one but every photograph. Óbidos is a bit like a young girl in former times who goes to a ball and is waiting to be asked to dance. We can see her sitting pertly in her chair, not moving an eyelid, worried because she's not sure whether the curl on her forehead has come loose in the heat. But she is a pretty girl, that's for sure.

Situated next to the harmonious main square, the whole of the church of Santa María is pretty too. The proportions of the façade create an immediate

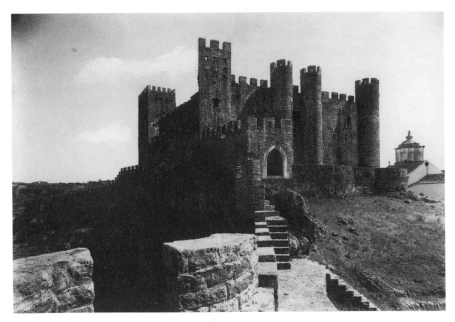

47 *Óbidos castle*

impression, as does the delicate Renaissance portal, and the simple, sturdy belltower. The sensation continues inside, with the magnificent painted wooden ceiling, a feast for the eyes that never tire of admiring scrolls, medallions and other decorative elements, which include mysterious and non-canonical figures. It also includes the tomb of the Mayor of Óbidos and his wife, thought to be by the extremely productive Nicolas de Chanterenne, one of the most splendid creations of the Renaissance school in Coimbra; the paintings by Josefa de Ayala, although the traveller does not swoon at the mention of her name; and the glory of Santa María de Óbidos even survives the falsely archaic altarpiece by João da Costa, who worked in the town.

By sundown, the traveller will return to Óbidos to spend the night. But now, before it's too late, he heads for the coast again. He goes through Serra d'El-Rei, which is no mountain but did once belong to a king. Still to be seen are the ruins of a palace Dom Pedro I had built for the beautiful Inês, which was used later on by other kings and lords. Little can be seen from outside, and the attempts the traveller made to get in, his shouts to anyone inside, received only the by now traditional barking of dogs for reply. If the traveller were His Highness, it would be the peacocks of Dom Afonso V that would be screeching from inside, paid for by Diogo Martins' rent money.

There were several things to see in Atouguia da Baleia, but the traveller only visited the church of St Leonard. It is Romanesque-Gothic in style, and the purity of its lines is probably accentuated by the fact that its walls are bare. Restoration work started ten years ago, and there is still no end in sight. All the decor was removed, so there are no paintings or sculptures to admire. But looking at its huge naves, it is not hard to imagine how beautiful the church could be if the restoration respected its spirit and if the works that were here before are returned, or other worthy ones brought in. The only piece that is still here, carefully preserved in sacking and thick sheets of plastic, is the amazing fourteenth-century high-relief showing the Nativity. It is an extremely delicate work. The sculptor did not worry unduly about tradition: if this was the kind of place Mary and Joseph sought refuge in, it has to be said that stables in Galilee were well appointed, because the Virgin is reclining on a very grand bed (and this is another departure from tradition, as she is usually shown seated), while Joseph looks solemnly on, in Gothic pose. The heads of the ox and the ass, which appear between two angels, look more like hunting trophies than pious onlookers. The traveller may appear to be joking, but that's just his style when talking of serious matters: this work is without a shadow of doubt a masterpiece.

He then went to Ferrel for a simple reason: because it's the place where it is

planned, or was planned, to build a nuclear power station. The traveller did not investigate whether the local people were in favour of it or not, he just wanted to see a place that was so important to the ecologists and was the banner for so many political protests. The ecologists have lots of arguments in their favour, as the defenders of the nuclear plant probably do too, but the traveller wonders about the day when our known sources of energy run out, and if by then we will be able to use alternative energy (solar, wind, sea) rationally and cheaply. Man has always been a poisoner; the beast who soils his own nest. What cultural revolution is needed for him to climb the evolutionary ladder and become a clean animal?

Since he asked no questions in Ferrel, he expected no replies. Unless the scene he now describes could be counted as one. He was busy consulting his big map, which has so much detail on it that it makes your head spin, when three young boys came up. To judge by the smiles on their faces and their bags of books, they had just got out of school. One of them said: "Look, a map." "And such a big one," the second added. And the third, who obviously thought maps were something else, asked: "Is that a map?" The traveller is proud to have such a big map that three shcoolboys come to a halt in front of it. So he replies: "Yes, it is a map. But not like the ones you study. This is a military map." The three boys look crestfallen. The traveller, anxious to please, goes on: "Do you want to see your village? Look, here it is: Ferrel." One of the boys leans over and spells out solemnly: "Fer-rel." And the traveller, who has never really got on with children, tries to capitalise on the situation: "Everything is on it. Here's Atouguia da Baleia, here's Peniche, and here on this point, Baleal." At which, the boy who had doubted whether this was a map or not ended the conversation with: "But it doesn't show the road from Baleal to Peniche." The three of them then said goodbye politely enough, and went off to eat. The traveller looked annoyed at the map he had praised so much. It's true, there's no road there. When the mapmakers drew the map, there was no road between Baleal and Peniche, and there should be a road to Peniche.

The traveller took the road that was finally built, followed the broad curve to the north, and instead of going out to the Cabo Carvoeiro, turned down into Peniche. Almost as soon as he arrived, he went to ask about the timetable for boats to the Berlenga islands. The traveller has given more than one indication that he must be mad, and here is another. He had thought it was as easy to get to those tiny islands as it was to take a bus or train. But no. There is a regular service only from the month of June onwards, and to get someone to take him specially there now would need to be an emergency. The traveller

stood on the quay looking the picture of desolation, as if no-one could ever rescue him from his despair; but our bodies have their own disconcerting defences, and all of a sudden his disappointment was replaced by a keen hunger. For some obscure atavistic reason, the traveller is a fatalist when there's nothing to be done about something: where's there's no solution, the problem is suddenly solved. Since he can't go to the Berlenga islands, he'll go to lunch.

Life takes away with the right hand and gives with the left, or vice versa. The traveller had the Berlenga islands on his plate, the islands, the sea around them, the deep blue waters, the booming caves, the fort of St John the Baptist, the trip by boat. Could all that really fit in a plate of grouper? It could, and there would still be fish left over. He can see the sea through the restaurant window, the sunlight sparkling on the waves and, in a state close to beatitude, returns to the manna stolen from the table of Neptune, who by now must be really annoyed and be asking all his mermaids and tritons who had eaten his lunch-time fish. Heaven forbid that the angry king of the seas should send a tempest as punishment. A large group of English tourists has just come in to the Gaivota restaurant. Nearly all of them ask for steak. The Saxons are still barbarians.

Today is market day in Peniche. Down this side of the street are open-sided shops where they sell mattresses, curtains, and sheets. They look like pavilions from some mediaeval tournament, all that's needed are for the knights to come and start jousting in defence of their lady's honour, taking time off from their usual task of splitting the sides of Moors and Spaniards. Nearby is Peniche fortress, which used to be a prison but now has open doors. The traveller looks at its thick walls, forgets Amadis and Oriana and wonders about other things, such as trying to guess where the escaping prisoners ran to. La Ribeira is a forest of masts, a confusion of brightly-coloured hulls, the sun gleams everywhere as if it were inside things and were struggling to get out. It's like a man who has another man inside him, his own sun. The traveller decides to push on to Cabo Carvoeiro; if he cannot get to the Berlenga islands, at least he can see them from a distance. The traveller is an ingrate: a moment ago he was in ecstasy over his plate of grouper, now here he is dreaming of the islands again. Let him make do with Nau dos Corvos, with the Passos de Leonor and the Laje de Frei Rodrigo, they are pleasure enough.

It's time to return to the arts – not those of fishing, but others, those of painting and other plastic arts. The church of St Peter with its eighteenth-century additions does not greatly interest him, and the Misericordia, with its famous roof beams, is being restored. The beams have been removed and

kept in safe storage; all that there is to be seen are scaffolding, tired masons, cement mixers, he'll have to be patient. Fortunately there is the church of Nossa Senhora da Conceição, which makes up for his earlier and current disappointments. The ceiling is magnificently decorated with flowers, angels, and scrolls in warm colours that do not clash in the least with the blue and white tiles on the church walls. The tiles tell the story of the Virgin's life. This tiny, enclosed church is like the inside of a precious reliquary: here, it is not hard to see that a believer might find beings from other spheres with whom to communicate.

The traveller ended his afternoon in the shade by the lake at Óbidos, falling asleep and dreaming that he was surrounded by an escort of swimming angels, riding on the back of a grouper towards the Berlenga islands, while vast flocks of white doves rose from the battlements of the fort at Peniche.

8

There Was Once a Slave

The layout of the Óbidos Museum was done by an expert hand. It cannot have been an easy task to design something on so many different levels. And as each room is small, there must have been a temptation to overfill it with items. Fortunately, this was avoided. Or perhaps there were not so many exhibits. The fact is that those on show are given enough space of their own so that one's eyes are not distracted by something else close by; the visitor can gaze for as long as he likes, and if he has the good fortune to be the only person there, as the traveller was, he will leave the museum in a state of perfect contentment that is not achieved every day.

Near the entrance is a magnificent fifteenth-century St John the Baptist, with flowing hair and a blond beard. The traveller could not distinguish what its original colours had been, so it is quite possible that this blond colour was the base on which the final one was later painted. The impression given by this statue is of St John as an elderly man, which seems at odds with the biblical version, which makes him younger than Christ. Besides which, if the traveller be allowed for a moment to peer into the recesses of someone else's soul, this venerable old man would never rouse the kind of dangerous passion in the dancer Salomé that would make her remove her seven veils, stir incestuous feelings in Herod, and ask for the head of this man who had rejected her. But here, St John still has his head on his shoulders. This statue of him is one of the most beautiful the traveller has seen, due to the gentle air of the saint, and the sculptor's harmonious conception.

Other noteworthy works in the museum include the Tríptico de San Brás, especially the right-hand panel showing the saint in glory. The angel bending from the skies and pointing the way for the saint is wonderfully embodied, and seems to have been inspired elsewhere, in the Italian Renaissance. The group of four panels depicting the martyrdom of St Vincent are also very effective. There is also the collection of banners from the Misericordia church, a *Pietà* in which the figure of the dead Christ seems to be shrinking to the size of a child to fit onto his mother's lap, an angel holding a paten, a high-relief Visitation. On one of the lower floors, the traveller saw, for the first

time he can recall, a painting of St Sebastian in which the saint has been removed from the post he was martyred on. Women in courtly dress are removing the arrows from his body. It seems like an aristocratic pastime, and that the saint has fallen asleep rather than died.

All these works of the brush or chisel declare immediately what they are. The same cannot be said of the font from a Christmas crib, smaller than an open hand, which at the sides has what appear to be a pair of enormous ears, and on top boasts a fish with an arrow for a tail. This must be the devil's work, thinks the traveller, who always blames the devil for things he cannot understand. The ceramicist who made this particular work left no explanations, either by inclination or because everybody in his day understood that fonts have ears, just as today we say that walls do. And it's understandable that a font with ears should have a fish swimming along with an arrowtail. Or so the traveller imagines, to conceal his ignorance.

Before leaving Óbidos, the traveller called in at the Misericordia church, which has a striking ceramic Virgin over the portal and some fine tiles inside; then he walked along the sentry path round the castle, considering the landscape all around. In the end, he decided he preferred the northern side, deep and level until rising to hills in the far distance. This contemplation enables him to situate one place among many. For the traveller, Óbidos is not simply an area filled with people, streets with too many flowers, good paintings and sculptures. It's also part of a wider landscape, a geological accident, a wrinkle of earth and stone. It might be thought this diminishes the importance of the works of man. But the traveller does not think so.

There is no shortage of Carvalhals in Portugal. Some big, some small, some in between, some of them in the singular, others in the plural, all of them reminding us of the days when Portugal was full of oaks, those magnificent trees whose wood everyone wanted. To be useful, the oak tree had to die. So many were killed, they were all but exterminated. In some places, all that's left is the name, which, as we know, is the last thing to die.

To distinguish this Carvalhal from the rest, it used to be called Carvalhal de Óbidos. It has a tower known as the tower of the Lafetás, from the name of a family from Cremona which came to Portugal at the end of the fifteenth century and owned this and other possessions. By saying the family came to Portugal, I don't mean they all came. In the fifteenth and sixteenth centuries, they were very rich bankers, a powerful international trading company which did business not only in Portugal but also in Spain, France, England and Flanders. They lent money to kings, they dealt in sugar and pepper: the Affaitati family are here to remind us that the voyages of discovery were also

a vast business enterprise, and also because of a slave they owned in this Carvalhal. A long time ago a collar was found in this tower, engraved with the words: "This negro belongs to Agostinho de Lafetá do Carvalhal do Óbidos". That's all the traveller knows about this slave, whose collar must have been thrown away after his death. It was probably tossed into some corner, where possibly the children of this Agostinho de Lafetá and his wife María de Távora played with it. Perhaps it was from this model that dog collars came, with their own similar inscriptions: "My name is Piloto. If found, tell my owner." Then follows an address and telephone number. There has been some progress: in the case of Agostinho de Lafetá's slave, there was no mention of a name. As we know, slaves didn't have a name. That's why, when one dies, he leaves nothing behind, except for the collar, which could be used by another slave. Who knows, the traveller muses, how many slaves might have worn this same collar, as long as there were necks of slaves to be used in this way. The traveller has found out that this collar is now in the Archaeological Museum at Lisbon. He promises himself, in all solemnity, that this will be the first thing he goes to see in Lisbon. Such a big, rich and famous city as Lisbon, where the local and foreign Lafetá families made their fortunes, can be approached in many ways. The traveller will start with a slave's collar.

He had to use all his arts of persuasion to get to see the church of the Sacrament. The woman with the key was very suspicious, even though she acknowledged he had a kindly-looking face, and in the end took a companion with her. She explained that there had been two attempted robberies in the church, and that in the nearby village of A dos Ruivos nearly all the images had been stolen. The traveller has heard the same complaint throughout his travels, and so often that it seemed more had been stolen in the past few years than during all the French invasions. The panels in the sacristy, arranged on what is left of the altarpiece, are interesting, especially the Last Supper showing the table receding into the picture, and a theatrical Resurrection. After the church, the traveller visited the chapel of Nossa Senhora do Socorro outside the town. Beside it was a house empty except for a dog, a brave animal which unusually for its race greeted the traveller with enthusiasm. It seemed bored to be on its own, and so pleased to see the traveller that it appeared to think the visit was just for him. The traveller called out, and a woman finally appeared from the back garden. After the usual greeting and the explanation of what he wanted, the traveller added: "Your dog isn't much of a guard. It greeted me as if it had known me a long time." To which the woman replied: "What can he do, poor thing, he's still very young." The

traveller thought about it, and concluded this was a pretty good reason. Almost as good as the dog, who would not stop wagging his tail.

The chapel has some fine decorated beams and tiled panels depicting scenes from the life of the Virgin. At the foot of the decorations, close to the high altar, we learn that the tiles were placed there in 1733, during the time that one António Gambino was the local judge. In other words, the artist did not sign his work, but the judge who had it paid for, doubtless by contributions from the faithful, was so vain that he ordered his own name put there, in clear letters so that the future would know. From then on, António Gambino probably paid scant attention to the divine services, caught up as he was in the contemplation of his own name. Of course, Erostratus did far worse, when he sought to win immortality by setting fire to the temple of Diana at Ephesus.

The traveller realises he has been in a historical mood today. He has gone from Italian merchants to French invaders and Greek pyromaniacs, from Jews who order beheadings to slaves forced to wear round their necks another kind of decapitation, and all with the kind of levity typical of someone who does not have to put down roots in the region he is travelling through. Now he has to take the same road as everyone else, and go through Bombarral to Lourinha, to see the famous painting of St John on Patmos. This St John is the evangelist, and he is on the island of Patmos to write the *Apocalypse*. The painter of the panel is unknown. It is attributed to the Master of Lourinha, because there had to be someone responsible for it in order to satisfy the cataloguing needs of any observer. The panel is delightful, with its background of houses and walls, and streets in which people are getting on with their everyday lives, as if they will go on doing exactly the same for all eternity, while the saint is busily writing about the end of time. The traveller is convinced the Master of Lourinha never read the *Apocalypse*; if he had done, he would not have depicted this calm scene, this wide, gentle river, the boats and galleons, the unruffled trees. It would need a Bosch to do justice to St John composing the *Apocalypse*, and in his painting on the theme now in Berlin-Dahlen, even he could not match the horror implied.

Less known but equally interesting is the St John the Baptist in the office at the Misericordia church. In the other panels, the traveller also picks out a sixteenth-century painting of the Virgin surrounded by a circle of liturgical symbols which are not integrated with each other, but probably had a didactic intent: any believer looking at the panel would identify the Marian attributes and would remember a phrase that could so easily be trans-

formed into a joke, as in the *Morgadinha* by Julio Dinis, where Henrique de Souselas's aunts changed *turris eburnis* into *turris e burris*.

The traveller really must control his tendency to digress. Fortunately, his attention was taken by the sober round table in the middle of the office, with four carved chairs in a circle and one set apart for the chairman. They are all excellent examples of the art of woodcarving. The table top turns on its axis; the traveller at first thought this was a defect due to age, but is kindly informed that no, it was made that way: the top was turned so that everyone seated at the table could sign the minutes of their meetings without having to get up. So the forerunner of modern-day assembly lines is to be found here in the church of Misericordia at Lourinha.

The traveller then headed for the coast once more. He went to the beach at Santa Rita, and was horrified at the monstrosity of the hotel built on a clifftop there. If this were the Cape of Storms, Vasco da Gama would not have got round it, so great would have been the fear aroused in him by this concrete Adamastor. It is all the more regrettable because the countryside from Vimeiro down to here is so beautiful: the road follows the banks of the River Alcabrichel, playing hide-and-seek with it among groves of trees. The traveller stopped for a drink in a sad wayside café: it was warm. But the sea was untouched by all these insults: its waters must surely have been cold. If he had not been in such a hurry, the traveller would have loved to get his feet wet.

As he continued south, the traveller was worried by the memory of that hotel. The cliff was no doubt strong, but could it really withstand such a monstrosity? His worry was not so much over the weight of the building, but the right that any honourable stone has not to have to bear such an unbearable physical and moral weight on its tired shoulders. Then the traveller remembers where he is headed, and gives a sigh of both relief and apprehension. He has yet to visit Ericeira, and enjoy the painted ceiling beams of the church there, and then beyond it the monastery of Mafra, which he can already see so clearly in the distance that he can almost count the windows in the façade. There is no way the traveller can avoid it. He advances feeling hypnotised, incapable of thought. And when he finally gets out of his car, and sees the distance he still has to go to the vestibule of the church, the grand stairway, and the atrium, he almost faints. But then he recalls Fernão Mendes Pinto, who travelled to such distant lands often along such awful roads, and with this example in mind, swings his knapsack on his back and sets off in heroic mood.

The monastery of Mafra is big. Big is the monastery of Mafra. Mafra's big monastery. Three ways of saying it, and there could be many more, all of

which could be resumed in the simple phrase: the monastery of Mafra is big. It may seem a joke, but the traveller is at a loss as to how to come to grips with this façade more than 200 metres in width, an overall area of 40,000 square metres, with its 4,500 doors and windows, its 88 rooms, the 62-metre-high towers, the turrets, the dome of the basilica. The traveller searches anxiously for a guide, and clutches on to him like a drowning man. The guides at Mafra must be very used to this. They are patient, they don't raise their voices, they treat their charges with great care, aware of the challenges awaiting them. They miss many rooms, doors and windows, leave out whole wings of the palace, and only give the strictly necessary information so as not to overwhelm the brain or the heart. The traveller saw the atrium, and all the statues brought from Italy: they may well be masterpieces – who is the traveller to say – but they leave him absolutely cold. And the basilica, which is vast but seems to lack the proper proportions, does nothing to warm him either.

There have been plenty of saints already during this journey, but here there are more of them than all the rest put together. In village churches and in larger ones, the traveller saw half a dozen saints celebrated, and he celebrated as well, praising them and even believing in their proclaimed miracles. Above all, he saw they had shown love. The traveller has been moved by many imperfect images, and felt deep emotion over many other perfect works of art, but in Mafra the St Bartholomew in stone displaying his flayed skin causes him an indefinable sense of repugnance. The statues at Mafra are for religious fanatics, not simple believers.

The guide's words buzz like wasps. He knows from experience what he has to do to put the visitors to sleep, how to anaesthetise them. The traveller is so confused he thanks him for it. By now they have left the basilica, they climb an endless staircase, and he can remember vaguely that they saw (how on earth does the guide survive all this?) Dona María's apartment, in richest imperial style, the hunting-trophies room, the reception room, the friars' infirmary, the kitchen, this room, that room, room upon room upon room. Now it's the library: 83 metres long, books which are so high up they can hardly be made out, let alone touched to see what stories they are telling; the guide hurries on, and soon it's time to leave. Then it's back to the basilica, this time seen from a high window, and the traveller only keeps up out of politeness. The guide looks pale, and the traveller realises he must be made of the same clay as other mortals, he must get dizzy, have sleepless nights and suffer from indigestion. It's no easy thing to be a guide at Mafra.

The traveller escaped out into the street. Thank goodness, the sky was

blue, the sun was shining, and there was even a refreshing breeze blowing. The traveller slowly came back to life. In order to recover completely, he visited the church of St Andrew, the monastery's oldest victim. It is a pure and beautiful late thirteenth-century building, and the harmonious encounter between its Romanesque and Gothic elements comes as a sheer relief. Beauty is not dead.

Paradise Encountered

On the Ericeira road the traveller finally turned back, after reaching the northernmost point on the bend of the River Cheleiros, and headed south. The roads here are rather erratic: they spring up with the firm intention of serving all the tiniest villages in the region, but they never take the shortest route: they meander up and down hills, completely losing their head when they spot the Serra of Sintra in the distance. This wouldn't be a problem if the sierra had been the traveller's immediate goal: it is so obviously in front of him that any of them would do. But before that there is a hamlet called Janas, famed for the chapel of San Mamede which has a rare circular layout, and so the traveller made the necessary detour. He did not regret it.

From a distance, the hermitage looks more like a country dwelling than a place of worship. It has a long verandah where it is pleasant to linger a while, and behind the entrance (in this case, it is hardly appropriate to speak of a façade) the walls are supported by sturdy buttresses. The door is locked, but inquisitive travellers can take advantage of any of the windows, even if they are covered with a grille and wire netting. Inside, in the centre of the circle, four columns make a kind of sanctuary where an oil lamp is burning. The altar is up against a wall, which must make the celebration of Mass quite difficult. In the empty space are rows of benches, which look clearly out of place in this circular design. What does look right is the continuous stone bench around the walls of the church. It is true that it is interrupted on either side of the high altar, but its disposition suggests a ritual very different from the normal one. Seated on this bench, the faithful look towards the central area defined by the columns, not at the altar. The traveller cannot understand how this can be reconciled with the usual rite which has the celebrant and his congregation face to face for their gestures and responses. This is either a small mystery, or none at all. Be that as it may, the traveller is almost convinced that in earlier times, the chapel of San Mamede must have been used for other cults and rites. It would not be the only church that had once been a mosque. Or some cult to the sun or moon could have been celebrated here, as a circular space is often the symbol of divinity. This hypothesis

may be wrong, but at least it is based on something concrete and objective.

All roads lead to Sintra. The traveller has already chosen his. He will go round by Azenhas do Mar and Praia das Maçãs, and take a look first at the houses cascading down from the clifftop, then the sandy beach lashed by the ocean waves; but he must admit he did all this without much enthusiasm, as if he could sense the sierra behind him, asking over his shoulder: "What's keeping you?" The same question must have been heard in that other paradise when the Creator was messing about with the clay before he created Adam.

On this side of the sierra, he first comes to Monserrate. But which Monserrate? The oriental palace, inspired by the moguls, now in a state of ruin, or the park that sweeps down from the road into the valley? The fragility of stucco, or the exuberance of vegetation? The traveller takes the first path he comes to, goes down the uneven steps that penetrate the foliage, the deep-green avenues, and finds himself in the kingdom of silence. It is true that there are birds singing, and every now and then some creature crawls through the undergrowth, a leaf falls or a bee goes buzzing by, but these are the sounds of silence. Tall trees rise on both sides of the valley, the tree ferns have thick trunks, and at the very bottom of the valley where streams flow, there are plants with huge, spiky leaves under which a fully grown man could stand to protect himself from the sun. Waterlilies abound on small lakes, and every so often a dull thud startles the traveller: it's a dry pine cone falling from a branch to the forest floor.

Up above stands the palace. From afar, it still has a certain grandeur. The round turrets with their characteristic lintels catch the eye, and the moulding of the arches is softened by distance. Close to, it saddens the traveller: this English folly, paid for by the cloth trade, and Victorian in its inspiration, shows how fleeting all revivals are. The palace is being restored, which is all to the good: Portugal has more than enough ruins. But even when it is fully restored, and open to the public, it will still be what it has always been: a monument to an age that had every taste imaginable, but never really defined any of them. These nineteenth-century architectures are usually imported, and are eclectic to the point of eccentricity. As empires dominated the world economically, they amused themselves with alien cultures. And this was always also the first sign of their decadence.

From the palace verandah, the traveller looks down at the mass of vegetation below. He already knew the land was fertile: he is more than familiar with wheatfields and pine forests, with orchards and olive groves, but it is only here that he realises that this fertility can reveal itself with such serene force, like a pregnant womb nourishing itself on what it is creating. Just by

48 Monserrate park

placing his hand on this trunk, or dipping it into a water-tank, or touching a fallen moss-covered statue, or closing his eyes and listening to the subterranean murmuring of roots. And the sun completes all of this. A small push from the trees would lift the entire earth all towards it. The traveller can feel the vertigo of the great cosmic winds. To make sure he will not be cast out of this paradise, he retraces his steps, counts the tree ferns and discovers a new one, and departs thinking that perhaps the earth will not come to an end so soon after all.

The narrow, winding road clings to the sierra as if embracing it. Deep green vaults protect it from the sun, and carefully shield the traveller fom the surrounding countryside. Who needs a distant horizon when the one close up is a scintillating screen of trunks and foliage, a ceaseless interplay of greens and the light? The Palace of Seteais looks almost out of place, with its enormous elevated terrace that in the end is little more than a belvedere looking out over the plain and offering a scenic view of the Palácio da Pena, perched in the distance.

To try to explain the Palácio da Pena is something the traveller would rather avoid. It's enough just to look at it, to withstand the shock of this mishmash of styles, to go within ten paces from the Gothic to the Manueline, from the Moorish to the neoclassical, much of it with little sense to it. What

is undeniable is that from a distance the palace has the appearance of a rare architectural unity, which probably owes more to its perfect integration into the landscape than to the relationship between any of its various components. Taken bit by bit, the Pena palace shows the aberrations of the imagination when it does not take into account aesthetic affinities or contradictions. Its main tower is clearly at odds with the cylindrical tower at the other end, which in turn clashes with the tiny octagonal turrets that flank the Porta do Tritão. Unity and grandeur are only to be found in the strong arches which support the upper terraces and galleries. Here the traveller is reminded of Gaudí, although it might be more exact to say that the same exotic sources inspired the great Catalan architect and the German military engineer Von Eschwege, who came to Pena at the command of another German, Don Fernando of Saxe-Coburg Gotha, to embody the romantic fantasies so beloved of that race.

It is nonetheless true to say that without the Palácio da Pena the Serra of Sintra would not be the same. To remove it from the landscape, to erase it as if from a photograph of these heights would be to drastically alter what already seems natural. The palace is like an outcrop of the rocky mass that supports it, and this is without doubt the highest compliment that could be paid to a building whose individual components, as someone once wrote, are characterised by "fantasy, insensibility, bad taste and improvisation". But where this fantasy, insensibility, lack of taste and improvisation go altogether beyond the pale is inside the palace.

This statement calls for a clear explanation. It cannot be denied that in the audience chamber, in the apartments of Queen Amélia, in the state room of Saxe for example, there are many precious items of furniture and objects of considerable worth and artistic merit. Taken one by one and isolated from all that surrounds them, they warrant close attention. But unlike the palace's structural elements, which achieve harmony in an unexpected unity of conflicting details, inside the palace these decorative ornaments fail to achieve even the simple harmony that comes from an affinity of taste. And when certain antiques were brought here, they were first of all neutralised, then subverted by the general atmosphere: Dona Amélia's apartments are a case in point. If the traveller were up to making a joke about it, he would say it looks like a suburban villa stuffed inside a palace. To put it plainly: the romantic excess of the exterior did not deserve the bourgeois excess of the interior. To the artificial sentry walk and the pointless lookout towers at every corner, the arrow loopholes reminiscent of bygone wars, was added the theatrical scenery of a court whose idea of culture was essentially

ornamental. When the last Portuguese kings came here to rest from the burdens of government, they entered a theatre: there is little difference between this and a painted backdrop. If he had to choose, the traveller would prefer Von Eschwege's organised chaos to the nouveau-riche splendours of the royal personages.

From these palaces he could see the Castelo dos Mouros, and the traveller felt that was enough. Castles should be seen from outside, and this one, tiny in the distance, was meant to be seen this way, that is symbolically.

The traveller resumes his journey, and finds himself taking so many turnings because of the wealth of vegetation, and taking in so many impressions, that the journey seems much longer than it really is. Long and happy: one of the rare occasions when those two words can be put together.

As for putting words together, remember how Philip II did so when he boasted that the sun never set on the lands he governed, and then went on to say that his kingdoms contained the richest and poorest convents in the world: the Escorial and the Capuchin one at Sintra? But Philip II had everything: the greatest wealth and the worst poverty, which naturally enough meant he could choose. Kings have the strange privilege of being praiseworthy either way: when they enjoy the wealth that goes with their station, or when they are poor, like all those they never bothered to help. What they sought for the peace of their souls was to be able to go and drop in on poverty whenever they wanted to, by coming to visit the friars. The traveller has no idea whether Philip II ever climbed the Serra of Sintra to visit the Franciscans in the poorest of convents in order to balance the periods he spent in the richest convent of his empire. But before him Dom Sebastian often came to talk with the friars, who must all have been delighted at His Majesty's visits. These were the rings – the caretaker tells the traveller – to which Dom Sebastian tied his horse, and it was at these tables that he sat to take refreshment and rest after the steep climb. It is astonishing how a simple caretaker knows these wonderful facts, and can speak of them as if he had seen them with his own eyes, describing them with such conviction that the traveller looks at the rings and the tables, and almost expects to hear a horse neigh and the king speak.

Those were still peaceful times. There was as yet no reason to fear Castile; Philip II was happy enough with his Escorial and had no desire to take possession of this poorest of convents built of stone, whose only comfort and protection against the biting cold of the sierra was a lining of cork, some of which can still be seen today. It must have been a sign of true humility to choose to live and die here. These tiny doors, obliging even a child to bend

down to pass through, demanded the radical submission of body and soul, and the cells they gave on to must have caused their limbs to shrink. How many men could have put themselves through this, or rather, come in search of this self-denial? In the chapterhouse there is only room for half a dozen people, the refectory is like a toy one, with a stone table taking up nearly all the room, and the constant mortification of benches made from wood with rough bark still on it. The traveller thinks for a moment what it must mean to be a friar. To him, so much a man of this world, there is something myste-rious and intriguing about someone who leaves his home and work, goes to knock on the convent door, asks: "Let me in," and from then on is oblivious to everything; even when the king was no longer Dom Sebastian but another one, it was all the same to the Capuchin friars. Considering their place in heaven secure, they even said that the angels don't speak Portuguese or Spanish, but tried to improve their Latin, as everyone knew that was the celestial language. The traveller mutters this to himself, but deep down he is impressed: every act of sacrifice, renunciation or self-denial moves him deeply. Even being as egotistic as they were, the Capuchins of the convent of Santa Cruz paid a high price. This heretical thought will probably mean the traveller is thrown out of paradise. He could take other roads, or try to hide in the vegetation, but then night would fall and he is not brave enough to confront darkness among these crags of the sierra. So instead he descends to the town, which means leaving paradise for the world, leaving behind too the shadows of the friars, whose only sin was the pride of thinking themselves saved.

The Palácio Nacional in Vila is almost as heterogeneous in style as the Palácio da Pena. But it is more like a vast shoreline where the tides of time have bit by bit deposited their flotsam, slowly accumulating, slowly putting one thing in place of another, and so leaving more than a simple souvenir of each one: the Gothic palace of King Dom Dinis, then the additions built by Dom João I, and later Dom Afonso V, Dom João II, and finally Dom Manuel I, who ordered the construction of the east wing. In the Palácio da Vila you can sense the passage of time. It's not the petrified time of the Palácio da Pena, or the lost time of Monserrate, or the great question mark of the Capuchins. When the traveller remembers that the painter Jan van Eyck visited this palace, he thinks to himself that some things in this world do make sense.

For his taste, some of the rooms should be more sparse, as close as possible to their original state. It is just as well the ceilings are spared the clutter from which the floors cannot protect themselves. This allows the traveller to view

the panelled ceiling in the Sala dos Brasões almost as they might have done in the reign of Dom Manuel, even if his intepretation is different, and to verify that the royal coat of arms is shown here as a sun, around which the coats of arms of the royal princes revolve like satellites, and in an outer ring, those of the noble families of the day. Also the ceiling in the Sala dos Cisnes, by Maceira, and in the das Pegas, where the painted magpies all bear the legend "por bem" in their beaks, even when they are saying what is better kept quiet. But it would be churlish not to praise these wonderful tiles, the ones in the Sala da Galé and all the others, made by secret methods probably long since forgotten. And this greatly disturbs the traveller: nothing invented or discovered by man should be lost, everything ought to be passed on. If the traveller does not know how to reproduce this azul-de-fez colour, he is poorer than all the Capuchin friars put together.

There can be few things more beautiful and restful than the interior courtyards of the Palácio da Vila, few things more serenely inspiring than its Gothic chapel. When the Christian spirit encountered that of the Arabs, a new art form struggled to emerge. They clipped its wings so it could not fly. Among the birds of paradise, this must be one of the most beautiful. But it cannot fly, it cannot live.

At the Gates of Lisbon

Because of something he heard in the palace of Sintra, he started thinking of the king who was held prisoner there for nine years: Afonso by name, and the sixth of the line. Ordinary people are very touched by the fate of their kings, and the thought of a legitimate monarch stuck between four walls pacing the floor until he wears out the tiles has aroused much misplaced indignation. Afonso VI was not only half-witted but had many other failings, among them the minimum of virility needed at least to guarantee succession. These are stories of families with tainted blood, which do not improve even though they are renewed. The Aviz dynasty ended with a degenerate Dom Sebastián and a cachectic Cardinal-Infante. After them, following the death of the brilliant Dom Teodosio, all that the house of Braganza had available to put on the throne was a mentally deficient rogue. The traveller would like to feel sorry for him, but is prevented from doing so by the memory of the dreadful palace intrigues they all indulged in: King, Queen, Infante, the French and Italian favourites, while around them the common people were born, worked and died, and paid the cost. And the traveller thinks: there have been prisoners who deserved respect. But not all are in the same category.

In Cascais, the traveller went to the Museu Castro Guimarães to see Lisbon. This may seem a contradiction, but it's the truth. This is where the *Crónica de Dom Afonso Henriques* by Duarte Galvão is kept, the frontispiece of which has a painstaking miniature drawing of the city in its sixteenth-century walls. Ships of every kind and size float on the river in haphazard fashion but without ever colliding. The illustrator either knew nothing about winds, or knew so much he could use them as he pleased. The museum has other things to offer, but the traveller particularly wanted to see this ancient image of a lost city, sunk in time, blown away by earthquakes; one which has devoured itself as it has grown.

This coastal region is the tourists' favourite. The traveller is not a tourist, he's a traveller. There's a big difference. To travel is to discover; the rest is simply finding. That is the reason why he did not spend much time on these pleasant beaches, and if he decided to have a brief splash in the calm waves

of Estoril, he will not dwell on it here. The traveller likes parks and gardens well enough, but the floral skirt between the casino and the beach is not for strolling on: it's like a palace carpet, which the visitors pass by with great care. And the quiet streets that crisscross the steep hills are nothing but walls and closed gates, railings and box hedges. This is not Lamego, no tipsy man is going to appear to offer the traveller a room for the night and swap theories on the destiny of humankind. The traveller recalls that close by were found the remains of bones and skulls that had lain hidden for thousands of years, together with stone axes, chisels, adzes and other tools or ritual objects; then he looks again at the luxury hotels, the forbidding gardens, the passers-by and the loungers, and comes to the conclusion that the world is complicated. This idea is so original that the traveller should reward himself with a proper swim or by going into the casino and breaking the bank, but he thinks better of it.

So finally, here is Lisbon. But before undertaking the adventure, which he finds somewhat intimidating, the traveller wants to visit the village on the estuary known as Carcavelos, to see something that few people know about, when you think of the million inhabitants of Lisbon and the thousands who come to this coast, that is, to conclude, the parish church. From the outside it doesn't look much: it has four walls, a door, a cross up above. A Jansenist might say that to worship God that is all one needs. Thankfully, whoever built this church did not see things that way. Inside are the most wonderful decorative tiles it has been the traveller's privilege to set his eyes on. Apart from the dome over the transept, all the walls, arches and window recesses are covered in this inimitable adornment, which nowadays is so crudely employed. Living nearby, the traveller promises himself to return, more than once. There can be no greater praise.

It would probably seem impolite not to visit Queluz. So the traveller decides to go, overcoming the dislike he feels for two monarchs who lived there: Dom João VI who, when referring to himself, used to say: "His Majesty has the stomach ache," or "His Majesty would like pork scratchings," and Dona Carlota Joaquina, an ungainly, scheming woman who to add insult to injury was as ugly as a stormy night. The conversation between those two must have been amusing, and their love lives nothing short of hilarious. But the traveller is very discreet when it comes to private lives, and he is not on this journey so that he can behave like a vulgar gossip afterwards: so let's leave the queen to her flunkey lovers, and the king to his digestive complaints, and see what the palace itself has to offer us.

From the outside it looks like a barracks, or a giant pink sweet if viewed

from the garden of Neptune. Inside, there is the usual succession of state rooms and private apartments: here is the music room, then the throne room, the tea room, the queen's dressing room, the chapel, this room, that room, the imperial bed, the Venetian lamps, fine woods from Brazil, marble from Italy. But very little in the way of serious, authentic art. Everything is decorative, superficial, to titillate the eyes and leave the brain untroubled. The traveller is lulled to such an extent by the litany of the guide showing the way to his docile flock of tourists that he is almost sleepwalking until suddenly he is jolted awake by an ancient sense of resentment.

He is in the Don Quixote room, where King Pedro IV is said to have been born and died. But it is not this beginning or this end which disturbs the traveller: it would be ridiculous for him to shed tears now over such a common occurrence. What upsets him is the absurdity of these painted scenes from the life of the poor hidalgo of La Mancha, the guardian of honour and justice, the crazy idealist, the inventor of giants – here in this Palácio de Queluz which interpreted the rocaille Baroque in a Portuese way, and the neoclassical in a French way, and did neither of them justice. Some things are all wrong. Poor Quixote, who ate but little and seldom, who suffered more than his share of hardships, finds himself displayed in the court of a queen who deprived herself of nothing and a king who always gave in to the temptations offered by pheasant or pig's trotters. If it is true that Dom Pedro was born here, and if he did actually feel, above and beyond family or dynastic concerns, a real love of freedom, then Don Quixote de la Mancha did his best to take revenge for the insult of finding himself painted on these walls. Beaten black and blue, raising his body on his weary arms, his eyes cloudy from falling into or out of consciousness, he hears the infant king making his first sounds and says to him, in that fine Cervantesque language of his here translated by the traveller: "Listen, kid, since I have to be here, just make sure you don't do anything to make me ashamed of you." And if it is also true that Dom Pedro came here to die, the same Quixote, now mounted on his horse as if about to ride off again, must have raised his arm in farewell and said to him at the very last moment: "Well, you didn't do so badly". Out of such a mouth, and addressed to a mere king, no words could be more comforting.

They Say It's a Good Thing

Here is the collar. The traveller made a promise and now he keeps it: as soon as he gets to Lisbon, he will go to the Archaeological Museum and look for the collar worn by the slave owned by the Lafetá family. On it can be read the following words: "This negro belongs to Agostinho Lafetá do Carvalhal do Óbidos." The traveller is repeating it again here in order to impress it on forgetful memories. If a price were put on this object, it would be worth millions upon millions: as much as the monastery of the Jeronomites next door, as much as the tower of Belém, as the presidential palace, as all the cars put together in one huge traffic jam, probably as much as the entire city of Lisbon. This collar is just that, a collar that hung round the neck of a man, soaked by his sweat, and perhaps also some drops of blood from a lash of the whip aimed at the back but which missed its target. The traveller is truly grateful to whoever picked it up and did not destroy the evidence of such a horrendous crime. Since he has never refrained from speaking his mind, however outlandish his views may have seemed, he will now make another judgment: that the collar of Agostinho de Lafetá's negro slave should be placed in a room all of its own, so that there will be nothing to distract visitors from it, and no-one could say they had not seen it.

The museum has thousands of exhibits that the traveller will not mention. Each of them has its own history, from the palaeolithic age to the nineteenth century, and they all have something to teach us. The traveller can imagine starting with the earliest and going down through history to the most recent. Apart from a few well-known gods and Roman emperors, the rest are unknowns, faceless and nameless. Every object has its description, and the traveller discovers to his astonishment that when it comes down to it, the history of mankind is the history of these objects and the words used to name them, the links between words and objects, their use and subsequent neglect, how, why, where and by whom they were made. Envisaged in this way, history does not become cluttered with names, it is the history of material acts, of the thoughts that shaped them and the way they shaped thoughts. It would be good for example to take one's time to find out about this bronze

goat or that anthropomorphic plate, this frieze or that chariot dug up in Óbidos, so close to Carvalhal. In order to show that it is both possible and necessary to relate one thing to another in order to understand them.

The traveller regains the street and feels lost. Where should he go now? What is he to visit? What shall he leave aside, either on purpose or because of the impossibility of seeing and commenting on everything? And anyway, what does it mean to see everything? It would be just as valid to stroll through the gardens and to go and look at the ships on the river as to visit the Jeronomite monastery. Or to do none of this, but simply sit on the bench or on the grass, enjoying the splendid bright sunshine. It's said that a ship at anchor is not sailing. That is true, but it is preparing to set sail. So the traveller fills his lungs with fresh air, like someone hoisting sail to catch the sea breeze, and sets course for the monastery.

He is right to use naval imagery. Here on the left of the entrance is a statue to Vasco da Gama, who discovered the route to India, and on the right the reclining figure of Luís de Camões, who found the route to Portugal. Nobody knows where his bones lie; those of Vasco da Gama may or may not be in the monastery. There are genuine bones to be found further back, on the right, in a chapel off the transept: here lie the mortal remains (or do they?) of Dom Sebastian, the unhappy sixteenth King of Portugal. But that is enough of tombs: this monastery of the Jeronomites is not a cemetery, but an architectural miracle.

The architects of the Manueline period produced a great deal. They never made anything more perfect than the vault of the nave here, anything more daring than the transept. The traveller feels overwhelmed. He has so often defended the beauty of unadorned stone, but now he surrenders to the decorative detail of what looks like weightless lacework, and before pillars that seem too slender to support any weight. And he recognises the stroke of genius in the decision to leave part of each pillar free of any decoration. The architect, reflects the traveller, wanted to pay homage to the basic simplicity of stone, while at the same time introducing a feature that would give the spectator a jolt, waking him out of his lazy way of looking.

But what captivates the traveller most of all is the sight of the vault over the transept. Twenty-five metres high above a floor twenty-nine by nineteen metres. The vaulting soars in a single arch, with no pillar or column to support it. Like the hull of a giant ship turned upside down, this soaring belly shows its ribs, its innermost structure, so amazing the traveller he does not know whether he should kneel on the spot and praise whoever conceived and designed this miracle. He walks down the nave once again, and again is

overcome at the sight of the slender shafts of the pillars which, high above him, embrace or sprout the ribs of the vaulting like palm trees. He wanders up and down in the midst of tourists speaking half the world's languages, while a wedding is taking place, and the priest is saying the usual fine words, and everybody looks happy: let's hope they go on being so, and have all the children they could wish for, as long as they do not forget to teach them to enjoy the beauty of these vaults, which their parents have hardly glanced at.

The cloister is very beautiful, but it does not impress the traveller, who has very firm views in these matters. He acknowledges its beauty, but he finds its decorative detail excessive, overloaded; beneath this ornamental surface however, he can sense the harmony of its structure, the balance of the great blocks of stone, strong yet light. Nevertheless, it fails to excite him. His heart has gone out to other cloisters he has seen. This one offers pleasure only for his eyes.

The traveller has not mentioned the portals: the one facing south that gives on to the river; the other to the west on the church's axis. They are both beautiful, carved like filigree, but although the first is more elaborate because it extends over the whole front, the traveller prefers the other, possibly due to the magnificent statues of King Dom Manuel and Queen Dona María, by the sculptor Chanterenne, but more probably because of the harmony it achieves between Gothic and Renaissance features, without any Manueline effects. Perhaps in the end it is simply the traveller's known preference for simpler, more rigorous forms. Other people have other tastes, and so much the better for both.

Between the Maritime Museum and the Carriage Museum, between maritime and land means of transport, the traveller decides first to visit the tower of Belém. At a moment when coining rhymes was easy, and patriotic feeling hard, a poet wrote: "So isto fazemos bem, torres de Belém" ("There's only one thing we do well, build towers of Belém.") The traveller does not agree. He has seen enough to know there are many other things the Portuguese excel at, like the vaults of the monastery of the Jeronomites he has just come from. Either the poet Carlos Queirós did not see them, or preferred the easier rhyme with Belém than the harder one with monastery. However that may be, the traveller cannot understand what military use this exquisite piece of jewellery could have had, with its wonderful lookout turrets facing the River Tagus, much more suited to watching naval regattas than for positioning cannon to help repel any invader. It should be said that the tower was never used in any battle. Fortunately for us. Imagine what destruction this lacework of stone would have suffered in a sixteenth-century

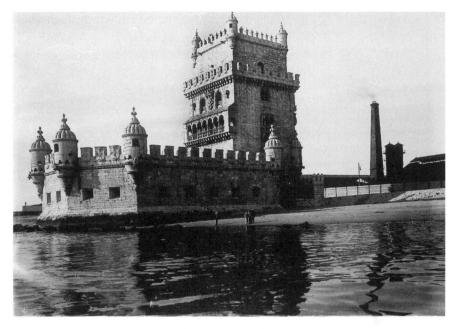

49 Lisbon, tower of Belém

bombardment or assault. As it is, the traveller can visit the rooms on each
level, go up to the lookout posts, lean over the battlements facing the river,
and feel disappointed he cannot see himself looking out from such a beautiful
spot. And finally he can go down to the dungeons where the prisoners were
kept. It's one of mankind's strange obsessions: he cannot see a dark, dank
place without wanting to imprison a fellow human being in it.

The traveller did not spend much time in the Maritime Museum, and even
less in the Carriage Museum. To see ships out of water makes him sad, to see
carriages used for pomp and ceremony annoys him. The ships, thank heaven,
can at least be taken back to the river and shown in their element, but what
a ridiculous sight it would be if one of the carriages were to set out creaking
its way along streets or motorways, like a clumsy tortoise that would lose its
legs and shell along the way.

For several good reasons and one even better one (to clear the cobwebs
from his mind) the traveller next went to visit the Museum of Popular Art.
It's a respite from the heat. It also raises any number of questions. The
traveller would prefer to divide it in two, each part capable of considerable
development: popular art as such, and the art of work. This does not mean
making two separate museums, but making the links between art and work

more visible, showing the compatibility between the artistic and the useful, between object and sensory pleasure. This is not to deny that the museum offers an extraordinary lesson in the beauty of objects, but museums suffer from the original sin of a simple exhibition of things which have far from simple ideological implications, such as those behind their creation and organisation. The traveller enjoys museums, and would never vote for their abolition in the name of so-called modern ideas, but nor can he accept that they offer simply a neutral catalogue, taking an object, defining it and putting it in among other objects, thereby severing the umbilical cord which connected it to its creator and its users. A popular ex-voto has to be put in its own social, ethical and religious setting: equally, a garden rake does not make sense without reference to the work it was made for. New moral values and technology are pushing these objects into the realms of archaeology, and this is just one more instance of the increasing demands made on museums.

The traveller spoke of any number of questions being raised. Here is just one of them: seeing that Portuguese society is undergoing such a crisis of taste (especially with regard to architecture and sculpture, objects in every-day use, and in urban planning) it would be no bad thing if those who are producing and pronouncing judgment over this general aesthetic decline, as well as the few who are still struggling against this suffocating trend, were to come and spend a few afternoons in the Museum of Popular Art, simply to look and think, to try to understand this almost vanished world and discover what part of it can be rescued to pass on to the future in order to safeguard our cultural survival.

The traveller walks along the river, so different here to the tiny stream in its upper reaches near Almourol, but still almost a trickle compared to the wide estuary it becomes at Sacavém, casts a contented glance at the bridge now named after the 25 April (formerly called by the name of the hypocrite who until the very last moment claimed he had no idea it would be named after him) and climbs the steps of the Rocha do Conde de Óbidos to visit the National Gallery. Before going in, he enjoys looking at the moored ships, the intricate confusion of hulls and masts, funnels and winches, the booms and pennants, and promises himself to return at night to marvel at all their lights and try to discover the meaning of all the metallic sounds that echo sharply over the dark water. The traveller wishes he could have twenty senses, but would still not find them enough, so contents himself with the five he was born with to hear what he sees, see what he hears, to smell what he feels with his fingertips, and taste on his tongue the salt which at this very moment he can hear and see on the wave sweeping in from afar.

From the height of the Rocha do Conde de Óbidos, the traveller applauds life.

For him, the most beautiful picture in the world is in Siena in Italy. It's a tiny landscape by Ambrogio Lorenzetti, scarcely longer than the palm of a hand. But the traveller does not wish to be exclusive in these matters: he knows full well there are other pictures which could claim to be just as beautiful. The Portuguese National Gallery houses one of them: the "Painéis de S. Vicente de Fora", or also the "Temptations of St Anthony". And perhaps also "The Martyrdom of St Sebastian" by Gregório Lopes. Or the "Descimento da Cruz" by Bernardo Martorell. Every visitor has the right to choose, to select his own most beautiful painting in the world, the picture which at a certain time and in a certain place he puts above all others. This museum, which should be called by the more evocative name of the Museum das Janelas Verdes after the street it stands in, is not particularly well known or as well endowed compared to rivals elsewhere in Europe. But if properly exploited, there is more than enough in it to satisfy the aesthetic needs of all Lisbon and its surroundings. Without getting into the adventures into which the rooms devoted to foreign paintings could lead the visitor, the traveller found himself delighting in the ways that the sixteenth-century rooms of Portuguese works of art dealt with human and animal figures, the landscape, still lives, real or imaginary architecture, natural or skilfully altered flora, ordinary or ceremonial dress, and all those pictures which delve into fantasy or copy foreign models.

And, to go back to the panels – whether or not they are by Nuno Gonçalves – they show every feature of what makes up our Portuguese character. Depicted in the background of the portraits, these versions are so powerful they cannot be diminished by the greater emphasis placed on the figures of kings, nobles and clerics in front of them. It is not hard to match these faces with contemporary ones: in the country outside the museum there is no lack of twins for those shown here. But, beyond the easy exercises in nationalism these juxtapositions offer, here in Portugal we seem incapable of drawing any more meaningful conclusions about our national identity. At a certain point in our history, we Portuguese lost the ability to recognise ourselves in the mirror these panels offer us. Obviously, the traveller is not referring to the cult of the age of discovery for which these panels provided inspiration. Rather, he places these paintings alongside the objects he saw in the Museum of Popular Art, and hopes this will explain his train of thought.

We are not talking about the Louvre in Paris, the National Gallery in London, the Uffizi in Florence, the Vatican, the Prado in Madrid, or the Gallery in Dresden. But this is the museum of the Janelas Verdes: this is what

we have, and it is good. The traveller is a regular visitor; he has the healthy habit of visiting one room at a time and then leaving. It's a method he recommends. A meal of thirty dishes does not nourish thirty times more than a meal of just one dish; looking at a hundred pictures can destroy the benefit and pleasure one of them might give. Apart from the organisation of space, arithmetic has little to do with art.

The weather in Lisbon is fine. The road leads us down to the garden of Santos-o-Velho, where a clumsy statue to Ramalho Ortigão is swallowed up in all the greenery. The river is hidden behind a line of sheds, but its presence can be felt. And beyond Cais do Sodré it spreads out to welcome the open space of the Terreiro do Paçó. This is a beautiful square we have never quite known what to do with. There are few government offices or dependencies left here: these huge blocks from the time of the Marquês de Pombal do not fit in with today's view of a bureaucratic paradise. As for the square itself, at times a vast car park, at others a lunar desert, what it needs is shade, shelters, focal points that could attract people to meet and talk. It is a royal square: one king was assassinated in a corner here, but the people have never taken to it, except in shortlived moments of political passion. The Terreiro do Paçó still belongs to King Dom José. The statue of one of the dullest monarchs ever to reign in Portugal faces out over a river he must never have liked and which is far greater than he ever was.

The traveller walks down one of the commercial streets which has a shop in every doorway and banks which are shops as well. He tries to imagine what Lisbon would have been like here without the earthquake. What was lost from an urban point of view? What was gained? A historic town centre was lost, and another gained, which with the passage of time has also become historical. There is no point arguing with earthquakes, or trying to discover the colour of the cow whose milk was spilt, but as the traveller ruminates, he comes to the conclusion that the reconstruction of the city ordered by the Marquês de Pombal did represent a huge cultural break from which the city has not yet recovered, and which continued in the confused waves of architecture that have washed over the urban space since then. The traveller is not nostalgic for mediaeval houses or Manueline revivals. He simply notes that these and other reconstructions were made possible only due to the violent shock of the earthquake. Not only houses and churches collapsed. A cultural bond between the city and its inhabitants was also broken.

Rossio Square has fared rather better. It's an important thoroughfare, and has a lot of traffic, but for this very reason it detains the passer-by. The traveller buys a carnation from one of the florists by the fountain, turns his

back on the theatre they refused to name after Almeida Garrett, then follows the ups and downs of the Rua da Madalena to reach the Cathedral. On the way he is frightened by the cyclopean equestrian statue to King João I in the Plaza da Figueira. This is a perfect example of the sculptural problem we have only rarely been capable of solving: there is usually too much horse and too little man. Back in the Terreiro do Paçó, the sculptor Machado de Castro showed how it should be done, but few others understood him.

The Cathedral almost succumbed to the changes made in the seventeenth and eighteenth centuries, after the earthquake, all of which were thoughtless and in bad taste. Luckily the front was restored and now looks dignified in its military-style crenellations. It is not by any means the most beautiful church in Portugal, but that adjective can be applied without hesitation to the magnificent combination of the ambulatory and the chapels of the apse, whose equal would be hard to find. The French Gothic-style chapel by Bartolomeu Joanes is also noteworthy. We should also mention the harmonious arches of the triforium, on which the eye lingers. And if the visitor has a romantic soul, there is also the tomb of the unknown princess, which will guarantee a tear. The sarcophagi of Lopes Fernandes Pacheco and his second wife, María Villalobos, are also fine works of art.

Until now the traveller has not mentioned the fortress named after St

50 Lisbon, "Almeida Garrett" theatre

51 *Lisbon, Cathedral tombs*

George. From here below, it is almost hidden by vegetation. A fortress during so many and such distant battles, from the time of the Romans, the Visigoths and the Moors, it now looks more like a public park. The traveller doubts whether this is an improvement. He remembers the grandeur of the impressive ruins at Marialva and Monsanto, and cannot help feeling that here, despite the restorations which were intended to strengthen the sense of the fortress's military heritage, the strutting white peacock or the swan on the lake make more of an impression. The terrace makes one forget the fortress. It does not seem possible that the knight Martim Moniz should have been crushed to death keeping this gate open during the recapture of Lisbon. That's how it always is: one man's death is another man's garden.

The traveller has not shown any great affection for eighteenth-century Portuguese art, whose chief manifestation is the so-called Joanine style,[14] rich in carvings and Italian imports, as displayed at Mafra. Unless it is some obscure form of flattery, it seems somewhat lacking in imagination to call these styles after kings and queens who never so much as lifted a finger to help: the British have their Elizabethan or their Victorian styles, we have our Manueline and Joanine. This just shows that the people, or those who claim

to speak on their behalf, still cannot do without a father or mother, however dubious the paternity may be in cases like these. But then the monarchs had the authority and the power to dispense the people's money, and it is thanks to this obsession with paternity that we have to congratulate Dom João V for building the church of Menino-Deus in gratitude for the birth of an heir to the throne. The floor plan of the church is attributed to the architect João Antunes, who was no slouch if this magnificent building is anything to go by. The Italianate style could not be avoided, but it does not manage to obscure the flavour of our native soil, as can be seen from the use of tiles. With its octagonal nave, the church forms a perfect balance. When he has time, the traveller must find out why the church was given the unusual name of the Child Jesus: he suspects this was decided by His Majesty, who subliminally linked the dedication of the church to the son and heir born to him. That is

52 *Lisbon, Castelo de San Jorge, detail*

53 *Lisbon, Castelo de San Jorge, courtyard*

just the kind of thing that Dom João V would do, given his well-known folie de grandeur.

It is not yet time for the traveller to go down to the Alfama. First he will visit the church and monastery of San Vicente de Fora which, tradition has it, were built on the site of the camp the German and Flemish crusaders put up when they gave the first Portuguese king, Dom Afonso Henriques, a necessary hand in the taking of Lisbon. Nothing remains of the monastery the king had built on this spot: it was demolished at the time of Philip II and replaced by the one still standing. It is an impressive architectonic machine, characterised by a certain frigidity of design that is typical of Mannerism. The façade, however, shows a distinct if subdued personality of its own. The interior is vast, rich in mosaics and marble, and with an imposing altar commissioned by Dom João V that has heavy pillars and large saintly images.

What must not be missed in San Vicente de Fora are the tiled panels in the entrance, especially those which represent the conquest of Lisbon and of Santarém, conventional in their distribution of figures, but full of movement. Other tiled panels decorate the cloisters. In its entirety, the church gives a cold impression, monastic in the sense given by the eighteenth century and which has defined it ever since. The traveller does not deny that there is merit in San Vicente de Fora, yet he does not feel a single fibre of his body or soul truly moved by it. This may be his fault, or simply perhaps because he is moved by other, stronger sensations.

Now it's time for the traveller to visit the Alfama, accepting he will be lost at the second corner, and determined not to ask for directions. This is the best way to get to know the neighbourhood. There is a risk of missing some of the famous places (the house in the Rua dos Cegos, the house of the Menino de Deus, or the one in the Largo Rodrigues de Freitas, or the Calçadinha de São Miguel or the Rua da Regueira, the Beco das Cruzes, etc.) but if he walks far enough, he will eventually see them all, and in the meantime he will have discovered a thousand and one surprises.

The Alfama is a mythological beast. It is a pretext for all kinds of sentimentalism, something everyone lays claim to for their own advantage. It does not shut itself off from any visitor, but the traveller can feel the ironic glances shot at him. These are not the serious, closed faces of Barredo. The Alfama is more accustomed to cosmopolitan life, it plays along if it thinks it can get something out of it, but in the secret of its houses there must be a lot of mirth at the expense of anyone who thinks he can know it after spending an evening there for the St Anthony celebrations, or for its special rice dishes. The traveller follows the winding alleys, almost brushing his shoulders against the houses on either side while, up above, the sky is a chink of blue between overhanging roofs barely a foot apart; he crosses sloping squares where the different levels are accommodated by two or three flights of steps: he can see there is no shortage of flowers in the windows, or canaries in their cages, but the stench from the open gutters in the streets must be even stronger inside the houses, some of which have never seen the sun, and others at street level whose only window is the open front door. The traveller has seen much of the world and of life, and has never felt comfortable in the role of a tourist who goes somewhere, takes a look at it, thinks he understands it, takes photos of it and returns to his own country boasting that he knows the Alfama. This traveller must be honest. He went to the Alfama, but he does not know what it is. All the same, he walks and walks, and when he finally comes out at the Largo de Chafariz de Dentro – after being lost

54 *Lisbon, the Alfama*

more than once as he knew he would be – he wants to immerse himself once more in its dark alleys, the twisting dead-end streets, the slippery steps, until he feels he has at least learnt the first few words of the immense dialogue going on between houses, inhabitants, personal histories, laughter and the inevitable tears. Turned into a mythological beast by outsiders, the Alfama lives its own, difficult story. At times it is a healthy beast; at others it cowers in a corner licking the wounds that centuries of poverty have cut into its flesh and which do not heal. Even so, these houses have roofs, unlike other slums where the travellers' eyes could discover no roofs and so doubted whether to call them houses at all.

Beyond it is the Military Museum, with its bounty of glory, flags and cannon. It is a place to look at with a clear mind, a sharp awareness, in order to try to detect the civilian spirit that seeps into everything, the polished bronze, the steel of the bayonets, the silk of the standards, the stiff cloth of

the uniforms. The traveller has another of his very original ideas: that anything civilian can become military, but it is very hard for anything military to become civilian. Many misunderstandings are rooted in this lack of reversibility. And they are dangerous roots.

This part of the city is not beautiful by any means. The traveller does not include the river in this judgment, because however much it is obscured by ugly sheds, it always finds a ray of sunshine to catch and return to the sky. But the buildings, the old ones like walls perforated by windows, and the new ones like something out of a neurotic dream, are horrendous. The traveller takes heart in the promise of the convent of Madre de Deus.

Seen from outside, it is a huge wall with a Manueline portal at the top of half a dozen steps. It helps to know that this doorway is false. It is a curious case of art imitating art in an attempt to recover reality, none too concerned whether it was reality that the imitated art has imitated. This sounds like a puzzle or a tongue-twister, but it's true. When in 1872 it was decided to reconstruct the old Manueline façade of the convent, the architect studied the "Retábulo de Santa Auta" in the National Gallery and copied line for line from the painting – only extending them a little – the details of the portal through which the procession carrying the relic entered. João María Nepomuceno considered this idea as brilliant as that of Columbus and his egg, and perhaps it was. After all, in order to rebuild Warsaw after the devastation of the Second World War, they used the eighteenth-century paintings by the Venetian artist Bernardo Bellotto, who spent some time in the city. Nepomuceno came before him, and he would have been silly not to make use of the documentary evidence at hand. But we would all be silly if it transpired that the original portal was not like the present one at all.

Despite the fact that the decorative elements of the church, the choir and the sacristy date from different periods (from the sixteenth to the eighteenth centuries), the impression given is one of a great unity of style. This unity probably derives in part from the golden splendour everything is coated with, but it would be more honest and preferable to say it is the result of the high artistic value of the entire building. The brightness of the light, which leaves no relief untouched, nor any colour dull, is part and parcel of the feeling of euphoria the visitor experiences. The traveller, who has always protested so strongly at excesses of gilt carving that can stifle the architecture, finds himself overwhelmed by the rocaille of the sacristy, one of the most perfect examples of a certain kind of religious sentiment, precisely the kind known in Portuguese as "a spirit of the sacristy". No matter how many pious images cover the walls, it is the sensual appeal of the world that shines out

from the mouldings and the altarpieces, with all their shells, feathers, palms, scrolls, garlands, and festoons of flowers. To express the divine, all this is covered in gold, but it is life outside that swells through all this decoration.

The main choir is a jewel casket, a reliquary. To express the inexpressible, the sculptor used every stylistic resource. The visitor loses himself in the profusion of forms; he renounces using his eyes as an analytical tool and contents himself with the overall impression, which is not so much a synthesis as a bewilderment of the senses. The traveller wants to sit in the stalls to recover the simple sensation of plain wood, something that has survived all the carver's modelling.

The cloisters and the adjacent rooms house the Museu do Azulejo. It is worth mentioning that the exhibits are only a very small part of all those kept in store awaiting the space and the money to display them. Even so, this museum is a precious place that the visitor regrets is so little visited, or if it is visited, is so poorly made use of by those responsible for design in our own day. As far as Portuguese decorative tiles go, there is a lot to be done, not in the sense of rehabilitation, but of understanding. Understanding what it means to be Portuguese. Because, whereas for a long time this century they were an undervalued art form, now tiles have made a strong comeback for

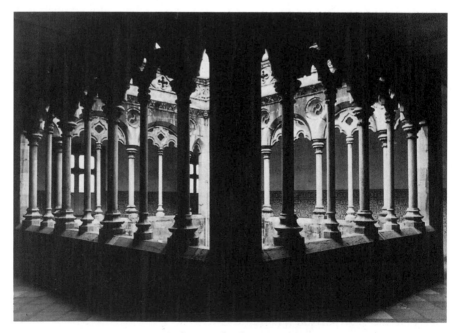

55 *Lisbon, Madre de Deus convent*

the external facing of buildings. To unfortunate effect, in most cases. Those who design these modern tiles do not know anything about them. And to judge by the evidence, those who teach about tiles or write about them are pretty ignorant too.

The traveller retraces his steps, discovering another fountain called El-Rei, although no-one can be sure which king is meant because some of it was built during the reign of Dom Afonso II, and in the reign of Dom João V it acquired its nine spouts, all of which are now dry. It is most likely that its name comes from Dom João V, o Magnânimo, who was a great one for naming things. There is little else left of the old city in these parts: there is only the Casa dos Bicos, a poor cousin of the Palace of Diamonds in Ferrara, and further on the beautiful Manueline portico of the church of Conceição Velha, which the earthquake did not succeed in toppling.

Walking under the arcades of the Terreiro do Paço, the traveller thinks how easy it would be to breathe life into these archways by organising on certain days each week or month small fairs for the sale or exchange of stamps or coins, or exhibitions of paintings and drawings, or to set up flowerstalls; with a bit of thought there are plenty of things it could be used for. Then this sandless and duneless desert would be repeopled. The people who rebuilt Lisbon bequeathed us this square. Either they knew in advance we would need it as a car park, or they were trusting to our imagination. Which, as is plain for all to see, is negligible. Perhaps the fact is that the motorcar has taken the place reserved for the imagination.

The traveller has heard that somewhere down this street there is a Museum of Contemporary Art. As a man of good faith, he believed what he heard, but as someone who also believes in objective truth, he has to confess he does not think he saw it. It is not that the museum lacks merit, because some of the pieces are quite interesting, but the promised contemporaneity must have been from some other age, before even the traveller's time. The paintings by Columbano are excellent, and if other names do not immediately spring to mind, it is not to belittle them, but to indicate that either the museum does what it says it is meant to, or merely adds to the confusion over our national artistic heritage. The traveller is not worried about critics and artists in general, because they obviously know who and what they are, but about the general public, who must come in here at a loss, and leave completely lost.

In order to rest and recuperate from the museum, the traveller climbs up to the Bairro Alto. Anyone with nothing better to do stirs up rivalries between this district and the Alfama. That is a waste of time. Even at the risk of

exaggeration, which always accompanies making any peremptory judgment, the traveller considers them radically different. It is not a question of saying that the one or the other is better, which would only lead to the problem of what is meant by better in this kind of comparison, but simply that the Alfama and the Bairro Alto are diametrically opposed, in their appearance, their language, in their ways of being in the street or leaning out of the window, in a certain highhandedness of the Alfama which in the Bairro Alto becomes insolence. And my apologies to anyone living there who is not in the least bit insolent.

The church of San Roque is close by. To judge by its appearance, we wouldn't rate it very highly. Inside it is a sumptuous hall where in the traveller's modest opinion it must be hard to talk to God of poverty. Look for example at the St John the Baptist chapel which the inevitable Dom João V commissioned from Italy. It is a jewel of jasper and bronze, mosaics and marble, totally inappropriate for the passionate forerunner of Christ who preached in the desert, ate locusts and baptised Jesus with water from the river. But after all, time passes, tastes change, and Dom João V had a lot of money to spend, as we can tell from the reply he gave when told that a carillon of bells for Mafra would cost the astronomical sum of four hundred thousand reis: "I didn't think it was so cheap, I'll have two of them." The church of San Roque is a place where one can find a saint for all occasions: it is crammed with relics, and has images of almost the entire celestial host in the two exuberant reliquaries flanking the high altar. But the saints did not smile down on the traveller. Perhaps in their time such things were seen as heresy. They are wrong: nowadays looking kindly on someone else is a way of trying to understand.

Lisbon never liked ruins. They have always been either rebuilt or pulled down altogether to make room for more lucrative buildings. The church of the Carmo is an exception. In its essence, the church is as the earthquake left it. There was talk at one time of either restoring or rebuilding it. Queen Dona María I was keen that it should be rebuilt, but her plans came to nothing, either due to lack of money or lack of real interest. So much the better. But the church, dedicated by Nuno Álvares Pereira to Our Lady of Victories, had to suffer numerous indignities after the earthquake: first it was a cemetery, then a public rubbish dump, and finally stables for the City Guard. Even though he himself was a horseman, Nuno Álvares must have turned in his grave as he heard the horses neighing and kicking, let alone when they took care of more animal needs.

Today finally the ruins are an archaeological museum. It does not have

56 Lisbon, San Roque

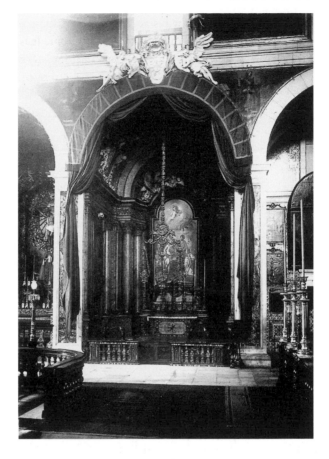

many exhibits, but they are of considerable historical and artistic interest. The traveller admires the Visigoth pilaster, the Renaissance tomb of Rui de Meneses, and other objects he will not detail. It's a museum that pleases for many reasons, to which the traveller will merely add one other of his own: he enjoyed it because it showed how the stone was worked on, the trace of man's hand. There are others who obviously think the same way, and this gives the traveller the pleasant feeling of being accompanied: in two engravings from 1745 by Guilherme Debrie, one of the façade of the convent, and the other a side view, the figure of Nuno Álvares Pereira appears of course, conversing in courtly fashion with nobles and clergy, but so too does that of the stonemason, cutting the stone blocks, with the rule and square he used to help build this and other convents.

The traveller's trip round Lisbon is coming to an end. He saw a lot, but hardly saw anything. He wanted to take a good long look, but perhaps hasn't

succeeded. That is the risk one always takes on a journey. He walks up the Avenida da Liberdade, a fine name that should be preserved and defended, walks round the gigantic pedestal supporting the statue to the Marquês de Pombal and a lion, symbol of power and strength, although there is more than one malicious tongue which suggests that this is a case of taming the beast of popular power, so that it lies at the feet of the strong man, and roars to order. The traveller likes the Parque Eduardo VII (although here is a place name which, meaning no disrespect to Great Britain, we could surely change to something closer to our own interests) but regrets it is like the Terreiro do Paçó, an abandoned empty space scorched by a hot wind. He visits the Calouste Gulbenkian Museum, which without doubt represents a prime example of how to use the science of museums to present a non-specialised collection that offers a documented view of the evolution of the history of art.

The traveller is leaving Lisbon by the bridge over the Tagus. He is heading

57 *Lisbon, Marquês de Pombal statue*

south. He sees the tall columns, the giant arches of the Aqueduto das Águas
Livres over the River Alcântara, and reflects on how long and desperate the
thirsts in Lisbon must have been. Their need for water was assuaged by
Claudio Gorgel do Amaral, the administrator of the city who started the
project, and the architects Manuel da Maia and Custódio José Vieira.
Probably to satisfy Dom João V's Italianate taste, the first person in charge,
although only for a short time, was António Canevari. But those who really
built the aqueduct and paid for it with their own money were the people of
Lisbon. This was recognised in the Latin inscription on a plaque on the arch
in the Rua das Amoreiras, which read: "In 1748, in the reign of the pious and
magnanimous King João V, the senate and people of Lisbon, at the people's
expense and to their great satisfaction, brought the Águas Livres into the

58 Lisbon, Aqueduct das
Águas Livres

city after a wait of two hundred years, thanks to twenty years' hard work in drilling and transporting blocks of stone up to a distance of nine thousand yards." This was nothing more than the truth, and even the proud Dom João V could not deny it.

Nevertheless, only twenty-five years later, by order of the Marquês de Pombal, the inscription was deliberately altered "in order to remove the existence of the previous inscription". And in place of the truth, the hand of authority imposed deceit and lies, robbing the people of all their effort. The new plaque, approved by the Marquês, falsifed history in the following way: "In the reign of Dom João V, the best of kings, the benefactor of Portugal, safe and healthy water supplies were brought to the city of Lisbon along aqueducts strong enough to last forever, and measuring nine thousand yards in length, the work being carried out at reasonable public expense and with the sincere gratitude of everyone. In the year of our lord 1748." Everything was falsified, even the date. The traveller is convinced it was the weight of this plaque which finally precipitated Sebastião José de Carvalho e Melo into hell.

14. Joanine architecture. King João V ruled from 1706 to 1750, and during his reign many Baroque architectural projects were undertaken, such as the monastery at Mafra and parts of Coimbra university. Many of Portugal's Baroque churches date from this period, with splendidly gilded interiors.

Chimneys and Orange Groves

Perhaps because he is crossing a river, the traveller remembers when he crossed the River Douro, and gave his sermon to the fishes, a long time earlier at the start of this journey. It was then that he came across the Infant Jesus of Cartolinha, a lovable child who went into battle on the side of the people of Miranda and, if not winning the fight single-handed, at least helped them a lot. Now high above him stands the Cristo Rei, tall and majestic as befits a king, but lacking in beauty. The traveller reflects on how many regions and people he has seen, is amazed at the distance he has covered, and the distance too between the child of Miranda and the Christ of Pragal.

Everything is big in this region. The city is big and beautiful, the pillars supporting the deck of the bridge are big as well, so are the cables between them. And so are the chimneys that fill this narrow shore between Almada and Alcochete, with their cascading plumes of white, yellow, ash-coloured or black smoke. The wind sweeps them away, and the long swirls of cloud cover the fields to the south and west. This is a region of factories and ship-yards: Alfeite, Seixal, Barreiro, Moita, Monitjo, a turbulent place where metal whines, roars, and thumps, where gases and vapours hiss, where endless pipes direct the flow of fuels. Everything is bigger than man. Nothing is as big as him.

The traveller promises himself that if he lives a long life, he'll come back here and investigate just what kind of region this is, and what the people living here are like. This time, he is only passing through. His first stop is at Palmela, a high village that produces a wine so good that two sips of it transform anyone. The traveller does not always go inside castles, but on this occasion he makes an exception. From the top of the moat tower the eyes seem to travel round the world, and once they've done so, come back to the same spot. Somewhere down in the village there's a market going on. A woman is using a powerful loudspeaker to sell her wares: bed linen and pots and pans. She seems to be a clever saleswoman. Her voice resounds across the landscape, and she sounds so jolly that the traveller is not annoyed at the noise.

It was in the well at the foot of this tower that the Bishop of Évora, Dom García de Meneses, died. Of poison, if we are to believe Rui de Pina. Since Dom João II could not do to the Bishop, who was plotting against him, what he had done to the Duke of Viseu, that is kill him with his own hands, poison would have been an effective and discreet way of getting rid of the person who was the ringleader of the plot. This happened some five hundred years ago, in 1484, and the traveller is horrified at how quickly time passes: it seems only yesterday that Bishop García de Meneses was here, and now he is here no more.

In Palmela there are two sights worth seeing: the parish church with its eighteenth-century tiles depicting the life of St Peter, and the fifteenth-century Convento de Santiago, a solid construction that looks more like another tower within the fortress.

To mention Vila Fresca de Azeitão is to speak of the Quinta das Torres and the Quinta da Bacalhoa. Also the palace of the Dukes of Aveiro, but the traveller did not go there. Quinta das Torres is a charming spot, with beautiful trees reflected in the lake. In the middle of it is a temple in Italian Renaissance style, a romantic building whose only purpose seems to be to please the eyes. In a terrace that offers a magnificent panorama, there are two fine majolica panels from the sixteenth century, which show the Sack of Troy and the Death of Dido, both from the *Aeneid*. This Quinta das Torres conserves a slow, bucolic atmosphere, so different from that of today that the traveller feels he has made a journey in time and must be standing there in seventeenth-century costume.

The Quinta da Bacalhoa does not give the same impression, despite being even older, perhaps because the ravages of time are very obvious, and made even worse here because of both a lack of care and deliberate destruction. What remains is very beautiful, and very serene. The so-called "houses of pleasure", open on the lake side and decorated with tiles that are beautiful in spite of being damaged, have a secret charm all of their own. Their bareness makes them feel like one of the most inhabited places the traveller has been in. And the doors are placed in such a way as to create a real mystery, as if someone were about to appear at any moment. Seen from the main road, these pavilions are like the initial, dangerous part of a labyrinth: that is the effect the open doors convey, as if waiting for someone to enter to slam shut behind them. A tile panel inside tells the story of Susannah and the Elders. Susannah is about to bathe; the old men can't get used to the fact that they're old. It's a true reflection of life: some doors open, others close.

But not everything is so complicated. This man accompanying the traveller

must be between sixty and seventy years old. He's worked here since he was a boy, and it was he who planted the plane tree that provides shade for them both. "How many years ago?" the traveller wants to know. "Forty," comes the reply. The man will die some day soon. The tree is still young: if it does not catch a disease or get struck by lightning, it will live a hundred years. Goodness, how resilient life is! "When I die, he'll still be here," says the man. The plane tree hears him, but pretends not to. In common with all other trees, it does not speak in front of strangers, but once the traveller has gone, it will surely say: "I don't want you to die, father." And if anyone is wondering how the traveller happens to know this, he will say it's because he's an expert when it comes to talking to trees.

Between here and the Cabo Espichel there are lots of vineyards and almost as many orange groves. The traveller can remember a time when to say "an orange from Setúbal" was to talk of the quintessential orange. It might be a trick of memory, but for him the term always conjures up unforgettable sensations of taste. In order not to be disappointed, he decides not to eat an orange. Anyway, it is not the orange season.

The traveller confesses that the Santuário da Senhora do Cabo goes straight to his heart. The two long blocks of the guests' quarters, the simple arcades, all this rustic, rural simplicity moves him far more than the great pilgrim industry that exists elsewhere in Portugal. But few people come here nowadays. Either the Senhora do Cabo does not perform miracles any more, or the pilgrims have been diverted to more lucrative spots. So the glories of the world fade away – or to say it in Latin, which always gives the words more weight: *sic transit gloria mundi*: in the eighteenth century, a vast horde of pilgrims used to come here, and now it's as you see it, a deserted esplanade, no-one sheltering in the shade of the arches. Nevertheless, it is worth making the pilgrimage here simply for its beauty. And inside the church there are other reasons: marble from the Arrábida, paintings, sculptures, and fine carvings.

The valley down from Santana to Sesimbra offers glimpses of the sea. It opens out to the green waves and the blue sky, but conceals the old town in the folds of the hill that the castle stands upon. The traveller rounds the final bend and finds himself in the middle of Sesimbra. However often he comes back here, he always has this feeling of discovery, of a fresh encounter.

Fish stews can be eaten all along this coast, from north to south. But in Sesimbra – who knows why? – they taste different, perhaps because the traveller is eating one out in the sun, and the white wine from Palmela is just cold enough to offer all the taste and aroma that wine at room temperature

can have, while at the same time harmonising with all the qualities that come from the coolness of the bottle. Probably because he had such a good lunch, the traveller did not visit the parish church as he should have, and as a punishment discovered that the Misericordia church, with the panel of its patron saint painted by Gregório Lopes, was shut. Some other time. Another debt to pay.

After not even attempting to describe the Serra of Sintra, the traveller is not going to fall into the temptation of talking about the Arrábida. He will limit himself to saying that whereas Sintra is feminine, this sierra is masculine. And if Sintra is paradise before original sin, Arrábida is the same but even more so. Here, Adam and Eve have already met, and the moment it eternalises is the one just before the thunderbolt from God and the dire warnings from the angel. The animal of temptation, which in the Bible is the snake, in Sintra is the eel, and here is the wolf.

Obviously the traveller is using metaphors to describe how he feels. But when from the top of the road he spies the immense sea in the distance, and the white strip that is beating inaudibly at the foot of the cliffs, when in spite of the distance the sea is so transparent he can see the sand and the pebbles, the traveller reflects that it would take sublime music to express what the eyes simply see. Or perhaps not even music: possibly only silence, not a single sound or word or painting: simply, in the end, the miracle of sight: I praise you and thank you, eyes of mine. Something similar must have been in the minds of the monks who built their monastery here on the hillside, sheltered from the north wind: every morning they could adore the sunlight glinting off the sea, the vegetation of the hillside, and keep admiring it the whole day through. The traveller is convinced that those good monks of Arrábida were nothing more than great, unrepentant pagans.

Portinho is like a fingernail of sand, a sliver of crescent moon sent down upon us. The traveller, who is short of time, would be silly to resist temptation. He slips into the water and floats on his back in the gentle to and fro of the waves, dialoguing with the tall cliffs that from where he is look as though they are toppling over into the sea. Afterwards he visits the Convento Novo, and feels sorry for the statue of Mary Magdalene kept behind railings there: not only has she renounced the world, but she has had to give up the Arrábida hills.

To the traveller, Setúbal seems like Babylon, the greatest city in the world. And now that it is surrounded by motorways and newly built suburbs, he is not sure in which direction he is heading, and when he decides to head straight on towards the river, he eventually discovers he is further away

from it than when he started out. It is not an easy city to feel affection for.

This was where Bocage began his short life. He is on the top of a column outside the church of St Julian, and must be wondering why they put him up there all on his own, when he was such a Bohemian, a man who loved to improvise verses in taverns, who made love extravagantly in rented beds, a man who quarrelled and drank wine. His case is different from that of the plane tree: the one who survived did a disservice to the one who died. Manuel María deserved a passionate gesture, not this stiff romantic vision of some senator going to the forum to read his verses of adulation. The traveller would like to learn one day that the people of Setúbal decided to erect a statue to their poet that partook less of stone, even if it cannot be of flesh and blood.

The church of Jesus and its adjacent monastery are said to be the most beautiful monuments in the city. Perhaps this is because the outside promises what the inside cannot deliver: its plain, harmonious façade gives way to the overdone twisted columns inside, and the stone ribs of the roof. This is not the first time the traveller has seen this kind of column, and he has always passively enjoyed, and even applauded, them. His doubt here must have been as a result of the shock they caused him. So much so that, after leaving the church, he turned round to see if they shocked him quite so much. They did. The traveller feels there was something unresolved in the balance between the church's height and its breadth. Leave him to puzzle it out.

There are excellent Levantine and Moorish tiles round the high altar and in the crypt, built for the son of the founder, Justa Rodrigues, nurse of Dom Manuel I. On the walls of the church, eighteen panels depict the life of the Virgin, and this again is the theme of more panels in Setúbal's museum, which are thought to be by Jorge Afonso, with the help of Cristóvão de Figueiredo and Gregório Lopes. But perhaps the most valuable exhibit in the museum is the series by Lopes on the life of St Francis, in particular the Aparição de Um Anjo de Santa Clara, Santa Ines e Santa Coleta. All these panels, and that of Christ's Passion, provide an invaluable guide to our understanding of Portuguese painting in the sixteenth century.

The traveller is no great lover of gold and silver work. He pays them no more than a passing glance, and when any particular object attracts his attention, you may be sure it is because it is the simplest of its kind. This fifteenth-century cross, in rock crystal and gilded silver, with a wonderfully sculpted figure of Christ, makes the traveller pause and appreciate it: the detail of the sculpting is almost always more interesting than the Christmas-crib effect of the whole. The traveller is well aware that this is not a precise

art-historical way of describing things. But he trusts he is making himself understood.

The traveller would like to follow the banks of the River Sado. But it forms an irregular-shaped estuary, and its waters extend inland, creating islands in midstream. If it were a little bolder, the Sado would be another Volga. So the traveller has to make a long diversion as far as Águas de Moura, before he can head directly south once more. Now he is in the Alentejo region. But the traveller decides that Alcácer do Sul should mark the boundary of the journey that has brought him here from the Mondego. Every traveller has the right to invent his own geographies. If he didn't, he would be no more than a traveller's apprentice, still bound by what his teacher taught him.

Alcácer do Sal is situated at the point where the river is starting to gain strength to open wide its arms and embrace the lowlying lands to the south of the railway line at Praias Sado, Mourisca, Algeruz and Águas de Moura. Here it is still a provincial river, but it already has Atlantic ambitions. It is hard to imagine the force it gains just a few leagues further downstream. It's like the River Tagus as it leaves Alhandra. Rivers, like people, only know why they were born when they are close to their end.

V

THE VAST AND BURNING LANDS OF ALENTEJO

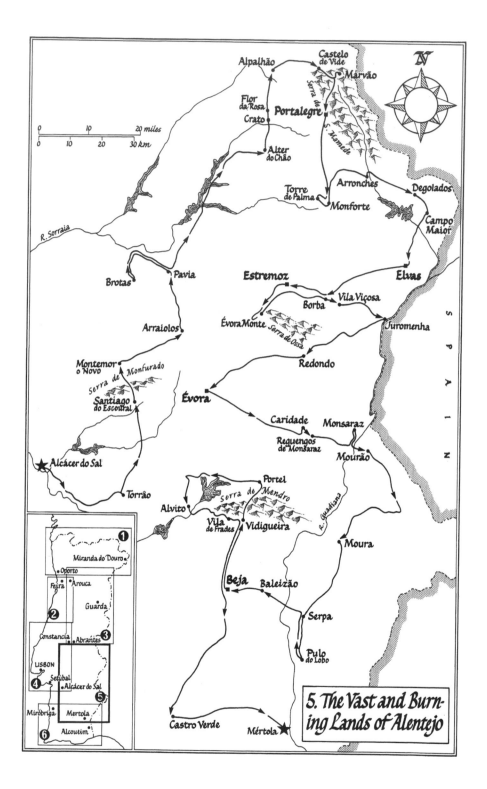

5. The Vast and Burning Lands of Alentejo

Where the Eagles Rest

The traveller is on the road to Montemor-o-Novo. In Alcácer do Sal he visited the churches of Our Lord of the Martyrs, built in the thirteenth century by the Order of Santiago, and of St Mary, within the castle walls. That's the one belonging to the martyrs, with its powerful buttresses, an architectural piece of general merit of which much more could be said. Among the items of greatest note are the chapel dedicated to St Bartholomew and a second Gothic one, where the tomb of the order's first Commander is displayed. There above it, the church of St Mary is looked after by an extremely old lady, though less deaf than she appears, with an ironic twinkle in her eyes which swiftly hardens as she slyly inspects the tip she quickly slips into her pinafore. But her complaints have a ring of authenticity: the church is in a sad state of neglect, its statues removed, even the altar cloths vanished never to return, and she thinks the priest, perhaps in order not to have to climb back up the steep slope, prefers his ministry down on the plains and has taken all the prized items there with him. Fortunately, it was unfeasible for him to loot or carry off the porches so well suited to the primitive architecture of the building, still less its beautiful Romanesque capitals. The traveller still has his doubts whether such ancient items would excite the interest of a modern cleric.

Higher up lie the ruins of a convent. The lattice is opened by an extremely young woman, one given to disinterested gestures and prompt responses, begging pardon for being so ill-informed. Tirelessly she takes the traveller to the top of the highest walls, simply to show him the countryside, with the Sado curving broadly through the lush green rice paddies. In addition she has a complaint of her own: the blue-and-white tiles that once covered the parish church from top to bottom have been removed. "So where are they now?" the traveller asks. The woman replies that someone told her the panels could now be found in Batalha parish church, at least all that would fit in there, and that the rest were stored in boxes somewhere or other. The traveller trawls his memory but his memory won't let itself be trawled. He needs to return to Batalha to clarify the situation. Meanwhile, it's

important to do justice to this Castelo de Alcácer [Castle of the Fort]: in earlier days it must have had considerable scope, capable of putting the fear of God into anyone, and only declaring itself open to the Portuguese populace under the reign of Afonso II.

The traveller takes a roundabout route through the freshest of fields which the sun seems never to reach, crossing the River Sitimos (an enigmatic name only gradually falling into oblivion); anyone looking at it would assume that it runs direct to the South, leaving behind the lands of the high Alentejo. But this proves to be merely a diversion. In Torrão, having gone into the parish church to view the tile-covered walls and thank the person who, in opening the door to him, had to break off eating lunch, he resumed the road going north towards Alcáçovas, a region of the country yet to receive the honour due for its discovery of the secret of how to protect works of art, at least those still preserved in churches – something that may not be honour enough but at least has to be worth something. A real Columbus' egg, this one: place the church alongside the barracks of the Republican Guard (or the other way around); place the key in the custody of the person in charge; then whoever wishes to visit the liturgical treasures of Alcáçovas has to surrender their identity card, and continue under escort, to attend the ceremony of drawing back the bolts. Surely anyone turning up there with evil intent would be deterred, finding their nerves unable to withstand its wealth of ceremonial.

The traveller had long held its scenic Baroque façade in high esteem. Inside it's a spacious, relaxed kind of church-cum-drawing-room with tall Doric columns and a wide vault boxed in with decorative heraldic paintings. On the right-hand side of the entrance, there's a chapel entirely covered in tiles displaying a sacred Virgin who moved the traveller, as he resisted his suspicions that it was a modern imitation: whatever, the effect is magnificent. Entirely different is the sepulchral fifteenth-century chapel of the Henriques of Trastâmara. The traveller paused for longer than the beauty of its interior demanded in order not to offend the spirits of the porters' convention. Finally, he went to retrieve his identity card and journey on to Santiago do Escoural, where the caves excite his curiosity. The main road runs close by, but not even this could detract from the wild nature of the place, any more than the cultivated fields of the surrounding countryside. The caverns open to the public are very low and difficult to penetrate. The guard went on ahead, pointing out vestigial paintings, skeletal sediments appearing on the surface, and it's obvious he enjoys his job. He must have to keep repeating the same lines but, since every visitor is different, he relays them with a sprightly air

of novelty as if, on every occasion, the latest visitor and he have only just discovered the grottoes. They say that 17,000 years' ago men and women lived here, then the place became in turn a sanctuary then a cemetery. This order has an impeccable logic to it.

The traveller begins by visiting the castle at Montemor-o-Novo which, at a distance and viewed from the east, looks a solid and intact construction but, once behind the outer walls and the eastern turrets, turns out to be nothing but ruins. And there's no easy access to what as yet remains. The traveller was obliged to see the Moorish abattoir with its elegant cupola at close quarters. Everything was in a state of disintegration. Time has caused the stones to come unstuck and tumble down, there's been no lack of interested parties to gather them up and cart them away under their own steam. The Manueline porch of the old church of Santa María do Bispo still stands, its lattice gate made out of wire-netting like a rabbit hutch. The remains of the Alcaides palace amounts to no more than some worm-riddled turrets and shutter-boarding, the church of St John is nothing but a pile of stones. This journey has had its fair share of desolate spectacles, but this outdoes them all. The traveller hoped to win his prize by visiting the monastery of Saudação (Salvation), but entry was denied him. Patience. He sought comfort in St Anthony's monastery, gazing at the magnificent polychrome tiles coating the church from top to bottom. Adaptations to the old cells have resulted in a museum dedicated to bullfighting. Each to their own. The traveller encountered his in the Sanctuary of Our Lady of the Visitation, devised as a bucolic variation in a Manueline-Moorish style, resolving into little cylindrical towers and wide whitewashed surfaces. The façade dates from the eighteenth century, yet fails to cover up all traces of the original. Inside, the sight of its time-honoured tiles and the ribs of the vaulting raise the spirits. In the entrance a huge wooden arch contains grain gathered in for the harvest festival. The traveller peered in: a few scant handfuls of cereal, hidden in the depths to serve by way of encouragement, or perhaps merely the leftovers of the last Mass collection.

Straight on to Arraiolos, a region of tapestry-weavers, and to Sempre Noiva where the traveller would have been bound to end up whether or not he went out of his way to Gafanhoeira. Here there lives a troubadour poet in the satirical tradition, a specialist in ten-line compositions on grotesque themes, for long a wandering songster rejoicing in the marvellous name of Bernardino Barco Recharto. Lack of time prevents the traveller from stopping and visiting him, but he guesses that within the hour he'll regret his decision. It's late, after all. He promises himself to follow the impulses of his heart more

closely henceforth, if reason could only be sufficiently benevolent not to contradict his heart with irrefutable rationalisations.

Arraiolos suprises the traveller. He's well aware that people in the Alentejo do not laugh all that easily but there's a considerable gap between the gravity assumed with a first step beyond the cradle and closed expressions like these, rarely encountered on a daily basis. Evils must have been committed and on a grand scale. The traveller pauses in a small square in order to orientate himself, and enquires the way to the Sempre Noiva and the Convento dos Loios. An exceedingly wrinkled and ancient old man, whose soft eyelids expose their pink and sticky underneath, offers directions. And as the two of them were thus engaged, the old man explaining and the traveller listening, three men passed by, armed and in uniform. Suddenly the old man fell silent, nothing more could be heard in the square beyond the stamping of the guards, and it was only when they moved out of view around a corner that the old chap resumed his patter. Only now his voice was tremulous and faintly hoarse. The traveller is discomforted to be going in search of a monastery and a manor house, so asks after them almost apologetically, but it's the old man who, smiling at last, informs him: "Plenty of people come through these parts looking for the Sempre Noiva. Are you from Lisbon?" and the traveller, at times uncertain as to where his home really is, replies: "I've been around there a while." And the old man adds: "So have we all . . ." And withdrew into the shade of his house.

The Sempre Noiva country house, on the way to Évora, has an attractive name ["Forever New"]. It would be a fine work of architecture, were it not so over-decorated with inauthentic additions. Despite all this, the building itself, dating from around 1500, sustains a sense of proportion resulting from the application of the golden mean in its central structure, a name the gilded youth who flocked there richly merited. Earlier the traveller lamented not having come across further fruits of either Christian or Moorish spirituality. It might rather have been an act of intelligence and sensitivity to combine their interplay of strength and grace. Instead it was deemed simpler to chop off heads, one lot shouting "At the Moors – in the name of St James!" and the other lot: "In the Name of Allah!" What kind of a conversation would Allah and Jehovah conduct on high, that's what we really need to know.

To reach the Loios monastery, descend into the Vale de Flores. There's an enormous house there with an outsized belfry. The church, entered through a large porch, is reinforced across both the façade and side walls by gigantically high buttresses, those in front pitched slightly lower. The effect given is that of a plastic sense of movement modifying our angles of vision, and therefore

our interpretation. Its overall style is Manueline-Moorish, and the tiles once covering the interior of the nave (but now disappeared) were painted by a Spaniard, Gabriel del Barco, in 1700. The traveller is, as has already been seen, given to imaginings. Knowing, according to what the authorities say, that Arraiolos was founded by Gallic Celts, three hundred years before Christ or else possibly, slightly later, by the tribes from near Rome (Sabines, Albans and Tusculans) he felt equally authorised in supposing that the troubadour of Gafanhoeira could be descended from the artist, with both of them sharing the Barco surname. Many family trees have been constructed with less material to go on.

The place where the traveller discovered not one of this variety of family trees but a whole wood of them, was in Pavia, a village on the road to Avis, on the lower banks of the Tera. A colony of Italians once lived here, whose leader was one Roberto de Pavia, a name for posterity, in turn derived from the lands where he lived. Such is the way of the world. The traveller has learnt a great deal from this journey. Something as simple as the fact that seven hundred years ago a man arrived here from an Italian city, announcing: "Call me Roberto, of Pavia," and without our knowing why, perhaps because they liked the sound of the word, Pavia became the village name, right down to today. This one example gives us immediately to understand why Manuel Ribeiro, a designer, on his arrival to work and earn a crust in Lisbon, informed anyone interested: "My name's Manuel Ribeiro de Pavia," and so he stayed, leaving the comma to the debates of prosody pedants.

At times travellers search, across deserts and wastelands, for those evocative monoliths called dolmens and arches. This one has already given an account of how he expended all his energies in finding one while journeying through the North, while here in Pavia, inside the manor, he happens on an extremely tall dolmen which the people transformed into a hermitage centuries ago. It is dedicated to St Dinis, not a saint of wide renown, something which leads this traveller to believe the pagan building was dedicated to him as the result of uncertainty over which altar he should best be placed upon. The hermitage door was shut and it was impossible to make out anything inside. Crammed between two props, St Dinis must be asking himself what he'd done to deserve his position in such an obscure place, since being beheaded by the Romans ought to have merited at least a statue, and preferably ensured him a place where his eyes could survey a sunlit world. From the shady side of the square some elderly men observe the traveller: they must have difficulty in understanding his interest in seven grey stone slabs standing there since before they were born. Had the traveller time, he would explain it all to them

and, in turn, listen to other examples in the course of which, had heads not been felled, there was certainly no shortage of manacled wrists.

From his standpoint he continued on to verify whether Pavia's parish church was as unique as he'd been told. Unique it certainly is and, at first glance, impenetrable. Built at the highest point of the village it seems, particularly on its south side, more of a castle than a church. Not that such characteristics are unusual: rather it is that here they're taken to an extreme where not a single structural element conveys the fact that this is a house of prayer. The wall is crowned with battlements in Islamic fashion, with two pitched roofs, regularly spaced, topped with perfect cones, reinforced by workmanship of massive solidity. The façade is where it openly admits to being a church, until you reach the door, which refuses to open. That's as far as the traveller has got, wondering if it's a question of going in search of a key (although he isn't in the mood for this frequently awkward pursuit) when suddenly the church bell rings in a way that, to judge from the special tone of the peals, has to mean something special. All at once he hears a heavy creaking of bolts and keys and the door gradually opens. Nothing of the kind has ever happened to the traveller before, without need for him to pronounce so much as: "Open, Sesame."

The matter has to have an elementary explanation: at five-thirty in the afternoon it's perhaps time for Mass, and if the traveller mentions it

59 Pavia, Alentejo, villagers leaving church

doubtfully, it's because in his entire time there no-one has come near, still less gone into the place. Seated on his bench, the priest must have been so deep in prayer or meditation that he'd rung the bell and opened the door. The traveller mutters an apologetic "good afternoon" and gives the matter his attention. Pavia church is very beautiful, with octagonal granite pillars, topped with capitals decorated with foliage and human shapes. The main chapel has an altarpiece showing St Paul on the road to Damascus: peering in through the open door, the traveller sees no further Pauls in the process of arriving. The street opposite, coated in shingle, is deserted. The burning sun scorches all Pavia. The traveller returns to considering the altarpiece and notes that at the banquet, beside a bishop and St Anthony, St James is mashing Moors as if there were no tomorrow. See here what a pretty pass matters have come to: the architecture of the church is unarguably Moorish, and the Moors were forced to pay by being named after Santiago.[15] It's an unequal battle, for the saint always has to win. The traveller returns to his good-afternoon greetings. The priest utterly fails to hear him. In retracing his steps across the square with St Dinis' hermitage in it, the traveller comes across the armed guards again.

The road leads to Mora, which he'll lose no time in reaching. The afternoon is closing in, and although the days are long the traveller wants to view the Torre das Águias, near to the village of Brotas, with tranquillity. The path here advances between broadly undulating hills which still don't allow you to forget, despite everything, that the altitude is low, no higher than a hundred metres. Inhabited places here are few and far between.

Brotas appears on one side in ascending narrow streets of white houses. The street is forced between irregular corners and façades arranged in broken lines. There's a sanctuary built as much in Gothic as in Baroque style, a grass-roots lesson learnt by a foreman who didn't bother overmuch with rigour.

If we are to believe the publicity, it's very easy to reach the Torre das Águias. The traveller has been through worse places, but this up-and-down road, which either jumps hurdles or is leapt by them, is more suited to farming than urban vehicles. Finally, having chosen between three forks, crossed three streams and leapt over stony patches where the trees spread their shade, he finds the last fold of the hill and, like an apparition from an earlier epoch, the Torre das Águias appears. On other occasions the traveller has found himself taken aback by sixteenth-century domestic architecture, but has never met the equal of this. Giela can be seen from the motorway; Lama hardly at all; and Carvalhal emerges wholly in view around a bend in the road. None of this applies to the Torre das Águias. Still tucked away today, it

consists in a hidden and powerful block of stone crowned with conical towers, over and above what all the rest have to boast. Openings, in the form of windows and arrow-slits, are rare. On one wall the gaps form a single, vertical line, leaving long spaces in the blank wall of masonry to either side. But perhaps the overwhelming impression of the tower is its central pyramidal trunk, most unusual in that style of building.

It once belonged to the Counts of Atalaia. Nobody knows who is the architect whose stroke of genius put the little conical turrets up on top, to no visible practical purpose other than as flowerpots. Nor is it known whether the place-name has its roots in an ancient visitation of the site by eagles. We do know, however, because it's obvious to the eye, that the tower could have been given no other name. Its wonderful and perfectly simple architecture doesn't require being sited on the highest rockface, it's not essential that clouds brush the summit, since this way any little bird can reach the top just by beating its wings, finding itself safely below the adjacent hill where there's an eagles' nest. After several days' journeying, the traveller was still days away from the region of Sintra: the poor, insignificant Palace of Pena and he so high up at the foot of these rough-strewn stones. The traveller inscribes his new love upon his heart. And when at last he withdraws, he takes but one concern away with him: were he never to return here, he would miss out on something very important in life.

The sun is about to set. And the traveller follows its course. He crosses Ciborro. To his right, rising up across the plain, is Guarita de Godeal. The traveller enters the village of Lavre and goes to find a door to knock on. It's a house belonging to some friends. And there he'll sleep.

15. Santiago [James the Greater] was the patron saint alike of gentlemen and of Crusaders against Islam. His links with Galicia date to the seventh century, when the story circulated that his body was brought to Compostela after martyrdom at Jerusalem. Since the Middle Ages it has remained a major site of pilgrimage, although there has never been confirmation that the remains disinterred there in the ninth century were those of Santiago. All pilgrims who come on foot earn the right to wear the emblem of his cockle shell.

A Rose Flower

Via Mora again to Montargil, alongside the dam that gives it its name, and just as well because there's nothing worse than being called after any old thing, and so the traveller arrives at Ponte de Sôr. Now here's a modest name: being on the bank of the Sôr (and Sôr what of that? Is Sôr a Sir?) a bridge was needed and so a bridge was built. Then came the village, and what was that going to be called? Presumably there's no point even in discussing it: there was the bridge, and there the river with its monosyllabic name, so it had to be Ponte de Sôr and let's hear no more about it. It didn't turn out badly but the traveller, considering that ultimately it would all merge into the River Longomel, thinks of what a sweet name Ponte de Sôr would have were it called Longomel [much honey]. And if there's a Longos Vales, then it would be proper for it to be a region as big as the Alentejo, with a name that expresses as much in a single word, given that it already has one that puts it poorly: *latifundio*.[16] And this is it: Longador [much pain].

The traveller doesn't have to do more than look in order to speak, or being unable to speak of as much as he sees, starts putting words in front of words, in a playful and lighthearted fashion, in the hope that by ordering them in this manner rather than that, the truth might shine through, and a lie be laid. On the other hand there is none too much time to be spent dawdling between Ponte de Sôr and Alter do Chão, crossing their great wastes of solitude among cork trees and stubbled fields under a clear but still tepid sun.

In Alter do Chão the castle sits in the town centre like a jelly on a plate. In general, castles tend to be situated up on inaccessible heights, where the traveller deems there is little to be gained by vanquishing them, given that it's in the valleys the agricultural and grazing wealth lies, along with the enjoyment of good things to be found on the riverbanks, in the orchards and kitchen gardens, or simply by smelling the garden roses. Here the town surrounds the castle rather than the castle walls surrounding and protecting the town. It's reminiscent of another castle the traveller saw in Ghent in Belgium, also with a door giving onto the street, almost as though it too deserved a street number. Nonetheless the Alter do Chão Castle, with its

cones and cylinders, gives an impression of airiness. King Pedro I commanded it be constructed in 1359. He only ordered that it be built, he never saw it, and so did badly out of it: its fortifications are worthy of the royal gaze. Still, the visitor should not throw stones at others' glasshouses, for it's not that long since he crossed the Roman bridge at Seda, and never made mention of the fact. So he's now prepared to tell you that with its six rounded arches it's a majestic achievement, and even if down the centuries it has received but little maintenance, it has to be said that the solidity of the ashlars should be enough to make it superfluous. In earlier days Alter do Chão's Latin name was Abelterium. How times change.

Alter also has another thing of beauty, not to mention its horses, which the traveller failed to go and see. A fountain. Of delicate construction made to order for King Teodosio II, the fifth Duke of Braganza, in 1556, it's a nostalgic reminder of the days when it offered to quench the thirst of all in the centre of the main square. Today it has a bench on its left and a snack bar on its right. But it remains generous in its abundance, as was made clear when the grandmother of us all went there to collect her jar of fresh water. The fountain is Renaissance, severely battered with the years, its vaults and medallions corroded, its Corinthian capitals shattered. The traveller cannot come to terms with the demise of things of beauty. It's a veiled way of not coming to terms with the demise of anything.

Going due north, he again hits the Seda River, at this juncture served by a more modest bridge. Ahead lies Crato, an old town from where you can peaceably contemplate the rolling yet severe countryside. Perhaps the impression of severity is no more than the consequence of the fields of stubble. It's quite feasible that in springtime the sea-green hue of the fresh crops makes the heart sing. For now the countryside looks dramatic. Only if the traveller once more gave free rein to his inclination to project his own state of mind onto what he's looking at, only then would the solemnity of the fields come to mean no more than that the land was resting.

Would that the traveller could do likewise. The heat was murderous, all the crickets had fallen into a collective ecstasy, and only the mad were out on the streets at such a time of day. Crato remains an example to all the towns, with few daring to set foot out of doors: closed doors and windows are the only barricade to stave off the oven heat filling the streets. The traveller asks advice on where to find this and that from a young boy with a heroic lack of fear of the leadenly burning heat of the sun. By some miracle the parish church is open. Apart from some fine fifteenth- and sixteenth-century paintings and the *Pietà* brought there from Rhodes, bequeathed by the Grand

Master of the Order of St John of Jerusalem, it has some good tiles displaying
the usual religious motifs but which unexpectedly claim the attention of the
faithful with profane scenes of hunting and fishing. It's the best of homilies:
pray for your soul to be saved, but don't forget that the body also requires
food and rest. The traveller re-views what he has already seen, for what he
wants is to make the most of a cool interior. Ultimately, however, necessity
remains the mother of invention, and may he who denies it be chastised.

Crato church has a cornice covered with an intriguing confection, both
fantastical and human, entirely unknown in these lands: urns, chalices and
gargoyles appropriated as support and justification in the representation of
saints, angels and strange creatures of the mediaeval imagination. The stone
employed is a very dark granite which at this hour of the day stands out
blackly against the sky's blue background. The traveller, who has been known
to lament the fragility of stone, can now permit himself to be surprised by its
resistance: fifteen hundred years'-worth of summers like this one, and even a
saint of granite would have the right to say "enough" and crumble into dust.

Flor da Rosa is two kilometres away from Crato. You go to Flor da Rosa
to see the castle (a castle, convent and palace in one) which Dom Álvaro
Gonçalves Pereira, the Hospital prior, and father to Nuno Álvares Pereira,
had constructed in 1356. There the traveller would go, but first he's obliged
to take note of the singular character of a village which leaves wide spaces
between the houses, spaces that could be as well enjoyed on today's holidays
as during the jousts and cavalcades of earlier high and holy days. The impres-
sion one gets is that a relaxing space was designed around the solidly built-up
centre, organising a fine town where the people are situated well away from
the aristocracy, and that this assumed determination was so rooted in social
custom that the rules effectively remained unbroken for a period of six
centuries. The traveller was about to call them not rules but taboos. The
Convent of Flor da Rosa, although today half-ruined, still reigns and rules
over the surrounding area.

Outside, as has already been mentioned, the aggregation of buildings give
a sense of massiveness and strength. But the church, or what's left of it,
stands out by the unusual elegance of its proportions. The thickset mass of
its exterior suggesting a church-fortress is belied by what has already been
described in writing: "despite the small size of the openings and the stolidity
of its arches and ribs falling abruptly into the granite walls, it's the most
vertical of any Portuguese church built in the Middle Ages." The traveller,
for whom the memory of Alcobaça is still fresh in his mind, is surprised when
he stands before this architectonic rapture: the relation between the height

and breadth of the nave is truly extraordinary, especially when taking into account the first impression left by the exterior. Flor da Rosa, by dint of this and given its peculiar urban environment, and with its oddly quiet and distant atmosphere, is a gift extended to you on delicate fingertips: a spirited rose, whom time cannot wither; whoever sees her cannot forget her. Just like a passing shade, towards which we reach or murmur a few words, but which neither sees nor hears us, and for this very reason persists in our memory like a dream.

An interminably straight line, only interceptible by force, follows the course of the Várzea's embankment, linking Flor da Rosa to Alpalhão. After a while the terraces begin dropping, even more steeply in the vicinity of Castelo de Vide, in the extreme northwest of the São Mamede region. Only yesterday the traveller remembered Sintra for its Torre das Águias. Now he needs to remember it again to reassure himself as to the aptness of Castelo de Vide's expression for itself as the "Sintra of the Alentejo". It's always an indication of an inferiority complex for somewhere to be identified by reference to some-where else, like sticking up those distichs for those who, by their greater or lesser efforts, ought to have no need of them. It's been said that Aveiro is the Portuguese Venice, but nobody would think to say that Venice is the Aveiro of Italy; we're told that Braga is our Rome, but it'd be a joke to call Rome the Italian Braga; and so, finally, we learn that Castelo de Vide is the Sintra of the Alentejo, when of course it'd occur to no-one to call Sintra the Castelo de Vide of Estremadura. The trees surrounding Castelo de Vide are not those of Sintra, which is as it should be. Because rather than have an imitative landscape we have a real one before us, under another sky, surrounding a distinct urban reality, with its own way of life. Were Castelo de Vide another Sintra, there would be no point in coming here from so far away.

Of the churches this town has to offer, the only ones the traveller managed to visit were those of St James and the Chapel of the Saviour of the World. In each he was able to admire the walls covered with tiles, coating the whole of the former's interior, the vaulting as well as the side walls. Salvador do Mundo, whose earliest construction dates from the late twelfth century, is also covered inside with tiles, with eighteenth-century panels showing the "Flight into Egypt" and an "Adoration of the Virgin and Child, with Two Angels". The south door of this chapel is of primitive construction. At the pinnacle of the broken arch surmounting the door is a human face, roughly cut from granite, silent on the subject of who he is and what he's doing there. These are the type of missing links lamented by the traveller: there has to be a reason for that face at the point of the arch, and not knowing it prevents

us from understanding the sculptor who visualised the work of art. This door
(like so many other sculptures and paintings) is part of the alphabet from
which our words are made. And it's no small impediment to have to make
sense of it, all the more so if some of the letters are missing.

Lands so abundant in water have to have their monumental fountain.
And here it is, the Fountain of Vila, its roof supported by six marble columns
and the four spouts pouring from the urn. The decrepitude of it all is a
major disappointment: its stone wasted by time and misuse, its basin and its
surrounding pipes left filthy. Castelo de Vide's fountain resembles an orphan:
if there is such a thing as mercy, may it take care of these stones which so
richly deserve it.

The traveller cupped his hand and drank, and went to the Jewish quarter.
There the streets mount the steep slopes where the synagogue once stood,
and the traveller feels as though he himself were a figure out of a Christmas
crib, with all its little winding steps, its corners and patio walls. The Jewish
and Arçário quarters are of an incomparable rustic beauty. Their gateways
have been preserved with a love and respect that move the traveller. Their
stones are the stones of earlier centuries, some dating back to the fourteenth
century, which previous generations came to love and protect. The traveller's
close to believing what's written in Castelo de Vide's chronicles and with
testimonial acknowledgement: "And I leave to my sons a doorway to be
kept undivided within the family."

Marvão can be seen from Castelo de Vide, but you can see anywhere from
Marvão. The traveller's exaggerating, yet this is precisely the impression he
had before ever coming there, while crossing the plain when suddenly there
rears nearer than ever a tall and near-vertical promontory. At over eight
hundred metres high, Marvão reminds you of one of those Greek monasteries
on Mount Athos which you could only reach by putting yourself into a
basket and being pulled up to the top by a rope, the abyss at your feet.
Nobody has to undertake such an adventure. The road strains on its way to
the summit, curve after curve of a wide arc circling the mountain, but at last
the traveller can set foot on the ground and take stock of his triumph. All
the same, if one is a lover of justice, before going into ecstasy over the wide
vistas spread before him, he should recall those two lines of trees bordering
a stretch of the road for some two or three hundred metres immediately
beyond Castelo de Vide: a lovely avenue of strong tall trunks, and if one day
it's decided that they're a threat to high-speed traffic, that being a madness
of our times, may God grant that we refrain from cutting them down, and
may they move over the motorway instead. That way maybe members of

some future generation will be able to come and ask questions concerning the reasons for two such straight and regular rows of trees. Thus, as you can see, the traveller is clearly clairvoyant: if there's no answer to the human face at Salvador do Mundo at least here you can find one for the mystery of the unforeseen avenue.

It's the truth. From Marvão you can see virtually all the lands thereabouts: on one side Spain, with Valencia de Alcântara, São Vicente and Albuquerque, as well as a mass of little villages; to the south along the ravine separating the Serra of São Mamede and another, a spur of the former, the Serra of Ladeira da Gata, where you can pick out Cabeço de Vide, Sousel, Estremoz, Alter Pedroso, Crato, Benavila and Avis; to the west and northwest, Castelo de Vide, which the traveller visited only recently, together with Nisa, Póvoa and Meadas, Gáfete and Arez; and finally, to the north, where the air is limpid, the final blue shadow belongs to the Estrela highland; it comes as no surprise to be able to see Castelo Branco, Alpedrinha, Monsanto quite clearly. You can understand why, here in a place like this, from the heights of the tower, in homage to Marvão castle, the traveller is bound to mutter respectfully: "How wide is the world."

16. A large estate belonging to the landed gentry.

One Ancient Stone, One Man

If cities were given nicknames, as once upon a time they were by royalty, the traveller would feel bound to propose that Portalegre be given the sobriquet of "a place well surrounded". In 1259 King Afonso III must have had his reasons to order the building here of Portus Alacer, which gave rise to Portalegre, *porto alacre, porto alegre* [the port of happiness]. Surrounded by countryside and woodland, its buildings so neatly divided off from the surrounding wild landscape, we can well understand how José Régio wrote and repeatedly rewrote:

> In Portalegre, a city
> Of the high Alentejo, ringed
> With mountain ranges, winds, cliffs, olive groves and
> Spanish oaks . . .

Any traveller with a love of foreign letters and native riches could well become obsessed by this ditty as he walks along.

It's been some time since the traveller came across Nicolas de Chanterenne. Having been unable to take more than a couple of steps without encountering evidence of either his handiwork or that of his workshop, suddenly a vacuum had opened which had appeared final. It wasn't. Right here, in the convent of Our Lady of the Conception or of St Bernard, is the grave of Dom Jorge de Melo, which must have been the last work of the early French sculptor so opportunely come to Portugal. The tomb, with its recumbent statue, is set against a magnificent screen whose niches and ledges are covered with religious imagery and with a variety of architectural perspectives typical of the Mannerist style. Bearing in mind the alabaster screen at Pena in Sintra, also by Nicolas de Chanterenne, you can again see what expressiveness the work of art owes to the material from which it is made: here it's Estremoz marble, so much more communicative than the rich alabaster of the Convent at Pena. Nor is it simply a matter of personal choice: the traveller has already declared his preference for granite over marble, so he can now prefer the stone of Estremoz over the finest alabaster. For those loath to go into that

degree of detail, the only possible response is that travels and travellers would only be impoverished were detail to be banished.

Being so near at hand, he decides to visit the Manufactura de Tapeçarias de Portalegre [a Carpet Weavers'], whose manufacturing techniques were so warmly praised by the Frenchman Jean Lurçat. The traveller has no great sentimental attachment to carpets, unlike the considerable amount of feeling he attaches to handmade artefacts. If he did not especially like all he saw, he was probably at least as much to blame as those sketching the templates he saw being executed but, whatever his ignorance in the matter, he could at least recognise the weavers' skills and the efficiency of their preparations in arranging all the colours and knotting. Again he was able to enjoy the friendliness which greeted his visit and the simplicity and candour of the explanations offered. The traveller was grateful then. He is grateful again for the memory.

It's now time to go to the old town. Almost entirely set within the perimeter of the city walls, it boasts the usual characteristics of similar-sized cities: narrow, winding streets and low houses with few upstairs floors. To this can be added an unusual serenity without a degree of tedium, only conformity. The Cathedral square is spaciously four-cornered, highlighting the position of the church, and seems, by its very tranquillity, like a village square. Its towers dominate the building. Stacked in angular pyramids, they can be seen from a long way off. Moreover, the upper part of the Cathedral soars above the roofs of neighbouring houses.

From inside, its grand scale looks even more impressive, separated into three naves of equal height by large granite pillars. It's an exceedingly lovely church, its five chapels at the high-altar end linked by narrow corridors. The screen of the lady chapel, with its scenes from the life of the Virgin, shows the apparition of Christ to his apostles on its tympanum, a work of dramatic effect. The cloister, on only one level, lacks intimacy. But the Baroque decorations with alternating urns and bull's-eye windows on its upper edge, manage to give it the aspect of a quadruple colonnade, an additional and unexpected attraction.

Also right beside him stood the City Museum, with no dearth of beautiful pieces to its credit. It may not be the most daring of museums, but it's certainly among the most impressive, with a human-sized Christ throwing his body forward with enough force to launch himself from the cross. His face bears an expression of indignant surprise, his eyes dilated until they appear to be popping from his head: the entire man is begging for our help. It's as if he were telling us that the sacrifice of his life were not after all

indispensable to the salvation of our souls. This terracotta bas-relief is enormously beautiful, showing us passages from the life of Christ: little figurines filled with movement, admirable little vignettes. In addition there are some patient works in marble, in high-relief this time, leaving the traveller astonished by their tiny details, by the authentic acrobatics performed with eye and hand, as demanded by the artwork. There's also a *Pietà* carved in wood, likewise in high-relief and possibly of Spanish origin given the dramatic nature of its composition and the cruel realism of its treatment of Christ's body. The traveller continued through further rooms crammed with valuables, culminating in a selection of some renowned sixteenth- and seventeenth-century dinner plate, taking up a whole museum department of its own.

José Régio's house is a museum in itself, with everything or nearly everything that a museum could hold: paintings, sculptures, furniture. This museum houses a remarkable collection of Christs, ex-votos, reliquary boxes, samples of local handicraft, and it's a home "filled with cobwebs, but alive, an unfailing reminder of people and times gone by, its windows filled with light and its corners with shadows, fears and tranquillity, sighs and silences". No visitor today would say as much (albeit, certainly, recognising these verses in the commonplace saying into which the traveller has converted them), but at the window of which José Régio speaks, his "sole distraction" – according to the guide – was that "everything's open to the scorching sun, the hammering cold, ice, and the winds that blow to and fro and roundabout, and circle around my house in Portalegre, a city in the high Alentejo, ringed with mountain ranges, winds, cliffs, olive groves and Spanish oaks." The traveller does whatever is necessary for the duration: he leans over the small verandah which suffices for the pose of a poet; looks over the new houses at the ancient countryside; and attempts to understand the secret of the words that seem to be taken simply from a geography lexicon: *Em Portalegre, cidade/Do Alto Alentejo* . . . To strive to comprehend him is the least one can do.

Had the traveller a modicum of scientific learning, he would have been obliged to dedicate it to researching an essay on a theme that could be roughly described as: *On the Influence of the Latifundium on Depopulation*. The term "depopulation" is an abstruse one, but the terminology of the essayist should not sound just like everyone else's. What the traveller wishes to say, in everyday speech, is the following: What the devil is the reason why the Alentejo has so few inhabited regions? It may well be the case that the subject has been well studied and every explanation given, and who knows whether

one of them may take up the traveller's hypothesis, but a man who journeys all these distances, where for kilometres on end there's no sign of a house, could be forgiven for thinking that large estates are the enemy of population density.

On reaching Monforte the traveller takes the route to Alter do Chão: he goes to the Torre de Palma estate, where some remains of a Roman villa have attracted his attention. It's only a short distance, but if you travel without paying attention you'll lose your way and miss finding the sign which reads: UCP Torre de Palma. UCP, for those who don't know, stands for *Unidade Colectiva de Produçao* [Collective Production Unit]. It's not surprising: if the bridge at Lisbon can change its name, so can arable lands alter their shape. The traveller arrives at a large gateway, and enters a vast estate glittering in the sunlight. Ahead is a high tower of many storeys. It's not of Alphonsine construction, as he saw when he approached close, but intimates that someone, in much more recent times, decided to display his wealth visibly to the people thereabouts. On the wall adjoining the tower is a coat of arms. Below it, either resting from recent labours or preparing for fresh efforts, are arms of another kind: a collection of agricultural tools.

The traveller advances, but he is a timid traveller, ever apprehensive that he is about to be hailed with demands to explain his intrusion, which he alone knows is a well-intentioned one. As he reaches a bend he can overhear men's voices. It's an inn. The traveller goes inside, wishing those there a good afternoon, and asks the man leaning on the bar where the ruins lie, and whether it's permitted to visit them. The man is called António, as he loses no time in informing him, and he's small, squat and with a calm manner. He says yes twice over, and begins giving the necessary directions. The traveller's thirsty and so requests a drink; whilst knocking it back, he asks the magic question: "And how are things going with the UCP around these parts?" Senhor António looks at him with attention, but before he can reply, another question appends itself to the first. "Are there any reserve demarcations in these parts?" Whether due to the orange juice, the bar's dim lighting, or for another reason entirely, the air seems to turn fresher, and Senhor António replies simply: "Not too bad, but there's talk of a petition around here, and if it were accepted it'd leave us without any land to till." He left a pause before adding: "When you've finished your drink we'll go to the office. It's easier to talk there."

The office was at the end of a row of houses along one side of the quad-rangle in the middle of which stood the tower. Seated at the desk was a dark

girl with shining black eyes and a wide smile, pretty and obviously of gypsy origin. All formal introductions concluded, the girl, whose name the traveller either forgets or never caught, explained the situation. Her smile remained as she talked, and the traveller was obliged to decipher whether she was smiling while talking seriously or was talking seriously while smiling. It seems to amount to the same thing, but isn't. He listened with attention, asked a few more questions, said a few more words of luck and encouragement, and as he found himself to be smiling as well, he decided that everyone there must be talking seriously.

Senhor António now goes on to demonstrate some of the co-operative's newer installations, including the machine park and the olive press. Both have only been recently installed. The oil press is impeccably cleaned and lubricated, ready for the new season's harvest. When they return to the patio, the traveller enquires whether he can go to the tower. "Let's go," says Senhor António, "I'll collect the key." They go back into the office, and as he opens a drawer to take out the key, the girl remarks: "Not even the oldest workers here can remember ever having seen the owners." She says as much by way of an addendum to their earlier conversation, something that still remained to be accounted for. The traveller nods his agreement. The girl smiles.

Senhor António shows off the ground floor of the tower, with its old kitchen, a type of mediaeval redoubt, to judge from the thickness of its walls, beside which there are some rustic benches and tables of white marble. "Here was where the farmhands used to sit and eat," he told us. The traveller looks on, fascinated, imagining the men sitting on those benches, waiting for their soup. He murmurs to himself: "Bread soup at a marble table. A title which has no need of a book."

They continue on up to the higher floors, past empty rooms, corridors and stairs. In one spacious room there are still chairs and a writing desk. "Here was where we held our meetings," Senhor António told me. Then, suddenly: "Look, a house sparrow. He must have got in through a hole in the roof." The little bird, scared now, began flying at the windows, not knowing why the soft, smooth skies of yesterday had turned so hard. On the other side of the window, there were trees sun, open fields, and inside just her, shut in. So Senhor António and the traveller set about attempting to catch the bird, stumbling over chairs, getting to the point of catching her, but she mistrusts their intentions, escapes, flies up to the roof, where there's nowhere to alight, then reverts to hurting herself at the window panes, and the traveller begins to laugh, and Senhor António begins to laugh, and the

Torre de Palma is a joy. Finally the traveller succeeds in catching the sparrow, feeling extremely proud that it should have been him, and says to her in a fraternal fashion: "Are you stupid? Couldn't you tell that we were chasing you with the best of intentions?" The little bird's heart was pounding like crazy, with fear and striving. She was still attempting to escape, but the traveller held onto her firmly. At the top of the tower they opened the doors to her prison. All of a sudden the sparrow is released, the air is as it ever was, and in an instant she vanishes into the distance. The traveller considers that at least half his sins must have been pardoned.

Now Senhor António is busy explaining the extent of the cooperative's lands, its stores now designated, and more still to be marked up. From below a man called out a phrase in which the word *borregos* [lambs] could be made out. Senhor António was obliged to go down and set to work. The traveller returns to asking the whereabouts of his Roman ruins, there, over there, and then they continue on, bidding farewell to each other like the friends they now are, until the next time.

The traveller pays his visit to the ruins. He gives them what attention he may, especially to the early Christian basilica and the baptistery font, but feels distracted in the midst of these old stones. It's because he's so close to the new men that the traveller is incapable of finding the nexus, its tributaries and the current linking one with the rest. Yet this current exists, as the traveller knows full well. It's enough to see how the battles between Theseus and the Minotaur still go on being enacted, as shown in the mosaics carried off to Lisbon.

The traveller didn't get to see the monuments of Monforte. There's the church of Our Lady of the Conception with its Spanish-Arab crenellations, the covered porch of the Prior's House with its Baroque stucco, the church to St Mary Magdalen with its narrow, pyramidal belfry. These are his memories of the outside. With the Torre de Palma borne on his back, the traveller thought it better not to enter. Certainly, he would never have fitted through the doorway.

The next stop was to be in Arronches, a town ringed by five bridges, on ridges to the north, west and south and with waters gushing through the river and Arronches itself, which is Eça de Queiroz' famous Caia. On the façade of the parish church the traveller could find traces of Nicolas de Chanterenne, not directly by his own hand, but of a humble copy: cherubim and warriors in high relief demonstrate an unmistakable family connection. But what most interested the traveller was the church of Our Lady of Light, with its Renaissance porch, the beautiful chapterhouse, with its stucco

figures and its cloister, tranquil and well shaded from the suffocating heat from the beating sun.

Once again the traveller progresses through wide open spaces and desolate places, to a mid-point between the frontier and the dam of Caia. He goes through the village of Our Lady of the Cut-throats and this name, whether or not on the highway signpost, gets the traveller thinking of the number of the beheaded who populate the history of Christianity, to such an extent that it could seem appropriate to dedicate a special Our Lady to their protection. The traveller's worry hinges on whether the protection has to be invoked before or after the throat-slitting.

He had the time and went as far as Ouguela, not so much to see the castle re-built by King Dinis, but to see what aspect a riverside called Abrilongo might have, whether due to April being long because it extends itself, or because it begins so late. Here he paused at Campo Maior, which also boasts a castle, thanks to one and the same Dom Dinis, and takes a look at the octagonal church of St John the Baptist, its marble carved to a classical design, without coldness, perhaps as a result of conforming to the tradition of local religious architecture, and also thanks to dating from the time of His Majesty King João V, and which inevitably make it a part of the lay ambience.

The traveller leaves by the gateway facing Elvas, still following his tranquil path, then on over the bridge of Caia, passing two lorryloads of armed guards also going in the direction of Campo Maior. Not all travellers are equal, and not all roads lead to the same Rome.

Elvas has an abundance of military pomp. So say the city walls which surround it, and so say the reinforcements at Santa Luzia and Nossa Senhora da Graça, supporting the central fortress. But the city isn't only adorned with the evidence of warlike struggle. Other heroic deeds have also been enacted here, to which António Dinis da Cruz e Silva gave punctilious regard in his *Hissope*,[17] and it was no small act of heroism for the dean and bishop of Elvas Cathedral to fight over an aspergillum [*hissope*] and the protocol of its use or non-use before the Mass. It was equally no small matter when their lordships fought His Excellency, invoking the intervention of court and council, over whether Castile would take advantage by using the debate as evidence of a strong fortress mined by internal religious factions.

The Cathedral itself holds no record of these events. In fact there's no proper cathedral, merely a parish church dedicated to Nossa Senhora da Assunção. It has the presence of a castle, given the wide mouth of the entrance porch, its flying buttresses and crenellated battlements, and its gargoyles.

60 Salvada, Alentejo

Inside, the fluted columns sustaining its three naves merit attention. The traveller finds the most beautiful feature of this old cathedral lies in its façade and its solitary tower. Architect Francisco de Arruda really didn't deserve the row over questions of precedence between dean and bishop erupting into his masterpiece. Whatever their relative merits, be sure to see the main Gothic chapel in São Domingo with its narrow arrow-slits, and to avoid viewing the gilded capitals on the columns: as for quarrels, those about the aspergillum should be quite sufficient.

Between the castle, or its miniature version, the whipping post and the coat of arms, the Fountain of Mercy and the Fount of Blessedness, the traveller lost a fair amount of time before visiting the museum. On entering, what pleased him was the Baroque porch and the blue-and-white chequers tiled on its cupola. Inside, there was no dearth of architecture worthy of appreciation, but Elvas Museum is not especially well endowed, except in coats of arms and some archaeological pieces. Particularly magnificent is Santa María dos Açougues, dressed like a female courtier, a sixteenth-century lady and arguably even lovelier to the eye today than during her own epoch.

It's impossible to discuss Elvas without mentioning the Amoreira aqueduct. It behoves the traveller to tell of an astounding work of art: 843 chiselled arches, laid out in four rows of separated sections. It took more than a hundred years to construct (124, to be precise) while the people forever paid

their water rates, generation after generation. When at last the Fountain of Vila began to give water in 1622, it could be argued that Elvas' population might as well have sweated its clear waters. Just as at Lisbon's Águas Livres. Just as everywhere in pipes and plumbing, in watering cisterns and animal troughs.

17. António Dinis da Cruz e Silva (1731–1799), neoclassical poet. He cultivated a number of genres – epigrams, sonnets and odes. In 1766 he wrote his satire called *Hissope*, a comic-heroic poem narrating the row between the Dean and Bishop of Elvas on the question of precedence, whether or not the dean was obliged to bring the aspergillum to the bishop in his palace in time for any ceremonies. The poem remained unpublished until 1802.

The Destruction of Nests is Prohibited

The traveller came to know little more than the upper town in Estremoz, where the old town and castle are enclosed. The roads within the city walls are narrow. From there on down the area opens out, less into a town than into a city. Estremoz stretches forth so far it almost loses sight of its origins, while still encircling the celebrated Torre das Três Coroas [the Tower of Three Garlands] with its obvious attractions. Nowhere else has the traveller so strongly experienced the demarcation that can be made by city walls between those within and those without. Of course, the impression made can only be a personal one, thus subject to a caution which naturally the traveller lacks.

Whitewashed with chalk, employing marble as if it were an everyday stone, the houses in the upper city are of themselves reason enough to visit Estremoz. But on its summit is also the aforementioned tower, with its decorative balconied battlements, along with the remains of King Dinis' Palace and its portals of twinned colonnades where the traveller discovered pictures of the moon and of lambs. Here too is the eighteenth-century chapel to the saintly Queen Isabel, with its theatrical choir stalls and extravagantly ornamented tiles representing stages in the life of the miraculous lady who transformed bread into roses, since she was unable to transform roses into bread. Here too the Municipal Museum, which boasts much to see and little to forget.

The traveller ignores the pieces he knew he'd be able to find without too much trouble in other museums, in order to gaze at his leisure upon the clay dolls called after Estremoz. "Wonder at them," says he, "wonder – there's no happier name for it." Hundreds of little figurines arranged with good taste and judgment and each one worthy of slow examination. The traveller doesn't know which way to turn: they're called popular pieces, showing scenes of rural labour or Christmas cribs fit for a house altar, toys of diverse inspiration; it's a world that cannot be catalogued item by item. One example must suffice: a single shop front uniting, in ordered confusion, "negroes on foot and horseback; an Amazon and riders; a parish priest on his horse; a shepherd and flock; a man eating crumbs while another man prepares a bread broth; sentries standing or sitting about in a garden; a mischievous lad

out in the fields; an accordion player; emblems of spring with and without garlands; popular figures of chestnut-pickers, milkmaids, water-carriers; rustic maidens with their spinning wheels or guarding hens, ducks or flocks of sheep and goats; women washing, ironing, gazing at themselves in the mirror or taking tea; a fishwife; and three figurines engaged in killing the pig while the women make sausages from the pork". Oh, how magical! he says over and over again. You'll go to Estremoz, you'll see its little dolls and you'll save your soul. That's a saying invented by the traveller to bequeath to posterity.

He could well have remained there, but it was impossible. Having contemplated the endlessly rolling landscape he could glimpse here and there, he goes down into the lowlands, another way of saying that he went to Rossio where, just outside, there stands the church dedicated to St Francis. Here also is the monastery where King Pedro I died, leaving his heart to the monks. If it's true the brothers inherited this gift, when the Day of Resurrection occurs in Alcobaça, Pedro will no longer have a heart to bestow upon his Inês.

In St Francis there's a beautiful seventeenth-century *Tree of Jesse,* and in the adjoining chapel, belonging to the Third Order of Franciscans, the traveller comes across the most unsettling collection of saints he'd ever set eyes on. It was not that they were posed in attitudes of excessive suffering or of insufferable anguish. Quite the contrary. All, men and women alike, were identically dressed in long, simple robes of natural silk; all were characterised by the same impassivity in their faces, the same rigidity in their gaze. Tall and slender, posed in glass cases, they ring the walls of the chapel. They don't stand there like judges – more like manifestations of human servitude. The traveller, more disturbed than he wished to acknowledge, dared to take note of the names of that frightening company, inscribed on the corbel: St Luísa de Albertónia, St Delfina, St Rosa de Viterbo, St Isabel da Hungria, St Luís Rei de Franca, St Ivo Doutor [i.e. a doctor of the Church]; St Isabel de Portugal, St Roque, St Margarida de Cortona. The traveller didn't manage to jot down the near-obliterated emblem over the last of the saints. In fact he lacked the strength to do so: his hands were trembling so much and his head was bathed in the sweat of the afflicted. May the other saints grant him forgiveness, for these are not the sort from whom to beseech pardon.

Overwhelmed, the traveller withdraws. He's on the point of leaving when, providentially, he catches sight of a tomb nearby, set into a proudly sculpted arch, showing a bearded personage lying down, ministered to by a cherub with spread wings and displaying the soles of its feet (a sign that it could walk as well as fly), fronted by two coats of arms, emblazoned with half-moons and two powerful cats with, in between them, a hunting scene, with the master on

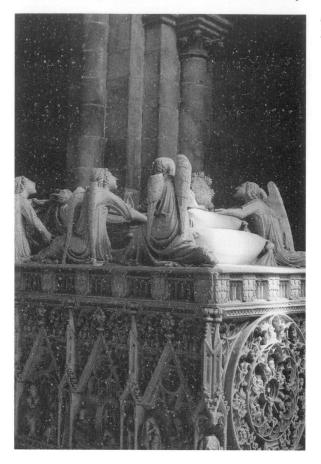

61 *Alcobaça, tomb of D. Pedro I and Inês*

horseback, falcon on wrist, and a man with a lance blowing his horn, while another urges on the hounds who are barking and snapping at a wild boar. The traveller heaves a sigh of relief. Finally, under this funeral arch life breaks through with a force that swallows up the hyper-reality of the terrible saints and mollifies their scorn of the world. Like Dom Pedro de Barcelos in São João de Tarouca, this Vasco Esteves de Gatos desires to take the memory of happy days spent hunting in the hillsides with him, galloping along behind the hounds, while the trumpet sounded and the trees bloomed. The traveller emerges from the church as contented as the sparrow restored to liberty in Torre de Palma.

The moment to go to Évora Monte has come. It's close at hand and on his way. This was the village where Dom Miguel surrendered to Dom Pedro, as we all learnt in school. And, a matter worthy of note, instead of peace negotiations in familiar surroundings, as at first sight seems appropriate,

namely the castle and its Paço de Homenagem, they met in a little one-storeyed house, whose entrance was beside the main door inset into the city walls, where the Dukes of Terceira and Saldanha (for the Liberals) and General Azevedo Lemos (commander of the Absolutists) met beneath the benevolent eye of John Grant, secretary to the British delegation to Lisbon: friends, as has often been said, are made for such occasions. The house still stands and the Paço do Homenagem, restored from top to bottom, would today offer yet further comfort and security to any fresh negotiations. That the traveller says so is due to the restorations the palace is in the process of undergoing: three Republican guards, who left the jeep in which they'd arrived outside, set to opening up channels in the walls in order to instal new electric wiring as they swopped jokes and whistled bravely. And so let's leave them to the things of their youth and to the ways of the young.

They say that the Paço de Homenagem is of Italian inspiration. It must be, for the traveller has never seen anything like it around these parts: a square central body which dissolves into little circular cubes at its corners. Inside, the effect is magnificent, with heavy columns supporting vaults that rise to three storeys high, each of them different, vaults as well as columns, the rooms communicating openly with the little hexahedrons. The surroundings look truly Renaissance, suitable for parties or similar celebrations. Now the guards are busily engaged in a conversation about the films they've recently seen or are about to see. The traveller, intrigued, observes the columns on the lowest level: at its base, and all the way around, there are carved braziers. Why braziers? What fire is this, frozen in the stone of Évora Monte? The traveller's baggage is already laden with enigmas, so hopefully this one won't set the rest alight.

The traveller would like to have visited the parish church, but it was shut. Shut too was the church of St Peter, despite his questing and questioning: the key lady wasn't around, although six placid dogs guarded the area and, despite the traveller's best hopes of a fair return on his yawns and conversation with the dogs, no key appeared. Way up behind the parish church there was a walnut tree where twenty or thirty crickets were chirruping in unison and in such a way that you could hear but a single sound, rather than the customary discordant strum. The traveller was surprised that neither walnut tree nor crickets launched into flight and set off for the heavens, singing loudly. To say the least, the walnut tree must have experienced grave difficulty in keeping its roots underground.

The traveller retraced his steps, passing below Estremoz and, en route for Borba, crossing dense olive groves. The day promised to be extremely hot. After getting to Borba he visited its simple chapel, no more than a door,

façade and cupola, dazzling with a near-unbearable whiteness. The traveller says it was but a simple chapel. Not so, in fact. If its dimensions were not quite astounding, its monumentalism was: the door reached up as high as the cupola, which sat directly above the entablature. Flanking the façade there were two beautiful seated figures, letting their feet dangle into the ether, sustaining a conversation which did not travel all the way from above to below. The traveller asked some women having a chat in the shade the name of their chapel. Not one of them could tell him. Perhaps it was a processional shrine? Perhaps it was.

A few metres further on stood the Renaissance church of St Bartholomew. In these parts there are always two things in abundance: the Renaissance and whiteness. Outside, there is no great ostentation, but within the church is sumptuously bedecked in marble. But its greatest beauty lies in the paintings on its roof, embellished with figureheads and landscapes, a decorative style only rarely encountered. Decidedly, the traveller is enamoured of Borba. Maybe it's down to the sun, to the morning light, the whiteness of its houses (who was it who said that white is not a colour but the absence of colour?), it

62 *"Alminhas" wayside shrine*

has to be all of these and more, plus the tracery of its streets and the people who walk along them, after all, no more is required for a sincere devotion to develop, when, all of a sudden, on a garden wall the traveller sees the most extraordinary declaration of love on a poster with the following lettering: THE DESTRUCTION OF NESTS IS PROHIBITED FINE 100$00.

It's as well to bear in mind that any town which publicly declares that the full force of the law will fall upon all those who think of destroying an adobe wall that's home to birds deserves the greatest possible praise. Home to swallows, to be precise. Given that the sign was positioned on the wall below where the swallows choose to build their nests, it's clear the protection applies to them. All other birds, vagrants, a few of them belligerent and less given to human confidences, make their nests in trees outside the town, and subject themselves to the hazards of war. It's excellent that the community in this now highly-praised region has a law of its own devising. Otherwise all laws for the protection of birds and men would come to an end except, of course, for those unworthy of the name of laws, wrongdoers on one or the other side. Probably due to the effects of the heat, the traveller is not having one of the most clearheaded of days, but hopes you may yet understand him.

Much has been said about the Fountain das Bicas [of Spigots], and with good reason. Conceived as a little temple with the piping concealed, it tempers the neoclassicism of its style with the white marble typical of the region. But what the traveller liked best or, more precisely, what amused him most, was a kind of labyrinth leading up to the fountain, almost a game of piping that successively opens and shuts off the flow. A newly-arrived stranger feels uncomfortable with it. He estimates that there will always be Borba residents kept entertained by disconcerted visitors.

On the way to Vila Viçosa and on either side of the main road, the traveller encounters an abundance of marble flowerpots. These earthly bones still bear traces of the flesh-coloured mud which once coated them. And, speaking of old bones, the traveller observes how to his right and along the far horizon rear the heights of the Serra de Ossa, meaning bear, and not the feminine of bone, which doesn't have a feminine form. As you can deduce from the visual evidence, not everything is what it appears.

From Vila Viçosa, proceed to the Ducal Palace. The traveller isn't exempt from the obligation, which is also a matter of taste, but he's loath to admit that these palaces always leave him in a condition approaching mental confusion. The plethora of objects, the wonderful alongside the mediocre, and successive rooms weary him as much here as in Sintra or Queluz. Or, without wishing to appear presumptuous, in Versailles. All in all, it's unjust that Paço

de Vila Viçosa merits as attentive a visit as their timetable allows, obviously devised by the guides there. It's not always the object of interest they note that the traveller is likely to most appreciate, but its selection in all probability follows an owner of uncertain taste intended to please everybody. In any case, unanimity of choice is guaranteed for the rooms named after the Virtues, the Duchesses or Hercules while in the north wing, in the rooms dedicated to the Queen and to David, there's particular distinction given the plaza lined with Talavera tiles like the Duchesses' room. Equally magnificent are the chests in the Dukes' Room, and the oratory of the Duchess Catalina is also extremely beautiful, its ceiling painted with themes drawn from decorations at Pompeii. There's no lack of painting in the Vila Viçosa, much of it done by contemporary Portuguese artists, and more by some good sixteenth-century copyists, most notably Van der Goes' "Descent from the Cross". If the traveller should venture into the kitchen, he'd be taken by surprise by the variety and quantity of copper utensils there. If he visited the weaponry, armour and trappings, if he didn't fail to see the stage-coach belonging to João V, it's because it all has to be seen in order the better to understand the lives of the dukes and their servants, despite the fact that where these are concerned, they didn't add much to a tour of the palace.

Once outside, the traveller takes a turn around the equestrian statue of Dom João IV. He finds it very similar to the one in Lisbon of Dom João I, which neither devalues the former nor enhances the value of the latter. To lift the weight of these concerns from his heart the traveller goes to the old town, possessing a beauty particular to ancient Alentejo communities. Before climbing the road to the castle, neglected by the numerous tourists, he goes into the church of Our Lady of the Conception, covered from top to bottom in polychrome tiles, yet another illustration of how far we've gone towards losing our taste for this splendid material or perhaps how far we've gone in adulterating it as a modern utility.

The traveller admires the justice inherent in the image of the female patron saint whom João, without taking account of any divine preferences, crowned and proclaimed patron saint of Portugal, and then went on to other tiles, of Policarpo de Oliveira Bernardes, a fully accomplished artist. As has been noted many times previously, highly attentive as the traveller is to everyday minutiae, even without disregarding rare and important matters, it's not so strange, he finds, that ears of corn and oil should be embedded in the substantial arches supporting the entrance, and again on the impressive collection boxes, one of which, older in its design and lettering, is intended for the Papal Bull for the Crusaders, while the other, for the patron saint of the church, is as

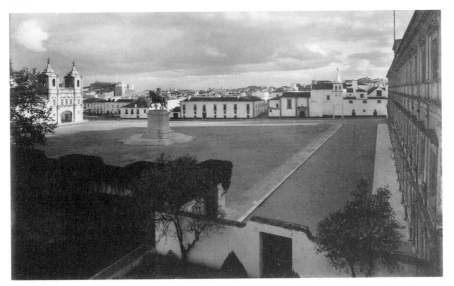

63 Vila Viçosa

theatrical as any Baroque screen. To either side of the central nave, leaning against the columns, they are in a position to solicit a believer's generosity. Whoever enters the parish church of Vila Viçosa with money, oil or corn to spare, must have the hardest of hearts if he's not moved to part with them.

The castle of Vila Viçosa, by which the traveller means the New Castle, a sixteenth-century edifice built according to the instructions of Duke Jaime, is first and foremost a fortress. Everything in it is subordinated to a military function. A fortification of this kind, with walls which in places are as much as four or six metres thick, was conceived with an eye to great and lengthy blockades. Its dry moat, powerful cylindrical towers, each of them extended to cover two sides of the quadrangle, its wide interior ramps to facilitate troop movements, involving the defensive artillery and no doubt including their draught animals, allowed the traveller to inhale, in a manner he has only rarely encountered, and from then on never again as intensely as upon this occasion, the atmosphere of war and the smell of gunpowder, despite the total absence of the instruments of war. Inside the castle walls sits the dukes' citadel with some fine paintings, and within it you can see situated, and well situated, let it be said, the Archaeological Museum and the Archive of the House of Braganza, a pile of enormously rich documentation still awaiting proper exploitation. The traveller saw, with flagging spirits, attached to a wall so all could see, the enlarged photograph of a document signed by Damião de Góis a few weeks before the Inquisition seized him. Flagging spirits is not

perhaps the most apt description: let's call it melancholy, or another of those indefinable sensations, whatever is invoked by one's sensitivities in the face of the irremediable. It's as if the traveller, knowing that Damião de Góis was about to be imprisoned because dates and facts had advised him so, was obliged to set history to rights. Only he simply couldn't: in order to correct history it's always necessary to correct the future as well.

The traveller reaches the main road by way of Ciladas de São Romão which passes through Juromenha on its way from Alandroal to Elvas. And when he finds some shade under which to consult his maps, he's pulled up short by the fact that, in the military map he uses as his guide, it's not actually recognised as the frontier to Olivença. In fact there isn't a frontier there at all. To the north of the Olivença River and south of the Táliga, both on the far side of the Guadiana, the border is picked out with an intermittent red line. Between the two currents of water, it's as if Portuguese territory extended far beyond the sinuous blue fretwork of the river. The traveller is a patriot. He's forever heard tell of how Olivença was ignominiously snatched from us: it's a belief he was brought up in. Now the belief is transformed into a conviction. If the army's mapping services so irrefutably demonstrate how Portugal, over thirty or forty kilometres, has now opened the way to reconquest, there's nothing to prevent us from invading Spain and taking what belongs to us. The traveller vows to give the matter further thought. There's just one thing he's afraid of: there's no lack of frontier markings on the Spanish maps, so to them it'll appear as a cut-and-dried case. So he'll have to prepare himself in order to join in the forthcoming joint meetings on frontier questions. He'll listen attentively to what has yet to be said, all the whys and wherefores until, when the moment arrives, he'll pull out the map he's furtively secreted about his person and say: "Fine, but now we're going to move to a resolution over this issue of Olivença. My piece of paper shows that the frontier is yet to be demarcated. Let's mark it out at Olivença on our side". The traveller is dying of curiosity to know what would happen if he did so.

Until this glorious day arrives, the traveller will continue on, next climbing the road to Juromenha. Outside the walls of this ancient fortress, effectively destroyed by a terrible explosion in 1659, the village can boast of the white-ness of its houses and the near-clinical cleanliness of its streets. Beneath the round and scorching sun an old man comes forth to offer directions, silhouetted against the wall's white background as though he were merely two-dimensional. There was almost no-one to be seen on the streets, but you could sense that village was as full as an egg.

The traveller goes on to the castle. In fact it's a sea of ruins. At the entrance

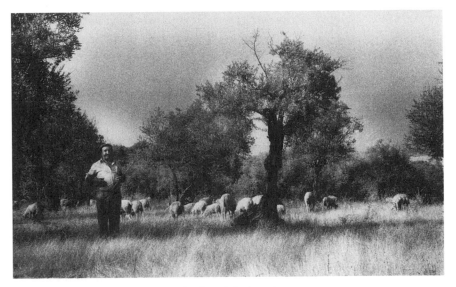

64 Shepherds and flock in olive grove

to its seventeenth-century precinct, underneath the entrance arch, a cow and her calf are patiently (or obligatorily) ruminating over what they've already digested. Once inside, you can spot the places where people once lived: a chimney breast, against which the settle where the inhabitants used to sit is now suspended in mid-air. The precinct is spacious and the traveller isn't going to get round it all. Further ruins, the remains of a chapel, probably to Our Lady of Mercy, and others too – more impressive – to Our Lady of Loreto, where a herd of sheep are taking their siesta, unperturbed even by the traveller's untimely arrival. Perhaps it was because at this stage he felt in himself a vast lassitude, a desire to pause, remain immobile, here among the sheep, beneath this once-triumphal arch where other travellers, desirous of immortality, had inscribed their names. Every journey has its end, and Juromenha is no poor place to end this one.

These are fleeting thoughts. The traveller refuses to let himself be hypnotised and, in suffocating heat, crosses the dirt yard covered with loose stones. He carefully looks where he's putting his feet (there can always be treasure underfoot, can't there?) but a smoother and cleaner walk allows you to at least raise your eyes. He had forgotten about the Guadiana and there it is, fresh and magnificent, with its little streams escaping their sources, the final refuge of wildflowers and ducks. The Guadiana bathes its banks in life, without distinction to left and right which, to judge from the map, also

includes where he stands, giving the curious appearance of being a wild river, even when observed from an inhabited vantage point. It is surely the least-known river in all Portugal.

The traveller returns to the main road, heading towards Alandroal, where he pauses only for refreshment. From there he heads south towards Terena. He wants, of all the fortress-churches, to see one that's more fortress than church. So the photographs say, and the confirmation soon lies here before his eyes. If you discounted the left-hand tower you'd be left with a perfectly symmetrical little castle, equipped with spiked battlements and a little balcony that could easily be converted into a barrier, assuming that this weren't in any case its original function.

The sanctuary dedicated to Nossa Senhora da Boa Nova is laid out like a cruciform tower, with equally short, thick and stumpy transepts, although from the inside it appears to gain in height. It's a precious gem of our mediaeval architecture, exceptional for having remained intact: this Gothic church of Boa Nova is set to remain in the traveller's memory. So it remained in his mind and in other people's memories too, for example Afonso X of Castile, who referred to it in the *Cantigas de Santa María*. According to tradition the Boa Nova was built in 1340 on the orders of one of the daughters of the Portuguese King Afonso IV. But Afonso X died in 1284. So is the church of Boa Nova older than anyone has been prepared to let on, or was there an earlier church on the same site? It's a matter that awaits clarification, just like the enigmatic paintings on the ceiling of the high chapel, which at first sight look like an illustration of the *Apocalypse*, yet containing figures with no place in St John's Gospel. The other church transepts contain paintings of more popular hagiography.

When the traveller reached Redondo he was running out of time. He looked at the parish church from the outside, and also at Our Lady of Mercy, within the castle precincts, with its gateways called Revessa and Relogio (Clockhouse). Nothing else. He resisted going to visit the dolmens on the Ossa[18] mountainside, less for fear of the she-bears, who have disappeared into the mists of time, but because of the weather, that was likewise washed up. En route he devoured the most succulent and sumptuous pork chops that had ever passed his lips in his entire life. If Redondo serves everyone this well, it'll never run short of friends.

18. Can translate as female bear.

The Night the World Began

The traveller has reached Évora. Here he finds the famous Giraldo Square with its leaping cavalier or cavalier leaper who, in order to obtain pardon from Afonso Henriques for his crimes and misdemeanours, decided to conquer Évora. He obtained it through skilful dexterity and the Moorish innocence which had left only an old man and his daughter on guard in their fortress who, if the truth were told, weren't on guard at all, but rather were sound asleep when old Sem Pavor[19] beheaded them in a fit of piety. Poor little girl. Amid the racket of this piece of treachery, imagining they were being attacked from across the city, the Moors left the doors to the fortress open through which the other Christians poured, supported by *mouriscos* and *moçárabes*[20], and took prisoners or killed at will. This took place in 1165. The traveller is quite incapable of imagining what sort of place Évora was when Giraldo conquered it. Nor has he a clearer idea of how many Moors were on hand to defend the city. There's now no means of evaluating the relative bravery of the opposing forces but the outcome proved permanent: Évora was never again to return to Islamic hands.

These stories are familiar to everyone from the first grade upwards, and the traveller was not inclined to further inventions. In any case, what more could a humble devotee of prose and kilometres discover in Évora that had not already been discovered, what words could he find that had not already been uttered? That this is the most monumental of all cities? And, if he says so, what is he really saying? That Évora possesses more monuments than any other Portuguese city? And if it doesn't, are those that do to be more highly esteemed than those elsewhere? The apostles on the outside of the Cathedral are magnificent: but are they more or less magnificent than those on the portals of Batalha? Futile questions, a waste of time. But in Évora, it's true, there's an atmosphere impossible to find anywhere else. Évora has definitely History's continual presence on its streets and squares, in every stone or shadow. Évora has succeeded absolutely in defending the past without doing so at the expense of the present. With this happy pronouncement, the traveller feels liberated from other overall judgments, and goes into the Cathedral.

65 *Évora Cathedral*

More spacious churches may exist, even taller and more sumptuous ones. Few have this degree of secluded gravity. Mother church to those in Lisbon and Oporto, it also outdoes them in its own particular individuality and a subtle difference in tone. With every voice stilled, silenced the organs on either side, if you muffle your steps you can hear its deep sonority, nothing less than the vibration of columns and arches, of the infinite geometry created by the alignment of its stone. A religious space, Évora Cathedral is also an entirely human space: the destiny of these stones was dictated by intelligence, this it was that selected them from the ground, giving them shape and feeling, this it was which asked and defined solutions onto a diagram drawn on paper. It's intelligence which raises up the lantern-tower, harmonising the guidelines of the triforium, and composing its sheaves of columns. It could be said that the traveller praises Évora Cathedral to excess, singing praises that could be as valid, or more so, elsewhere as here. So be it. But the traveller,

who has seen much already, has never come across stones so capable of fomenting an exaltation of spirit as these, so confident in the power of intelligence. You can keep Batalha, the Jeronomite Museum and Alcobaça in all its religious fervour. Nobody can deny that these are wonders, but Évora Cathedral, at first sight so impenetrable and severe, received the traveller as if with open arms, and if his first response is an emotional one, the second has to be dialectical.

These are probably not the terms in which to discuss architecture. A specialist would tilt his head, either in condescension or irritation, wishing he could be addressed in more objective language. For example, in speaking of the lantern-tower that "the granite drum is flanked at its corners by a trilobate cornice with low windows, overhung by buttresses and crowned by a narrow slit covered in overlapping scales." There could be nothing more precise and scientific, but aside from what is demanded by the description, in some passages, by way of a parallel explanation, this is not the proper place for it. The risks undergone by the traveller in frequenting heights like these ought to suffice. This is the reason why his inadvertent excursions in these domains are simple and trivial, this the reason why he trusts his faults may be forgiven, those he has committed and those he has yet to commit. He uses his own forms of speech to express his own thinking. Since this is the case, he'll be daring enough to thumb his nose at Ludovice de Mafra who also reached these shores, covering the main chapel with marble and engravings in Joanine style, to create the gravity of a church intended to respond to the spiritual needs of a less magnificent period. If the bust upon the triforium is truly by the Cathedral's first architect, Martim Domingues, the stone from which it was carved must have suffered cruelly in the process.

The traveller leaves in search of the cool shadows around the fringes of the Marquês de Marialva Lake, goes up the short ramp, and having surveyed, with requisite delicacy, the Temple to Diana (who isn't and never was Diana, its name being due to the inventive Father Fialho) he heads for the museum. He goes there thoughtfully, as ever befits a traveller, contemplating the fortunes of certain human constructions: they relish their period of splendour, then decay and perish, in a few instances to be rescued at the very last minute. So it was with this Roman temple: destroyed in the fifth century by northern barbarians who arrived in the peninsula, it served, in the Middle Ages, as the castle strongroom and so it remains, its parallel columns lodged into a solid wall, before ending up as the town's main abattoir. In the 1383 revolution it was occupied by labourers in insurrection against supporters of

66 Évora, temple of Diana

Queen Leonor Teles, and from the battlemented terrace it once boasted they attacked the Castle by firing flurries of arrows until the point of surrender was reached. Thus is it recorded in the honourable words of Fernão Lopes. It was only in 1871 that the Roman temple recovered its looks, as first conceived and as far as was possible. But the traveller still goes on his way thinking well of those partisans of the Master of Avis who, in order to shelter from the projectiles showered down on them from the castle, could count on nothing more than what little was afforded beneath the temple's columns: not one of them escaped. And if not one escaped, they could not have seized the fortress and if they didn't seize it, who knows what would have happened next? It's highly likely that, given such reductive logic, we'll soon end up losing at Aljubarrota.

This museum has to be the most disloyal institution the traveller has come across. It demands to be visited, giving the impression that to pass it by would be a grave cultural stain on one's conscience, then once we're trapped inside, like disciples approaching the Master, rather than instructing us with moderation and high standards, it throws a couple of hundred masterpieces in our faces, two thousand works of merit, and an acceptable quantity of middling value. Évora Museum isn't all that rich, but it has more than enough for one day, already far more time than the traveller can afford. So what is

he to do? Slip through the Roman sculpture like a cat on hot bricks, and if he delays longer in the mediaeval section, it's because here recline the statues of Fernão Gonçalvez Cogominho and the three bishops, but there's nothing he eschews that doesn't give his conscience cause for concern. He behaved somewhat better in the Renaissance hall, where he again met up with the prodigious Nicolas de Chanterenne in the tombs of Álvaro da Costa, royal chamberlain to King Manuel, and to Bishop Afonso of Portugal; this being arguably his best work, as those in the know maintain. Then there are also the magnificent pillars of the Convent of Paradise. There's no way of elucidating the great beauty of the works in Nicolas de Chanterenne's so-called Alentejano cycle other than by invoking his particular use of marble, permitting the greatest precision, deftness and finesse in its handling. This may well be, for there exists sufficient material of the highest degree of perfection, easily sufficient to teach an artist how to work it.

It's possible that the best of Évora Museum is its paintings. This being so, to have in addition sculpture like this is its great good fortune. It needs to be recognised, above all, that only rarely in a national museum do you come across friezes like the thirteen panels which together compose a cycle of "The Life of the Virgin". Although by a variety of hands, reflecting the influence of diverse sources (objectively it's simple enough to enumerate the stylistic characteristics of Gerard David, Hugo van der Goes and Roger van der Weyden) these panels, which the aforementioned Bishop Afonso of Portugal commissioned in Flanders, stand out by the rigour of their draughtsmanship and their richness of colour. Although at a later period the greater artistic integrity represented by the artist who painted the Virgin as Our Lady in Glory was noticeable: of opulent composition, it shows musician-angels and singers playing and singing in unison, while four more angels hold a crown over the Virgin's head. All the panels are anonymous. In those days workshops run by great masters were populated by great artists: they fulfilled their daily chores by painting the background landscape for each of the pictures; then the architecture and clothes or the greater or lesser amounts of flora and fauna demanded by the subject; occasionally the faces of secondary characters; and then came the master with his giant's finger pointing out where to touch it up here, retouch there, correct something else and, when the work was judged worthy of being seen, he'd set it free to pursue its destiny. Who was the artist, who made the painting? No-one knows. When many hands are involved, a viewer has eyes only for the work.

Nearby is the church of Lóios. You just follow the steps down from the

main door to get into the church, which is Gothic-Manueline. Since Masses are no longer celebrated there, there's a certain coldness in the atmosphere, on this occasion exacerbated by the eighteenth-century tiles. This church was exceedingly well chosen by whoever wished to create a good impression after their death: there are headstones of rare beauty in it, and in the adjacent museum there are two bronze lutes, Flemish work of the fifteenth century, astounding in their chiselled handiwork, capable of reproducing and projecting a meticulous flamboyant Gothic in which your gaze becomes lost.

The traveller did not enter the Palace of the Dukes of Basto, once the seat for the Order of the Knights of St Bento de Calatrava. But he admired its walls, set into the Roman-Visigoth city walls, admitting to between fifteen and seventeen centuries but preserving an air derived from the first flush of youth. The whole world finds the idea of old stones supporting new ones entirely natural, but there's no lack of those who smile at those who'd like to know the origins of gestures and attitudes, of the ideas and convictions of the anonymous passer-by who passed by that way, or of this traveller who's here now. Such people are deeply convinced that Minerva literally sprang fully-formed and armed from the brow of Jupiter, without passing through the miseries and blessings of childhood or the mistakes and adventures of learning.

Along the road of his choice, there's the Institute on his left, founded as a university and now returned to its original role. With its light and airy arches, its cloister has something of a rural feel to it. The central form of the ancient chapel that became the Sala dos Actos fights with the surrounding arcades but is, taken alone, among the most harmonious façades bequeathed to us by the first phase of Baroque.

Were the sun less piercing, perhaps the traveller might have stayed in Portas de Moura Square for hours. Here the arcades offer plenty of shade, but what the traveller most fancied was to go to the upper level, from where the Cordovis fountain and belvedere can be seen, and on to the lower level, where he would view the fountain and Cathedral turrets. It may seem no great matter to someone who has seen so much, but despite everything this square, in its simple humility, is (if you allow for the sun that falls like lead) a soothing spot so evenly toned, so clear and tranquil. The traveller approaches to read the inscription on the great Renaissance sphere: "Anno 1556" and is surprised to encounter proof that there are people who do not age. But the heat is, in truth, unbearable. Let us enter the Church of Mercy, to savour its fresh benevolence, and savour somewhat less its tiled panels representing works of spiritual mercy: of conventional manufacture,

67 Évora, market arcades

they serve to support specific injunctions as firmly as a panel or canvas, with consequences as unconvincing as the transference of a painting to a carpet. But at least the temperature is comfortable, and the screen in the main chapel, thanks to an excess of decoration, sacrifices the acknowledged resistance of the traveller to the artifices of the workshop.

Here are the *Meninos da Graça* [Children of Grace]. They're called 'little children' out of affection, for the giants seated atop the pillars would infuse only terror, were they not up so high. The church of Nossa Senhora da Graça, the traveller observed, had earlier fallen to ruins, its floor of disturbed earth home to old stones and old bones. Now it's in a prime state of restoration, its flagstones re-set, the floor recovered, the old bones gathered up and thrown onto the rubbish tip and all the rest redecorated. The traveller

finds it better like this but cannot forget the way it looked before. The giants still remain the same, they look as if they could have been sculpted by Michelangelo, and the beautiful rosettes likewise resist the ravages of time. To the traveller this church, by dint of its radical difference from the more familiar religious buildings of its epoch, has a certain enigmatic air, as if the rites there celebrated had more to do with pagan sects than with any orthodox religion.

The traveller reached the church of St Francis with no strength left at all. The streets of Évora are a desert, you'd only walk them if you really had to. The sun beats down, the heat feels as if it were exhaled from the mouth of a stove. How must it be in the open country? The traveller's not about to waste time in finding out, for he's still much ground to cover today, but first he has to cover the ground beneath St Francis' great nave, gazing at paintings attributed to García Fernandes; an eighteenth-century St Bruno attributed to Cartuxa; and also, if you like and it appeals to you, you can indulge a morbid fancy for a Franciscan mortification of the flesh by visiting the Chapel of Bones to find, contrary to what you'd expect, that its architectural ranging of human bones, which ultimately lose their connection with human feeling, verges on obscenity. The traveller has seen them previously and so feels no need to visit them again today. He cannot forgive the Franciscan friars that image of prevalent disorder in the chapel, bones scattered at random and dragged from communal graves (while those of the gentry rested beneath good embossed headstones), whilst the above-mentioned friars, their sleeves rolled, went about looking for a tibia to fit into this hole here, a rib to fit over an arch there, a skull to round off the effect. No and again No. You bones, where you lie, why did you never rebel?

Let's go and get some air, though there's not much to be had, in the Galería das Damas do Palácio de Dom Manuel. We'll profit from some shade to regain our strength. The traveller sees the hermitage of St Brás at a distance, its colour that of sliced bread, a Moorish fortress with buttresses and sentry boxes, a wide porch, nobody would think of describing it as a church were it not for the belfry at the back. It's time to leave. This may be the hottest hour of the day, but so be it. The traveller has already eaten in the Praça Luís de Camões in Porta Nova, so he takes one more turn about the town, crossing the Travessa da Caraça, past García de Resende's window, the aqueduct and the gateway named after Queen Isabel. Still at least half of Évora remains to be seen, while the half he did see was only sketchily taken in. What most impresses the traveller, if you'll forgive him his obsession, is that all he saw (leaving aside the city walls and the Roman temple) didn't exist at all

in Sem Pavor's day, nor even during the 1383 insurrection. The traveller
discovers it all came down to luck: someone-or-other had conquered a fine
space for the construction of Évora, someone had raised it up and defended
it, someone had fought for things to be the way they were and no other
way, and all in order for it all to be properly regulated both artistically and
functionally.

There's not so much as a breeze; were there one it would only make matters
worse. The traveller crosses the plain which extends as far as the banks of the
River Degebe, and beyond it, to the heights of Monsaraz. Before he reached
Reguengos he suddenly awoke from the torpor into which he'd fallen, to
see a road sign indicating that nearby there lay a village called Caridade
[Charity]. The name attracts him, even though it wasn't in his plans to deviate
– of course a traveller cannot keep stopping off here, there and everywhere –
but a name like that deserves at least a detour. It's a village decked in white,
superwhite and extra-white (the heat is causing the traveller to lose his
command of vocabulary) and into all this whiteness, under the scorching
sun, a woman dressed in black is throwing a fresh bucket of whitewash over
the walls of her house, for this passion for white lies deep in the souls of these
dark-skinned people, tinted by sun and sweat. Caridade church is rustic in
style with a violet skirting, a source of amazement to the traveller. This
Caridade existed, with a river of the same name running beside it, and the
traveller never knew it. Aye, what a man could miss in the course of a lifetime,
and not even know it!

There's no cause to stop in Reguengos de Monsaraz. Just enough time for a
cooling drink, with another to follow, then on down the road again. Ever
onwards, between the road and the riverbank of the Pega, lie the remains of
dolmens invaded by brambles among which no plough has penetrated. The
thrumming of the crickets reverberates aggressively. In this heat the poor little
beasts lose all control of their wings, just as the traveller lost his control of
words in Caridade. Who knows if ants' historic obstinacy doesn't derive from
having spent entire summers subjected to this constant sawing in the air?

In any case, every cloud still has its silver lining. The heat keeps the villagers
indoors, all those who aren't working far away, and the traveller has the
run of the streets as though he were in a derelict village. All well and
good but, to give a sense of balance, it also has its bad side: there's nobody
around to talk to. From the main square the traveller can contemplate
discreet and pretty houses, some of them uninhabited, acquired by people
with money who live a long way away; he can survey their façades rather
than their interiors, then lapse into regret that, after all, Monsaraz amounts

to little more than a façade. But perhaps the traveller does it an injustice: some must have grown up, body and soul, within these castle walls, these steep alleys, in the fresh or freezing shade of these uncomfortable houses. In Monsaraz, whether you are a native or an incomer, you live either in- or outdoors, often escaping from the tastes and bad habits of the big city; or maybe you know less of this than you do of the harshness of lives whose horizons extend no further than the eye can see.

Chastised by the sun, the traveller sought out someone to open up the parish church for him. From within, the building defies all expectation: quadrangular, it has three equal naves separated by enormously thick columns constructed of great wheels of stone. Its ambience and its state of erosion make it appear much older than it actually is: a mere four centuries. Here you can find a fine thirteenth-century sepulchre belonging to Gomes Martins, Procurator General to Queen Beatriz, wife to Afonso III. It illustrates scenes of falconry and funeral dirges for the deceased, with a kind of tragic realism only further accentuated by its crude imagery.

From here the traveller went on to visit the fifteenth-century fresco showing the just and the venal judges, painted in large planes of colour, then drawn so deftly as to look engraved. There's a surprising modernity about this wall which time has not tarnished, evidently assisted by men's ignorance and lack of care. Not that the traveller takes his hints of modernity from what has most recently surfaced in a certain pseudo-mediaevalism practised in Portugal to no very good result.

The plain descends from the fortified knoll at Monsaraz. One might call it out-of-this-world. The riverbeds are currents of stone, burnt and scorched again by the sun. One comes to doubt that these channels ever contained water, and now it seems the remotest of possibilities that there could be even the merest promise of water. Even after following its path the traveller, if he were squeezed, would fail to produce a single drop. So on he goes, once more in a stupor, on the point of cursing his journey to the devil, when suddenly a river appears before him. It's a hallucination, the traveller sceptically tells himself, knowing full well that deserts generate mirages: a well for those who are dying of thirst, an oasis for those dreaming of shade. Just in case, he consults his map, to check whether a stream of water is still to be found in this neighbourhood. Here it lies: the Guadiana! It was the very same Guadiana that he'd been shown in Juromenha in an untamed state and that he'd later abandoned. Friendly Guadiana, delicious Guadiana, river born in paradise! What would any traveller do, and what did this one do? At the first place where it was no more than a simple matter to get from the road to the

river he climbed down, stripped off in seconds and in a few moments more was in the clear cold water, though it seemed impossible that water could get so cold. For longer than the traveller had to spare he indulged himself in its limpid currents, swimming amid the glitter which the sun sparked from its watery surface, so happy a traveller, so satisfied with both sun and river, that all three united in a single delight. But, while evil never ceases, no good lasts forever: he leaves the water like a Triton scorned by the nymphs and, heartbroken, wetly puts his crumpled clothes back on, still damp with sweat.

Close by the bridge where the road joins the one coming from Reguengos, boys and girls are busily bathing. They laugh, the wretches, splashing each other. There ought to be a law against it: the traveller senses the soul of Nero rise up inside him and is on the point of committing a crime. Finally, the feeling passes. He waves to the swimmers from the bridge, may the gods keep the river safe forever, and may all of you keep your youth for as long as can be.

Mourão does not have great things to offer. All in all, the traveller decided to proceed rapidly to the castle, which encloses the parish church, but both were shut and nothing outside promised great wonders within. Yet this was not sufficient reason no longer to encounter things of beauty: here the chimneys began, round and with conical tops. They are found almost nowhere but around these parts, ever the same yet never monotonous, their whitewashed faces forever reflecting the chromatic scale acquired by white-ness in a play of low or intermittent light, in the hard shadows or the soft twilight of a corner only touched by the light after a thousand fractures – for even this is indeed possible on an afternoon as stark as this.

This was the countryside the traveller was ruminating over as he continued southwards: it has no need of heat to prove suffocating. Between Mourão and Póvoa, Póvoa and Moura, and on either side of the road, cornfields extend their infinite palid yellow – almost white where footfalls part the corn and allow its white lining to gleam forth – until the vision began to swivel like a kaleidoscope. To stare fixedly for minutes on end at all that corn ripe for scything is to topple into a gentle vertigo, a kind of hypnosis both offered and received, approaching ecstasy.

In Moura, with its beautiful square, much more of a reception room than a corridor to pass through, the traveller felt the first breeze of the day. Still timid, it was quick to rue its daring on a day reserved for Lord Sun, but thanks to it he could summon up his courage to go to the castle and leap over its many and varied ruins. It's a setting fit for noble drama, for decadent or terrible sword duels under the full moon. The traveller, now speaking in

all seriousness, is surprised by the distance characters in Portuguese cinema have in relation to the natural scenery which we have in abundance, enough to satisfy every taste and need.

Whether or not this sentence was thought or spoken, he returned to the square, seeing from the outside the beautiful trefoiled doorway of the parish church, with its canopied arch reminiscent, or once reminiscent, of the gateway into Penamacor, also the highly non-ecclesiastical and courtly canopied balcony with its Ionic columns and wrought iron. The master stonemason, Cristóvão de Almeida, doubtless had a taste for this type of work, just as the abbot who admitted so much that was worldly into his church had a taste for palaces.

The evening is drawing in, subtly refreshing if it's possible to speak of freshness at all, although the trees lining the road help, the landscape shifting a little with the rippling in the hills, and the traveller starts inhaling deeply and pleasurably. But before he gets to Pias, at the bottom of a slope two Republican Guards are demanding identity papers from anyone coming through, something commonplace enough, while close at hand there's a lorry carrying still more Guards, which is something out of the ordinary. The traveller demonstrated that his hands were not stained with blood and was allowed to pass. In Pias, with people on the streets once more, he asked the way to the parish church. He wanted to see the screen showing Martim Moniz crushed by the door of St George's castle. But the church was shut, which turned out to be a matter of poetic justice: a person sacrificed of his own volition, that those yet to come may live and flourish, is not lacking today. And in these very lands.

The traveller is going to sleep right here in São Gens, near Serpa. Close behind it is the Hermitage of Our Lady of Guadalupe. What there is to be seen can be viewed from outside. It's quite unlike the landscape extending further and further out of the traveller's sight, demanding to be seen from within. It covers a distance of levelled trees and hills, little hillocks easily confused with the plains. The sun has set but the light is not yet gone. The countryside is bathed in gilded ash until the gold pales and the night slowly invades from the far side of the sky, as the stars light up. The moon will arrive later, and the owls are calling to one another. The traveller feels like crying at what he sees. Perhaps it's his own pain he feels, a disgust at being unable to express in words what that landscape is. He can barely frame the words: this is a night on which the world could begin.

19. The conquest of Évora [1165] is inseparably linked to the name of Giraldo Sem Pavor [Gerald the Fearless], a knight of the nobility in the service of King Afonso Henriques, who lost royal favour when he joined a gang of mounted thieves who robbed Portuguese and Infidel impartially. To regain royal favour he and five of his fellow gangsters assaulted a fortress in the city of Évora, killing the watchman and the daughter there with him. Thus this legendary knight vanquished perhaps the most important of Muslim cities.

20. Mouriscos are the Moslem converts to Christianity (many of them forced) and particularly of the fifteenth and sixteenth centuries. Moçárabes are subject Moors, sometimes of mixed Arab/European race.

Looking and Leaping

When the traveller awoke and opened the bedroom window, the world had been created. It was early, the sun was not yet up. Nowhere could be more calmly beautiful, nobody could be happier with such simple things as the broad earth, the trees, silence. The traveller, who has seen many things, appreciates these to the full, and waits for the sunrise. He experienced it all: the light gradually changing, the first shadows being created, the first birdsong, and he was the first to hear a woman's voice calling these simple words out of the darkness: "It's going to be another hot day." Prophetic words, as the traveller was later to learn to his cost.

A detour via Serpa did not produce much of interest: the Renaissance portal of the former leper hospital of Santo André, nowadays known as the church of Nossa Senhora da Saúde, the walls of the fortress and its giant, ruined tower. The best of the village were the ordinary houses, built solid and white, like whitewashed arms embracing the streets, moonlight that has impregnated the walls and never fades. The traveller finds someone to ask what road he has to take to get to Pulo do Lobo. The traveller is still an innocent. He's thought this many times before, but today he gets the proof. The man he asks, a calm man with a slow drawl, explains how to get there, then wants to know: "Are you going in that car?" It's still too early for the traveller to grasp the meaning of such a question, and he thinks it's just an insult. So he replies curtly: "Yes, in that car, thank you." The man shakes his head pityingly, and moves off.

As far as São Brás, the road is a good companion. The traveller crosses a wide empty plain, a landscape of low knolls, like a choppy sea, with one or two clumps of trees suggesting wooded hills that are invisible from the road. There isn't even the tip of a chimney to be seen. There are a couple of kilometres of reasonable road, then the torture begins: the surface becomes a skating rink of loose stones, full of potholes and uneven patches. The traveller has been through this kind of thing before, but this time the chaos goes on and on, and worst of all is the feeling of complete isolation: there are no houses, the fields look as if they have not changed in the past thousand years,

the grassy knolls line up as though to watch if the traveller skids, goes off the road or simply gives up. The traveller grits his teeth, imagines he's as light as a feather in order to spare the car's suffering suspension, breathes a sigh of relief when finally he comes across a stretch of smooth road, and accepts the challenge of this unknown planet.

But still he almost gives up. There's a steep hill down, with a sharp left turn at the bottom, as if the road were suddenly cut short. The descent is so steep that pebbles shoot from under the car and roll off over the side of a rocky valley at the bottom of which a strip of green announces the presence of water. The traveller is seriously worried, and thinks of going back, but how? It's impossible for him even to turn round here. As long as the road doesn't really come to an end, he has to follow it. The traveller pushes cautiously on. A snail would go faster. And finally there's the corner, almost a right

angle. Down below there's a stream and next to it two men and a boy are looking up at him in amazement. He goes over and asks: "Good morning. Is this the River Guadiana?" He knows very well it isn't. But he is asking the question as if trying to break a spell. "No, sir. This is the River Limas." "And is Pulo do Lobo far?" "About three kilometres," says the elder of the two men. "How is the road?" "No worse than up to here. There's a bit more with stones, then it gets better. I bet it made you sweat so far, didn't it?" The traveller tries to smile, but it's more of a grimace. "Don't remind me of it. So where is Pulo do Lobo?" "Carry straight on, go past two small hamlets, then down a steep hill; when you see an oak tree, take the right-hand road, from then on you can't go wrong."

The traveller crosses the stones of the river bed, which is almost dry in this

69 *R. Guadiana, Pulo do Lobo*

season (but what must it be like in winter?). The road starts to climb again; the traveller tries not to think of all the stones – in for a penny, in for a pound – but can't see the farmhouses, or the tree, or the dirt road that is supposed to take him to this accursed Pulo do Lobo. If the traveller had an ounce of common sense, he would turn back, but he is stubborn, obstinate, he's got his teeth into this idea and he won't let it go; nothing can make him change his mind. And finally the desert comes to an end. There's the first group of houses, then the second, although there's not a soul to be seen, then further on is the oak tree, the turning off to the right. The road is a sheer delight. It stays up above all the hillocks, never descends into the valleys, rounds a broad bend and ends at a ruined farmhouse. From here on it is no more than a track, with the marks of tractor wheels. The traveller gets out of his car and starts to walk down it. He's happy again. Pulo do Lobo must be down here somewhere, even if he can't see it, and just to get this far is no mean feat.

All of a sudden, as if a curtain were being drawn back, he sees the Guadiana. The Guadiana? On this side, a narrow thread of water with white rapids looks as if it is a river. But not this huge jumble of rocks to the left, which looks like a dreadful scar in nature, and where signs of white foam sparkle here and there. This is not Portugal, it's something from another world, like a huge meteorite that fell to earth and in so doing split in two to let the water come gushing out. The rock is so cindered, so rugged and with such jagged edges that not a blade of grass can grow on it. The river boils in between these iron walls; the waters roar, froth, beat, swirl around, and eat away perhaps a millimetre every century, or every thousand years, a mere nothing in this eternity: the world will come to an end before the water has completed its task. The traveller is in a state of utter bewilderment. He has forgotten the dangers of the route, the hot and cold sweats, the fear of an accident, the way the man in Serpa shook his head. And he asks himself: "How can this be in Portugal and so few people know about it, and still fewer come to see it?" It's going to be hard for him to leave here. He goes back not once but twice, as if he had continued on his journey and was coming back to visit here after a year or two. This is Pulo do Lobo. The gap between the two rock faces is so narrow that a hunted animal could well have leapt from one side to the other. As the name indicates, it was said to be a wolf. And it escaped. That is how the traveller feels too: to have reached here, to have seen these amazing rocks, this deep wound in the flesh of stone, is a kind of liberation. When finally he tears himself away, not even the road seems so bad. Perhaps it is no more than the necessary ordeal to sort out those worthy of reaching such a marvellous place from those who are not.

When he gets back to Serpa, the traveller has to make a great effort to get used to the world of ordinary mortals once more. On the road out towards Beja he admires the abandoned chapel to St Sebastian, with its beautiful mixture of Manueline and Moorish styles. A mixture, he thinks, that would be better called a symbiosis, because the two are combined in a living, vital way. But it can't have been so vital, the voice of reason tells him, because this particular style never spread beyond the Alentejo, nor did it last for very long. Yes it can, his intuition replies, because all civil architecture – houses, chimneys, porches – betrays the signs of where it has come from: Arabic methods of building, which lasted far beyond the Reconquest, and those Gothic ideas that were added to them at a later stage.

The traveller is lost in this kind of musing, when suddenly the River Guadiana appears before him again, this time broad and peaceful. The two of them are playing hide-and-seek, to show how much they care for each other. As he crosses a bridge, the traveller thinks how much he would like one day to travel down the river in a boat from Juromenha in its upper reaches as far as its estuary. Perhaps the idea will remain no more than that, perhaps one day he will suddenly decide to launch himself on the adventure. He has a mental image of the Pulo do Lobo, hears the water gushing through the rocks, the possibility of death. From now on, the traveller will look at himself with a slightly sceptical, mocking air: come on, let's see if you're up to it.

Soon he comes across a sign pointing off to Baleizão. There does not seem anything special about it, but the traveller mutters to himself: "Ah, Baleizão, Baleizão," and sets off towards it. He does not intend to stop in the village, or to speak to anyone. He simply wants to pass through. Anyone seeing him would think: "Look, a tourist." That could not be further from the truth. The traveller takes a deep breath in Baleizão, drives between two lines of houses, and on the way picks out a man's face, then a woman's, and if when he emerges on the far side of the village there is no sign of any transformation in him, that is because when he has to, a man can hide almost anything.

He is soon in Beja. Built on its hill (and in these flat lands, to call something a hill does not mean anything very grandiose) the ancient Roman Pax Julia does not seem so steeped in time. It is true that there are remains from Roman times, and others from before and afterwards, like the Visigoth ruins, but the layout of the town, the way things have been torn down or built up, the neglect and yet again sheer ignorance, make it seem at first sight no different from others with little or no history. One has to dig for it: the castle, the church of Santa María, the church of the Misericordia, the museum all bear traces of the passage of history through Pax Julia (which the Arabs, who

had no Latin, called Baju, which then became Baja, and finally Beja).

The traveller heads first for the church of Santa María. The interior leaves him indifferent: three naves in classical style, a curious *Tree of Jesse*, but not much else. It is from outside that Santa María can be seen to the best effect: its three frontal arches, gleaming white as befits a building in this Transtagano land, the capitals left in their natural stone colour, with the cupola rising from them. This view keeps the promise that the interior failed to fulfil: but everyone who goes in somewhere and is disappointed has to come out again, and will then cheer up.

To continue in the same vein, the traveller would say that the castle left him cold as well. But he must admit that the magnificent keep is worthy of praise. If he sang praises in Estremoz, all the more reason to do so here. Of all the rooms inside, the traveller would take with him, if he could, the main hall, with its vaulted ceiling painted with stars. This clearly shows that Christian architects understood that a style and a technique which had originated with the Moors and had deep cultural roots in the region could still be used successfully. Which just shows how crazy it was to ignore them later.

For Pax Julia to end up as Beja, after defeating the Moors for pronunciation, is one thing. But for an abattoir to end up as a church is something else altogether. Then again, necessity always triumphs in the end. Whereas in Évora the Roman temple became an abattoir, here in Beja the building was thought to be too beautiful to leave to the butchers, and on the same spot where they sacrificed cattle to the appetites of the body, they decided to construct a place where the sacrifice of the Lamb of God could be celebrated for the salvation of the soul. The paths trodden by men are only complicated at first sight. When we look more closely, we can see traces of earlier feet, analogies, contradictions that have been resolved or may be resolved at some future date, places where suddenly languages are spoken in common and become universal. The columns of the Misericordia church show a perfect adaptation (understood in the sense of a collective local appropriation) of the Renaissance architectural style seen as being compatible with earlier regional styles.

The traveller would like to see the Visigoth capitals in the church of St Amaro, but on this occasion could not face the search for the miraculous key. Perhaps he was wrong. It might have been easy to find, but if he has had problems even in the smallest village, what might it be like in a town of this size, busy with its own concerns. So the traveller chose the safer option of going to see the museum.

The museum in Beja is regional and is right to claim nothing more than

that. Its chief merit is that all its exhibits are local or were dug up in the region, which makes them doubly from here. The museum occupies what used to be the Convento da Nossa Senhora da Conceição, or to be more precise, all that is left of it: the church, the cloister and the chapterhouse. This is where Mariana Alcoforado breathed the sighs of her carnal passion. She was perfectly right to do so: no-one should expect to shut up a woman within the four walls of a convent to moulder away and not have her rebel. But what the traveller doubts is her famous love letters:[21] can they really be written by a Portuguese hand, and from a convent? They show a command of sophisticated rhetoric that seems beyond the reach of a girl born in these harsh lands, however well-off her family may have been in spiritual or worldly possessions. Be that as it may, the great love that Mariana Alcoforado felt – if she really was the author of the famous Portuguese letters – did not shorten her life in any way: eighty-three years she spent in this vale of tears, more than sixty of them in this convent. If we compare that to the average lifespan of people in her time, we can see what a headstart she got in paradise.

The traveller does not intend to give a description of the museum. He wishes simply to mention those exhibits that stayed in his mind (and there are many reasons, not all of them objective, for why something stays in our mind), for example the silver litters to carry the two St Johns – the Baptist and the Evangelist – heavy enough to wear out two sets of bearers. He detects a rivalry between the two saints to see which could be the richer and more popular, which could attract more prayers. These litters did not exist in the time of Mariana, so the traveller cannot imagine the passionate sister inventing celestial messages to advance her earthly loves, but he has no doubt that other nuns, on seeing these rich and sensual objects, called for divine protection as soon as the saints stepped up to their sumptuous thrones.

The chapterhouse is well proportioned, has an exquisitely painted ceiling, and a collection of decorative tiles equalled only by that in Sintra. Some are Moorish ones from Seville, a sort of Gothic brocade; others, also from Seville, are carpet tiles; still others show the influence of Valencia and are smooth, with blues and greens of a coppery hue. What is especially note-worthy is the way that all these different styles sit harmoniously together in this one room, although the patterns, the colours used, and the age they were made in – the fifteenth or sixteenth centuries – are so varied. The overall effect of their design is one of complete unity. The traveller, who sometimes finds it hard to match his shirt and trousers, feels humble faced with this lesson in fusion.

Next he goes to look at the paintings, which are suprisingly good and very

little known. The one exception to this is of course the St Vincent by the Master of Sardoal or his school. It is no exaggeration to say that this is a masterpiece which any foreign museum would put on a pedestal of fame. We here in Portugal are so spoilt for choice, and spend all our time quaffing champagne, that we have no time for such things. Beja meanwhile keeps the secret of its St Vincent, and a rich secret it is. There are many more things the traveller could mention, but he will merely point out the Ribera paintings: the St Barbara, the wonderfully powerful Christ by Arellano, the impressive "Flagellation" and above all, though not so much for its artistic merit as for the involuntary humour it displays, the "Birth of St John the Baptist". The familiarity with which the scene is treated, the huddle of people and angels crowding round the newborn baby, while in the background, still in her bed, St Anne is busy drawing up the child's birth certificate, all make the traveller smile with pure delight. It gives him excellent provisions for the next stage of his journey.

But the itinerary he is following seems like that of someone lost. From Pulo do Lobo to Beja he was heading northwest, and now he is aiming due north, to visit first of all Vidigueira and then Portel. Yet he finds whatever he is looking for, and if he asks for directions, always learns how to get there; so he is a lost person who has managed to find himself.

Vidigueira means Vasco da Gama and white wine, with apologies to all those purists who find this linking of history and wine inadmissible. The Admiral of the Indies' bones have been taken to Belém in Lisbon. All that is left from his time is the Clock Tower, where even today one can hear the bronze bell he had cast, four years before his death in 1524 in the distant land of Cochin. The white wine is still going strong, and is sure to outlast the traveller.

North from the top of the Mendro hills is the district of Évora. Portel is a few kilometres further on. Its narrow twisting streets are charming, with their wrought-iron balconies. It also has some Gothic and Manueline portals, and a few ancient buildings, like the Açougues, with its coat of arms, and the church of the Misericórdia where in addition to the opulent platform for the Easter Week processions, there is a wooden sculpture of Christ from the fifteenth century that is a good example of Gothic carving. The traveller went up to the castle to see its stones and the view of the world to be had from there. He was fully rewarded by the views: the battlements of the keep look out over the land and it seems as if by stretching out your arm you could touch the horizon. That is the characteristic of the Alentejo: it hides nothing, but immediately shows all it has to offer. The castle is octagonal in

shape, encircled by two rows of walls; some of its round towers date back to the thirteenth century and the days of Dom Manuel I. There are traces of a palace belonging to the Dukes of Braganza, and of a chapel, though it takes a trained eye to find them. Those who do know about these things recognise the hand of Francisco de Arruda, who was the architect and overseer of the building of the walls.

The traveller likes names, and has a perfect right to do so. Since there is no reason for him to stop in Oriola, a small village on the way to Viana do Alentejo, he contents himself with repeating its Italian-sounding syllables, and wonders if it is linked linguistically to Orihuela in the Valencia region of Spain. And while on the subject of names, he finds it hard to understand why Viana was happy to be simply called "do Alentejo" and rejected the far more picturesque title of Viana-a-par-de-Alvito. Perhaps it should use the even more ancient name of Viana de Fochem, which might help divert visitors to it instead of seeing them all go either north to Évora or south to Beja. It's obvious that Viana cannot compete with the two local capitals, but with its castle, cross, church, chapels and shrine situated in and around the old town and its narrow, whitewashed streets, it has its own powers of attraction for visitors. The castle walls are not very high, signifying either that they have not seen many battles, or a pleasing sense of proportion. If one approaches the castle from the southeast, above the Moorish battlements one can appreciate the geometry of the town church roof, the crenellations and the pinnacles, the buttresses and flying buttresses. To put it simply: a feast for the eyes. The entrance to the castle is on various levels, like terraces. In the shade of some trees on one of these levels, out of the burning sun, two boys and two girls are busy discussing their studies, what they have already done, what is still to be faced. It's obviously a serious business.

The traveller goes and fetches the church key. On his return, the youngsters are still talking, this time about exams. How youth is made to suffer! The interior of the church is fascinating for the sense of space it gives: the ribbed ceiling is held up on thick, well-made octagonal pillars, and the three naves are divided into five broad sections, each with a perfect arch. The choir, both in its open design and in the way it is integrated into the main body of the church (it occupies the first of the five sections) is not as distant and cut off as these places usually tend to be. On the contrary, it almost invites one to climb up and down it, as if it were somewhere to observe all the services and ceremonies from. The traveller climbed up and down, as happy as a schoolboy who's finished all his exams. As he leaves the church, he admires the richly decorated Manueline portal and its intricate arch, the

royal emblems (coat of arms with its diamonds, Christ's cross, and spheres) amid scrolls of vegetation and human figures: this partly concealed portal is a perfect lesson on how to achieve a hybrid ornamental style.

Now it's time for the traveller to complete the loop he began in Beja. He is headed for Alvito, but beforehand wants to pay a visit to the Quinta da Água de Peixes, a fourteenth-century palace modified in the early years of the reign of Dom Manuel I by Moorish or Jewish craftsmen possibly expelled from Spain after the conquest of Granada. The entrance porch is very beautiful, supported on fine stone columns, and with a rectangular roof whose rear side is less sloping than the others, which introduces a pleasant sense of asymmetry. The corner balcony has delicate Moorish ornamentation which makes the traveller sigh with content.

Alvito was preparing for a fiesta. There was no-one in the streets, but a loudspeaker was booming out to the four winds a song with a Spanish title sung in English by a pair of Swedish women. Down below the town is the castle, or fortified manor house, of a kind unusual in Portugal – round corner towers, tall windowless walls. For some reason, its gates were shut. The traveller went on to the main square, drank some tepid water from the fountain which only increased his thirst but, lucky man that he is, was soon refreshed because as he entered a nearby street, he looked up and saw its sign: Rua das Manhãs. Oh, blessed land of Alvito, which on a street corner like this can pay homage to all the mornings of the world and of men, take good care that no night falls on you other than the natural one! The traveller is beside himself with joy. And since joy never comes unaccompanied, not only did he have the hilarious experience of mistaking a tax office for a chapel, but then stumbled upon the parish church, which must have been the most wide open and welcoming he has ever seen, its three doors letting in vast swathes of light – which only goes to show, the traveller thinks, that there is no mystery in religion, or if there is, it is not what it is commonly imagined to be. Inside, the traveller found the same octagonal columns as in Viana do Alentejo, and some interesting seventeenth-century tiles showing scenes from the Bible.

The same road leads through Vila Ruiva and Vila Alva to Vila de Frades, where Fialho de Almeida was born. But the artistic jewel here is the Roman villa at São Cucufate, a few kilometres further on in the middle of olive groves and grassy hillocks. A tiny signpost points the way down a dirt track: that must be it. The site is so hidden, the atmosphere so calm, that the traveller feels he is discovering an unknown world. It does not take long to reach the villa. The ruins are enormous. They are spread over a considerable distance,

and the main structure, which has several floors supported on sturdy brick arches, shows what an important place this must have been. Excavations are being carried out, obviously with great scientific care. In an open area that was apparently used as a burial place, large rectangular trenches have been dug, in the bottom of which can be seen a number of skeletons. In mediaeval times the site was turned into a monastery, so the bones are probably those of monks, but surely not the ones that look so small they must have been a child's, or the other one which to judge by the size of the hip bone, must have belonged to a woman.

Ruins are generally melancholy places, but for some reason this one – perhaps because of all the work going on – is a very pleasant spot. It's as though time had been foreshortened: the day before yesterday the Romans were here; yesterday it was the turn of the monks of São Cucufate, today it's the traveller: a slight confusion, and they would all have turned up at the same time.

To one side is a church, presumably built by the monks. It's used now as a shed for the excavation tools, but the roof of the small central nave is still covered with a fresco, some of it in relatively good condition, and to judge by appearances painted much earlier than the usual attribution of the seventeenth or eighteenth centuries. The traveller is no expert, but he disagrees with this dating: he prefers to conjure up the image of a mediaeval monk painting his own Sistine chapel for a poor order in an even poorer country. The empty eyes of the saint stare down at the traveller, whispering a question that is not asked out loud: "How are things out there, after all these centuries?"

Out here, dusk is falling. In some rocks on the hillside there is the mark of a horseshoe. It's said it was St James' horse that made it, as it prepared to leap across the valley and land on the other side. The traveller sees no reason to doubt the story: if a wolf could leap across a gorge in Serpa, why shouldn't a horse jump over St Cucufate?

21. *The Love Letters of a Portuguese Nun*, attributed in fact to the seventeenth-century French diplomat Guilleragues, are published in English by The Harvill Press.

The Italians in Mértola

When the traveller left Beja for a second time, he was not taking by way of provisions the wonderful smile that the birth of St John the Baptist had offered him. But he found sustenance in another Roman villa, at Pisões, refreshed by the geometrical mosaics and the generally relaxed atmosphere of the remains there. This stood him in good stead for the torrid heat he was about to venture into. But the smile he set out with disappeared in just a few kilometres, as fleeting as a snowflake. Only the day before yesterday the traveller was speaking of his astonishment, not to put it more crudely, at the fields of Entre-Murão-e-Moura and Entre-Moura-e-Serpa. So what can he say about the flat lands leading to Castro Verde through Trindade and Albernoa? Oh, all those of you who stretch out on a beach to enjoy the sun, come and see the fields of Albernoa if you really want to know what the sun really is! See how dried up the streams are, at Marzelona, or the River Terges, the tiny, invisible streams that hardly make any impression on the landscape, each as dry as the other. Here you don't need a dictionary to know the meaning of the words heat, thirst, and major landowners. The traveller thought he knew what to expect, but what one sees with one's own eyes is always more than one bargained for.

A hawk glides above the road. It was plummeting down in search of its prey among the bushes when suddenly, with a flap of its wings, it halted its descent, changed course and set off in a new direction the other side of the hills. It is hunting, all alone in the immensity of the sky, all alone in that other burning immensity of the land, a bird of prey, all silk and iron; only those who have not seen you could criticise your ferocity. Go forth and live.

Castro Verde is as green as its name suggests. Perched on a hill, it has more than enough vegetation to soothe the eyes from the harshness of the plain. If the traveller were only concerned with monuments today, it would hardly be worth his while having come so far to see what is here, despite the value of the experience of crossing forty kilometres of scorched earth. The church of the Chagas do Salvador is open, and can show some charming paintings of battle scenes, as well as a panel of tiles, but the parish church, here given the

title royal, is firmly shut. The traveller despairs. He goes in search of the priest, and is told he lives in such and such a place, in a house completely surrounded by vines, and after a couple of false starts, manages to find it, and yes, there are vines. But no priest. The traveller walks round the whole place, even to the bottom of the garden, but there isn't so much as a dog to bark or a cat to hiss at him. Annoyed, he returns to the church, rattles the heavy doors (it's a huge building, and inside there are meant to be panels of tiles showing the battle of Ourique), but does not succeed in moving it to pity. If these things were properly organised, whenever the priest were absent, a guardian angel would appear, fanning himself with his wings, and ask: "What do you want?" To which the traveller would reply: "I've come to see the tiles." And the angel: "Are you a believer?" The traveller, owning up: "No, I'm not. Does it matter – just to see the tiles?" The angel: " No, it doesn't. Come in." And when the priest returned, the angel would tell him: "There was a traveller here who wanted to see the tiles. I let him in. He seemed decent enough." The priest would reply, just to say something: "Was he a believer?" And the angel would say, even though he hated lying: "Yes, he was." In such a world, there would be no tiles showing scenes of battles.

It's strange. As he came across Albernoa he saw a hawk, and now he sees another one, although this time in a cage. The bird has still not got used to the situation, if they ever can do, especially when caught as adults. This one puts its head close to the bars and suddenly lets out a piercing cry, which terrifies the traveller. Castro Verde seems to like birds. Together with the hawk's cage are others containing turtledoves, parakeets, pigeons, half a dozen kinds of bird, all of them in pairs, except for the hawk, still all alone.

The traveller goes and chats with friends, waiting for the events scheduled for the afternoon and evening. There have already been three days of fiestas in honour of St Peter: the band and the rock group have played, the young and those who still want to think of themselves as young have danced, there have been running and bicycle races, the requisite Mass, and now the celebrations are nearing their end. As the scorching sun is finally setting, some steers, wily old beasts who lunge with their eyes open, are to be let loose in the bullring, and we'll see how many of the young men from Castro Verde and Entradas leap into the ring to receive applause and a goring. There's no great danger. The animals are lively and stupid enough in their first charges but gradually they are worn down by all the shouting and the dust, the misses and the tail-pulling, and lunge forward only halfheartedly, stopping as soon as they feel the cape touch the unwieldy arc of their horns. The public, seated in rows on the temporary stands, is not deceived. They shout their

disappointment – the beast is too tired, bring on another one. Everybody is enjoying themselves. The band plays to add a bit of sparkle, the trumpet sounds. A youngster from Entregas sneaks up on the steer from behind, perhaps to give it a slap, but all at once it spins round towards him: the poor boy is paralysed with fear, and by the time he has recovered, he's flying through the air, stuck on the tip of a horn. He's lucky though, because after being tossed onto the animal's back, he lands on his feet in front of it again, and is knocked about in a way rarely seen even here in the Baixo Alentejo. Five hundred people burst out laughing, they're not taken in by this either. Finally the boy gets a big round of applause, and the band strikes up a *paso doble*. The traveller, who forty years earlier had had his own experience with a steer that chose him as target, knows what these passing moments of glory are like. But then again, they're as sweet as any others.

That evening there is a festival of songs from the Alentejo; seven or eight groups from the region are competing. They sing of the hours and the days, of love and landscapes. Two thousand people sit watching them silently in the dark, applauding only at the end of each song, or when a new group comes on – though in this case, the applause is very discreet, as everyone knows that the clapping should only start when the men come forward to sing, with that slow, swinging movement of their legs that makes it seem as though they are going to land in exactly the same place as they started, though they do in fact advance. The tenor starts off the melody, the counter-tenor takes it up, then the choir comes in, a solid mass of bodies, filling every corner of the square and singing with all their hearts. The traveller has a lump in his throat, he couldn't sing even if asked to, he's more likely to put his face in his hands to hide his tears.

He spent the night in Castro Verde, and dreamt of a choir of angels without wings, dressed as farmhands, singing with rough country voices while the priest came running to bring the key to the church so that everybody could see the tiles of the battle. By the time he awoke, it was already late, so he said his goodbyes and set off as quickly as possible.

The landscape is changing almost imperceptibly. To the north are the flat-lands the traveller has already crossed. To the south, it becomes more undulating. Beyond São Marcos da Ataboeira are two tall hills. The higher of them, Alcaria Ruiva, rises so steeply out of the plain that it looks artificial. From there on, the change is more noticeable: brush and scrub replace the fields, the hills are more pronounced, the valleys are deep and dark. In half a dozen kilometres or less, the plain gives way to the sierra. The traveller has seen the landscape change literally before his eyes.

He has never seen such a rapid transformation. That is why to him the land around Mértola is already the Algarve. He does not mean by this to take land away from the Alentejo to give it to the Algarve. If the traveller were to take away land, it would be in the following way: he would take land from the Alentejo to give to the people of Alentejo, take land from the Algarve to give it to the people living there, and starting from the north of Portugal, would do the same in the Minho region, the Trás-os-Montes region, and so on down through the entire country. That's what the traveller would do.

The River Guadiana, the river he played hide-and-seek with earlier, also runs through Mértola. This river was born beautiful and will end its days beautiful: such is its destiny, which it will have to fulfil. The traveller goes again to stare down at it, and sees it has lost none of its deep colour, nor any of its life, even when as now it flows between tranquil banks. It is part of its nature, like the cry of the hawk.

There is a climb up to the church, and it is shut. But the traveller is not upset: what today is a church was once a mosque, and this historical fact seems to warrant any number of bolts and locks. Why on earth the traveller should think so, heaven only knows. He is simply relating his thoughts. He knocks on a door, and is told the key is not there, but down in the village. He doesn't have to go and fetch it though, it's enough for the woman to let out a piercing yell that seems more like the call of the muezzin, and a few

70 *Mértola, on the R. Guadiana*

seconds later her neighbour comes up with not just one key but two. The first is to open a tiny shrine set into the wall, barely big enough for three people to stand in. This is the chapel of Senhor dos Passos. There is a big sculpture of Christ, dressed in red, with wounds on his feet, his hands, and his suffering face. But much more interesting are two small sculptures, one showing Christ on the cross, the other an *"Ecce Homo"*. Both show a well-built man, and are traditional enough apart from all the musculature shown – some of the muscles are the ones we all show when making an effort, others that only an athlete could exhibit. When the traveller expresses surprise at finding such outstanding works in such a tiny chapel, his companion seems to have been expecting the question. They tell him the wonderful story of how many years earlier a prisoner kept in Mértola jail spent all his many idle hours sculpting these two images of the Lord. But when the traveller wants to know more about the prisoner, the woman simply repeats the same story from the beginning again. In his frustration, the traveller decides the whole thing is an invention (all that's missing is that the prisoner was released as a reward for his work) and doesn't believe a word of it. Perhaps he was wrong. At the very least the story is a good one: the prisoner in his cell working away with his gouge, carving out not one but two Christs, not one but two keys, and most likely neither of them would open the prison door.

At that moment he heard a car pull up in the street outside, and the sound of lively voices. It's an Italian family who have come to visit the church that was once a mosque. The traveller was just leaving the chapel in the wall, and his companion was busy locking up; it was obvious that everyone was heading in the same direction, so he smiled at the family: father, mother and a girl around twelve years old. They move on from smiles to the attempt to speak to each other, in French at first, until he discovers that his broken Italian is enough to make himself understood. They start asking who each other is, why they are there, and the traveller discovers they have already seen each other back in Sintra, when he visited the Palácio da Vila and they were also being taken round by the guide. They had just come from the Algarve, where the traveller is headed: and Rome, how are things in Rome? It's always a good idea to ask Romans how things are in their city, except that if time hadn't been short and the woman standing there patiently with the key, they would have gone on for hours talking of the Piazza Navona, Sant'Angelo, the Campo de' Fiori, the Sistine Chapel. They are the Baldassari family, and own a modern art gallery in the Via F. Scarpellini, according to the cards exchanged between them and the traveller; it just shows that nothing is easier than making friends. They all go into the church. How marvellous!

exclaims the traveller. *Che meraviglia*, the older Baldassaris agree; only the young girl says nothing, contenting herself with a smile at the way these adults are behaving like children.

And the church at Mértola is as wonderful as both languages made out. Outside it, both Italian and Portuguese eyes had feasted on the crenellations, the buttresses, the round pinnacles and the belltower, as well as the Renaissance portal that is of a completely different style to all the rest, and yet still fits in. Inside they all admire the five naves, the open central area, the Gothic and horseshoe arches, the low cupolas, and the series of naive panels round the walls depicting the Stations of the Cross, such as the "Senhor da Cana Verde", showing Christ with his hands tied and his scarlet robe slipped from his bloody shoulders, a perfect portrait of suffering man, of all those who have been wounded, robbed, mocked. Looking at all this, the traveller has forgotten his new Roman friends, which is a shame. The Baldassari family are full of praise for the church, and the girl keeps on smiling – what will her memories be back in Rome when she thinks of the village of Mértola that has a church that used to be a mosque and that in the days when her ancestors were here went by the name of Myrtilis?

It's time for them to go their separate ways. The Baldassari family is going on to Monsaraz, while the traveller is heading south. They wish each other a good journey, *buon viaggio*, exchange smiles and handshakes, who knows whether they'll ever meet again. The traveller leaves Mértola and rejoins the main road. The landscape becomes harsh and rugged: who would think that a little further on, by the sea, lie the lands of pleasure, the honeypot that all the ants aim for? The traveller is doing his duty: he is going there and will report what he sees. If he seems not to be saying all there is to say, either it's his mistake or the reader is not paying enough attention. But some things are beyond doubt. Here for example, crossing the River Vascão, is where geography dictates that the Algarve really begins. About time too.

VI

OF THE ALGARVE, SUN,
DRY BREAD AND SOFT BREAD

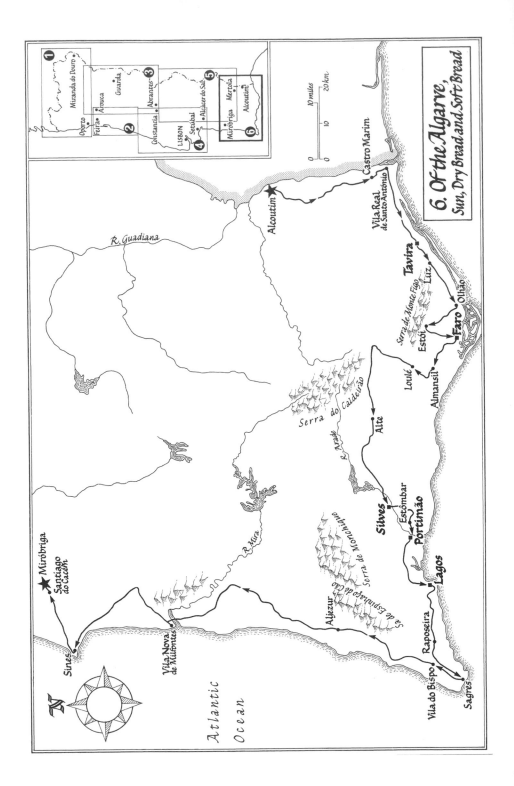

6. Of the Algarve,
Sun, Dry Bread and Soft Bread

Atlantic Ocean

The Director and his Museum

When the traveller was in Alcoutim, he saw perched on a hill a round and massive castle, that looked more like a truncated tower than a complicated military construction. He thought it would offer good views over the plain. But he was wrong. From a distance, he imagined it was still in Portugal, but in the end to get there he discovered he would have to cross the Guadiana, hire a boatman, show his passport – in short, it would be a whole other journey. The far side of the Guadiana is Sanlucar, and there Spanish is spoken. But the Portuguese and the Spanish town face each other like mirror images across the water, both of them with their white houses, both built as steeply as a Christmas crib. They must be very similar when it comes to laughter and tears as well.

Wherever the traveller arrives, he likes to strike up a conversation. Any excuse will do, and finding a former chapel that is now used as a shop and a crate warehouse is as good as any other. All the more so because at the back there is an altar with the sculpture of a saint on it. The traveller asks if he can go in. The sculpture is a fine one of St Anthony with the infant Jesus in his arms. How on earth does it come to be in here, in the midst of all the hammering and goods for sale, without even a prayer to console it? The traveller talks to the owner outside, sitting on the steps. He is a short, scrawny man of sixty or more years. He says: "It came down the river during the Civil War in Spain, and I found it." It could well be, the traveller thinks – the war was forty years ago, when the saint's saviour must have been around fifteen. "I wouldn't think of selling it. He's there for whoever wants to look at him. That's enough."

At that point a policeman comes up, attracted either out of curiosity or simply doing his duty. He's young, with a long, constantly smiling face. He doesn't say a word throughout the conversation. "The other day the priest was in here. He's a thin, stooped man: he came in and went down on his knees. He stayed a long while, then came up to me and spoke in that mishmash of Portuguese he speaks, yes, a mishmash, because he's Irish you see, he's only been here a year, they say he had to leave his own country, he spent

a week hiding in a tar barrel when there were troubles over there, I can't say when that was, but now he's living here anyway, and he told me that the saint should be in the church with all the other saints, but I told him that if anyone tried to take it they'd rue the day for the rest of their lives, and so the priest went off with his tail between his legs, and now whenever he comes by he looks the other way, as if he was frightened of seeing the devil." They all laugh at this, the traveller included, but deep down he feels sorry for this priest, all alone in a foreign land, who only wanted to have the saint for company – who knows, perhaps there was no St Anthony in the church.

They can see the church opposite them. It's at the top of a set of steps, and has a fine Renaissance portal. The traveller prepares to be disappointed as usual: either the door will be locked, or the priest will be away somewhere. But this priest is Irish, and used to the idea that the church should be open, so if there is no-one looking after it, that must mean he is inside. He was. Seated on a bench, like the priest in Pavia. When he heard steps, he got up, nodded his head solemnly, then sat down again. The traveller was so intimidated he did not dare open his mouth. He looked up at the magnificent capitals of the columns in the nave, the bas-relief in the baptistery, and then crept out again. Inside the front door were two easels with religious notices stuck on them: the hours of the Mass and other announcements, some of them in Portuguese, but mostly in English. The traveller suddenly wonders which land he is in.

He soon discovers. The land to his right, which rises in a series of waves that never reach higher than six hundred metres, and where the rivers struggle to flow forward, is Caldeirão, also known as Mu. A land of scrub and dry earth. The main roads seem to bypass it; the only ones that cross it are poor and few and far between. It's a harsh place, where even the names of the towns sound rough: Corujos, Estorninhos, Cachopo, Tareja, Feiteira. The story of the journey would be very different if the traveller had the time to venture into the interior of this dry plateau.

He probably owes a debt to Castro Marim too. He stopped here only to look at the beautiful archangel Gabriel in the town church, and walked up to the castle, attracted by the unusual red colour of its stone. Then, after looking round the original Arab fortress, he returned to the highway, and headed for Vila Real de Santo António. The sea is in sight, the waves gleam in the distance.

The traffic in Vila Real was crazy. The traveller, who had been hoping to take his time to savour the street layout designed by the Marquês de Pombal, found himself caught up in the game of snakes and ladders of the one-way system, soon discovering to his cost there were many more snakes than

ladders. This is where the village of Santo António de Avenilha was, until it fell into the sea. The Marquês de Pombal came down here to repeat in miniature the urbanistic feat he had pulled off in Lisbon, drawing straight lines and squares and succeeding – not him, but his architects – in conserving a neighbourly atmosphere. In the main square, the traveller particularly liked the attic windows, which looked too large for the buildings they were a part of, and yet managed to stay in harmony with the overall context of the town.

From there he went to Tavira, where he promised himself to return one day to see all he wanted to: the Carmo, Santa María do Castelo, the Misericórdia, St Paul. Impossible to detail all the doors he knocked at, all the people he stopped in the street. There was no shortage of information offered, but when he acted on it, either the person who should have been there wasn't, or whoever was there did not have the authority to show him round. The traveller made his way down to the quayside to soothe his troubled brow with the sea breeze, because even three paces inland he was in a baking oven. But, so near to the end of his adventures, he was determined not to admit defeat (die if he must, but he will see everything first) and continued on to Luz. Here fortune was on his side. The church is by the roadside, and appears as if by a happy coincidence – and this adjective is very appropriate, as the church of Luz de Tavira is easy to walk around because it has no other buildings close to it, and shows an unusual purity of style, heightened by a subtle use of colour, and is genuinely a happy church. Inside, this first impression is only reinforced, thanks to its wide naves and tall columns, its three baptismal fonts: anyone who arrives in Tavira feeling hot and bothered, should visit Luz, and may be fortunate enough to find the door open. And even if it is closed, he should feel contented with the view of the outside – that is reward enough.

The traveller did not see much in Olhão apart from an uninteresting parish church (which does, though, have a magnificent Baroque Risen Christ), but he did buy a bunch of grapes and make a discovery. The grapes, which he ate down on the fishermen's wharf, were not particularly sweet, but his discovery, in all modesty, was a brilliant one. It is related to the well-known story of the Moorish king married to a Nordic princess who was pining away for her snowy home country, which troubled the king greatly as he loved her a lot. The story goes that the king found a clever answer to the problem: he ordered his servants to plant thousands, millions of almond trees and then one day, when they all came into bloom, he went to the room of the palace where his princess was wasting away, and had all the windows flung open. Seeing the countryside covered in white blossom, the poor woman thought

it was snow, and immediately recovered. That's the legend of the almond trees, although nobody knows what happened next, when all the flowers turned into nuts.

But the traveller has always wondered the following: how was it possible for the consumptive princess to cling on to life until all the millions of almond trees grew and were ready to blossom? To his mind, this just goes to show that the legend is false. The traveller suddenly hit on the true story: the royal palace was in a city, or an important place like this one, and round it were houses, walls, all the buildings one finds in a town, all of them painted the colours their owners had chosen. Few of them were white. So then the king, seeing that his princess was on her death-bed, published a decree which said that all the houses had to be painted white, and that this should be done on a certain date, from one day to the next. And so it came to be. When the princess looked out of the window, she saw the city all in white, and this time there was no danger the flowers would wilt and die, so she really was cured. And that wasn't the end of the story. There are no almond trees in the Alentejo, but the houses are white. Why? Because the king ruled over that province as well, and ordered the same thing done there. The traveller finishes his bunch of grapes, thinks over his discovery and finds it convincing, and so tosses the old version of the almond legend aside.

In Estói, the traveller sought out the palace of the counts of Carvalhal and the ruins of Milreu. And just when he thought he was going to have to move heaven and earth to get into private property to see the palace and its gardens, he found a wooden gate that opened to his touch, and an avenue of trees welcoming him in. The only sign of life were two dogs, who were only bothered about the flies troubling them in the heat. All the time the traveller was inside, climbing and descending staircases, looking at all there was to see, nobody came to ask him to leave, or even to ask him what he was doing there. It was true that an iron gate giving on to a third part of the ruins was locked, but there was more than enough of interest on this side of it. Styles and tastes from the eighteenth and nineteenth centuries were mixed in the layout of the gardens, the profusion of statues and busts, in the balustrades, and the decorative tiles. Two large reclining statues of Venus and Diana had a background of tiles decorated with plants and exotic birds, creating a very Art-Nouveau effect. The busts on the mouldings showed the tranquil faces of Herculano, Camões, Castilho, Garrett, and, somewhat surprisingly, the Marquês de Pombal. If the traveller did not have such set ideas about Sleeping Beauty palaces, and if the mysterious evening light at Junqueira had faded from his memory, perhaps he would have adopted these gardens and

71 *Estói, palace of Counts*
of Carvalhal

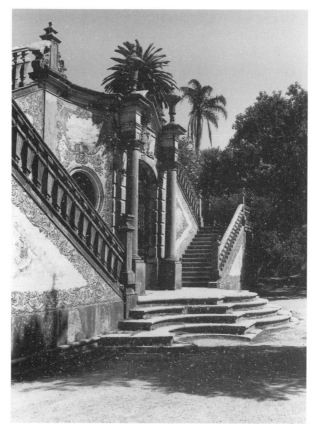

architecture. But the light here is too strong, and the deserted aspect of the
whole place robs it of mystery. So the traveller simply accepts what he is
given, and does not try to make too much of it: if he sees a pair of busts that
are the Emperor and Empress of Germany, he simply finds it curious, nothing
more. The lake is empty, and the harsh whiteness of the marble statues hurts
the eyes. The traveller sits on a bench, listens to the ceaseless chirrup of the
crickets, and is almost lulled to sleep. Or rather; he *was* lulled to sleep,
because when he opened his eyes again, he had no idea where he was. He
could visualise the ruined temple in front of him, imagined the fiestas that
took place there, with music, dancing, the couples strolling around or dis-
persing through the park, and slowly recovered his senses: life here must
have been good. Eventually he stood up, went over to look at some doors
with stained-glass panels, and peered inside. All he could see was the fine
Moorish stucco of the ceiling, some painted scenes from the birth of Christ:
the people living here must have wanted to see only the happy episodes

from the Bible. But the traveller cannot complain: he found a door open, so what more could he hope for?

The ruins of the Roman villa of Milreu are a bit lower down. They are dirty and neglected. Even so, they are the most complete Roman remains in Portugal. The traveller visited them under a noonday sun, and made what he could of them, but felt the need for someone to point out all the different parts to him, someone who could teach him to see. What he found hardest of all to understand was a ruined house at the top end of the site: in it he could see troughs for feeding animals, which gave on to rooms where people lived. So where did the animals get in? And what does the panel of tiles on the façade of the house mean, showing an old man and the Latin word Caritas, or charity? The traveller felt suddenly sad. Perhaps it was the ruins, or the heat, or his own lack of understanding. He decided to seek out places with more people, and continued on to Faro, the regional capital.

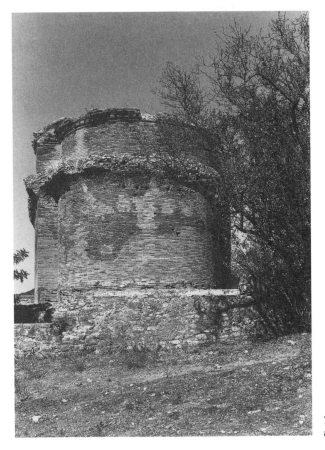

72 *Estói, ruins of Roman villa at Milreu*

The coast wind is waiting for him. But the traveller is so ragged from the heat, so depressed, that to receive this stiff sea breeze in his face is like taking a quick pick-me-up. For this alone, he would feel grateful to Faro. But there are many more reasons for his gratitude. It was here for example that in 1487 the second earliest Portuguese incunabula was printed. It may seem strange to praise Faro for being the birthplace of the second rather than the first printing feat, but the truth is that there is still a lot of debate as to whether Leiría was first with the *Coplas* by the Constable Dom Pedro, or Faro with its Pentateuch, produced in the workshop of the Jew Samuel Gacon. If the date of 1481 is correct, then Leiría was the first; if not, then Faro is the winner. Whatever the truth, to come second in such an illustrious race brings a laurel wreath as precious as that for the victor.

The traveller found the church of the Carmo closed, but was not too worried. To have to climb all those steps, even with the wind behind him, seemed a superhuman effort in this heat. So instead he headed for the nearby church of St Peter, to see and admire the multicoloured eighteenth-century tiles and the other blue-and-white ones in the Capela das Almas and, though recognising the beauty of the St Anne, above all the bas-relief showing the Last Supper, a profoundly humane scene of friends sitting round a table, eating roast lamb, bread, and drinking wine. Christ has a halo, which isolates him from the rest somewhat, but they are all sitting shoulder to shoulder, and the Judas portrayed in the foreground so that he cannot escape the indignation of the faithful, looks as though a few kind words would lead him to throw his thirty pieces of silver onto the floor, or put them on the table to pay the shared expenses of the meal.

From St Peter's the traveller went to visit the Cathedral. This part of Faro, inside the walls, is the Vila-a-Dentro, the old town. Ossóboa fell into a terminal decline, and then on its ruins a new town slowly emerged. Later, much later, the Arabs came and built their walls, and the town became known as Hárune in Arabic; from Hárune to Faro the distance in linguistic terms is not nearly so great as it might seem. Once he has entered the Porta da Vila, the traveller feels hot again. The wind has stayed outside, in the end it's a timid kind of breeze that does not dare penetrate these narrow, silent streets, and which even the square in front of the Cathedral cannot tempt to come out and play. Perhaps on the avenue of São Francisco, which used to be marshland, the wind will enjoy the open space and the river estuary. If he has time, the traveller might go and see: there's no point insisting on the church of St Francis anyway, because a disappointed traveller coming in the opposite direction tells him it is shut.

The Cathedral is definitely old: some of its stones date back seven hundred years. But since then it has seen so many adventures and misadventures (lootings, earthquakes, changes in taste and in power) that between Gothic and Renaissance, Renaissance and Baroque, it ended up losing far more than it gained. From its earliest phase there remains the magnificent tower-portal (which, even if the Cathedral itself were closed, would make the visit worthwhile) and in the interior, the end chapels of the nave. Apart from this there are Renaissance paintings, golden statues, plump marbles, and a wonderfully colourful eighteenth-century organ. The traveller did not hear how it sounded, but if its music gives as much pleasure to the ears as the sight of it does to the eyes, then Faro Cathedral is generous indeed.

The museum is nearby in Afonso III Square. It's run on a first come, first served basis – there's a guide who takes one group around for the allotted amount of time, and anyone who arrives too late has to wait for the next tour. This is an obvious remedy for poverty: when there are not enough plates for the whole family to eat off, they dip into the common pot; when there are not enough guides to have one in each room, the visitors have to go round in groups.

The traveller was lost in reflections of this kind, waiting his turn patiently, or rather showing his impatience by pacing up and down the ample courtyard that gives on to the cloister of what was once the convent of the Assumption, when he spotted a weary-looking man seated at a table that showed signs of having put up with many years of elbowing and bits of paper from our Portuguese bureaucracy. The man had the gentle face of someone who knows enough of life to take it seriously but also to laugh at it and at himself. The man gave a slight smile; the traveller paused in his pacing to acknowledge that he had noticed the smile, and the dialogue began: "You'll have to be patient. They won't be long coming out." The traveller replied: "I am patient. But people who are travelling don't always have the time to wait around like this." The man said: "There should be someone in each room. But there's no money for it." The traveller: "With all these tourists, there should be plenty of money. Where does it all go?" The man replied: "I've no idea! Would you like to know something? Some time ago we asked for the money to pay for labels for all the works, but we've only just received it." The traveller returned to his pet idea: "There should be attendants. Sometimes a visitor goes back to a museum just to look at one work or one room, and doesn't want to do a tour: all he might want to do is sit for an hour in that particular room or in front of that particular object. How can he do that here? Or in Aveiro, or Braganza, for that matter . . ." The man at the table smiled

again, and his eyes lit up: "You're quite right. Sometimes all one wants to do is to spend an hour looking at a single work of art." At which he got up, crossed the courtyard, and went into a small room at the far side of it. A few seconds later, he came out with a pamphlet in his hand. He said to the traveller: "Since I can see you're interested in this kind of thing, please take this, which tells the history of the place." Surprised, the traveller took the pamphlet. He thanked the man briefly, and then in just a few seconds, several things happened: the guide with his group of visitors arrived, another four people appeared, the traveller flicked through the pamphlet, and the man from behind the table disappeared.

After looking at the pamphlet more closely and asking the attendant a couple of questions, the traveller realised that the man must have been the director of the museum. Sitting there at a table empty even of official papers, with his weary air and his complaints about the lack of money, papering over grievances old and new with a smile, was the director. The traveller saw all the rooms, liked some better than others, accepted or rejected the temporary exhibitions being put on there, but understood above all that the museum at Faro is a work of stubborn love. And the best of what is there is worthy of a great museum. Take for example the room dedicated to the ruins of Milreu, with its Roman and Visigoth objects, or how other rooms recreate the atmosphere that sets off the works being shown, or the excellent collection of decorative tiles, or the mosaics brought here, or the explanations. The list only ends there due to lack of time. What Faro Museum needs is space to organise its collections, and money to maintain it. The guided tour comes to an end (with a surprise, a small room full of excellent works by Roberto Nobre, including a magnificent portrait of Manuela Porto) and the traveller looks into the courtyard for the director. He is nowhere to be found. He must be somewhere in his hidden world, perhaps to avoid seeing any suspicion of disappointment in the visitor's face. He need not have worried. The traveller has seen many museums, and likes them all. Yet this was the first where he saw the director sitting peacefully at the post-room table. The director and his constant, everlasting love.

Portuguese as She is Not Spoken

The traveller has a long way still to travel: if he can, he will go down to the beaches; if he can, he will have a swim. And he succeeded in doing so in Monte Gordo, in Armacão de Pêra and in Senhora da Rocha, in Olhos de Água and in Ponta João de Arães. Reading this list makes it sound as if it became a way of life , but each time was barely more than a quick dip, hardly enough time to get wet. And he deserved his reward, as on these beaches he is the palest person to be seen.

There is one person paler than him, however, and that is someone who will never travel again. As the traveller was climbing up to the church in São Lourenço de Almansil, he could see groups of men in black standing chatting in the atrium and the street next to the church. Then he saw the women, all sitting on benches outside the church waiting for the Funeral Mass to start. A sign on the door said in three languages: "To visit the church, call next door". The traveller is a specialist in this kind of thing by now, but does not need to put his skills to the test on this occasion, because the church door is already open. The person they are opened for is inside, in his coffin. The traveller did not bother to find out whether it was a man or a woman, he was not really interested. There are wreaths, the priest has not yet arrived, the women are sitting there whispering to each other. What should the traveller do? He can't walk up the side of the church because there is no room between the benches and the walls. He is worried he might never get any further than the threshold, when suddenly he gets the feeling (he can't explain it, but it is real enough) that nobody will mind if he does go in, if he makes his way between the mourners, makes his excuses, and as far as the unusual situation allows him to, admires the famous tiles by Policarpo de Oliveira Bernardes, the magnificent cupola, the jewel that is the entire church. Without offending the people waiting, and even with the discreet, silent permission granted by all those who move out of his way, he is able to admire these works full of life. As he left the church, the bell started tolling for the dead.

In Loulé nobody had died, it seemed. The parish church was locked, so was the Misericórdia, so was Nossa Senhora da Conceição. The traveller was at

least able to compare their portals and their façades – the former, all beautiful, the latter nothing special. But the finest portal of all was that of the Convento da Graça, with its richly ornamented capitals and archivolt. It's a shame that the building is in ruins, and that what is left has been damaged. The traveller looks round the centre of the town, has a drink in a bar where it seems all the thirsty people of the region have congregated, and continues on his way.

He is heading north, towards the hills. He crosses the River Algibre, close to Aldeia da Tôr, and after a thousand bends, or at least that's what it seems like, arrives in Salir. He decides not to stop, as he has no illusions about being able to see the famous bull issued by Pope Paul III in 1550, which is kept in the parish church there. It is said to be a beautiful illuminated manuscript. The traveller has seen others, so is not too despondent.

In Alte by contrast he was very lucky. Ten minutes later and this church too would have been shut. Church opening hours are hard to follow, whether due to times of Mass, the time of year, or from reasonable enough fears, because among the many thousands of light-footed tourists who flit through these towns, there are more than a few light-fingered ones too. If any of them turn up fifteen minutes later, they will find the church door slammed in their faces.

After São Lourenço de Almansil, the church at Alte is no River Lethe that leads one to forget everything else. Perhaps because at São Lourenço there was a perfect sense of unity between its Baroque architecture and the Baroque tiles. Perhaps because the Manueline style of this church does not go with decorative tiles, however hard they try to follow the strange distribution of volumes to be found in a style of architecture that is basically Gothic. Despite this, it would be crazy not to go and see Alte. You would miss the fine eighteenth-century angel musicians, the other angels with baskets of flowers on their heads, and the highly unusual tiles in the chapel of Nossa Senhora de Lourdes, tiles which do succeed in blending with their immediate architectural surroundings.

To those who think that all kinds of building stone are the same, a visit to the church of San Bartholomew at Messines is a must. Had it been made of granite, or ordinary limestone, or shiny marble, it would be very different from what it is, even if the stones were cut in exactly the same way. That is because its red sandstone, although dangerously friable, is still strong enough to have lasted through the centuries and in its uneven tones and the differing effects of erosion it shows, it is in itself another element of attraction. And the atrium, worked on by winds and rain, is fascinating because of its air of anticipated ruin. Inside, the twisted columns also of sandstone that support the round arches are wonderful, as is the rippled marble of the pulpit. In the

sacristy, the traveller was able to have a short conversation with the priest, a calm, wise man who looked up from the paperwork he was doing on a side table to answer all his visitor's questions and give information.

The traveller returns to the coast. He is aiming for Silves, and since he is in no hurry, he takes in the places, images, faces and words he overhears on the way. He remembers all those Albufeiras, Balaias and Quarteiras, advertising hoardings, signposts, reception desks, restaurant menus and information sheets, all of them written in such a wide variety of languages that he cannot find his own. He goes into a hotel to ask if there is a room free, and almost before he has opened his mouth they smile at him and reply in English or French. When he continues in his own native language of Portuguese, they respond to him sourly, even if it is to say that yes they do have one free. The traveller reflects how pleasant it would be on his journeys abroad to see the Portuguese language displayed in restaurants and hotels, in petrol stations and airports, to hear it spoken fluently by air hostesses and policemen, by the maid bringing breakfast and the wine waiter. But this is a mirage produced by the baking sun: Portuguese is not spoken outside these parts, my friend, it's only spoken by a few people, and they are too poor to count.

But the foreigners come to Portugal and we have to make them feel at home in a way the traveller would love to find himself made to feel at home in their countries. Good and fine things should be shared out equally, but in this case, the best goes to whoever can pay more. The traveller is not talking about helping others, but being servile to them. In this Algarve of ours, any beach that wishes to please calls itself not the Portuguese word praia but the English word beach; every pescador is a fisherman, and if we are talking about tourist resorts, they are all called either Holliday's Village or Village de Vacances or Ferienorte. Things have reached such a point that there is no word in Portuguese for fashion shop, it's either in English or is called a boutique, or Modesgeschafte in German. A sapataria is simply Shoes. And if the traveller started to mention all the names of nightclubs or *buates* (as the Brazilians call them in a spirit of unconscious revenge) he would not have got beyond the first letters of the alphabet by the time he reached Sines. Portuguese is held in such low esteem here that it could be said of the Algarve, where civilisation comes to enjoy its barbarism, that it is a place for Portuguese as she is not spoken.

The traveller will not complain any more. There on a high hill in front of him is Silves, with its high castle. If the Arabs who built it were still here, he would be happy to receive a menu from them in which he could read: grilled sardines, instead of this fancy Arab script on the one in front of him, which is

impossible to read even with a dictionary. The traveller finally understands that for the English, North Americans, Germans, Swedish, Norwegians, for the French and the Spaniards and sometimes the Italians who come here (but not the family he met in Mértola) Portuguese is simply an easier kind of Arabic. Just say yes to everything, and you'll be happy.

As the traveller has said, the castle was built by the Arabs. It is in ruins, but is still beautiful. And the red stone it is built from, like the church of St Bartholomew at Messines, lends it a strangely recent air, as if it were made of clay that is still wet from being moulded. The stonework must look even more beautiful when it is wet after rain. The traveller admires the huge well built in the middle of the esplanade, with its four columns like a mosque. And he also goes to look at the surprising invention of underground granaries they have also left.

The Cathedral at Silves is Gothic, with later additions that for the most part spoil it. But what is more important here than the architecture itself is once again the red sandstone, with its variety of tones ranging from almost yellow with a tint of blood red to a deep burnt-ochre colour. That it has been used to make a capital or a column, an arch or a simple decoration, is unimportant: the eyes do not see the shape or the function, they see only the colour. And when he has feasted enough on that, the traveller can see that Silves Cathedral has other attractions: the tomb of Bishop Dom Rodrigo, and João Gramaxo's or Gaston de la Ylha's. And also tiles and gilded carvings. But above all, the traveller wishes to take away with him the image of the dome over the transept, where the light is gloriously reflected: no two stones are the same colour, but together they form a marvellous painting.

Near the Cathedral is a stone cross known as the Cross of Portugal. Nobody knows how it got the name: there is no reason why here should be any more Portugal than anywhere else the Portuguese people has touched. Let's simply say that it is a magnificent example of Manueline art, fashioned like a gem. On one side it shows Christ crucified, and on the other the Virgin with the Dead Christ, and the two very dissimilar volumes are brought together with a sureness and freedom seldom matched elsewhere. The traveller hardly stopped in Lagoa. It was not the time of day to try the wine, particularly the sort which if the stomach has not been properly lined with food, leaves the drinker pleasantly warm after the first glass, and then if he unwisely insists, ends by taking his legs from him. It's a time instead for a glass of iced water. And so abstemiously he found his way to the parish church, with its remarkable painting of Nuestra Senhora da Luz, attributed to Machado de Castro-and let's hope the attribution is correct, because

that way we will know who we have to thank for this masterpiece of the Portuguese Baroque.

The traveller discovers that everyone is in a hurry on the roads of the Algarve. The cars are like hurricanes: anyone inside them is swept along. The distances between the towns are not seen as countryside, but as an inconvenience that has to be put up with. The ideal would be that between one town and another there were just enough room for the signs saying which one they were: that way everyone would save time. And if there were short and direct underground passageways between the hotels, rooms and rented apartments, restaurants, beaches and *boîtes*, we would see the incredible dream of being everywhere and nowhere really come true. Tourists who come to the Algarve obviously like to stick together.

The traveller himself is not entirely without blame in this regard, but since he is taking himself to task in this way, he will offer the excuse that having seen Lagoa, he had more things of interest awaiting him in Estômbar, and if he does not stop in either place as long as he would like, it's because he is not on holiday or *vacances* but is travelling in search of something. And searches, as is well known, are always anxious affairs. The best reward is to find something. Which is what happened in Estômbar.

Even the name of the town gives food for thought or for another search. In fact, the Algarve is full of odd names which only by convention or imposition from the centre could be called Portuguese. This is true of Budens and Odiáxere, and also of Bensafrim, which the traveller intends to visit, also Odelouca, which is a river up ahead, Porches, Boliqueime and Paderne, Nexe and Odeleite, Quelfes and Dogueno, or Laborato and Lotão, Giões and Clarines, Gilvrazino and Benafrim. But the search for the origin of these names, and how their roots have changed from ancient memory to today's necessity, is beyond the traveller's scope: that would need specialised knowledge and experience, not this simple act of looking and seeing, walking and coming to a halt, thinking and speaking one's thoughts.

Seen from the outside, the church at Estômbar looks like a miniature cathedral, as if the larger one at Alcobaça had been shrunk to fit into a village square. That in itself makes it a fascinating place. But it also has excellent eighteenth-century tiles and above all – ah, above all, it has two sculpted columns unlike anything else in Portugal. It seems to the traveller in fact that they must have been made in distant lands and brought here. They show (if you will excuse the traveller his fantasy) a Polynesian concern for leaving no surface empty, and the ornamental carving representing vegetation looks like what we call Amazon vines. None of the plants displayed in stylised form

looks like a native Portuguese specimen. It's true that the bases of the columns
represent hawsers (typical of the sixteenth century) and that the figures
shown are playing typical musical instruments from the same period, but the
overall impression is one of strangeness. Unfortunately for this hypothesis,
the sandstone they are made from is local. Perhaps the artist who sculpted
them came from somewhere else. Anyway, it's another little puzzle which
anyone who cares can resolve, just as the name of the village Estômbar itself
once meant something.

To reach Portimão you have to cross the bridge over the River Arade, if
river is the correct term in this estuary, because by now it is more a question
of the sea ebbing and flowing between the Praia da Rocha and the Ponta
do Altar than of the small water courses that flow down from the hills
of Monchique or Carapinha and converge here. The traveller went to the
church, and as usual found it closed. He was not too put out at this though,
because the best of the building is outside, namely the architrave showing
warriors which, although not in itself unusual in the fourteenth century
when churches were often also fortresses, in this case is out of the ordinary
because it shows both men and women in armour and carrying weapons.
The traveller would like to know how these Amazons got here. While it is
true that in those days there were female warriors, such as Deuladeus and
Brites de Almeidas, it is unheard of for them to be incorporated into the
regular troops, standing shoulder to shoulder with their male comrades-
at-arms. It was probably premonition on the part of the stonemason: he
realised that one day war would be total, and that women would have to
arm themselves just like men.

While talking of wars, this is the place to recall that the city of Lagos is
linked to the name of Sertorius, the Roman who commanded the Lusitanians
after the death of Viriatus. Although we normally associate the Lusitanians
with the mountains of Herminios or the Serra of Estrela, the fighting did
reach this far south. Sertorius, who had deliberately kept out of (or been kept
out of) the struggle between Marius and Sulla, was invited by the Lusitanians,
some eighty years before the birth of Christ, to lead them in their fight against
Rome. In those days, the concept of patriotism was much more flexible than
it is now, or there was no problem in subordinating it to the interests of a
particular group – which probably means that in fact it differed from today's
practices only insofar as nowadays we keep up more of a pretence. The fact
is that Sertorius accepted the invitation and, with two thousand Roman
and seven hundred Libyan soldiers, landed in the peninsula from Mauritania,
where he had taken refuge after several brushes with pirates. These are

complicated chapters in a general history which some people like to portray as simple: first there were the Romans, then the Visigoths and the Arabs, and then since there had to be a country called Portugal, Count Dom Enrique appeared, followed by his son Afonso, followed by more Afonsos, a few Sanchos and Joões, Pedros and Manuéis, with an interval to allow three Spanish Felipes to put in their appearance, after the death of an unfortunate Sebastião at the battle of Alcácer Quibir. That's all there is to it.

The ancient Lacóbriga, Lagos' Roman ancestor, was built on the hill of Molião. One day a certain Metellus, who was a supporter of Sulla, then the ruler of Hispania Ulterior (that is to say, the Portuguese part of the peninsula), decided to lay siege to Lacóbriga until they ran out of water, since he knew the town had only one uncertain well. Sertorius came to the town's aid, with men and two thousand wineskins of water, and when Metellus sent Aquinus with six thousand soldiers to meet him, Sertorius defeated them in battle.

Dom Sebastião, King of Portugal and the Algarve, also came to Lagos. In the towns walls there is a Manueline window from where, as tradition has it for lack of any real evidence, the king took part in an open-air Mass before his departure for Alcácer Quibir, where he not only lost his life, but Portugal lost its independence. If we look back at his reign, there is not much to thank him for, but the statue to him by João Cutileiro which stands in Gil Eanes Square shows him as a young and pure adolescent who has just removed his helmet after games of swordplay, and is waiting for his mother or his nurse to come and wipe the sweat from his brow and tell him: "What a silly boy you are!" The statue is almost enough to make the traveller forgive all the disasters that the half-witted, powerless and authoritarian Sebastião de Avis visited upon Portugal, which he has come to love even more now that he has travelled thousands of kilometres all round it and met so many of its people.

And since we are talking of Sebastião, next comes a visit to the church of St Sebastian. It's a steep climb up to it, and on the outside the most noteworthy feature is the door on the south side, a fine example of Renaissance art with its usual depiction of human figures, but here done with a great deal of subtlety, and in addition all the flora and fauna often found in this kind of work. Inside there is above all an image of Nossa Senhora da Gloria, larger than lifesize as befits the idea of glory, which should always be greater than the person winning it or being granted it.

Lagos also has a slave market, but it does not seem very proud of the fact. It is a kind of raised platform in the Praça da República, with pillars supporting the floor. This was where the auctions took place for the best price on a well-trained negro or a nubile negress with lovely breasts. There is

no telling whether they wore collars or not. When the traveller looked for the market, he almost missed it. The square is taken up with building materials and motorbikes: as if the modern day were trying to wipe away all trace of past stains. If the traveller were in a position of power in Lagos, he would have some sets of chains installed here, and a place to see where these human cattle were sold, and perhaps a statue of someone like Dom Enrique, who benefited so greatly from this trade.

To calm his spirits, the traveller finally went to visit the church of San António de Lagos. From the outside, it does not seem much: bare stone, an empty niche, a bull's-eye window surrounded by shells, the usual coat of arms. But once inside, after so many wearisome gilded carvings, so much wood carved in scrolls, palms, roots or vines, after so many double-chinned cherubs, plumper than decency recommends, after so many gargoyles and figureheads, it was time for the traveller to find all of this summed up and taken to its paroxysm within four walls, and yet somehow ennobled by its very excess. The master woodcarvers completely lost their heads in São António de Lagos: everything the Baroque age invented is here. It is not always perfectly executed, and not always in impeccable taste, but even these mistakes somehow help the overall effect: the eye stops and wants to make a critical judgment, but is immediately swept on in what the traveller can only describe as a devilish dance. Were it not for the edifying series of eighteenth-century panels depicting the life of St Anthony, said to be the work of the painter Rasquinho of Loulé, there would be serious doubts about the efficacy of any prayers said in a place like this, with so many worldly temptations displayed all around.

The wooden roof is barrel-vaulted, and painted in a daring perspective that continues the vertical of the walls, imitates marble columns, glass windows and finally, the vault itself, which seems much more distant than it really is. In the corners, the four evangelists peer down suspiciously at the traveller. Hanging from the ceiling is the Portuguese coat of arms as it was in the eighteenth century. This is the kingdom of artifice, of make-believe. But, and the traveller says this in all honesty, it is all wonderfully well done, and the geometrical challenges have all been superbly overcome. Who painted the ceiling? Nobody knows.

From the church one can move on to the museum, or visit it directly. Lagos has some good archaeological exhibits, well explained, dating from the palaeolithic times to the Roman era. The traveller particularly liked the pieces from the Iberian age: a bronze helmet, a small bone statue, ceramic pots, and much else besides. The statue is strange: one of its hands is across the chest,

the other across the sex, so that it is impossible to tell whether it represents a male or female figure. But what most demands a good look is the ethnographic section. It includes regional handicrafts, with a good display of rustic tools and implements, and some models of carts, boats, fishing tackle, and a water-wheel; but also some teratological specimens preserved in jars: a cat with two heads, a kid goat with six legs, and other objects that upset our notions of normality and perfection. But above all, the museum at Lagos has the best guide there could be (and could he be, as in Faro, the director of the museum, but too shy to admit it?): as the traveller was standing in front of a piece of lace or some object made of cork, or a dummy dressed up in regional costume, he could hear the guide's explanation whispered behind him, with invariably the final words: "the people". To explain it more carefully – imagine the traveller is looking at a wicker basket, perfectly shaped for the function it has to perform. The guard would tiptoe up and say: "a fisherman's basket". Then there would be a short pause, after which, as if he were saying who the work should be attributed to, he would add: "the people". There can be no doubt about it. As he reaches the very end of his voyage, in Lagos the traveller has heard the final word.

The museum contains collections of minerals, stamps, local history (thanks to Dom Manuel's gift), flags, pictures, parchments. To the traveller's mind, perhaps the most outstanding exhibit is the sixteenth-century diptych said to be the work of Francisco de Campos, showing the Annunciation and the Presentation. Just to see this would be reason enough to visit Lagos.

But now the traveller is headed for Finisterra do Sul. This is the world's end. Of course, there are villages, such as Espiche, Almadena, Budens, Raposeira, or Vila do Bispo, but they are increasingly few and far between, and were it not for all the holiday houses in their clusters, this could easily be the deserted wastes of the ends of the earth. The traveller is anxious to reach the end. He has still to visit the church at Raposeira, with its octagonal tower and sixteenth-century painting of Nossa Senhora da Encarnação, still beautiful despite being damaged, and the nearby chapel of Nossa Senhora de Guadalupe, built by the Knights Templar in the thirteenth century, which contains some of the finest capitals the traveller has yet seen, and further on he will gaze fascinated at the white dome of the church in Vila do Bispo, but will not be able to go in because the priest has just left for town and nobody knows where he is. But finally he aims in almost a straight line for the point at Sagres. From there he goes round the bay to the Cabo de São Vicente. This time the wind is blowing strongly offshore. There's an enormous wind compass here to help with directions. The wind and tide are right to

73 *Algarve, fishermen and their nets*

send out ships to discover the Spice Isles. But the traveller wants to go home. He can't go any further. From up on the cliff down to the sea is a vertical drop of fifty metres. Down below, the waves sweep silently against the rocks. Everything is like a dream.

The traveller is going to head north up along the coast. He will take in Aljezur, with its lines of houses in the lee of the mountain, Odemira, Vila Nova de Milfontes, and the gentle estuary of the River Mira, not in flood now, Sines with its ambitious breakwaters that the sea has already defeated, then on to other ruins at Santiago do Cacém, this time of the Roman town of Miróbriga, where the forum opens on to splendid countryside and conjures up images of Romans in togas strolling through the square as they talk of the harvests and the decrees from distant Rome. This is the country he is turning back to. His journey is over.

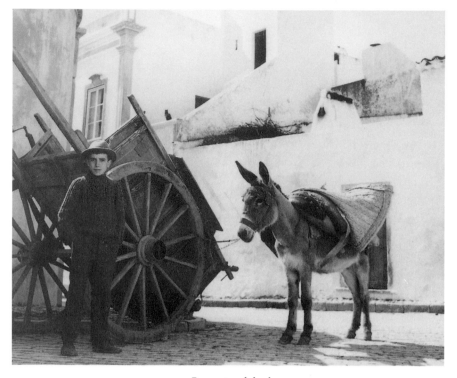

74 *Peasant and donkey*

The Traveller Sets Out Again

B ut that is not true. The journey is never over. Only travellers come to an end. But even then they can prolong their voyage in their memories, in recollections, in stories. When the traveller sat in the sand and declared: "There's nothing more to see," he knew it wasn't true. The end of one journey is simply the start of another. You have to see what you missed the first time, see again what you already saw, see in springtime what you saw in summer, in daylight what you saw at night, see the sun shining where you saw the rain falling, see the crops growing, the fruit ripen, the stone which has moved, the shadow that was not there before. You have to go back to the footsteps already taken, to go over them again or add fresh ones alongside them. You have to start the journey anew. Always. The traveller sets out once more.

THE END

INDEX

Figures in italics indicate illustrations